ANTIQUITY IN

THE RENAISSANCE

MFA Objects. Cat. no. 2, 14,27,28,29,45,60,68,78,80,88,102,111

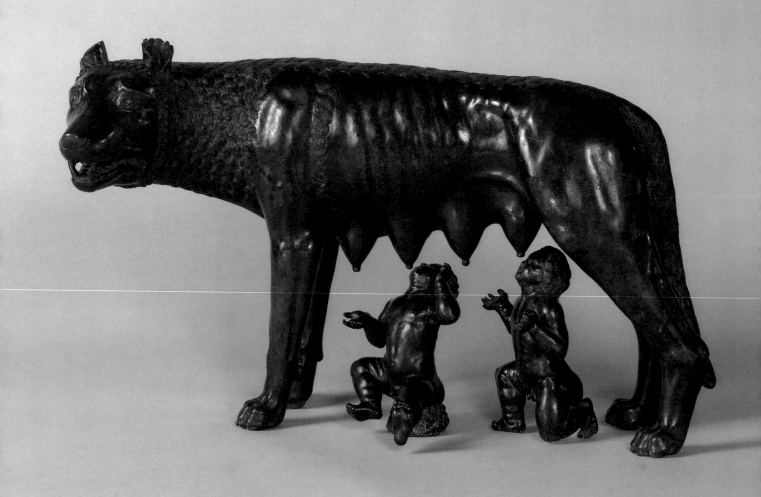

ANTIQUITY IN
THE RENAISSANCE

by Wendy Stedman Sheard

Catalogue of the Exhibition Held
April 6–June 6, 1978

SMITH COLLEGE MUSEUM OF ART

NORTHAMPTON, MASSACHUSETTS

ANTIQUITY IN

THE RENAISSANCE

Dedicated to

PHYLLIS WILLIAMS LEHMANN

This publication was made
possible by the
generosity of

Irene Rich Clifford
Priscilla Cunningham '58
Enid Winslow '54
an anonymous donor
and the
Museum Members/Smith College Museum of Art

Advisers
Phyllis Williams Lehmann
James Holderbaum
Lilian Armstrong
Phyllis Pray Bober
Suzanne Boorsch
David Alan Brown
James Draper
C. Douglas Lewis, Jr.
Konrad Oberhuber
Michael Vickers

Exhibition Officer: Charles Chetham
Curator of Exhibition: Wendy Stedman Sheard
Exhibition Design: Charles Chetham
 David Dempsey
Editorial: John Lancaster
 Linda Muehlig
 Sarah Ulen
 Ruth Mortimer
 Mina Kirstein Curtiss '18
 Charles Chetham
 Jane Shoaf '78
Catalogue Design: John Lancaster
 Charles Chetham
Type: Eastern Typesetting Company
Printed in U.S.A. by The Meriden Gravure Company

Published by the Smith College Museum of Art, Northampton, Massachusetts, with funds provided by Irene Rich Clifford, Priscilla Cunningham '58, Enid Winslow '54 and an anonymous donor. Additional funds provided by Elaine Loeffler '50, Sue Welsh Reed '58 and Museum Members/Smith College Museum of Art

ISBN 0-87391-016-8 soft cover

Photographs have been supplied by lenders and the following photographers: Herbert Vose, Jane Shoaf, and David Stansbury

Lenders

United States

	Anonymous lenders
Baltimore	The Walters Art Gallery
Boston	Museum of Fine Arts, Boston
Brunswick	Bowdoin College Museum of Art
Cambridge	Fogg Art Museum, Harvard University
	Houghton Library, Harvard University
	Henri Zerner
Chicago	The Art Institute of Chicago
Cleveland	The Cleveland Museum of Art
	Heinz Schneider
Detroit	Kenneth E. Swoik
Haydenville	Phyllis Williams Lehmann
Houston	The Museum of Fine Arts, Houston
Middletown	Davison Art Center, Wesleyan University
New Haven	Yale University Art Gallery
New York	The Metropolitan Museum of Art
	The New York Public Library
	The Pierpont Morgan Library
	Mr. and Mrs. Mark Salton
	Ian Woodner Family
Northampton	Smith College Museum of Art
Princeton	The Art Museum, Princeton University
	Princeton University Library
Providence	Museum of Art, Rhode Island School of Design
Washington, D.C.	National Gallery of Art
Wellesley	The Wellesley College Museum
Worcester	Worcester Art Museum

France

Paris	Ecole Nationale Supérieure des Beaux Arts,
	Musée du Louvre, Cabinet des dessins

United Kingdom

Devonshire	The Trustees of the Chatsworth Settlement
London	The British Museum
Oxford	Ashmolean Museum
	Bodleian Library

West Germany

Berlin	Staatliche Museen Preussischer Kulturbesitz

Acknowledgement

Antiquity in the Renaissance, organized by Wendy Stedman Sheard, was held at the Smith College Museum of Art from April 6 to June 6, 1978. Accompanying the exhibition of 131 objects borrowed from major American and European public and private collections were lectures by distinguished art historians, concerts, and receptions. All events were dedicated to Phyllis Williams Lehmann as a mark of respect for her contributions to her field and affection felt for her by her colleagues and students.

The introduction to the *Check List* points out that planning for the exhibition began several years earlier. "In a conversation with James Holderbaum, then Chairman of the Department of Art, Smith College, and with me, Phyllis mentioned that among her most pleasurable teaching experiences at Smith were the seminars she gave with the late Ruth Wedgwood Kennedy, Professor of Renaissance Art. These seminars studied the rediscovery of ancient art and its influence in the Renaissance. With that the focus of our exhibition was set . . . Wendy Sheard, who had taught Renaissance art at Yale and at Smith, was asked to become the guest curator. The germ of the exhibition's conception was provided by Mrs. Lehmann's studies on Cyriacus of Ancona in Samothrace and on Mantegna's *Parnassus.* The resulting double focus on the dawn of archaeology and the role of Andrea Mantegna in antique revival was expanded by Mrs. Sheard to include other aspects of artists' uses of antique art in the Renaissance. She selected the objects to be requested for the exhibition. . . . " During the selection process, Mrs. Sheard received valuable advice from Lilian Armstrong, Phyllis Bober, Suzanne Boorsch, David Alan Brown, James Draper, W.S. Heckscher, C. Douglas Lewis, Jr., Konrad Oberhuber, Richard Stone, and Michael Vickers.

The assistance of each contributed considerably to the unusually generous response to loan requests. We are particularly indebted to the many lenders. Except for those who wish to remain anonymous all are listed.

During the preparation of the exhibition and the work on the catalogue we received much information from colleagues on both sides of the Atlantic. While we cannot note the specific kindness of each, we can acknowledge their assistance by including their names in the following list.

Ashmolean Museum
H. J. Case, *Keeper, Department of Antiquities*
Kenneth Garlick, *Keeper, Department of Western Art*
Hugh Macandrew, *Assistant Keeper, Department of Western Art*
P. R. S. Moorey, *Senior Assistant Keeper, Department of Antiquities*
D. T. Piper, *Director*
Gerald Taylor, *Senior Assistant Keeper, Department of Western Art*
Michael Vickers, *Assistant Keeper, Department of Antiquities*

The Baltimore Museum of Art
Jay M. Fisher, *Assistant Curator of Prints and Drawings*

Museum of Fine Arts, Boston
Kristin Anderson, *Assistant, Department of Classical Art*
Christina Corsiglia, *Assistant, Department of European Decorative Arts and Sculpture*
Jan Fontein, *Director*
Robert C. Moeller, *Curator of European Decorative Arts and Sculpture*
Jeff Munger, *former Assistant, Department of European Decorative Arts and Sculpture*
Sue Welsh Reed, *Assistant Curator of Prints and Drawings*
Eleanor A. Sayre, *Curator of Prints and Drawings*
Barbara Shapiro, *Assistant Curator of Prints and Drawings*
Stephanie Loeb Stepanek, *Curatorial Assistant, Department of Prints and Drawings*
Cornelius C. Vermeule, III, *Curator of Classical Art*
John Walsh, Jr., *Mrs. Russell W. Baker Curator of Paintings*

Bodleian Library, Oxford
Bruce Barker-Benfield, *Assistant Librarian, Department of Western Manuscripts*
Margaret Crum, *Department of Western Manuscripts*
Robert Shackleton, *Director*
D. G. Vaisey, *Keeper, Department of Western Manuscripts*

Bowdoin College Museum of Art, Brunswick, Maine
Katharine J. Watson, *Director*

Brandeis University
Elaine Loeffler, *Associate Professor of Fine Arts*

The British Museum, London
J. A. Gere, *Keeper, Department of Prints and Drawings*
David Wilson, *Director*

Bryn Mawr College
Phyllis Pray Bober, *Dean of the Graduate School of Arts and Sciences*

University of California, San Diego
Sheldon A. Nodelman, *Professor of Art History*

The Trustees of the Chatsworth Settlement
Thomas S. Wragg, *Librarian and Keeper, Devonshire Collections*

The Art Institute of Chicago
Harold Joachim, *Curator of Prints and Drawings*
Evan Maurer, *Curator of Primitive Art*
Suzanne Folds McCullagh, *Assistant Curator, Department of Prints and Drawings*
The late John Maxon, *Vice President for Collections and Exhibitions*

The Cleveland Museum of Art
Arielle P. Kozloff, *Associate Curator in Charge, Department of Ancient Art*
Sherman E. Lee, *Director*

Yale University Art Gallery
James D. Burke, *former Curator of Drawings and Prints*
Susan Matheson, *Associate Curator of Ancient Art*
Andrea Norris, *Assistant to the Director*
Edmund P. Pillsbury, *Curator of European Art; Director,*
The Yale Center for British Art and British Studies
Alan Shestack, *Director*

Art and Architecture Library, Yale University
Judy Bloomgarden, *Technical Services Librarian*
Nancy S. Lambert, *Librarian*

Classics Library, Yale University
Carla Lukas, *Librarian*

Individual
Elsbeth Dusenbury
Michael Hall
Marjon van der Meulen
and others who wish to remain anonymous

Although Mrs. Sheard's extensive catalogue was complete well before the opening of the exhibition, for all too familiar financial limitations the Museum was unable to publish more than a check list. During the run of the exhibition and in the months following, many who were enthusiastic about it decided that the catalogue must be published. A large number became pre-publication subscribers. These patient individuals who have waited more months than any of us want to think about have earned our sincerest gratitude. Irene Rich Clifford, whose beautiful voice and presence still lives in the memory of those who know the history of film and of radio, made two extremely generous gifts to the Museum expressly for the catalogue. At the same time, two members of the Museum's Visiting Committee, Mrs. Priscilla Cunningham and Enid Winslow, asked that their gifts be used for it. This support combined with funds from the Museum Membership allowed us to publish.

The task of preparing the manuscript for the press was the work of a team of persons some of whom are members of the Museum staff, others not. Linda Muehlig, Curatorial Assistant at our Museum, and Sarah Ulen, now Museum Registrar, shared the major portion of responsibility for this publication with John Lancaster, Special Collections Librarian and Archivist, Amherst College. In earlier stages, the noted author Mina Curtiss (Mina Kirstein '18) edited a goodly portion of the publication as did Linda Muehlig, Sarah Ulen and the undersigned. Jane Shoaf '78, now assistant in Prints and Drawings at the Morgan Library, assisted in checking details and in numerous other ways. All read proofs. Both John Lancaster and Ruth Mortimer, Curator of Rare Books, Smith College, offered helpful suggestions for the catalogue entries on books in the exhibition. John Lancaster and the writer designed the publication, and John Lancaster, Linda Muehlig (who also prepared the index) and the undersigned saw it through the press.

Charles Chetham
Director, Smith College Museum of Art

Introduction

Cyriacus and Mantegna: Recording and Transforming

Two figures, one an amateur archaeologist, the other an artist unsurpassed in inventiveness and technical skill, played key roles in the fifteenth-century revival of antiquity. Though he lacked professional competence, the first, Cyriacus of Ancona (c. 1391–1455), nevertheless succeeded in conveying the essential quality of the antique motif, if not its style, in his sketches and written descriptions. The second, Andrea Mantegna (1431–1506), investigated all aspects of classical, especially Roman, culture more rigorously and with greater emphasis on archaeological accuracy than any other artist or scholar of his time. Phyllis Williams Lehmann, to whom this exhibition is dedicated, has published major studies on these two men.[1]

Although both were enormously influential in the fifteenth and sixteenth centuries, Cyriacus and Mantegna exemplify remarkably different approaches to Greek and Roman antiquity. Cyriacus regarded the remains of the past as a vast treasure house of wonder and enchantment. With inexhaustible curiosity and diligence he recorded whatever he saw in his unusually wide-ranging travels. As Phyllis Lehmann has shown, Cyriacus recorded and interpreted the scattered physical remains he encountered so knowledgeably because of his careful reading of such classical authors as Strabo. To judge from the numerous copies of his drawings that circulated throughout Italy and elsewhere in Europe, humanists as well as artists profited from his experience through the unique records he made (1).

Mantegna, on the other hand, transformed the fruits of his own research into some of the most awe-inspiring monuments of fifteenth-century art. Although examples of his achievement in painting cannot be included in this exhibition, they are evoked by engravings whose compositions and figural motifs were a part of the same process of gestation that gave birth to such masterpieces as the *Triumph of Caesar* panels (10, 11) and the canvases for Isabella d'Este's *studiolo* (14).

Many of the works of art assembled here in honor of Phyllis Lehmann were selected to illuminate the contrast between Cyriacus and Mantegna, one artist recording antiquity and the other transforming it. Additional objects were chosen to illustrate the often bewildering diversity of the many other uses of antiquity in Renaissance art.

The most obvious use of antique art by Renaissance artists, and thus the easiest to illustrate, is their literal study of specific monuments. Drawings are the commonest form of this kind of recording (16, 18, 19, 22, 23, 26–29, 46–48, 53, 62). The making of visual records of the remains of classical antiquity began at least as early as 1400 and possibly even earlier. Later artists, such as the anonymous master of the *Codex Escurialensis* (c. 1490) and Amico Aspertini (1475–1552), for example, made hundreds of drawings after antique sculpture and architecture. For many Renaissance artists some experience with this process of direct recording seems to have been a necessity to profit from the repertory of types and the mastery of anatomy and pathos that antique art had to offer. The translation of large marbles into small-scale bronze replicas (17, 24, 42, 57, 61) served a similar purpose both as artistic education and as a conduit for the widespread transmission of knowledge about the principal works of antique art in Rome.

The assimilation of antiquity was not steady and consistent. The influence of architectural and sculptural types and a change in the sense of volume employed in these can be seen as early as the reign of Frederick II Hohenstaufen (1215–50) and a short time later in the sculpture of Nicola and Giovanni Pisano (1258–1315). Giotto's Arena Chapel frescoes (c. 1304–5) represent an early apogee of the reintroduction of classical values of monumentality and the illusion of physical mass into painting. After his death, the impetus to incorporate classical values in the arts was for a time in abeyance. More than a half century later, in the Porta della Mandorla of the Florence Cathedral, artists again show an awareness of the antique ideal of human physical beauty. Ghiberti's competition relief, the *Abraham and Isaac* of 1401, reveals the new and decisive stage of antique revival in full bloom. Now too the antique subject matter, which persisted throughout the Middle Ages, is couched in a morphology and style recalling classical counterparts that had begun to be revived and to be appreciated with a greater depth of understanding.

Identifying the antiquities which contributed to the genesis of the works of such masters as Ghiberti and Donatello has proven a difficult task for art historians. These artists rarely if ever copied antique motifs exactly. Donatello's "Atys-Amorino" (c. 1440, Bargello) presents antiquity as the very stuff of contemporaneity. An ancient model inspired the work, but the Donatello sculpture has become something wholly new. For Donatello, as for Masaccio as well, the re-creation of antiquity was an aspect of a unique personal style. For this reason their achievements in absorbing antique art did not become the basis of a period style.

Our modern conception of antique art, of course, differs markedly from that of Renaissance artists and humanists, for whom many of the descriptions of art in ancient literary sources stood tantalizingly alone without reference to any known works. Today we are familiar with many more excavated sculptures. We know more about their origins than did artists in central Italy in the early to late fifteenth century. For them only a rudimentary idea of antique stylistic evolution could exist. Although adumbrated in classical literature, no application to extant art rendered concrete the famous names of antique artists and their works. Pog-

gio Bracciolini (1380–1459), for instance, writing c. 1431, just before both Donatello and Alberti visited Rome, stated erroneously that only six commemorative statues once displayed in ancient Rome were still *in situ.* He listed the *Horse Tamers* on the Quirinal Hill, the so-called *Marforio,* a colossal River God near Santa Martina at the foot of the Capitoline Hill, the equestrian statue of Marcus Aurelius in a field in front of the basilica of St. John Lateran, and two other river gods. He failed to include statues of Constantine and his three sons, also on the Quirinal Hill, and antiquities in private collections, such as the *Torso Belvedere* belonging to the Colonna family. Omitted, apparently because they were no longer *in situ,* was a group of bronzes of obvious importance and renown even then. The *She-Wolf* (17), the *Spinario,* the *Camillus,* and the colossal head and hand possibly of Constantius II were displayed on columns at the Lateran palace.

The single most important class of antiques not mentioned by Poggio was reliefs. These came from sarcophagi, some re-used in altars, tombs or walls of medieval churches, and they formed the major source in the quattrocento for knowledge of antique figural motifs. Sarcophagi preserved in the Campo Santo, Pisa, were equal in importance for artists working in Florence to those in Roman churches for Roman artists. The sarcophagi then available can be reconstructed with the help of collections of drawings after the antique made in the late fifteenth and early sixteenth century.

The reliefs encircling the columns of Trajan and Marcus Aurelius were not mined as sources much before 1475, perhaps owing to their relative inaccessibility. Trajan's column first appears as a major source for sculptural style in Sixtus IV's ciborium for the high altar of St. Peter's (c. 1475–80). At about the same time, Mantegna's interest in ancient art began to be concentrated increasingly on monumental prototypes. Accordingly, motifs derived from the great Trajanic frieze and other relief on the Arch of Constantine, as well as reliefs on the Arch of Titus, the Ara Pacis, and the "Altar of Ahenobarbus," appear in his *Triumph of Caesar* panels begun in the 1480s, and in engravings related to them (10, 11). His visit to Rome (1488–90) provided opportunities for first-hand study of these monuments and others hitherto known only through sketchbook renderings. Meanwhile a very different compilation of antiquities in Rome had been undertaken—one that drew on literary texts, inscriptions and personal inspection of the sites. This was Flavio Biondo's *Roma instaurata,* written between 1444 and 1449. It remained the only comprehensive and systematic study of Roman archaeology for a hundred years.

The Body in Repose and Action

Artists looked to antique examples to aid them in representing the human figure, draped or nude, standing at rest or engaged in vigorous action. Artists of long-past civilizations had mastered the secret of re-creating Nature in bronze and marble. Looking at their works was considered a part of the study of Nature itself. By 1421, Donatello, Nanni di Banco and Ghiberti had each based the drapery of large-scale sculptures for Or San Michele on antique types. After that, the *all'antica* mode dominated figure sculpture whether in tomb allegories (Michelozzo's *Faith* for the Aragazzi tomb in Montepulciano of c. 1430, for example) or angels. Drapery in the antique manner began to signify the advanced outlook of an artist—or of a patron (39, 68, 102, 107). Contexts varied from the popular (12, 13) to the sacred (40). A new significance was perceived in the relationship between body and covering drapery. It could reveal anatomical structure and movement as well as the shape of sculptural volume and could even provide decorative line. A century later, classicizing drapery, even when incompletely understood, was an important ingredient of High Renaissance *gravitas* (24, 26, 102).

Early innovative examples of antique canons of proportion and anatomy in Renaissance art should be borne in mind when assessing the adoption of Polykleitan types. An outstanding example of a Polykleitan type rendered at small scale preserved from antiquity is the bronze *Athlete Offering a Libation* (Louvre, 30). Juxtaposition with the life-sized marble figure of the same type from the Wellesley College Museum (31) provides an idea of the range of scale and medium that antique art offered to Renaissance artists. Like Polykleitos in the fifth century B.C., quattrocento and cinquecento artists were concerned with the problem of ponderation or contrapposto (34, 35, 59). The Greek sculptor's several variations on this theme offered solutions that were eagerly explored. In Renaissance sculpture, as in that of antiquity, the female nude appeared later than the male nude. When it did appear, as Eve, a long-torsoed, small-breasted figure type like that of the bronze *Aphrodite* (36) was followed (for example, Antonio Rizzo's *Eve,* before 1485, Venice, Palazzo Ducale; compare 37). Later, the modesty of the *Venus pudica* pose abandoned, Venus was allegorized as a Christian Virtue (38).

As a general method of learning anatomy the study of live nude models did not begin before the 1470s and the dissection of corpses for anatomical study was only just beginning when Michelangelo took up the practice in the early 1490s. Thus during most of the fifteenth century study of anatomy meant study of antique sculpture. This was true for anatomy at rest or in motion (44). The body in vigorous action became a specialty of Antonio Pollaiuolo. The program of his *Battle of the Nudes* may commemorate the death of a powerful Florentine, probably a Medici, by evoking an an-

cient funerary ritual adopted by the Romans from Etrurian custom. This mortal gladiatorial combat places the "great engraved double frieze" even more squarely into the context of antique revival than some previous interpretations had done.[2] Many of the poses found in this engraving to express agonistic conflict can be related to types known from Hercules sarcophagi. They also echo Pollaiuolo's large *Labors of Hercules* paintings for the Medici of 1460. These poses in turn formed the starting point for Rosso Fiorentino (1495–1540) in the designs for his series of the *Hercules Labors* commissioned by Baviera in 1526 (engraved by Caraglio, 95–97).

The Sixteenth-century Canon, High Renaissance Classicism, and the Image of Rome

Brunelleschi (1337–1446) and Donatello founded what might be called the artistic tradition of archaeological study, in which inquiry into the formal principles and variety of types of antique art took precedence over antiquarian aims. Early in the quattrocento they studied and drew Roman remains. Their notebooks, if they ever existed, do not survive. Several drawings, however, scattered throughout European museums, do record the comparable activity of Gentile da Fabriano and Pisanello in the 1420s (16). Two monumental sketchbooks preserve Jacopo Bellini's drawings of antique monuments and imaginary buildings *all'antica*. The drawing of a *Horse Tamer* attributed to Fra Angelico or a follower of Filippo Lippi (47) offers an idea of mid-century artistic attitudes to monumental Roman art. The artist studied the pose of the *Dioscure*, but lacked the fundamental understanding of anatomy necessary to make its dynamics convincing.

The *Codex Escurialensis* was copied c. 1490 by an assistant to Domenico Ghirlandaio from the large Vatican sketchbook of Giuliano da Sangallo and Ghirlandaio's own sketches of antiques. Its additions and omissions illustrate changes in artistic taste at the end of the century. This book represents the opening salvo in a veritable explosion in the copying of antique art. The style of drawings after the antique by Martin van Heemskerck (1498–1574) (48) or by Amico Aspertini (22), whose three sketchbooks, executed in the early 1530s, one at Castle Wolfegg, Wuerttemberg, the other two in the British Museum, climax the first intensive phase of copying antiques. They retain "the freedom and simplicity of a highly personal style"[3] when compared to the more formalized, objective style of post-1550 drawings (26–29).

In the 1490s greater attention began to be focused on antique free-standing statues as opposed to reliefs. A group of these statues gradually began to be regarded as a canon, knowledge of which became required in the visual education of artists. It included the *Apollo Belvedere*, the *Torso Belvedere*, the *Hercules and Antaeus*, the *Cleopatra* (Ariadne), the *Tiber*, the *Laocoon* and the *Dioscuri*. By early 1512, all but the *Torso* and the *Dioscuri*, which remained on Montecavallo, had been installed in the sculpture garden of the Vatican Belvedere. This garden sought to re-create the *locus amoenus*, or place fit for quiet pleasure, contemplation and divine inspiration, of a classical villa. The *Torso* reached the Belvedere only after the Sack of Rome in 1527 had provided Pope Clement VII with a means of taking it from the Colonna family. Four of these works have been singled out for the exhibition to exemplify the range of recording, reproduction, and transformation possible for antiquities. These are the *Dioscuri* or *Horse Tamers* (47, 48), the *Apollo Belvedere* (49–55), the *Torso Belvedere* (56, 57) and the *Laocoon* (60–64).

The style in painting and sculpture associated with the High Renaissance in Rome was connected intimately with the group of antique sculptures that formed this canon, most especially with the *Apollo Belvedere*, the *Torso Belvedere* and the *Laocoon*. The *Apollo Belvedere* was probably discovered during the papacy of Innocent VIII (1484–92). Dating from the Hadrianic era (A.D. 117–138), it is thought to be a copy of a Greek bronze which stood in front of the Temple of Apollon Patroos in Athens. The original was by Leochares, a collaborator of Skopas on the Mausoleum of Halicarnassus. Soon after its discovery, when drawings of the *Apollo* began to circulate, its effects became noticeable in sculpture and in graphic art (49, 51, 54). Many Renaissance artists seem to have thought its pose ideally suited to display the proportions and anatomy of man in the most perfect way possible. Dürer and other artists who used the *Apollo*'s pose for images of the ideal human figure paid tribute to the achievement that underlay the Hadrianic statue, even though that figure appears to us today a somewhat mechanical copy. This synthesis of a standing and a walking figure brilliantly combining the formal beauties of both included a gesture, unexplained in the original fragment and interpreted by one artist as holding out a torch (Musée Bonnat 704 bis) that further animated the pose and enlivened the expression. The *Apollo*'s diagonally constructed contrapposto provided artists at the turn of the sixteenth century with a more complex three-dimensional system. Self-containment was lost as a result of the expansive gesture, but the chlamys could be seen as a relief plane, especially in the aspect adopted as the principal view. In the paradoxical nature of its formal complexity, the statue must have seemed the next logical step in the investigation of contrapposto after the solutions offered earlier by Donatello and Verrocchio.

The numerous angles from which they drew it suggest the fascination the *Apollo Belvedere* had for Renaissance artists. They may have been seeking its most effective aspect, or they may well have been impressed with the fact that it could be seen effectively from several viewpoints. Each view, in fact, reveals some new potentiality of the *Apollo*'s form or expression. This antique was analyzed and studied exhaustively in the period c. 1500. These studies may well have led to the

cinquecento ideal of incorporating movement into figures even when portrayed standing still or in repose.

The coexistence of extremes of physical movement and heroic emotion and suffering implicit or explicit in many monuments of Hellenistic art was dramatically illustrated by the discovery of the *Laocoon* (1506), a work whose immediate fame and influence was, if anything, even greater than that of the *Apollo Belvedere*. The type of heroic torso in exaggerated contrapposto, seen in the elder priest of the *Laocoon* group (62), was also to be found in the flexed, twisted posture of the *Torso Belvedere*. Both works provided a visual metaphor, not only for suffering but for the nobility of spirit that transcends suffering and renders it redemptive. Michelangelo's Medici Chapel Allegories of the Times of Day exemplify the best known adaptations that achieve this exalted meaning. The strained muscles of Pollaiuolo's warriors are now abandoned in favor of heroic scale. By the High Renaissance the pose itself has acquired a significance that embraces more than the simple representation of human action (63).

The early sixteenth-century core of canonical statues together with the sarcophagi in Rome (which by then had been well studied in the various compendia of drawings) was gradually expanded. A list of at least 167 subjects eventually made up the catalogue of the publisher Antonio Lafreri (1512–77), who began distributing series of engravings from Rome c. 1544. Lafreri was taken on as the partner of Antonio Salamanca, the most successful engraver-publisher in Rome, in 1553. After Salamanca's death in 1563, Lafreri was the foremost dealer in prints in Rome until his death, after which his business was continued by his heirs Etienne and Claude Duchet (1579–86) and Claude's heir Giacomo Gherardi (1586–94). Although some contemporary art and events were included in the series, Lafreri's prints mainly depicted antiquities—architecture, fragments, inscriptions and small-scale works as well as statues, sarcophagi and monumental reliefs. In the 1570s sets of them, called *Speculum Romanae Magnificentiae* after the title page by Etienne Dupérac, formed the educated person's visual images of Rome. As the French names of these influential publishers suggest, northerners played an ever-increasing role in the dispersion of these images (25, 48, 50, 51, 55, 100).

By the later sixteenth century, there had been a rupture between the artist's and the antiquarian's interest in the antique. The artistic tradition of archaeological study had been expropriated by the academy. There it was imposed from above instead of being "discovered" as part of a new or currently evolving vision. This state of affairs is communicated with ironic humor by Goltzius' engravings after canonical antiques, including the *Apollo Belvedere* (55) and the Hercules Farnese (100).

Collectors and all'antica *style*

Beginning with Pietro Barbo, a Venetian who became Pope Paul II (1464–71), who was an early connoisseur of antiquities and the owner of the *Felix Gem* (8; also see 105, 114–116), artists' uses of antiquity were increasingly influenced by collectors. The prevalence of small-scale antique objects—gems, cameos, medals, coins and statuettes—in these early Renaissance collections ensured their use as models by artists. In the case of the Medici collections in Florence this is well documented. Book and manuscript collectors stimulated the fashion for *all'antica* styles appropriate to the decoration of classical texts. Peter Ugelheimer, a German merchant from Ulm, who had supported the printing firm of Jenson that was taken over by Andrea Torresani, had his luxury copy of Torresani's and de Blavis' 1483 edition of Aristotles' *Works* illuminated by the outstanding miniaturist of Italy at the time, whose name may have been Girolamo da Cremona.[4] The two frontispieces to this two volume work, in the Morgan Library, exhibit a style whose lavishness and quaint charm combine fantasies of ancient architecture and pastoral imagery in a synthesis that perfectly reflects the advanced taste of the 1480s.

Isabella d'Este (1474–1539) was one of the most important Renaissance collectors of antiquities. Her patronage of artists, and even sometimes her specific instructions to produce something that looked antique, helped determine the direction taken by the antique revival in northern Italy. By 1497, Isabella's passion for collecting began to be focused more specifically on antiques. Many were included in her collection, recorded as numbering 1620 objects. She devised an elegant program for their installation in her *Grotta* that was the talk of Italy. The patronage of her brother Alfonso d'Este (1476–1534) continued Isabella's encouragement of the use of antique models by contemporary artists. Alfonso's decoration of his palace at Ferrara beginning c. 1503 provided impetus for original interpretations of antique types and styles, both in marble and bronze sculpture (102, 107) and in painting (Titian's *Bacchus and Ariadne,* dated December 1520–December 1522, London, National Gallery).

Rising demand for antiquities provoked the making of fakes as early as the 1490s. The line between conscious frauds and works made to prove an artist's capacity is not always easy to draw (59). Giovanni dal Cavino's "Greek" and "Roman" coins are cases in point (20, 75). One great authority on Renaissance medals, G. F. Hill, could not decide whether Cavino operated "as a nefarious forger . . . [or] a well-meaning scholar of misplaced ingenuity." Michelangelo's *Sleeping Cupid,* bought by an art dealer who sold it to Cesare Borgia as an antique, is another famous case. Although Isabella d'Este let slip an opportunity to buy the *Cupid* when first offered for sale in 1496, she bought it in the summer of 1502, after it had been exposed as modern. This work was displayed in one of

two cabinets adjacent to the window in the *Grotta;* the other contained a marble *Sleeping Cupid* attributed to Praxiteles which Isabella had begun negotiating for in 1498. This extraordinary pairing undoubtedly contributed to the popularity of the subject in northern Italy and Venice (119). Isabella's collection included many "fragments" of antiquities, some no doubt of recent fabrication. The life-sized marble *Apollo* or *Hercules* (59) by a sixteenth-century central Italian sculptor— seemingly under the influence of Michelangelo's lost *Hercules* of 1492/93—lacking its head and extremities seems to have been created deliberately as just such a fragment, conceivably to adorn a classicizing garden.

In this context flourished an artist who, even more than Mantegna, concentrated on reviving antiquity as the major component of his style. Pier Jacopo Bonacolsi's elegant, smooth and "correct" re-creations of Hellenistic models verge on neoclassicism (68, 86, 89, 93). Appropriately known as "Antico," he worked first for Gianfrancesco Gonzaga di Ròdigo (1443–96) and his wife Antonia del Balzo (1441–1538), and later for Bishop Lodovico of Mantua (1459–1511) and Isabella, making what he himself called *"antichità."* His technical excellence in bronze had been equalled only by a few quattrocento Florentines, Pollaiuolo and Verrocchio, for example, but no artist heretofore had been so deeply affected by the furor of collecting that gave rise to a reinterpretation of the boundaries between ancient and modern art. Another north Italian bronze sculptor (perhaps Galeazzo Mondella, active by c. 1500), took the nickname "Moderno" as an intended antithesis to Antico's style. His challenge can be interpreted as a claim that the heritage of quattrocento expressionism established by Donatello in northern Italy ought not to be rejected in the name of classicism and ought to remain an indispensable source in the creation of a modern style (63, 91, 92). The works of both men partake of the overriding significance of bronze as the medium par excellence of antique revival in the later quattrocento. This aspect of the revival of antiquity was ushered in by the earliest signed and dated Renaissance bronze statuette, a small-scale version of the equestrian monument of Marcus Aurelius by Filarete in Dresden, dated 1465.

Portraiture

Portraiture too changed under the impact of the antique revival. The naturalism that had arisen in the late fourteenth century as part of International Gothic Style was combined with an idealization determined by Greek and Roman imagery. The profile portrait of Leon Battista Alberti on a bronze plaque shows the distinguished Renaissance architect and theorist with a short cropped hair style borrowed from Roman bronze statuary and a personal emblem concocted from the fourth-century *Hieroglyphica,* the winged eye (81). This plaque, considered to be among the greatest of fifteenth-century bronze portraits, is generally thought to have been designed and perhaps cast by Alberti himself. Its conscious adoption of an antique mode of presentation, in contrast to the medallic portrait of Alberti designed by Matteo de' Pasti, is wholly analogous to Alberti's achievements in architecture and architectural theory.

Marble busts such as the mid-third-century Roman *Portrait of a Boy* from the Cleveland Museum of Art (67) provided prototypes which quattrocento masters of marble portraiture like Desiderio da Settignano and Antonio Rossellino could study in evolving comparably brilliant marble cutting techniques. The type of Roman portrait bust with a rounded lower edge, a hollowed-out back, a pedestal and often a small cartouche seen in the *Portrait of a Boy* was not adopted in the quattrocento revival of the sculpted portrait. Descended from medieval reliquaries, the fifteenth-century Florentine bust was worked fully in the round, ended in a straight horizontal cut and lacked a base.[5] The antique bust type used by Antico for idealized portrait heads *all'antica* such as the *Ariadne* in Vienna and the *Cleopatra* (68) was adopted with full awareness of its prescribed features.

Artists turned to antique portraiture to study not only techniques of naturalistic representation perfected in Hellenistic times but equally important, to study its illusion of life, vitality and even of human consciousness. Facial expression was one factor in this illusionism. The penetrating glance, turn of the head, and dramatic use of light and shadow in a work like the *Portrait of a Young Man* of the mid second century from Asia Minor (65), exemplify those aspects of Roman portraiture that must have exerted particular appeal at a time when Italian painters of portraits, following in Leonardo's footsteps, adopted similar aims. There is comparable sensitivity and psychological penetration, but greater subtlety, in the *Portrait of an Antonine Lady* (66) and the *Portrait of a Boy.*

A unique and characteristic form of portraiture developed in the quattrocento was the bronze portrait medal, inspired by ancient coins and medallions. Humanists and artists as well as rulers and statesmen were celebrated in this fashion (82–84). The creation of the Renaissance medal in the 1430s by Pisanello and its continuing importance throughout the period testify to the importance of small-scale antiquities like coins, medallions and gems in the creation of antique revival art (8, 71, 73, 75, 80, 81). Renaissance traditions establishing likenesses of ancient heroes of history and thought depended on them as well. Coins began to supplement literary remains as sources for knowledge of ancient history and customs, even though coin inscriptions and the scenes pictured on their reverses were at first often misunderstood. Renaissance investigations of ancient coinage, by the time of Andrea Fulvio's *Illustrium imagines* (1517), had begun to be more systematic and comprehensive, while Fulvio Orsini's *Familiae romanae quae reperiuntur in antiquis numismatibus* (1587) was the pioneer publication on Roman prosopography.

Portraits of contemporaries in antique guise appeared in painted narratives where they figured as participants in scenes set in antiquity. An independent portrait of this type appears in Tullio Lombardo's *Bacchus and Ceres* of the 1490s (Vienna), in which an aristocratic Venetian couple appear as the ancient gods. Other portraits were based on antique types though the subjects retained modern dress (87, 88). Still others portrayed famous men and women from antiquity, providing evidence of their "living" importance to Renaissance culture (68–71). One Renaissance collector "restored" inscriptions on one of his antiques, a Roman funerary portrait that he interpreted as a symbolic representation of Faith, a virtue whose supremacy in both Republican Rome and Christianity could help to bolster notions of a fundamental ethical unity shared by both cultures. The same gravestone, before the inscriptions were added, had been recognized for the funerary portrait it was and used c. 1490 as the model for the Roman Renaissance tomb of Stefano Satri in San Omobono.[6]

Antique Subjects and their Transformations: Myth, History and Pastoral; Fantasy and Allegories all'antica

Throughout the fifteenth and sixteenth centuries subjects from antique mythology, poetry and history remained popular, sometimes with allegorical meanings that could be deciphered only by some elite group united around a particular common interest or belief; at other times with purely decorative or narrative intent (89, 91) or, in the case of engravings, as part of the dispersion of the High Renaissance figure style (90, 102). Often a contemporary allegory whose significance was tied to a particular political situation was presented in a classicistic vein, perhaps in order to gain an aura of timelessness or permanence (105, 107). Achievements of Renaissance rulers were thus linked by visual association with triumphs of the ancient past. Mantegna painted a series of Roman emperors in illusionistic grisailles on the ceiling of the *Camera degli Sposi* in the Palazzo Ducale, Mantua, as early as the late 1460s. The ambitious collection of sculpture in the Vatican Belvedere represents the invention of just such a program coinciding with aggrandizing aims of the papacy. Around 1480, exemplars of stoic, Republican virtue, Lucretia or Mucius Scaevola, for example, inherited from medieval *Uomini Famosi* programs, began to be depicted in a newly classicistic style. Likewise the deeds of Hercules, having appeared frequently in art throughout medieval times, began to be represented in a style that increasingly befitted their classical origins (92–97).[7]

Interest in classical literature, increasing as the texts began to be published in the 1460s and 1470s, was expressed, though in a context of civic pride, in monuments planned or executed, to ancient authors such as Livy in Padua (70), Pliny the Elder and Younger in Como, Virgil in Mantua and Catullus (one among a group of famous Romans from Verona, including Vitruvius, whose statues were made to decorate the new Palazzo del Consiglio in the 1490s). The popularity of Greek and Roman pastoral poetry reached a peak early in the sixteenth century. The idylls of Theocritus were published in Venice in 1495, while Jacopo Sannazaro (1458–1530), a contemporary pastoral poet in Naples, was finishing his *Eclogues*. In 1502 an unauthorized version of Sannazaro's *Arcadia* appeared in Venice. The tone of nostalgia and yearning that pervaded Greek pastoral odes was imitated by Sannazaro and other Renaissance poets in Ferrara (Tebaldeo, for example). A comparable mood had been introduced into Florentine painting by Piero di Cosimo (c. 1462–1521?) and Luca Signorelli (c. 1441/50–1523). The image of a Golden Age peopled with fabulous creatures living alongside men and with them enjoying primeval innocence and freedom from work and freedom from guilt captured the imagination. Related themes appear in the small bronzes of Riccio (1470/75–1532) and other Paduan and Venetian sculptors at around this time (109, 110, 124). Hybrid creatures, half human, half animal—satyrs, centaurs, sirens (108)—recalled this fabled antique pastoral world, where gods, humans and fabulous creatures cohabited amidst a beauteous plenty.

Beginning in the late 1490s Venetian painting combined qualities derived from ancient poetry with distinctive transformations of visual prototypes to create a lyrical mode of antique revival expressed most characteristically in *poesie*. This word is used in the sense of paintings that did not narrate or illustrate specific ancient texts but instead drew upon literary and visual associations arranged in unexpected ways. This new Renaissance genre, related in its origins to the *Hypnerotomachia Poliphili* and thus to the romantic archaeology that arose in Mantegna's circle,[8] whose mood is reflected in Jacopo de' Barbari's (c. 1460/70– c. 1516) *Large Sacrifice to Priapus* and other engravings of c. 1500–10 by Jacopo and Giulio Campagnola (c. 1482–after 1515), is most familiar from Giorgione's *Tempesta* and *Sleeping Venus*.[9] In Venice its blend of dreamlike, sensuous, at times erotic, imagery with rich yet delicate color and luminosity, lingered on through the next fifty years, revived in Titian's late *Nymph and Shepherd* (c. 1567–70, Vienna) and formed the background for Veronese's decorative mythologies (111).

Decoration all'antica

Antique decorative motifs, mainly animal or vegetable in nature, survived throughout late antiquity. Later in the Byzantine period and the Middle Ages such elements appear in architecture, architectural sculpture, painting, book illumination and decorative arts, and especially in small portable objects of metal and ivory. Sometimes, they are completely divorced in style from classical precedents. The acanthus scroll, a decorative device that symbolized the cyclically recurring energy and variability of plant life and hence

nature itself, is a case in point. Though ever-present, from late antiquity onwards the style of this motif varied according to era, geographical location, medium and scale. Suddenly in the Porta della Mandorla of Florence Cathedral (1390s) it assumed a "new" form, that of a double curved candelabra with standing figures in the parentheses of fleshy acanthus leaves. It was actually a re-creation of a Roman pilaster, now preserved in the *Grotte* of the Vatican. The revival of classical decorative forms at the turn of the fifteenth century thus signaled a change of style resulting from the fresh study of surviving antique prototypes and a conscious desire to re-create them.

In Mantegna's Eremitani frescoes (Padua, 1453–55, destroyed), the organization of the acanthus scrolls within the narrow oblongs of the pilasters they decorate follows one of two prescribed types: running *rinceaux* or candelabra. These painted pilasters reveal careful observation of the basic modes of Roman architectural decoration, typical of Mantegna's artistic-archaeological method.

This was encouraged by Mantegna's patron Lodovico Gonzaga (1414–78) and doubtless too by Mantegna's father-in-law Jacopo Bellini (d. 1470/71). In Padua, where Mantegna had spent time in his adolescence as a pupil of Francesco Squarcione (1397–1481), a school of manuscript illuminators adopted Mantegna's practice in creating a wholly new style of book decoration. These artists' use of antique motifs, though eclectic rather than "archaeologically correct" like Mantegna's, demanded a fresh look at the originals, whether these were coins, gems, fragments of architecture or even standing monuments like the Gavi arch at Verona.

A beautiful example of the production of this school is the copy of Suetonius' *Lives of the Twelve Caesars* written by a Paduan scribe, Bartolomeo Sanvito (1435–after 1518) and illustrated in the 1470s or 80s by an artist (Sanvito himself? or Lauro Padovano?) who had also worked for Cardinal Francesco Gonzaga (1444–83) in Rome. It has a frontispiece confected of classical trophies, richly carved, garlanded drums, and antique "battle relief," winged female Victories based on the type of the *Winged Victory* of Brescia, *Dioscuri*-derived Roman soldiers leading a rearing Pegasus, and frolicking putti. It ranks among the great masterpieces of Renaissance book illustration (Paris, Bibliothèque Nationale). Another leaf in the manuscript, at the beginning of the life of Octavian, is decorated with four of Augustus' authentic coin reverses and one portrait obverse (and one reverse of Tiberius).[10] This early use of coins as authentic documents of history and iconography can be traced directly to the influence and inspiration of Andrea Mantegna.

Around 1439, Filarete designed a pair of bronze doors for St. Peter's which had been commissioned by Pope Eugenius IV in 1433. Their richly embellished borders carried the antique revival in architectural decoration to Rome. Existing remains provided the richest possible array of sources for north Italian stone carvers and metal workers who began immigrating there to work on papal programs around mid-century. In the organization and decoration of these doors, Filarete drew on an unusually wide variety of antique sources. The fleshy acanthus of the borders, in their massively constructed stalks, which encircle profiles inspired by Roman imperial coins (74) or mythological scenes, recall the Severan pilasters of the Arch of the Argentarii. The composition of the reliefs on each door, and the archaisms in Filarete's style, suggest that sixth-century consular diptychs also figured among his sources.[11] Recourse to still a third period of antique style is suggested by the *Martyrdom of St. Peter* relief, where Filarete's study of the Column of Trajan is evident.

The purposes served by this *all'antica* style were not purely formal ones. Eugenius' new doors linked antique revival in its visual mode to a major ecclesiastic-political program. By ecumenism the papacy was trying to recoup the prestige and dignity lost through territorial depredations by *condottieri* and anarchy among rebellious Roman nobles. In his first step, the refurbishing of St. Peter's, the Pope began the restoration of the city of Rome as *caput mundi*. Images on the doors linking Rome's late antique past with recent history were part of the propaganda of papal authority and legitimacy. These were necessary to stave off the conciliar threat as well as later and even more radical challenges.

Subsequent popes with varying degrees of commitment to and interest in the study and appreciation of antiquity increasingly associated its revival with the fortunes of the papacy itself. Beginning with Innocent VIII's decoration of the Loggia of the Vatican Belvedere in 1487 by Pinturicchio, the revival of first-century A.D. Roman wall painting and unpainted stucco decoration, especially its free disposition of slender vegetable ornament and delicate and whimsical grotesques, became a decisive inspiration for *all'antica* decoration.

An artist known as the *grottesche* specialist in Raphael's shop was responsible for supervising masterpieces of High Renaissance interior decoration in the antique style in Rome. Among these are the *Logetta* and *Loggie* of the Vatican and the Villa Madama which was built and decorated for Giulio de' Medici, later Pope Clement VII (1478–1534). Giovanni da Udine's mastery of style and media win for him a unique position in the annals of antique revival. Viewed within this perspective, Giovanni's achievement is comparable to Raphael's in assimilating the classicism of antique art to a modern style in large-scale fresco painting and to Marcantonio's in inventing a graphic language capable of transmitting the drama of its plasticity and formal power (as in 45 and 102). In the Vatican rooms as well as the Villa Madama Giovanni's assimilation of both decorative principles and specific forms observed in Nero's *Domus Aurea* and other

Roman antique painted rooms excavated and explored at the end of the fifteenth century is complete. The observer is filled with a sense of astonishment and delight akin to that which Vasari describes Raphael and Giovanni experiencing when they suddenly realized how fresh the subterranean grotesque decorations looked and how superior their artistic quality was.

Raphael's and Giovanni's total re-creations of antique ambiances in programs like the *Loggetta* seem the apogee of a historical fantasy first generated a century and a half earlier. At first, the determination of Petrarch and Boccaccio to experience the great monuments of ancient literature stirred new awareness of Greek language and culture. By the end of the fifteenth century the passion and energy expended in the search for preserved texts, and in the case of Cyriacus of Ancona, for preserved monuments, characterized a widespread movement in the visual arts that sought to capture the essence of the antique achievement in sculpture and architecture and to incorporate its lessons within an equivalent modern style. The works of art collected together on this occasion will, I hope, provide a glimpse of the seemingly inexhaustible metamorphoses of antique inspiration that resulted.

Wendy Stedman Sheard

[1]"Cyriacus of Ancona's Visit to Samothrace" and "The Sources and Meaning of Mantegna's *Parnassus*," in Phyllis Williams Lehmann and Karl Lehmann, *Samothracian Reflections* (Princeton, 1973).
[2]Colin Eisler, quoted in Laurie S. Fusco, "Battle of the Nudes," Jay A. Levenson, Konrad Oberhuber, Jacquelyn L. Sheehan, *Early Italian Engravings from the National Gallery of Art* (Washington, D.C., 1973), pp. 68–71.
[3]Cornelius Vermeule, "The Dal Pozzo-Albani Drawings of Classical Antiquities in the British Museum," *Transactions of the American Philosophical Society*, n. s. 50, no. 5 (1960): 7.
[4]J. J. G. Alexander, *Italian Renaissance Illuminations* (N.Y., 1977), notes to plates 17, 18.
[5]Irving Lavin, "On the Sources and Meaning of the Renaissance Portrait Bust," *Art Quarterly* 33 (1970): 207–215, esp. 207–208.
[6]Phyllis Williams [Lehmann], "Two Roman Reliefs in Renaissance Disguise," *Journal of the Warburg and Courtauld Institutes* 4 (1941–42): 47–66.
[7]Erwin Panofsky and Fritz Saxl, "Classical Mythology in Medieval Art," *Metropolitan Museum Studies* 4, no. 2 (1933): 228ff.; Panofsky, *Renaissance and Renascences in Western Art,* icon ed. (N.Y.), pp. 82–115.
[8]Charles Mitchell, "Archaeology and Romance in Renaissance Italy," in E. F. Jacob, ed., *Italian Renaissance Studies* (London, 1960), pp. 455–483.
[9]Jayne L. Anderson, "The Imagery of Giorgione" (Ph.D. dissertation, Bryn Mawr College, March, 1972), pp. 6–11, 107–117.
[10]Alexander, *Illuminations,* plates 13 and 14 with notes.
[11]Charles Seymour, Jr., "Some Reflections on Filarete's Use of Antique Visual Sources," *Arte Lombarda*, 38/39 (1973): 36–47.

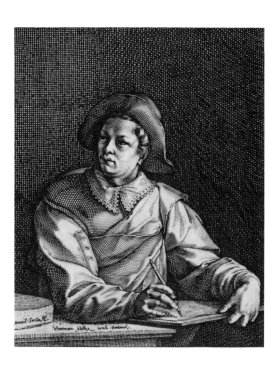

55 (detail)

Bibliography

Abbreviations and short titles of periodicals and reference works

AB	*The Art Bulletin*
AJA	*American Journal of Archaeology*
AQ	*Art Quarterly*
BJ	*Jahrbuch der Berliner Museen (Jahrbuch der Preussischen Kunstsammlungen,* n. f.)
BM	*Burlington Magazine*
EAA	*Enciclopedia dell'Arte Antica Classica e Orientale,* Rome, 1958–
EWA	*Encyclopedia of World Art,* 15 vols., N. Y., Toronto, London, 1959–68
GBA	*Gazette des Beaux Arts*
JKS	*Jahrbuch der Kunsthistorischen Sammlungen in Wien*
JWarb	*Journal of the Warburg and Courtauld Institutes*
Mitt Flor	*Mitteilungen des Kunsthistorischen Instituts in Florenz*

The following list could not and does not attempt to be a comprehensive bibliography on Antiquity in the Renaissance. The vast bibliography on antique art receives only token representation; certain familiar works of reference such as Nash's *Pictorial Dictionary of Ancient Rome* are mentioned, as well as recent attempts to summarize large chronological periods, such as Robertson's *A History of Greek Art* and Kraus's *Das römische Weltreich.* A few other major and frequently consulted works on aspects of antique art, such as Richter's *The Portraits of the Greeks,* also appear.

The contents of this bibliography were largely dictated, as the user will realize, by the objects catalogued. Certain basic books on Renaissance art, known to any scholar in the field, are included. A comprehensive bibliography on the subject may be found in Ladendorf, *Antikenstudium* (up to 1953). Emphasis is therefore given to more recent studies, and ones which directly aided research undertaken for this catalogue. Books and articles referred to more than twice in the references following each object have been given short titles.

Albright, *Master Bronzes* Albright Art Gallery, Buffalo Fine Arts Academy. *Master Bronzes.* Buffalo, 1937.

Amelung, *Kat* Amelung, W. *Die Sculpturen des Vaticanischen Museums.* Berlin, 1903–1908 (vols. I–II; vol. III by G. Lippold, 1936).

Amsterdam, Rijksmuseum. *Meesters van het brons der Italiaanse Renaissance,* 29 October 1961–14 January 1962, exhib. cat. with introd. by J. Pope-Hennessy.

Anderson, J. L. "The Imagery of Giorgione." Unpublished Ph.D. dissertation, Bryn Mawr College, 1972.

Andrén, A. *Il Torso del Belvedere.* Lund, 1952 (Institutum Romanum Regni Sueciae, Opuscula Archaeologica, 7).

Bange Bange, E. F., ed. *Die italienischen Bronzen der Renaissance und des Barock,* pt. 2, *Reliefs und Plaketten.* Berlin, Staatliche Museen, 1922.

Barocchi, *Rosso* Barocchi, P. *Il Rosso Fiorentino.* Rome, 1958.

(B.) Bartsch Bartsch, A. von. *Le peintre graveur,* 21 vols. Vienna, 1803–21.

Bean and Stampfle, *N.Y. Collections I* Bean, J., and F. Stampfle, *Drawings from N.Y. Collections,* I: *The Italian Renaissance,* exhib. cat., Metropolitan Museum of Art, Pierpont Morgan Library. Greenwich, Conn., 1965.

Becatti, G. "Raphael and Antiquity." In: Reynal & Co. *The Complete Work of Raphael,* introd. by M. Salmi, p. 491–568. N.Y., 1969.

Bergström, I. *Revival of Antique Illusionistic Wall Painting in Renaissance Art.* Göteborg, 1957.

Berlin, Staatliche Museen der Stiftung Preussischer Kulturbesitz, Kupferstichkabinett. *Zeichner sehen die Antike, europäische Handzeichnungen 1450–1800,* Feb.–April 1967, exhib. cat. by Matthias Winner.

Bernouilli, J. J. *Aphrodite, ein Baustein zur griechischen Kunstmythologie.* Leipzig, 1873.

Bianchi-Bandinelli, R. *Rome, the Center of Power, Roman Art to A.D. 200,* trans. P. Green. London, 1970.

Bieber, *Hellenistic Sc.* Bieber, M. *The Sculpture of the Hellenistic Age,* 2nd ed. rev. N.Y., 1961.

Blum, I. *Andrea Mantegna und die Antike.* Strassburg, 1936.

Bober, *Aspertini* Bober, P. *Drawings after the Antique by Amico Aspertini, Sketchbooks in the British Museum.* London, 1957 (Studies of the Warburg Institute, ed. G. Bing, 21).

Bober, P. "The Census of Antique Works of Art Known to Renaissance Artists." In: *The Renaissance and Mannerism, Acts of the 20th International Congress of the History of Art,* p. 82–89. Princeton, 1963.

Bober, P. "The *Coryciana* and the Nymph Corycia." *JWarb,* 40 (1977), 223-239.

Bode Bode, W. von. *Die italienischen Bronzestatuetten der Renaissance,* 3 vols. Berlin, 1907–12.

Bode, W. von. *Die italienischen Bronzestatuetten der Renaissance².* Berlin, 1922.

Die italienischen Bildwerke der Renaissance und des Barock, v. 2, *Bronzestatuetten, Büsten und Gebrauchsgegenstände,* cat. of the Berlin Museum by W. von Bode. Berlin, Leipzig, 1930.

Bodnar, E. W. *Cyriacus of Ancona and Athens.* Brussels-Berchem, 1960 (Collection Latomus, 43).

Bodnar, E. W., and C. Mitchell, eds. *Cyriacus of Ancona's Journeys in Propontis and the Northern Aegean, 1444–1445.* Philadelphia, 1976 (Memoirs of the American Philosophical Society, 112).

Bolgar, R. R., ed. *Classical Influences on European Culture,* A.D. *500–1500.* Cambridge [England], 1971 (International Conference on Classical Influences, King's College, Cambridge, 1969, Proceedings).

Bolgar, R. R., ed. *Classical Influences on European Culture,* A.D. *1500–1700.* Cambridge [England], 1976 (International Conference on Classical Influences, King's College, Cambridge, 1974, Proceedings).

Breckenridge, J. D. *Likeness. A Conceptual History of Ancient Portraiture.* Evanston, Ill., 1968.

Brown-RISD, *First Maniera* Brown University, Department of Art, Museum of Art, Rhode Island School of Design. *Drawings and Prints of the First Maniera, 1515–1535,* February 22–March 25, 1973, exhib. cat. by J. R. Benton et al. [n.p., 1973].

Brown, C. M. " 'Lo Insaciabile Desiderio nostro de cose Antique': New Documents on Isabella d'Este's collection of Antiquities." In: *Cultural Aspects of the Italian Renaissance,* ed. by C. H. Clough, p. 324–353. Manchester and N. Y., 1976.

Brown, C. M. "The Grotta of Isabella d'Este (Part I)" *GBA,* 89 (1977), 155–171; Part II: *GBA,* 91 (1978), 72–82.

Brummer, *Statue Court* Brummer, H. H. *The Statue Court in the Vatican Belvedere.* Stockholm, 1970 (Acta Universitatis Stockholmiensis, Stockholm Studies in History of Art, 20).

Brunn, H., and F. Bruckmann. *Denkmäler griechischer und römischer Sculptur.* Munich, 1888–

Cagiano de Azevedo, M. *Il gusto nel restauro delle opere d'arte antiche.* Rome, 1948.

Charbonneaux, J. *Classical Greek Art.* N. Y., 1972.

Chase, G. H. *Greek and Roman Sculpture in American Collections.* Cambridge, Mass., 1924.

Cleveland, *Ohio Bronzes* The Cleveland Museum of Art. *Renaissance Bronzes from Ohio Collections,* exhib. cat. by W. D. Wixom. Cleveland, 1975.

Columbia University, Avery Architectural Library. *Catalogue of the Earl of Crawford's "Speculum Romanae Magnificentiae,"* by L. R. McGinniss with H. Mitchell. N. Y., 1976.

Dacos, N. "A propos d'un fragment de sarcophage de Grottaferrata et de son influence à la Renaissance." *Bull. de l'Institut historique Belge de Rome,* 33 (1961), 143–150.

Dacos, N. "Ghirlandaio et l'antique." *Bull. de l'Institut historique Belge de Rome,* 34 (1962), 419–455.

Dacos, *Grotesques* Dacos, N. *La découverte de la Domus Aurea et la formation des grotesques à la Renaissance.* London and Leiden, 1969 (Studies of the Warburg Institute, ed. E. H. Gombrich, 31).

Dacos, N., A. Giuliano, and U. Pannuti. *Il tesoro di Lorenzo il Magnifico, le gemme,* exhib. cat. Florence, 1973.

Degenhart and Schmitt, "Gentile da Fabriano" Degenhart, B., and A. Schmitt. "Gentile da Fabriano und der Beginn der Antikennachzeichnung." *Münchner Jahrbuch der bildenden Kunst,* ser. 3, 11 (1960), 91–151.

Degenhart and Schmitt, *Zeichnungen* Degenhart, B., and A. Schmitt. *Corpus der italienischen Zeichnungen, 1300–1450,* pt. 1, *Süd- und Mittelitalien,* 4 vols. Berlin, 1968.

De Ricci, *Census* De Ricci, S., and W. J. Wilson. *Census of Medieval and Renaissance Manuscripts in the U. S. and Canada,* 3 vols. N. Y., 1935–40.

Detroit, *Decorative Arts* Detroit Institute of Arts. *Decorative Arts of the Italian Renaissance, 1400–1600,* exhib. cat. Detroit, 1958.

Dresden, *Dialoge* Dresden, Kupferstichkabinett. *Dialoge: Kopie, Variationen und Metamorphose alter Kunst in Graphik und Zeichnung, vom 15. Jahrhundert bis zur Gegenwart,* Sept. 27–Dec. 31, 1970, exhib. cat.

Dürer in America, see Talbot, *Dürer.*

Essen, C. C. van. "La découverte de Laocoon." *Mededelingen der Koninklijke Nederlandse Akademie van Wetenschappen, Afd. Letterkunde,* 18 (1955), 291 ff.

Fienga, D. "The Antiquarie Prospetiche Composte per Prospectivo Melanese Depictore: A Document for the Study of the Relationship between Bramante and Leonardo da Vinci." Unpublished Ph. D. dissertation, University of California, 1970.

Fogg, *Rome and Venice* Fogg Art Museum, Harvard University. *Rome and Venice, Prints of the High Renaissance*, May 5–30, 1974, exhib. cat. by J. Cook et al. (circulated as photocopy of typescript, unpublished).

Furtwängler, A. *Masterpieces of Greek Sculpture*, ed. E. Sellers. N.Y., 1895.

Gibbons, *Princeton Drawings* Gibbons, F. *Catalogue of Italian Drawings in the Art Museum, Princeton University*, 2 vols. Princeton, 1977.

Gombrich, E. H. "The Style *all'antica*: Imitation and Assimilation." In: *Norm and Form*, p. 122–128. London, 1966.

Harvard, *Sixteenth Century Architectural Books* Harvard College Library. Department of Printing and Graphic Arts. *Sixteenth Century Architectural Books from Italy and France*, June–Sept., 1971, exhib. cat., introd. by P. A. Wick.

Hekler, A. *Greek and Roman Portraits*. N. Y., 1912.

Helbig Helbig, W. *Führer durch die öffentlichen Sammlungen klassischer Altertumer in Rom*[4], ed. H. Speir, 2 vols. Berlin, 1963–1966.

Hermann, "Antico" Hermann, H. J. "Pier Jacopo Alari-Bonacolsi, genannt Antico." *JKS*, 28 (1910), 201–288.

Hill, *Corpus* Hill, G. F. *A Corpus of the Italian Medals of the Italian Renaissance before Cellini*, 2 vols. London, 1930.

Hill and Pollard, *Medals* Hill, G. F., and G. Pollard. *Renaissance Medals from the Samuel H. Kress Collection at the U. S. National Gallery of Art*. London, 1967.

(H.) Hind Hind, A. M. *Early Italian Engravings*, 7 vols. London, 1938–48.

Horster, M. "Brunelleschi und Alberti in ihrer Stellung zur römischen Antike." *Mitt Flor*, 17 (1973), 29–64.

Howard, S. "Some Eighteenth-Century Restorations of Myron's 'Discobolos'." *J Warb*, 25 (1962), 330–334.

Hübner, *Le statue* Hübner, P.G. *Le statue di Roma*, I, *Quellen und Sammlungen, Grundlagen für eine Geschichte der antiken Monumente in der Renaissance*. Leipzig, 1917. (Romische Forschungen, Bibliotheca Hertziana, 2)

Hülsen, C. "Romische Antikengarten des XVI Jahrhunderts." *Abhandlungen der Heidelberger Akademie der Wissenschaften*, 4 (1917).

Hülsen, C. "Das Speculum Romanae Magnificentiae des Antonio Lafreri." In: *Collectanea variae doctrinae Leoni S. Olschki*, p. 121–170. Munich, 1921.

Janson, *Donatello* Janson, H. W. *The Sculpture of Donatello*, 2 vols. Princeton, 1957 (all refs. are to vol. II except when otherwise indicated).

Janson, H. W. "Donatello and the Antique." In: *Donatello e il suo tempo. Atti dell' VIII Convegno Internazionale di studi sul Rinascimento*, p. 77–96. Florence, 1968.

Kennedy, R. W. *Novelty and Tradition in Titian's Art*. Northampton, 1963 (The Katharine Asher Engel Lectures, Smith College).

Knabenshue, P. D. "Ancient and Medieval Elements in Mantegna's *Trial of St. James*." *AB*, 41 (1959), 59–73.

Knauer, E. R. "Leda." *BJ*, 11 (1969), 5–35.

Kraus, T. *Das römische Weltreich*. Berlin, 1967 (Propyläen Kunstgeschichte, 2).

Krautheimer, R., and T. Krautheimer-Hess. *Lorenzo Ghiberti*, 2nd ed., 2 vols. Princeton, 1970.

Kristeller, P. *Andrea Mantegna*, trans. S. A. Strong. N. Y., 1902.

Ladendorf, *Antikenstudium* Ladendorf, H. *Antikenstudium und Antikenkopie*. Berlin, 1953 (Abhandlung der Sächsischen Akademie der Wissenschaften zu Leipzig, 46:2; 2nd ed., 1958.

Langemeyer and Schleier, *Bilder nach Bildern* Westfälisches Landesmuseum für Kunst und Kulturgeschichte. *Bilder nach Bildern, Druckgrafik und die Vermittlung von Kunst*, March 21–May 2, 1976, exhib. cat. by G. Langemeyer and R. Schleier. Münster, 1976.

Lee, R.W. *Names on Trees, Ariosto into Art*. Princeton, 1977.

Legner, "Anticos Apoll" Legner, A. "Anticos Apoll vom Belvedere." *Städel-Jahrbuch*, n. s., 1 (1967), 102–118.

Lehmann, "Cyriacus in Samothrace" Lehmann, P. W. "Cyriacus of Ancona's Visit to Samothrace." In: P. W. Lehmann and K. Lehmann, *Samothracian Reflections, Aspects of the Revival of the Antique*, p. 3–56. Princeton, 1973 (Bollingen series, 92).

Lehmann, "Parnassus" Lehmann, P. W. "The Sources and Meaning of Mantegna's *Parnassus*." In: P. W. Lehmann and K. Lehmann, *Samothracian Reflections, Aspects of the Revival of the Antique,* p. 59–178. Princeton, 1973 (Bollingen series, 92).

Levenson, Oberhuber and Sheehan Levenson, J. A., K. Oberhuber, and J. L. Sheehan. *Early Italian Engravings from the National Gallery of Art.* Washington, D. C., 1973.

Lugt Lugt, F. *Les marques de collections de dessins et d'estampes.* Amsterdam, 1921; *Supplement,* The Hague, 1956.

MacDougall, E. "The Sleeping Nymph: Origins of a Humanist Fountain Type." *AB,* 57 (1975), 357–365.

Magi, "Laocoonte" Magi, F. "Il Ripristino del Laocoonte." *Atti della Pontificia Accademia Romana di Archeologia,* Series 3, 9, pt. 1 (1960).

Mandowsky, E., and C. Mitchell. *Pirro Ligorio's Roman Antiquities, The Drawings in MS XIII.B.7 in the National Library in Naples.* London, 1963 (Studies of the Warburg Institute, ed. G. Bing, 28).

Mansuelli, *Uffizi* Mansuelli, G. A. *Galleria degli Uffizi, Le Sculture,* pt. 1. Rome, 1958.

Mattingly, *BMCI* Mattingly, H. *Coins of the Roman Empire in the British Museum,* vol. I, *Augustus to Vitellius.* London, 1923.

(M.) Meder Meder, J. *Dürer-Katalog, ein Handbuch über Albrecht Dürers Stiche, Radierungen, Holzschnitte . . .* Vienna, 1922.

Metropolitan, *Northern Italy, 1440–1540* Metropolitan Museum of Art. *Early Renaissance Sculpture from Northern Italy, 1440–1540,* June 5–Oct. 14, 1973, checklist by C. Freytag.

Meulen, M. van der. "Cardinal Cesi's Antique Sculpture Garden: Notes on a painting by Hendrick van Cleef III." *BM,* 116 (1974), 14–24.

Middeldorf, U. "Su alcuni bronzetti all'antica del Quattrocento." In: *Il mondo antico nel Rinascimento* (Atti del V Convegno internazionale di studi sul rinascimento, Florence, Sept., 1956), p. 167–177. Florence, 1958.

Milani, L. A. "Il motivo e il tipo della Venere de' Medici." In: *Strena Helbigiana,* p. 188–197. Leipzig, 1900.

Mongan and Sachs, *Fogg Drawings* Mongan, A., and P. Sachs. *Drawings in the Fogg Museum of Art,* 3 vols. Cambridge, Mass., 1940.

Mortimer Harvard College Library, Department of Printing and Graphic Arts. *Catalogue of Books and Manuscripts,* pt. 2, *Italian 16th Century Books,* 2 vols., by R. Mortimer. Cambridge, 1974.

Müntz, E. "Le Musée du Capitole et les autres collections romaines." *Révue archéologique,* n. s., 43 (1882:1), 24–36.

Nash, E. *Pictorial Dictionary of Ancient Rome,* 2nd ed., rev., 2 vols. N. Y. and Washington, 1967.

Neusser, M. "Die Antikenergänzungen der Florentiner Manieristen." *Wiener Jahrbuch für Kunstgeschichte,* 6 (1929), 27–42.

Oberhuber, *Renaissance in Italien* Vienna, Albertina, Graphische Sammlung. *Renaissance in Italien, 16. Jahrhundert,* February 18–May 18, 1966, exhib. cat. by K. Oberhuber. Vienna, 1966 (Die Kunst der Graphik, 3).

Ohio Bronzes. See Cleveland, *Ohio Bronzes.*

Panofsky, E. "The History of the Theory of Human Proportions as a Reflection of the History of Styles" and "Albrecht Dürer and Classical Antiquity, with an Excursus on the Illustrations of Apianus' 'Inscriptions' in Relation to Dürer." In: *Meaning in the Visual Arts,* p. 55–107, 236–294. N. Y., 1955.

Panofsky, E. *Renaissance and Renascences in Western Art.* N. Y., Evanston, San Francisco, London, 1972.

(P.) Passavant Passavant, J. D. *Le peintre graveur,* 6 vols. Leipzig, 1860–64.

Paul, J. "Antikenergänzung and Ent-Restaurierung, Bericht über die am 13. und 14. Oktober 1971 im Zentralinstitut für Kunstgeschichte abgehaltene Arbeitstagung." *Kunstchronik,* 25, pt. 4 (1972), 85–112.

Perry, M. "Cardinal Domenico Grimani's Legacy of Ancient Art to Venice." *JWarb,* 41 (1978), 215–244.

Planiscig, L. *Die estensische Kunstsammlung,* 1: *Sculpturen und Plastiken des Mittelalters und der Renaissance.* Vienna, 1919.

Planiscig, L. *Venezianische Bildhauer der Renaissance.* Vienna, 1921.

Planiscig, L. *Die Bronzeplastiken.* In: J. Schlosser, ed., *Publikationen aus den Sammlungen für Plastik und Kunstgewerbe* (cat. of Vienna Museum), v. 4. Vienna, 1924.

Planiscig, L. *Andrea Riccio.* Vienna, 1927.

Platner, S. B., and T. Ashby. *A Topographical Dictionary of Ancient Rome.* Oxford, 1929.

Pollitt, *Art of Greece* Pollitt, J. J. *The Art of Greece, 1400–31 B.C.* Englewood Cliffs, N. J., 1965 (Sources and Documents in the History of Art, ed. H. W. Janson).

Pollitt, J. J. *The Art of Rome, c. 753 B.C.–337 A.D.* Englewood Cliffs, N. J., 1966 (Sources and Documents in the History of Art, ed. H. W. Janson).

Pope-Hennessy, *IRS* Pope-Hennessy, J. *Italian Renaissance Sculpture.* N.Y., 1958.

Pope-Hennessy, *High Renaissance and Baroque* Pope-Hennessy, J. *Italian High Renaissance and Baroque Sculpture,* 3 vols. London, 1963.

Pope-Hennessy, "Statuettes" Pope-Hennessy, J. "Italian Statuettes—1." *BM,* 105 (1963), 18–23.

Pope-Hennessy, *Victoria and Albert* Pope-Hennessy, J. *Catalogue of Italian Sculpture in the Victoria and Albert Museum,* 3 vols. London, 1964.

Pope-Hennessy, *Plaquette* Pope-Hennessy, J. "The Italian Plaquette." *Proceedings of the British Academy,* 50 (1964), 63–85.

Pope-Hennessy, *Kress* Pope-Hennessy, J. *Renaissance Bronzes from the Samuel H. Kress Collection.* London, 1965.

Pope-Hennessy and Radcliffe Pope-Hennessy, J. and A. F. Radcliffe. *Italian Sculpture, The Frick Collection Catalogue,* vol. 3. N.Y., 1970.

Prints of the Italian Renaissance National Gallery of Art. *Prints of the Italian Renaissance, A Handbook of the Exhibition,* June 24–Oct. 7, 1973, by J. A. Levenson.

Reznicek, *Goltzius Zeichnungen* Reznicek, E. K. J. *Die Zeichnungen von Hendrick Goltzius,* 2 vols. Utrecht, 1961.

Richter, *Portraits* Richter, G. M. A. *The Portraits of the Greeks,* 3 vols. London, 1965.

Richter, G. M. A. *The Engraved Gems of the Greeks, Etruscans and Romans.* 2 vols. London, 1968–1971.

Robert, *Sarkophagreliefs* Robert, D. *Die antiken Sarkophagreliefs.* Berlin, 1890– (vols. 2, 3, pts. 1–3, and vol. 5, *Die Meerwesen,* by A. Rumpf).

Robertson, M. *A History of Greek Art,* 2 vols. Cambridge, 1975.

Rowland, B., Jr. *The Classical Tradition in Western Art.* Cambridge, Mass., 1963.

Salis, A. von. *Antike und Renaissance: Über Nachleben und Weiterwirken der alten in der neueren Kunst.* Zurich, 1947.

Salton Coll. Bowdoin College Museum of Art. *The Salton Collection, Renaissance and Baroque Medals and Plaquettes.* Brunswick, Maine, 1965.

Saxl, F. "Pagan Sacrifice in the Italian Renaissance." *J Warb,* 2 (1938–39), 346–367.

Saxl, "Classical Inscription" Saxl, F. "The Classical Inscription in Renaissance Art and Politics." *J Warb,* 4 (1941), 19–46.

Schefold, K. *Die Bildnisse der antiken Dichter, Redner und Denker.* Basel, 1943.

Scheller, R. W. *A Survey of Medieval Model Books.* Haarlem, 1963.

Schmitt, A. "Zur Wiederbelebung der Antike im Trecento." *Mitt Flor,* 21 (1977), 167–216.

Schweikhart, G. "Antikencopie und -verwandlung im Fries des Marcello Fogolino aus der Villa Trissino-Muttoni (Cà Impenta) bei Vicenza. Ein Beitrag zur Geschichte der Villendekoration des frühen 16. Jahrhunderts im Veneto." *Mitt Flor,* 20 (1976), 351–378.

Seznec, J. *The Survival of the Pagan Gods, The Mythological Tradition and Its Place in Renaissance Humanism and Art,* trans. B. F. Sessions. N.Y., 1961.

Smith College, *Renaissance Bronzes* Smith College Museum of Art. *Renaissance Bronzes in American Collections,* introd. by J. Pope-Hennessy. Northampton, Mass., 1964.

Spencer, J. R. "Filarete's Bronze Doors at St. Peter's." In: W. S. Sheard and J. T. Pasoletti, eds. *Collaboration in Italian Renaissance Art,* p. 33–45. New Haven, 1978.

Stuart Jones, H. *A Catalogue of the Ancient Sculptures Preserved in the Municipal Collections of Rome, The Sculptures of the Musei Capitolini.* Oxford, 1912.

Stuart Jones, H. *A Catalogue of the Ancient Sculptures Preserved in the Municipal Collections of Rome, The Sculptures of the Palazzo dei Conservatori,* 2 vols. Oxford, 1926 (reprint, 1968).

Summers, D. "Contrapposto: Style and Meaning in Renaissance Art." *AB,* 59 (1977) 336–361.

Talbot, *Dürer* National Gallery of Art. *Dürer in America, His Graphic Work,* April 25–June 6, 1971, exhib. cat. ed. by C. Talbot, entries by G. F. Ravenel and J. A. Levenson. Washington, D. C., 1971.

Thode Thode, H. *Die Antiken in den Stichen Marcanton's, Agostino Veneziano's und Marco Dente's.* Leipzig, 1881.

Tolnay, C. de. *The Youth of Michelangelo*, 2nd ed., rev. Princeton, 1969.

Tokyo, National Museum of Western Art. *Italienische Kleinbronzen und Handzeichnungen der Renaissance und des Manierismus aus österreichischem Staatsbestitz*, exhib. cat. by M. Leithe-Jasper. Tokyo, 1973.

Vasari Vasari, G. *Le vite de' piu eccellenti pittori, scultori e architettori*, ed. G. Milanesi, 9 vols. Florence, 1878–85.

Vasari, G. *Lives of the Most Eminent Painters, Sculptors and Architects*, trans. G. D. de Vere, 10 vols. London, 1912–14.

Venturi, A. "Il Gruppo del Laocoonte e Raffaello." *Archivio storico dell'arte*, 2 (1889), 107–112.

Vermeule, C. C. *European Art and the Classical Past*. Cambridge, Mass., 1964.

Vickers, "Santacroce Sketchbook" Vickers, M. "The 'Palazzo Santacroce Sketchbook': A New Source for Andrea Mantegna's 'Triumph of Caesar', 'Bacchanals' and 'Battle of the Sea Gods'." *BM*, 118 (1976), 824–834.

Vickers, "Intended Setting" Vickers, M. "The Intended Setting Of Mantegna's 'Triumph of Caesar', 'Battle of the Sea Gods' and 'Bacchanals'." *BM*, 120 (1978), 365–370.

Vollenweider, M. L. *Die Steinschneidekunst und ihre Künstler in spätrepublikanischer und augusteischer Zeit*. Baden-Baden, 1966.

Wagner, M. *Die Herrscherbildnisse in antoninischer Zeit*. Berlin, 1939.

Warburg, A. *La rinascità del paganesimo antico*, ed. G. Bing, trans. E. Cantimori. Florence, 1966.

Weihrauch, *Bronzestatuetten* Weihrauch, H. W. *Europäische Bronzestatuetten*. Braunschweig, 1967.

Weiss, R. "Lineamenti per una storia degli studi antiquari in Italia." *Rinascimento*, 9 (1958), 141–201.

Weiss, R. *Pisanello's Medallion of the Emperor John VIII Palaeologus*. London, 1966.

Weiss, R. "The Study of Ancient Numismatics during the Renaissance." *Numismatic Chronicle*, 7th ser., 8 (1968), 177–187.

Weiss, *Discovery of Antiquity* Weiss, R. *The Renaissance Discovery of Classical Antiquity*. Oxford, 1969.

Wildenstein Gallery. *Gods and Heroes, Baroque Images of Antiquity*, Oct. 30, 1968–Jan. 4, 1969, exhib. cat. by E. Williams. N.Y., 1968.

Wildenstein, *Italian Heritage* Wildenstein Gallery. *The Italian Heritage, an Exhibition of Works of Art, lent from American Collections for the Benefit of the Committee to Rescue Italian Art*, May 17–Aug. 29, 1967 exhib. cat. ed. by I. Gordon, introd. by C. Seymour, Jr. N.Y., 1967.

(W.) Winkler Winkler, F. *Die Zeichnungen Albrecht Dürers*, 4 vols. Berlin, 1936–39.

Winner, "Apollo Belvedere" Winner, M. "Zum Apollo vom Belvedere." *BJ*, 10 (1968), 181–199.

A note on the use of this catalogue

Identification of object and medium precedes measurements, which are given in centimeters, height preceding width (and depth), unless otherwise indicated. The dimensions given for the sculpture do not include pedestal or support.

The references at the end of each entry record the sources consulted for basic information on the object, and suggest directions for further research. Exhibition catalogues are always listed under *Exhibitions*, rather than under *References*, even in cases where they provide the major source of previously published information. Books and articles mentioned more than twice in the references have been given abbreviated short titles which appear in bold-face type in the bibliography. Cross references to other objects in the exhibition appear as arabic numbers in parentheses. Dealers' names are in brackets in the listings of *Ex collections*. Most of the other books used in the preparation of this catalogue are listed in the bibliography.

100 (detail)

Catalogue

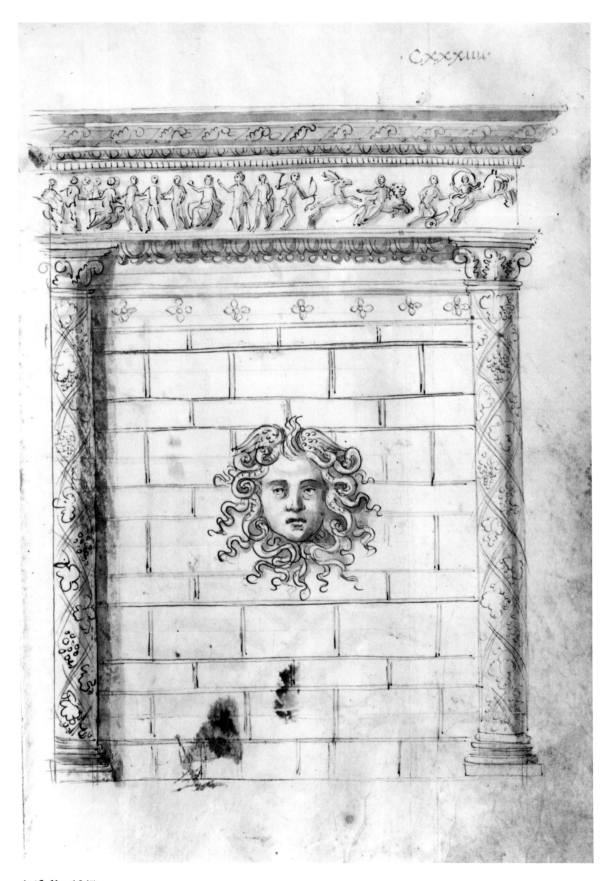

1 (folio 134ʳ)

Cyriacus of Ancona and the
Beginnings of Archaeology

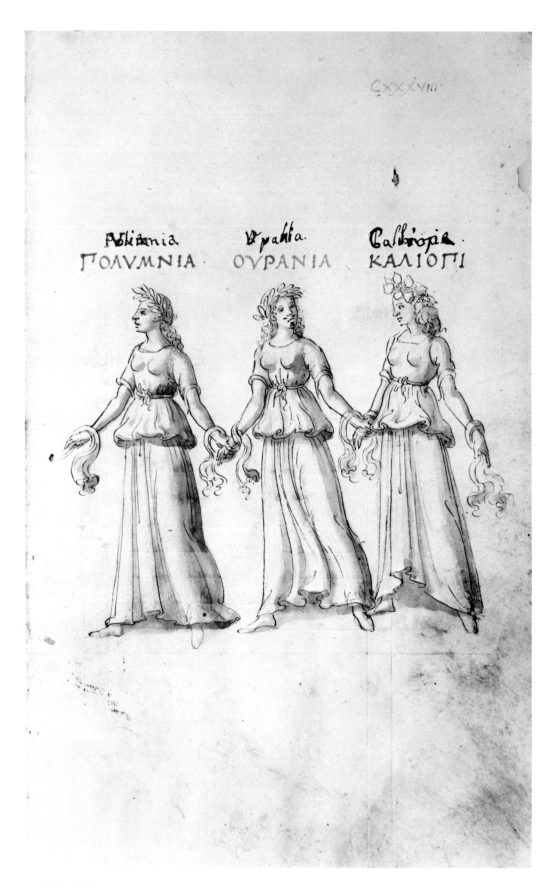

1 (folio 138ʳ)

1 *Codex Ashmolensis* Late 15th century

Bartolommeo Fonzio, compiler and scribe (Florence 1446/Florence 1513)

Codex manuscript, vellum; 115 ff. (numbered 41–86, 88–141, 152–166). Text: ink, rubricated; drawings: chiefly pen and sepia wash with names and text added in red ink (some later defacements in black). 26.3 × 18 cm.

Oxford, Bodleian Library (Ms. Lat. misc. d. 85)

Bartolommeo Fonzio was a scholar, chronicler, editor and copyist of classical manuscripts, as well as a professor of classics in Florence, Rome and Ragusa. He specialized in epigraphy, the collection and study of inscriptions. The *Codex Ashmolensis,* which he compiled and wrote, exhibits a style of script—chancery *all'antica*—that was itself part of antique revival. Though fragmentary (it begins in the middle of a long inscription) the *Codex Ashmolensis* is one of the most important of all Renaissance sylloges. In addition to the interest of its inscriptions, it has the added fascination of being richly illustrated with fine miniatures, mostly pen and wash drawings in a style influenced by Botticelli. It also contains selections from classical and modern authors, a list of the public works still extant in Rome, and a famous letter to Francesco Sassetti in Florence describing the opening of a tomb in 1485 on the Via Appia, in which the well-preserved body of a girl was found.

The bulk of the collection's epigraphic material consists of epitaphs from every corner of the ancient world. Some were modern but most were ancient, dating from 500 B.C. to the fourth century A.D. By far the majority of the inscriptions had already been discovered and circulated by Cyriacus of Ancona and his contemporaries. Although the manuscript was produced with care, the inscriptions have been given no systematic arrangement, neither topographical (cf. 3) nor according to contents. "Who ever had the book was supposed to read in it at random, enjoying one inscription after the other. Such an arrangement presupposes a class of readers equally interested in all manifestations of ancient life and capable of giving the single monument its proper place in the framework of their classical knowledge" (Saxl, 24).

The *Codex Ashmolensis* plays a crucial role in the reconstruction of the corpus of Cyriacus of Ancona's drawings after classical antiquities. It includes copies of certain drawings that have not otherwise survived. Its copies are among the most faithful reproductions of Cyriacus's originals. For example, the copies of Cyriacus's measured drawings of the colossal temple built by Hadrian at Cyzicus (considered to have been the eighth wonder of the ancient world) are "among the most extraordinary documents of the Italian Renaissance, the most eloquent of all testimony to the accuracy, the proto-modernity" of Cyriacus's archaeological investigations (Lehmann).

The drawings made by Cyriacus while visiting the island of Samothrace in the autumn of 1444 are known only through copies in this codex and three others. In her study of Cyriacus on Samothrace, Phyllis Lehmann discussed the most influential of these, the bust inscribed ΑΡΙΣΤΟΤΕΛΗΣ (fol. 141r), but actually representing a weathered bust from a pediment, possibly the blind seer Teiresias (see 2). Cyriacus's identification of the bust as Aristotle exemplifies his procedure. He was the first fifteenth-century student of antiquity to interpret physical remains in the light of ancient literature, of which his knowledge was prodigious. To his credit, as a result, must be laid the earliest stirrings of a reintegration of the legendary, the historical and the monumental into "an ever-expanding picture of the ancient world" (Lehmann). Here on the island of Samothrace, "where Philip had met Olympias, he saw in this venerable image a portrait of their son Alexander's tutor Aristotle." Phyllis Lehmann was the first to demonstrate that the Fonzio copy of Cyriacus's drawing inscribed with the names of six Muses and, in Greek, the Samothracian nymphs (fols. 137v–138v; see *Check List,* fig. 1) was related both to an archaistic relief of dancing maidens on Samothrace and to Mantegna's *Parnassus* (see 14).

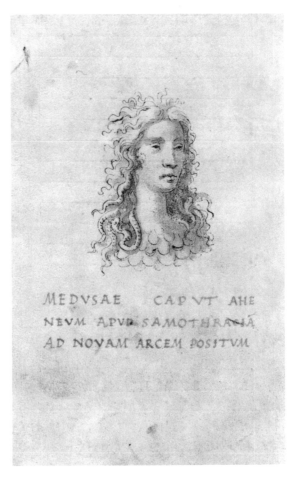

1 (folio 140ᵛ)

Cyriacus had added the names of the Muses in bold inscription-like Greek letters but the Italian transcriptions above these names in the *Codex Ashmolensis* are a later addition. Cyriacus's careful rendering of the relief was preserved by the artist who worked for Fonzio. As in Cyriacus's drawing, the figures in the copy look either forward or back over their shoulders and wear a combination of the girdled peplos and the sleeved chiton with a fluttering overfold. The strands of material linking each pair of figures, Cyriacus's interpretation of the elegant mantles worn by alternate maidens in the Samothracian relief, were retained by Mantegna in his *Parnassus* Muses.

Ex collections: Vincenzo Chiarelli, Lazio (19th cent.); John Marshall and E. P. Warren; Bernard Ashmole.
Exhibitions: "Greek Manuscripts in the Bodleian Library," Oxford, 1966, no. 48; "Autographs of Italian Humanists," Bodleian Library, Oxford, 1974, no. 19; "The Survival of the Ancient Library," Bodleian Library, Oxford, 1975, no. 149.
References: K. Lehmann-Hartleben, "Cyriacus of Ancona, Aristotle and Teiresias in Samothrace," *Hesperia,* 12 (1943), 115–134, esp. 123ff.; Saxl, "Classical Inscription," passim; B. Ashmole, "A Lost Statue once in Thasos," in D.J. Gordon, ed., *Fritz Saxl, 1890–1948,* London (etc.), 1957, p. 195–198; B. Ashmole, "Cyriac of Ancona," *Proceedings of the British Academy,* 45 (1957), 25–41, and plates; O. Pächt and J. J. G. Alexander, *Illuminated Manuscripts in the Bodleian Library Oxford,* 3 vols., Oxford, 1970, 2, no. 329; Lehmann, "Cyriacus in Samothrace," passim; S. Caroti and S. Zamponi, *Lo scrittoio di Bartolomeo Fonzio umanista fiorentino,* Milan [1974], 9–16, 84–90.

1 (folio 141ʳ; leaf mutilated)

2 *Bust of Aristotle* Early 16th century
North Italy(?)
Bronze (heavy cast, bust hollow); black-brown patina. Inscription on collar: ΑΡΙΣΤΟΤΕΛΟΙΣ. 67.9 cm.
Museum of Fine Arts, Boston, Grace M. Edwards Fund, 1941 (47.1380)

In 1592, a small marble bust inscribed ΑΡΙΣΤΟ-ΤΕΛΗΣ was found at the foot of the Quirinal Hill. This was the earliest known authentic inscribed portrait of Aristotle. Before that time, Aristotle had been portrayed with long flowing beard and a skull cap as seen in this bronze bust. The source of this representation was a drawing inscribed ΑΡΙΣΤΟΤΕΛΗΣ which Cyriacus of Ancona had made in Samothrace in 1444 (1, fol. 141r). Cyriacus's model, already much weathered in the fifteenth century, still retains the general contours of hair, mustache, and beard, even the diagonal folds of the mantle, later incorporated as features typical of Aristotle's likeness (Lehmann). Understandably, Cyriacus misidentified this Samothracian bust, now thought to represent the blind seer Teiresias (Lehmann), as Aristotle, having in mind both Aristotle's connection to the history of the island of Samothrace, as Lehmann shows, and the medieval tradition in which the philosopher was portrayed as an old man with a beard, long flowing locks, and a cap (Jongkees).

"Shortly after Cyriacus sketched his 'Aristotle' in the autumn of 1444, his drawing became known in Italy, known and accepted as an authentic document of the philosopher's appearance" (Lehmann, 21). Its earliest reflection appears in the portrait of Aristotle in one of the panels of Agostino di Duccio's *Arca degli Antenati e Discendenti* in San Francesco, Rimini, a monument completed in the 1450s (Saxl). Cyriacus's drawing, whether directly or through Fonzio's copy, served as the basis for a series of portraits of Aristotle on bronze medals and plaques. The Boston Museum's bronze bust is among these. Though the medals and plaques present the philosopher in profile, following characteristic Renaissance imitation of antique practice, the dependence of the type on Cyriacus's drawing seems nonetheless certain. Studniczka established in 1900 that the authentic portrait tradition of Aristotle is wholly foreign to this type. His demonstration does not, however, affect the belief in its authenticity widely held during the fifteenth and sixteenth centuries.

This *Bust of Aristotle* has often been associated with one having the same inscription described by Jacopo Tomasini (1597–1654) as having been in Petrarch's house at Arquà, near Padua. The suggestion has been made that the bust portrays a fifteenth-century luminary such as Leonardo or Manuel Chrysoloras—a Byzantine who was Professor of Greek in Florence in 1397—as Aristotle (Planiscig).

The wide open eyes with their fixed stare have a curious, unseeing expression. Perhaps remembering an ancient report that Aristotle was μικρόμματος led

Cyriacus to render the half-closed eyes of his model carefully (Lehmann). In this roundabout way the blindness of Teiresias could help to explain the bronze Aristotle's unseeing look.

Ex collections: Bachatitz; [P. Jackson Higgs; Duveen, 1941]; John Gellatly, N.Y.; Fritz von Gans, Frankfurt on the Main.

Exhibitions: "The Bachatitz Collection of Renaissance Bronzes exhibited at the Galleries of P. Jackson Higgs," New York, December, 1923 (cat. by Frank R. Washburn Freund).

References: F. Studniczka, *Festblatt zum Winckelmannsfest des arch. Seminars d. Univ. Leipzig,* Leipzig, 1900, and *Das Bildnis des Aristoteles,* Leipzig, 1908, 15ff.; L. Planiscig, "Leonardos Porträte and Aristoteles," *Festschrift für Julius Schlosser zum 60. Geburtstage,* Zurich-Leipzig-Vienna, 1927, 137ff.; Saxl, "Classical Inscription," 37; J. H. Jongkees, *Fulvio Orsini's Imagines and the Portrait of Aristotle,* Groningen, 1960 (Archaeologica Traiectina, 4), esp. 17ff.; M. Goukovski, in *Troudy,* 6, cit. by J. Bialostocki, "Recent Research: Russia—Early Periods," *BM,* 107 (1965), 431 (discusses a bronze bust in the Hermitage identical to this *Aristotle* and argues that they portray Leonardo as Aristotle; Bialostocki maintains the similarities in appearance are general, not specific); Pope-Hennessy, *Kress,* no. 373; Richter, *Portraits,* 2, 172; Lehmann, "Cyriacus in Samothrace," 15–25.

2

3 *Inscriptiones sacrosanctae vetustatis* 1534

Petrus Apianus and Bartholomeus Amantius

Printed book; Ingolstadt, Apianus; woodcut illustration. 28 × 19 cm.

Princeton University Library (Ex 10214.12q)

The practice of collecting ancient inscriptions in sylloges rapidly spread throughout Europe, following the example of Cyriacus of Ancona and his imitators in the next generation, Giovanni Marcanova and Felice Feliciano. Northerners like Choler, Peutinger, Pirckheimer and Celtes followed suit. Publishing such compendia in printed books began with small local collections, in towns like Ravenna and Augsburg. The first attempt to present a corpus of all the ancient inscriptions of Rome was Jacopo Mazzocchi's *Epigrammata antiquae urbis* (Rome, 1521). Its principal source was probably the sylloge of Fra Giovanni Giocondo (1443–1515), a Venetian engineer and architect who with Raphael succeeded Bramante in overseeing the *fabbrica* of St. Peter's (1514).

Giocondo had attempted to reform epigraphy by introducing three new principles. Inscriptions based on examination at first hand should be separated from those known only at second hand; the collection should be as comprehensive as possible, a "corpus"; and it should be arranged topographically. The second and third of these principles were followed by Apianus and Amantius. *Inscriptiones sacrosanctae vetustatis,* dedicated to the German art patron and book collector Raymund Fugger (1489–1535), was the first printed world-corpus of classical inscriptions. Their pride in this is expressed in the book's subtitle: *non illae quidem romanae sed totius fere orbis summo studio ac miximis impensis terra mariq[ue] conquisitae feliciter incipiunt.* Giocondo's first principle, however, was not followed. Apianus was a geographer and astronomer who founded the university press at Ingolstadt. He is not recorded as having traveled to Italy. He belonged to a learned circle of humanists who shared sketches of ancient monuments and records of inscriptions.

The disparity between the works illustrated in his corpus and their actual appearance was investigated by Phyllis Williams Lehmann in an article that continues

3 (p. CCLXXI)

to provide a starting point for the study of Renaissance attitudes toward antiquities (1941). One woodcut illustrates a monument to Cornelia Tyche and her daughter Julia Secunda (Louvre; fol. ccxxxv), in the form of a sepulchral altar with busts of the two women set into a shallow niche resting on an inscribed base divided into two panels, each carved with an inscription. The woodcut translates the Roman funerary busts on acanthus leaf pedestals into the stolid and complacent images of two burgheresses, their appearance based on female types in Dürer engravings. "The transformation is so complete that no vestige of their original appearance has been retained." The sketch Apianus's illustrator had to work from must have been very rude indeed. Otherwise the pediment relief, which contains empty chairs, a quiver and bow, cornucopia, torch, rudder on a globe, and a wheel—all the iconographic clues followed by Lehmann in her interpretation of the relief—would hardly have been totally omitted. Unlike Fra Giovanni Giocondo, Apianus and Amantius did not combine their antiquarian zeal for inscriptions with an appreciation for classical qualities of form, nor did they follow the example of Cyriacus of Ancona, who was always mindful of the importance of the details of the context of an inscription.

Apianus's illustrator based his woodcut of another funerary relief, an Augustan gravestone portraying the members of a family (Vatican, Galleria Lapidaria 80A) illustrated on fol. cclxxi, on a north Italian rather than a German artistic tradition, with results that more closely approached the monument's original appearance. This time the misleading aspect of the image is the inscriptions: "FIDII SIMULACRUM" above the relief of the figures in a windowlike frame (a misreading of "FIDEI SIMULACRUM" carved on the original), and, on the left and right, "HONOR" and "VERITAS". These words, along with "AMOR" over the central figure, were not part of the original Roman funerary relief, but instead had presumably been added by the relief's Renaissance owner only about thirty-five years before the woodcut was made.

Lehmann ingeniously reconstructed the context in which such alterations to a Roman gravestone would have been thought appropriate. The relief's image of clasped hands inspired the Renaissance interpretation of the gravestone as an illustration of the Roman concept of Faith. In conceiving of the three components of Faith as "HONOR," "VERITAS," and "AMOR," the owner of the relief may have been influenced by the Neoplatonic philosophy of Pico della Mirandola which stressed the threefold nature of truth.

Within a surprisingly short time, these inscriptions were accepted as antique and the monument had thus been transformed into a misleading pseudodocument of Roman religion! As such it received a number of learned commentaries, like Apianus's above his woodcut, explaining that the relief depicted Medius Fidius, the god invoked by the Romans in their oaths and hence an appropriate symbol of Faith. Vincenzo Cartari illustrated the relief in his *Le imagini de i dei de gli*

antichi (Venice, 1580) based on the same archtype that Apianus had used, but failed to notice the discrepancy between his illustration, which showed the inscription "AMOR," and his text, which omitted it. This error gave rise to a belief that two similar stones with different inscriptions existed, a belief that persisted throughout several generations of writers on Roman antiquities. "Fortuna herself could not have devised a more ironic and capricious fate for a legitimate monument of antiquity than to be valued for so many centuries primarily for its Renaissance inscriptions! . . . In the Renaissance, antiquity was not accepted in its native garb—before being presented to society, it was lightly but decently clothed in contemporary dress."

Ex collection: William Niven, Udney House, Teddington, England.
References: Saxl, "Classical Inscription," 31; P. Lehmann, "Two Roman Reliefs in Renaissance Disguise," *JWarb* 4/5(1941–2), 47–66; E. Panofsky, "Excursus: The Illustrations of Apianus' 'Inscriptiones' in Relation to Dürer," *Meaning in the Visual Arts,* Garden City, N.Y., 1955, 286–294.

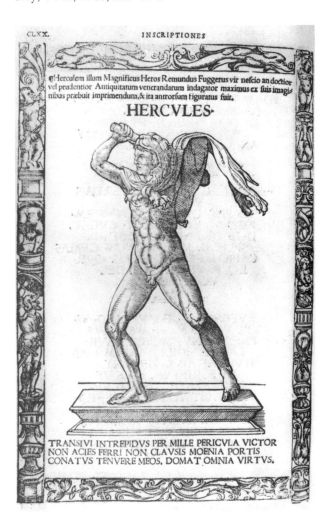

3 (p. CLXX)

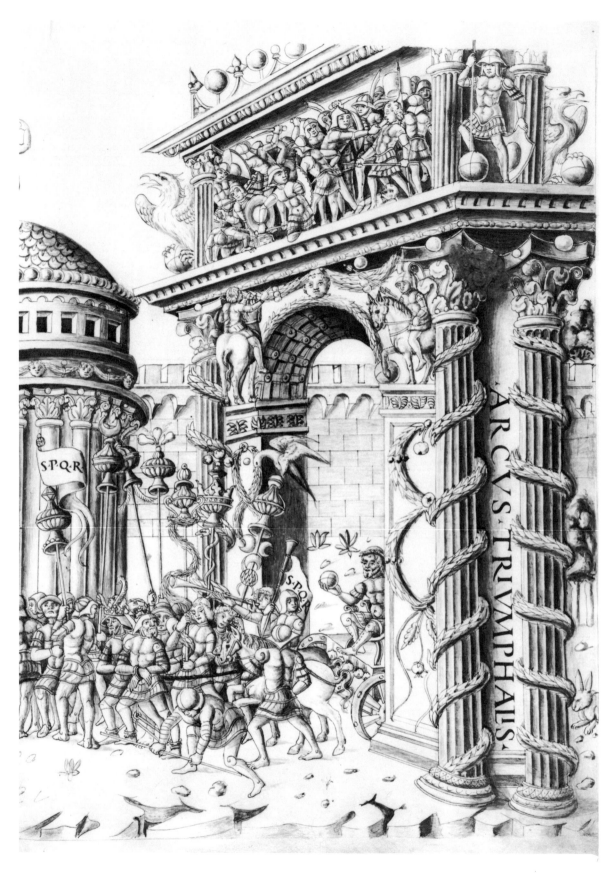

4 (folio 5)

Mantegna: His Context and Influence

4 *Antiquitates* 1465

Giovanni Marcanova (Venice ? c. 1410/Padua 1467)
Codex manuscript, vellum; 209 ff. Text: ink; drawings: ink, some with wash. 36 × 26 cm.
Princeton University Library (Garrett 158)

Giovanni Marcanova, the author of this sylloge of classical inscriptions, was a philosopher, physician and poet as well as an antiquarian. Marcanova went on an antiquity-hunting expedition on the shores of Lake Garda one September day in 1464 with Andrea Mantegna, soon to become the leading artist of north Italy. A vivid record of this day is preserved in a letter written by another member of the expedition, Felice Feliciano (1433–1480), an antiquarian from Verona:

[we] reached wooded gardens so like paradise they might have sprung up as an abode of . . . the Muses. We found these gardens not only brilliant and scented with the perfume of rose-hued and purple flowers but also shady on all sides from the leafy branches of the citrus- and lemon trees. And we inspected islands with streams flowing abundantly through the meadows and they were adorned both with palm-branched laurels lofty with years and with fruit-bearing trees. There we saw a great many antique remains, and first . . . this inscription on a marble column . . . [there follows the inscription] (trans. Meiss)

The dreamlike tone of this letter, in which the recovery of pagan antiquity is associated with a *locus amoenus* overtly conflated with Paradise by the writer, provides the tone that pervaded the fantasy played out by this group of remarkable men. Samuele da Tradate, a humanist at the court of Mantua, assumed the role of Emperor, while Mantegna and Marcanova acted the part of consuls. The "Emperor" played the zither in the boat carrying them across the lake. When, toward sunset, they entered a shrine and gave thanks to the Virgin and her Son "the supreme Thunderer" for granting them the wisdom and the will to seek out such delightful places and such venerable monuments (Meiss), their playful synthesis of antiquity and Christianity again comes to the fore. Mitchell's work has shown how on this occasion the artist, the humanist and the two antiquarians were seeking fresh reflections of an antiquity that shone in their imaginations with a kind of romantic glow, and how therefore the imitation of the classical past was becoming as much a lifestyle as a matter of dry and scholarly investigation. Mitchell compared the joyous, fanciful tone of this expedition to the more sober style exhibited by Florentines like Niccolò Niccoli and Piero de' Medici amidst their collections of codices, precious vases, gems and coins.

Antiquity appears as a dreamlike imaginary world too in Marcanova's codices. The Princeton *Antiquitates* was copied from a manuscript in the Bibliothèque Nationale (Parisinus 5825F). The master copy, in the Este Library at Modena, that Marcanova ordered made of his collection of inscriptions, was completed on October 1, 1465. Its contents in Latin—a dedication to Malatesta Novella of Cesena, a description of Rome, a collection of inscriptions, and selections from Latin authors—are repeated in the Garrett copy. Exactly when the Garrett copy was made is not known, but its first recorded owner was a French sixteenth-century humanist, Marc Antoine Muret (1526–85).

Although Cyriacus of Ancona's drawings of Rome, which he spent forty days making in 1424, are now lost, there is little likelihood that the *Antiquitates* drawings were derived from them. These, unlike Cyriacus's faithful copies, presented an image of Rome drawn from Marcanova's imagination or that of his unknown artist. The barely recognizable buildings resemble reflections in a distorting mirror that lengthens and squeezes everything together. Superimposed on these attenuated shapes are bizarrely enlarged details—moldings, swags, imbrication and the like—which provide a clue to what was most easily accessible of ancient Rome, that is, its decorative vocabulary, visible on ruins scattered throughout Italy. In the body of the *Antiquitates*, pseudo-facsimiles of lapidary inscriptions are given in squared capitals, sometimes framed by outlines which suggest slabs, urns or sarcophagi. Imagined scenes of everyday life—an execution on the Capitol (folio 3), a triumphal procession through an arch that never existed (folio 5)—are interspersed with the ruinscapes. Antiquities that had remained famous throughout the Middle Ages, such as the Marcus Aurelius statue on folio 14, are presented in ways that offer clues to their quattrocento contexts. On that leaf fragments of the colossus of Constantius II—the gigantic head and a hand holding a sphere—are displayed on capital bases atop a tall building opposite the Marcus Aurelius statue. These, properly deciphered, offer evidence for the location of the fragments (which probably still retained traces of medieval gilding) atop columns. Marcanova's drawings, despite their fanciful elaboration, thus help to fill in for us the unsuspected context of splendor and near-veneration in which the papal collection of ancient statues was displayed in the busy central precinct of the Lateran Palace courtyard in the mid fifteenth century. On the whole, however, examining the drawings of Marcanova's Roman album is like an excursion through the romance of archeology which later antiquarians, like Pirro Ligorio in the sixteenth century, felt compelled to reform.

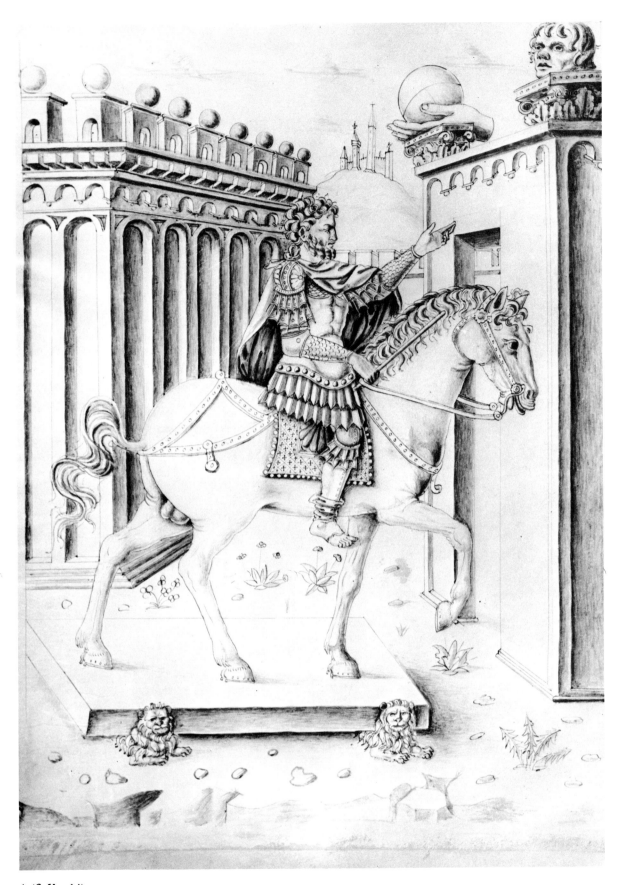

4 (folio 14)

Ex collections: Marc Antoine Muret, 1585; Muret (nephew of Marc Antoine); Collegio Romano, Rome, c. 1870; W. M. Voynich, 1924; Robert Garrett.

Exhibitions: Walters Art Gallery, *Illuminated Books of the Middle Ages and Renaissance,* Baltimore, 1949, no. 185; Princeton University Library, "Mirrors of the Medieval World," May–September, 1966, "Checklist of Miniatures shown," compiled by Rosalie B. Green, *Princeton University Library Chronicle,* 27, 3 (Spring, 1966), 186–190, no. 59.

References: H. Van Mater Dennis, III, "The Garrett Ms. of Marcanova," *Memoirs of the American Academy of Rome,* 6 (1926), 113–126, and E. B. Lawrence, "The Illustrations of the Garrett and Modena Mss. of Marcanova," ibid., 127–131 and plates 23–48; De Ricci, *Census,* I, no. 158, 897; W. S. Heckscher, *Sixtus IIII aeneas insignes statuas romano populo restituendas censuit,* Utrecht, 1955, and personal communication, December, 1977; M. Meiss, *Andrea Mantegna as Illuminator,* Gluckstadt-Hamburg, 1957, 55–56; C. Mitchell, "Archaeology and Romance in Renaissance Italy," in E. F. Jacob, ed., *Italian Renaissance Studies,* London, 1960, 455–483, esp. 475–481; J. J. G. Alexander, *Italian Renaissance Illuminations,* N.Y., 1977, 18 f., pls. 13, 14, 17, 18.

5 *Bacchanal with a Wine Vat* c. 1475

Andrea Mantegna (Isola di Cartura, near Padua, 1431/ Mantua 1506)

Engraving; H. 5, 13, 4. 26.6 × 41.8 cm.

The Trustees of the Chatsworth Settlement

The date c. 1475 to which Levenson, Oberhuber and Sheehan assigned Mantegna's *Bacchanal with a Wine Vat* is 10 to 13 years earlier than the two engravings which form the *Battle of the Sea Gods* (7). These three, together with the *Bacchanal with Silenus,* are Mantegna's four known engravings of mythological scenes.

The present engraving depicts the drunken coronation of the Wine God, Bacchus, in the midst of satyrs, fauns and putti. Mantegna's principal sources for this engraving were Bacchic sarcophagi. His literal use of sources has been demonstrated by Phyllis Lehmann. The man carrying another man recalls a satyr carrying Eros on a Bacchic sarcophagus, now in the British Museum (Rubenstein), which in the fifteenth century stood in Santa Maria Maggiore in Rome. Although Mantegna is not recorded as having visited Rome before 1488, he could have been familiar with such motifs earlier in his career from drawings circulating in north

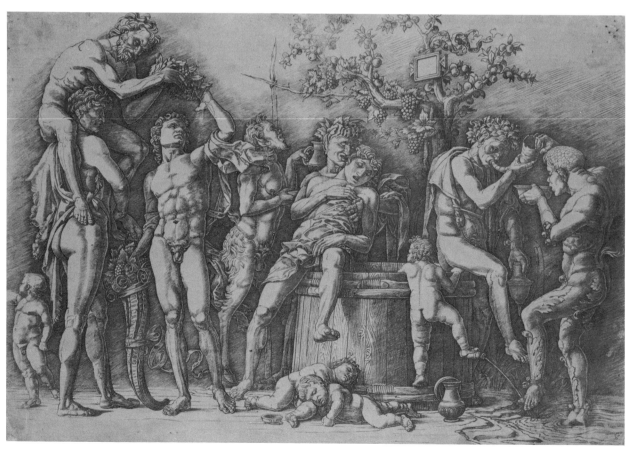

Italy. A reference to one sketchbook, dated 1476, specified drawings of battles of centaurs, fauns and satyrs, men and women on horseback and on foot, possibly even an Amazonomachy sarcophagus (Brown). Brown's discovery proves that Mantegna did indeed have recourse to at least one such collection of drawings immediately after finishing the Camera degli Sposi (1474). Vickers deduced from motifs in the *Bacchanals* and the *Triumph of Caesar* panels at Hampton Court that Mantegna saw drawings recording certain reliefs that stood in the Palazzo Santacroce, Rome, at least from 1683 until the early nineteenth century. These included the census and sea thiasos reliefs of the *"Altar of Ahenobarbus"* (Louvre and Munich Glyptothek) as well as Bacchic sarcophagi and an Ikarios relief, some of which were engraved for Jacob Spron shortly before his death in 1685.

Levenson, Oberhuber and Sheehan, followed by Langemeyer and Schleier, identified the figure holding the cornucopia as a conflation of the *Apollo Belvedere* and one of the Monte Cavallo *Dioscuri*. If this is true and the dating of the engraving in the 1470s is retained, the discovery of the *Apollo Belvedere* took place more than 15 years earlier than 1490, the date usually proposed, based on Antico's statuettes and on a reference in a Cesena chronicle (Brummer, 44, n.2). Panofsky suggested a relationship between Mantegna's "splendid nude" and the *Apollo Belvedere* in writing that the figure in the *Bacchanal with a Wine Vat* had "merged in Dürer's imagination with that of the *Apollo Belvedere*" as a source for Dürer's *Sol-Apollo* in London. This observation is corroborated by a sketch, possibly reflecting Mantegna's Bacchus, on an early study sheet by Dürer in the Uffizi (Winkler I, no. 86; Levenson, Oberhuber and Sheehan). Panofsky did not believe that Mantegna's source was the *Apollo*, but preferred to think that a version of the Dionysus mural in the Casa de' Vetti in Pompeii, which even shares with Mantegna's figure the motif of the cornucopia, could have been known in the Renaissance. The putto at the extreme left in the *Bacchanal* apparently depends on the same model as does the *Standing Putto* (6), probably by Mantegna. Other examples of the engraving's influence are listed by Levenson, Oberhuber and Sheehan.

Kristeller conjectured that all four of Mantegna's mythological compositions were originally designs for wall decorations. Tietze-Conrat suggested that the disjunction between the two *Bacchanal* scenes meant that a door or window was planned to separate them. Battisti connected the *Bacchanals* with Battista Fiera's description of frescoes, one of which apparently depicted a bacchanal, painted by Mantegna in a Gonzaga palace probably built before 1462. Vickers has proposed a hypothetical room designed for Gianfrancesco in 1486 which encompassed both the *Triumph of Caesar* on the long walls and the *Bacchanals* and *Battle of the Sea Gods* on the short walls. The expressions and gestures of certain figures in each composition seem to be directed outside it, as for example the putto at the left in the *Bacchanal with a Wine Vat*. Perhaps such figures were intended to relate to figures on adjacent walls. In this interpretation all four engravings are seen as depicting parts of a triumphal procession.

Compared to compositions on sarcophagi, Mantegna's are less crowded and, as noted by Levenson and other scholars, the figures are conceived as grouped in an illusionistic picture space. The illusion of depth, unusual in an engraving, is consistently applied in the sculptural conception of the individual figures and with their placement to one another in space. This plasticity of modeling and amplitude of space, which distinguishes the engraving as one of the finest of quattrocento prints, is evident only in a fine, early impression such as this one. Most impressions, pulled after the plate had become worn, lack sufficient textural differentiation to achieve the intended illusionistic effects. Mantegna's sculptural sources had by virtue of their medium a plasticity, density and hardness that challenged him to re-create these qualities in the two-dimensional media of painting and engraving. His successful response gave pictorial illusionism in graphic art a new dimension that amazed and delighted contemporaries and successors alike.

Ex collection: Devonshire collection since c. 1730.
Exhibition: Prints of the Italian Ren., no. 171.
References: P. Kristeller, *Andrea Mantegna*, trans. S. A. Strong. N.Y., 1902, 417; E. Panofsky, "Dürer and Classical Antiquity," *Meaning in the Visual Arts*, Garden City, N.Y., 1955, 253 and n. 47; E. Tietze-Conrat, *Mantegna*, London, 1955, 243; E. Battisti, "Il Mantegna e la letteratura classica," *Atti del VI Convegno Internazionale di Studi sul Rinascimento: Arte, pensiero e cultura a Mantova nel primo rinascimento in rapporto con la Toscana e con il Veneto*, Florence, 1965, 25–31; Brummer, *Statue Court*, 44–71; E. Simon, "Dürer und Mantegna 1494," *Anzeiger des Germanischen Nationalmuseums*, 1971–72, 26–28; C. M. Brown, "Gleanings from the Gonzaga Documents in Mantua—Gian Cristoforo Romano and Andrea Mantegna," *Mitteilungen des Kunsthistorischen Instituts in Florenz*, 17 (1973), 158–159; Lehmann, "Parnassus," 98f. and 146–148; Levenson, Oberhuber and Sheehan, 182–185, no. 73 (with previous bibliography); Langemeyer and Schleier, *Bilder nach Bildern*, 130, no. 102; R. Rubenstein, "A Bacchic Sarcophagus in the Renaissance," *British Museum Yearbook*, 1 (1976), 103–156; Vickers, "Santacroce Sketchbook" and "Intended Setting."

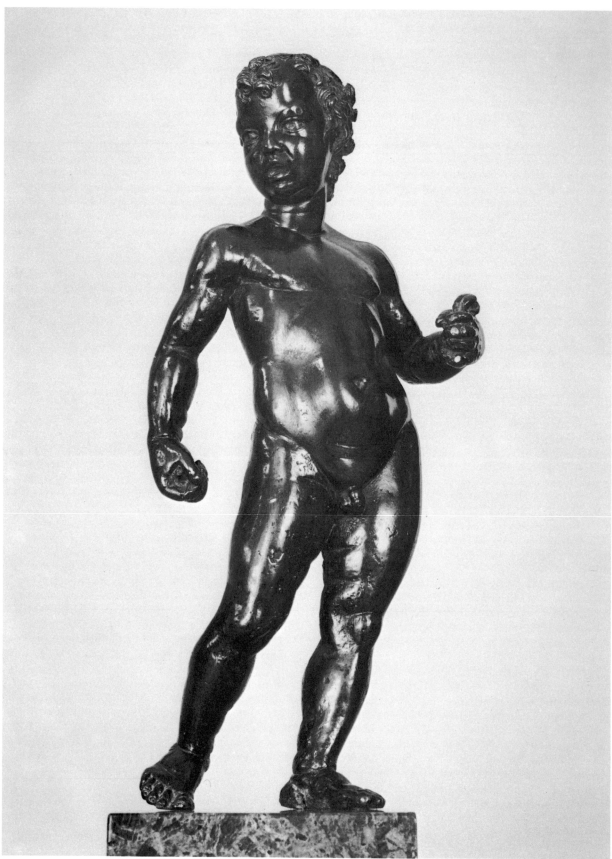

6

6 *Standing Putto* c. 1480

Circle of Andrea Mantegna (Isola di Cartura, near Padua, 1431/Mantua 1506)

Bronze (solid cast); greenish raw umber patina. 20.5 cm.

The Museum of Fine Arts, Houston, Edith A. and Percy S. Straus Collection (44–592)

In a review of *Renaissance Bronzes in American Collections* (Smith College Museum of Art, 1964) Jennifer Montagu pointed out that the relationship between the *Standing Putto* and a drawing attributed to Zoan Andrea in the Fondazione Horne (Inv. 5858) had been overlooked in the catalogue. Byam Shaw had earlier noticed that the model for the drawing, which shows the child holding a spoon in his right hand (ill. Ragghianti Collobi), was not an infant but a Renaissance bronze. He connected the drawing with the Houston *Standing Putto,* then in the Straus collection in New York, and to a version in Vienna. Planiscig had proposed an antique model for the bronzes and the drawing. Byam Shaw conjectured that such an antique came into Mantegna's possession late in his career, since many of his later pictures, in addition to the *Bacchanal with a Wine Vat,* contain variations on this motif. The putto at the extreme left in the *Bacchanal* is in fact a precise rendition of this type (5). It is just as likely that Mantegna invented the type himself, probably as a conflation of various antique putti, and then used it both for the *Bacchanal with a Wine Vat* and a wax model which was cast as the *Standing Putto.* One of its variants, also a solid cast, is in the Metropolitan Museum of Art. Its existence some years earlier than the *Bacchanal with a Wine Vat* is suggested by a putto belonging to the same type in the "May" section of Francesco Cossa's frescoes in the Palazzo Schifanoia (c. 1470), Isabella D'Este's Ferrarese residence before her marriage to Gianfrancesco Gonzaga (Montagu).

The high quality of the casting and chasing of the Houston bronze leads to the supposition that the sculpture was produced under Mantegna's supervision. Mantegna is mentioned in letters of 1483 as having made models for bronze vessels. Zoan Andrea employed the same and similar putto types in several engravings (Byam Shaw). The bronze was formerly attributed to the circle of Verrocchio.

Ex collections: Marquis de Pompignan, Paris; Edith A. and Percy S. Straus, New York, 1944.
Exhibitions: Albright, *Master Bronzes,* no. 123; Detroit, *Decorative Arts,* no. 239; Smith College, *Renaissance Bronzes,* no. 3 (with previous bibliography).
References: J. Byam Shaw, "A Group of Mantegnesque Drawings, and Their Relation to the Engravings of Mantegna's School," *Old Master Drawings,* 11 (1937), 57–60; L. Ragghianti Collobi, *Disegni della Fondazione Horne in Firenze,* Florence, 1963, 34, no. 104; ill. fig. 64 (Zoan Andrea drawing of *Two Putti*); J. Montagu, review of Smith College, *Renaissance Bronzes, BM,* 108 (1966), 46; J. Pope-Hennessy still adheres to the circle of Verrocchio attribution (personal communication, April 1978).

7 *Battle of the Sea Gods* c. 1485–88

Andrea Mantegna (Isola di Cartura, near Padua, 1431/Mantua 1506)

Engraving; H. 5, 15, 5 and 6(I); left and right halves joined. 28 × 82.8 cm. (irregular)

The Trustees of the Chatsworth Settlement

The *Battle of the Sea Gods* consists of two engravings joined together to form a unified composition. Hybrid marine creatures, hippocamps and tritons, leafy sea sprites, and a fearsome, roaring sea monster are engaged in a battle over which Neptune, the sea god, standing on a garlanded pedestal with back turned, keeps watch. The presiding spirit, Envy, a naked hag at the left who rides on the sea monster's back, holds a small titulus with the inscription "INVID" and a word interpreted either as ZHΛOΣ, the Greek word for Envy, or as Erinyes, the Furies. The pictorial illusionism in this print, particularly rich in this combination of rare early impressions, surpasses even Mantegna's own *Bacchanals.* It is difficult to determine, though, how much time had to elapse to allow for the evident growth in control of the medium resulting in such increased artistic freedom. Levenson, Oberhuber and Sheehan proposed 10–13 years.

Mantegna relied on surprisingly varied sources for this engraving. Several of the participants are actively fighting, yet the composition viewed as a whole is harmonious. The combination of violence in subject with classicism of style recalls certain battle sarcophagi. Undoubtedly too he had recourse to a Roman sea thiasos relief, although precisely which is not certain. About 30 examples were known before 1527. Bober nominated the relief fragment in the Villa Medici drawn by Pighianus in a codex at Coburg (ill. Bober, fig. 1) and earlier by the Ambrosiana Anonymous (Degenhart and Schmitt). Support for this hypothesis comes from the Mantegnesque drawing of *Tritons and Hippocamps* (Paris, Ecole des Beaux Arts, 190, ill. Paccagnini, fig. 147), now generally ascribed to Giovanni Bellini, possibly as a copy after a drawing by Mantegna, which shows a triton leading a sea horse similar to the central motif of the *Codex Coburgensis* drawing (Bober, 48). Vickers recently advanced the notion that Mantegna probably knew the much better preserved and more monumental sea thiasos reliefs of the *"Altar of Ahenobarbus"* (Louvre and Munich Glyptothek) from drawings of reliefs located in the seventeenth and eighteenth centuries in the Palazzo Santacroce, Rome. The leafy youth blowing a horn is particularly reminiscent of a figure in the Munich relief (Kahler, pl. 2). But belief in the *"Altar of Ahenobarbus"* as a source depends crucially on demonstrating Mantegna's use of its census reliefs in the *Triumph of Caesar* panels. On the other hand, the hippocamp at the right in the left half of the *Battle of the Sea Gods,* especially the position of the animal's forelegs and hooves, strongly resembles that of the right *Horse Tamer*'s horse, as Vickers himself admitted. The sea-centaur in the right half, which uses a bucrane as a shield, seems close in physique, gesture and head type to the left

Horse Tamer. Even the Ecole des Beaux Arts drawing invites the conclusion that the Villa Medici relief was augmented by the *Horse Tamers* in order to reconstruct the missing sections, which included the tritons' heads and arms and the hippocamps' forelegs. The *Horse Tamers* on Monte Cavallo thus gain credibility at least equal to that of the *"Ahenobarbus"* reliefs as a chief source for the engraved hippocamp and sea centaur.

The figure of Neptune seen from behind on a pedestal is without question drawn from an antique of very different scale, an intaglio known after its maker as *The Felix Gem* (8) (Vickers). By 1483 this gem was in the Gonzaga collection (Brown). Vickers notes that in both the gem and the engraving the Neptunes are close to vignettes of cities, and that the pedestal in Mantegna's engraving is decorated with swags which recall the altar in the gem. The form of the gem is repeated by the shape of the mirror to Neptune's right.

Mantegna supplemented ancient sources with contemporary ones. The pairs of mounted warriors ranged before a background of dense reeds and cattails recall Pollaiuolo's *Battle of the Nudes,* to which the *Battle of the Sea Gods* quite conceivably was Mantegna's response (cf. 44). Several authors have seen a connection with a miniature in a manuscript of Pliny's *Historia naturalis* in the Gonzaga collection now in Turin. Vickers believes that the figure of Envy was apparently inspired by two woodcuts by Reuwich in Bernard von Breydenbach's *Opusculum sanctarum peregrinationum ad sepulchrum Christi venerandum,* published in Mainz on 11 February 1486, a few days before Gianfrancesco Gonzaga apparently attended the Diet at nearby Frankfurt which elected Maximilian I emperor. Envy's sharp nose, high cheekbones, and open mouth, and the swirl of drapery behind her could have come from the illustration of an Ethiopian priest, while her nudity and withered breasts recall Reuwich's illustration of a "nameless" animal (a baboon) on a plate showing animals pilgrims had seen in the Holy Land. This same source was also possibly used by Mantegna for the hermaphrodite ape in *Minerva Expelling the Vices* for Isabella's *studiolo* (finished 1502; Louvre). It was Gianfrancesco's "triumphal progress" through France and Germany, according to Vickers's reconstruction, that prompted a program of decoration combining the subjects of the mythological engravings with the *Triumph of Caesar* panels. While in Frankfurt he could have seen von Breydenbach's newly published book (Vickers, "Intended Setting"). The date of this event (1486) corresponds with what Levenson, Oberhuber and

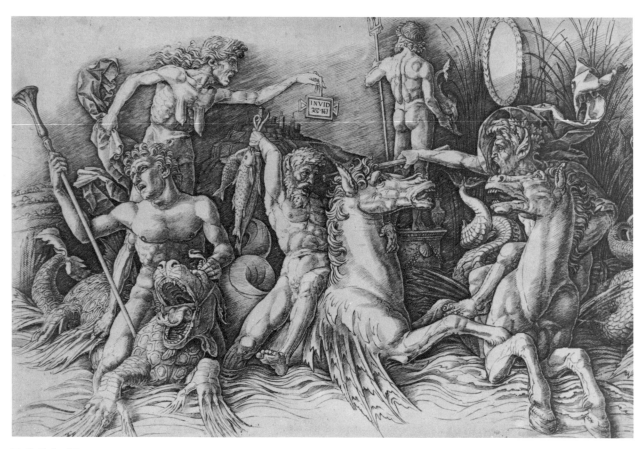

7 (left half)

Sheehan arrived at on stylistic grounds (1486–88). A terminus ante quem of 1494 is provided by Dürer's drawing of the right half (Winkler I, 60).

Envy appears in the *Triumph* series in the inscription identifying the procession as a triumph of Julius Caesar (panel 2). The presence of Envy recalls Virgil's famous description, at the beginning of the *Aeneid,* of a storm at sea that was caused by Juno's envy and took place behind Neptune's back (Simon). Virgil compares the storm to a popular uprising, in which Rage provides the weapons. Since Mantua was Virgil's birthplace, these lines may well have been in the back of Mantegna's mind, although the engraving probably does not illustrate them in a specific fashion.

Ex collection: Devonshire collection since c. 1735.
Exhibition: Prints of the Italian Ren., 175.
References: Degenhart and Schmitt, "Gentile da Fabriano," 131, nos. 23, 24, fig. 99; E. Nash, *Pictorial Dictionary of Ancient Rome,* 2, London [1961], 165, fig. 877; G. Paccagnini, *Andrea Mantegna,* Mantua, Palazzo Ducale, Sept.–Oct. 1961, 170, no. 127; P. Bober, "An Antique Sea-Thiasos in the Renaissance," L. Sandler, ed., *Essays in Memory of Karl Lehmann,* N.Y., 1964, 43–48; H. Kähler, *Seethiasos und Census, Die Reliefs aus dem Palazzo Santa Croce in Rom,* Berlin, 1966; Dresden, *Dialoge,* 31–33, no. 20 (Bober's contention that Medici–Della Valle sarcophagus was principal source accepted); E. Simon, "Dürer und Mantegna 1494," *Anzeiger des Germanischen Nationalmuseums,* 1971–72, 32–38; Levenson, Oberhuber and Sheehan, 188–193, nos. 75, 76 (full information and bibliog. in catalog entry and notes); Vickers, "Santacroce Sketchbook," esp. 831 and n. 50, and "The Sources of Invidia in Mantegna's Battle of the Sea Gods," *Apollo,* 106, no. 188 (1977), 270ff.; also, on the *Felix Gem:* personal communication (letter 10/31/77), and "Intended Setting"; C. M. Brown, personal communication, 11/11/77, and "The Current State of Research on Cardinal Francesco Gonzaga's Collection of Antiquities," article in preparation.

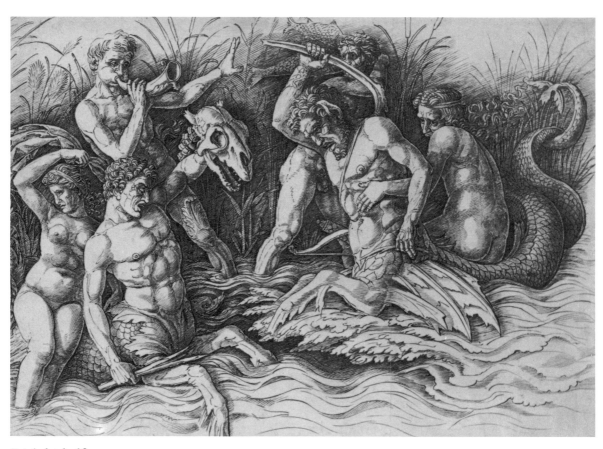

7 (right half)

8 *Felix Gem*

Felix (Second half of 1st century B.C.)

Sard intaglio. Signature on altar: φηλιξ ἐποίει (Felix made it). Inscription (evidently of Roman owner) over head of Diomede, at left: ΚΑΛΠΟΥΡΝΙΟΥ ΣΕΟΥΕΡΟΥ (Calpurnius Severus). 2.7 × 4.5 cm.

Ashmolean Museum, Oxford, (1966.1808)

Diomede, at left, holding the palladion in his left hand, a sword in his right, climbs from a garlanded altar to join Odysseus at right, who holds a sheathed sword in one hand and with the other gestures toward the slain guard whose legs and feet are visible on the ground. Both figures are nude but each has a mantle draped over one arm, as is also true of the statue of Poseidon or Neptune, seen from behind, atop a slender column between the two figures. Neptune's tall trident clearly identifies him. Behind Odysseus, the walls of Troy can be seen, with rows of blocks above a smooth base and a gateway, and to his right a quadrangular base shields the body of the slain guard from view.

To judge by the frequency of its representation on gems, the legend in the *Iliad* describing the bold capture of the sacred statue of Athena by the brave Greek warrior Diomede and the clever Odysseus became especially popular around the end of the first century B.C. The motif of Diomede with the palladion also appears on a Roman sarcophagus and coins of Antoninus Pius. A red-figured kylix, in the Ashmolean, shows an earlier version of the motif, with Diomede in mid-stride, carrying the statue. Diomede's popularity in Rome probably reflects his legendary sojourn in Italy, where he founded a city in Magna Graecia.

The *Felix Gem* is recorded in the 1457 inventory of Cardinal Pietro Barbo (1417–71), who became Pope Paul II in 1464. Valued at 100 ducats, it was the most highly prized intaglio in the inventory (most of the gems were valued at 1–5 ducats). Another very influential antique gem for Renaissance artists, a chalcedony intaglio (now lost) also showing Diomede with the palladion and of roughly the same size as the *Felix Gem,* is listed next to it in the Barbo inventory and valued at 80 ducats. After Paul II's death, his collection of gems was transferred to the Castel Sant'Angelo (Pesce). His successor, Sixtus IV, gave a number of them to the young Lorenzo de' Medici, including the chalcedony Diomede (Dacos, Giuliano and Pannuti). During his lifetime Paul II's collection was one of the best in Italy and included unquestionably the greatest collection of antiquities, having, among other precious objects, 821 incised stones, of which 243 were cameos and 578 intaglios, and 47 classical bronze fragments and statuettes (Weiss; Dacos, Giuliano and

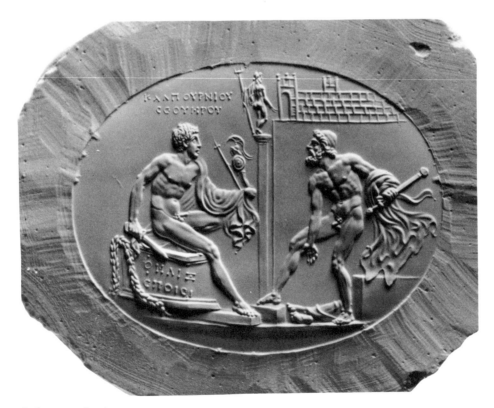

8 (impression)

Pannuti). The anonymous biographer of Brunelleschi, recounting his and Donatello's visit to Rome early in the quattrocento, commented "Qualche volta vi si truova delle medaglie d'argento e qualcuna d'oro benché di rado, così delle pietre intagliate, e calcidoni, e corniuole, e camei, ed altri simili, donde nasceva la maggior parte di quella oppenione, che cercassono di [un] tesoro" (Dacos, Giuliano and Pannuti, 4). These antique gems seem to have been discovered in Roman subsoil in the 1440–64 period, during the cardinalate of Barbo.

Vickers noted that Mantegna used the *Felix Gem* as a source in both the *Triumph of Caesar* panels and the *Parnassus*. The figure of Vulcan in the *Parnassus* resembles Odysseus. There is a striking parallel, furthermore, in the resemblance of the Neptune statue in the *Battle of the Sea Gods* (7) to the statue on the gem. Recently C. M. Brown discovered that by October 1483 the gem had come into the possession of the Gonzaga.★ Mantegna could thus have known it at first hand at precisely the period of the inception of the *Triumph* panels and the *Battle of the Sea Gods*. Mantegna's use of the gem demonstrates both the importance of small-scale antiques for the dissemination of classical figural motifs, and the disparate nature of Mantegna's visual sources. A plaquette based on the *Felix Gem* is in the National Gallery (A. 315.38B).

8 (detail)

Ex collections: Pietro Barbo (Pope Paul II), 1471; Cardinal Francesco Gonzaga (21 October 1483); Arundel; Marlborough; Evans; Spencer-Churchill.

References: G. Pesce, "Gemme Medicee del Museo Nazionale di Napoli," *Rivista del R. Istituto d'Archeologia e Storia dell'Arte,* 5 (1935–36), 51–52; R. Weiss, *Un umanista veneziano Papa Paolo II,* Venice, Rome, 1958, 25f.; Pope-Hennessy, *Kress,* 76, no. 258; H. W. Catling, "Recent Acquisitions by the Ashmolean Museum, Oxford," *Archaeological Reports,* 14 (1967–68), 55–56, no. 30; G. M. A. Richter, *The Engraved Gems of the Romans,* London, 1971, 153, no. 720; 56f.; N. Dacos, A. Giuliano, and U. Pannuti, *Il Tesoro di Lorenzo il Magnifico, Le Gemme,* cat. della mostra, Palazzo Medici Riccardi, Florence, 1972; Vickers, "Santacroce Sketchbook," 831, n. 50; G. Pollard, "The Felix gem at Oxford and its provenance," *BM,* 118 (1977), 574 (identification of the *Felix Gem* with the one described in the Barbo 1457 inventory); C. M. Brown, personal communication, 11/11/77.

★"Un corniola cum due figure che se guardano in faza e una sede e l'altra e in un casamento e quella che sede ha litere greche di sopra e de sotto, ligato ut supra [i.e., in ariento dorato cum un cordone verde] col fondo candenella e perla in una casetina d'ariento dorato cum l'Annunciata." *Inventorio de arzenti, zoye, camei, panni di razo, tapeti, panni, leni, vesti, libri, cavalli masarini et de ogni altri robe restante de la heredita de la bona memoria del Reverendissimo Cardinale de Mantua.* Archivio storico diocesano di Mantova: Fondo Capitolo della Cattedrale, Serie Miscellanea, Busta 2:21 c. 12 (October 1483). Transcription, C. M. Brown. Apparently the compiler misunderstood the walls of Troy as a *casamento* or a large house.

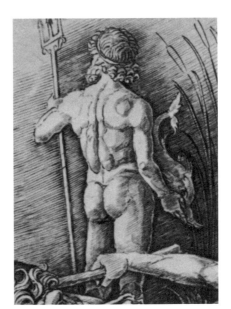

7 (detail)

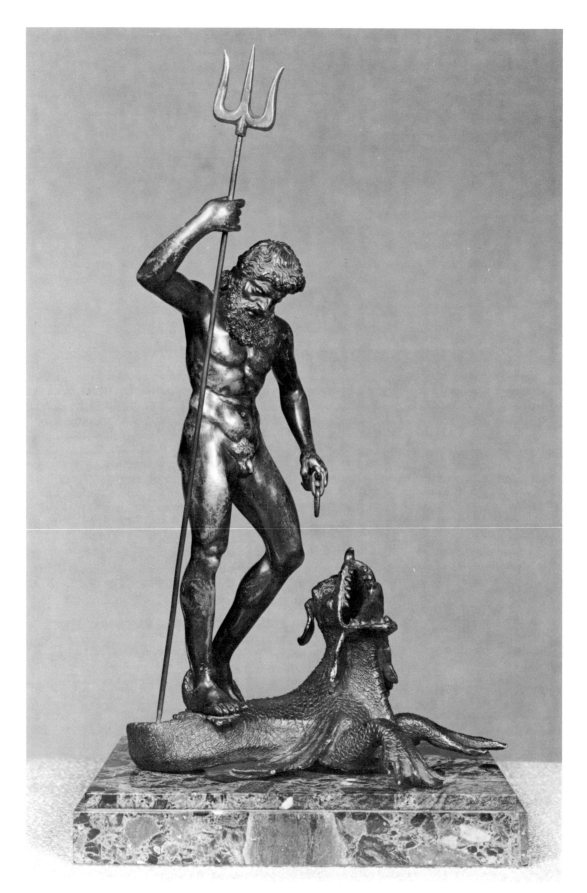

9

9 *Neptune on a Sea Monster* c. 1500

Severo Calzetta, called Da Ravenna (Padua, active c. 1500)

Bronze; dark red-brown lacquer, rubbed throughout to expose warm red bronze. 45.5 cm. (excluding pedestal); figure alone without trident 36 cm. (right thumb to big toe of left foot); width 26.7 cm.

National Gallery of Art, Widener Collection, 1942 (A–98)

Severo's *Neptune* recalls an anecdote from antiquity that sums up the way bronze as a medium, and especially intimate bronze statuettes, played so important a part in antique revival. Fifteenth-century connoisseurs knew that their ancient Roman predecessors prized such objects. Novius Vindex, for example, owned a celebrated bronze statuette by Lysippos, the *Herakles Epitrapezios*. The Domitianic court poet Statius reported, when he was invited to dinner by Vindex, that the *Herakles* "captured my heart; nor was my eye satiated by looking at him long. So great was the dignity enclosed within the diminutive scale of the work; so great its majesty... A god was he... tiny to the eye, yet a giant to the mind... to think that so small a body should create an impression of such scale... How great is the deception in that small form! What precision of touch! What daring imagination, to model a table ornament yet to conceive a colossus" (Pollitt, 149–150, translation slightly altered). Statius understood that the Graeco-Roman table top bronzes were something more than simply technical feats of reduction from larger bronzes.

Neptune balances on the scaly back of the sea dragon, dominating the creature and controlling its untamed energies. In his right hand he holds up the symbol of his power, the trident. This trident replaces one that was probably shorter, perhaps ending at knee level, like the original trident still held by the Frick version of Severo's *Neptune*. The monster, too, is a later cast, though close in various ways to one of Severo's typical sea monsters.

Marine gods and hybrid sea creatures are favorite Renaissance themes, often based on antique sarcophagi showing sea *thiasoi* or battles between marine creatures (Bober). Pope-Hennessy and Radcliffe suggested that Severo's monster is based directly on the monster in Mantegna's *Battle of the Sea Gods* (7). It seems likely, then, that the statue of Neptune in the *Sea Gods* should also be counted among Severo's sources. If this is so, the relationship between Severo's group and Mantegna's engraving shows how motifs from small-scale antiques entered into figural ideas for a variety of Renaissance media.

Ex collections: Bucquet, Paris; Jacques Seligman, Paris; William Salomon, N.Y. (to 1923); Widener, Elkins Park.
Exhibition: Albright, *Master Bronzes,* no. 128.
References: Bode, 1, pl. 24; S. Bernicoli, "Arte e artisti in Ravenna," *Felix Ravenna,* 13 (1914), 555–556 (Severo Calzetta da Ravenna); Pope-Hennessy, *IRS,* 99 (links Statius anecdote with revival of small bronzes); P. Bober, "An Antique Sea-Thiasos in the Renaissance," *Essays in Memory of Karl Lehmann,* N.Y., 1964, 43–48; Pollitt, *Art of Greece,* 149–150 (Statius on Lysippos's *Herakles Epitrapezios*); Pope-Hennessy and Radcliffe, 126–135; A. Sartori, *Documenti per la storia dell'arte a Padua,* Vicenza, 1976, 36–37 (documents on Severo Calzetta in Padua).

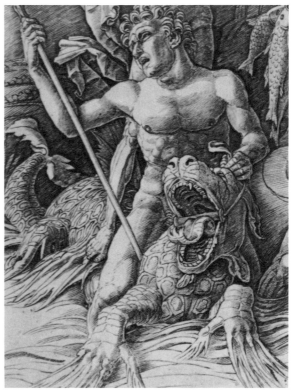

7 (detail)

10 *Triumph of Caesar: Soldiers Carrying Trophies*
c. 1485–90

School of Andrea Mantegna, attributed to Zoan
Andrea (Mantua and Milan, active c. 1475 or earlier/
1519 or later)

Engraving; H. 5, 23, 15. 27.3 × 26.8 cm.

The Metropolitan Museum of Art, Joseph Pulitzer Bequest, 1917 (17.50.30)

Soldiers Carrying Trophies is adapted from panel 6,
The Corselet Bearers, of Mantegna's series of paintings
depicting the First Triumph of Julius Caesar over the
Gauls, now at Hampton Court Palace. Except for two
panels that were never completed, the series was
finished in 1494. Although conclusive evidence has
never been put forward to date the project's inception,
Ercole d'Este of Ferrara saw the work in progress in
August 1486. The program may have been conceived
during the lifetime of Lodovico Gonzaga (d. 1478;
Martindale). On the other hand, Lodovico's son,
Federico, who initiated a "domus novo," may have included it as part of the decoration of the room referred
to in a letter of early 1484 (Brown). There is a third
possibility. According to an eighteenth-century source,
Federico's son and successor Gianfrancesco attended
the Diet of Frankfurt in the winter of 1486. By commissioning the *Triumph* panels, he would have been attempting to portray his own "march" through Gaul
on his way to the Diet, accompanied by about two
hundred mounted men, in the guise of an antique
military triumph, with all its attendant spectacle and
grandeur.

The location for which the panels were originally
designed is unknown. Their installation in a Mantuan
palace, with the panels separated from each other by
carved pilasters, was underway before the artist's death
in September of 1506.

The fame of the *Triumph* was immediate and widespread. These panels represent a high water mark in
the 300 years of antique revival. Mantegna's monumental canvases demonstrated a new mastery of ancient history, archaeology, painting techniques, human
anatomy and movement. Their new style was able to
evoke the military and political greatness of ancient
Rome in unprecedented ways. This new history painting rested on the foundation of Mantegna's archaeological research; nevertheless, it managed to
transcend antiquarian attitudes.

Two ancient literary sources supplied details for the
triumph; Appian's description of the Triumph of Scipio, and Plutarch's of the Triumph of Paulus Aemilius.
Very likely Mantegna knew two contemporary works
on Roman military matters as well: Roberto Valturio's
De re militari, published at Verona in 1472, and the lost
De dignitatibus romanorum triumphum et rebus bellicis by
his friend Giovanni Marcanova (see 4).

An antiquarian project of this scope—each of the
nine panels measures 9′ × 9′, is filled with figures, appurtenances of the triumphal procession and, in six of
the scenes, animals—implies a wide variety of visual
sources. Mantegna's work on the *Triumph* was interrupted by a trip to Rome to decorate a chapel in the
Vatican for Pope Innocent VIII (June 1488–September
1490). Remains of antiquity formerly apprehended
only through other artists' sketchbooks were now observed first-hand. As a result, principles of Roman relief composition were incorporated into the *Triumph*
panels in the years immediately following Mantegna's
return to Mantua.

The engraving shows nine soldiers, following close
behind a phalanx of elephants, as in the fifth of the
painted panels. The lead group carries a litter, which in
the painting is crowded with vessels of precious metal,
but in the engraving is unfinished. The relief of Roman
soldiers bearing away the spoils from the Temple of
Jerusalem in the Arch of Titus provided the antique
source for this scene. The cuirasses with helmets and
armor carried on crossed sticks by the two soldiers in
the right foreground and others behind them are less
ornate than the corresponding passages in the painted
panel. The inaccurate gap between the chest and abdomen pieces that Martindale noted in the painted
trophies has been closed and the head in the center of
the breastplate on the right is more a true gorgoneion
than was the putto-head decoration used in panel 6
(Lehmann). These observations suggest that although
the model for the engraving might well have been a
study made by Mantegna for panel 6 (Kristeller), the
drawing had been corrected for greater archaeological
accuracy, quite possibly during or after Mantegna's
stay in Rome. It is possible too that the composition
was redrawn with the engraving medium in mind,
using fewer pictorial effects and simplified contrasts of
value.

The technical delicacy and precision combined with
pronounced effects of plasticity and depth suggest the
hand of Zoan Andrea as the engraver (Levenson,
Oberhuber and Sheehan).

Ex collection: Earl of Pembroke (Wilton House Sale,
1917).

References: P. Kristeller, *Andrea Mantegna,* Berlin and
Leipzig, 1902, 291; Hind, 5, 5, 23–25; E. Tietze-
Conrat, *Mantegna,* London 1955, 184; Lehmann, "Parnassus," 79–82; Levenson, Oberhuber and Sheehan,
197–199, 214–217 (no. 82, entry by Oberhuber and
Sheehan); A. Martindale, "Andrea Mantegna, *Historicus et Antiquarius,*" inaugural lecture, Univ. of East
Anglia, 3 December 1974; A. Blunt, *Andrea Mantegna,
The Triumph of Caesar,* London, 1975; C. M. Brown,
personal communication, 11/11/77; Vickers, "Intended
Setting".

11 *Triumph of Caesar: The Senators* c. 1490–
1500

School of Andrea Mantegna, after Giovanni Antonio
da Brescia (Active c. 1490/after 1525)

Engraving; H. 5, 24, 16. 27.3 × 26.9 cm.

The Metropolitan Museum of Art, Jacob S. Rogers
Fund, 1920 (20.73.1)

Although *The Senators* is related to Mantegna's
painted *Triumph of Caesar* its traditional title is a mis-
nomer. Senators would not have marched in Caesar's
triumph. Mario Equicola's *Cronaca di Mantova,* printed
in 1521, states that Caesar's train and spectators were
still missing from the *Triumph* and that Lorenzo Costa
had been commissioned to add them. This may pro-
vide a clue to the group represented in this engraving.

The composition here resembles the seventh *Triumph*
panel, *The Captives* (ill. Blunt, p. 32). Rows of men
march four and sometimes five abreast in front of a
building (the Basilica Julia?) whose facade takes up
over half the background and locks the figures into a
narrow foreground space. The marchers are separated
into two groups by the end of the building. In a
preparatory drawing at Chantilly (Vickers, Fig. 6), the
Meta Romuli, a Roman monument, is seen at the right.
In the engraving, the structure appears at left and is
recognizable by its cylindrical shape, cornice and frieze
as the tomb of Cecilia Metella in the Roman Cam-
pagna (Lehmann).

The figures in the engraving differ from the group
of captive barbarians portrayed in the painted panel
and the Chantilly drawing. They are dressed as Roman
citizens in togas. The engraver seems to have inter-
preted the group, possibly following one of Mante-
gna's drawings made in Rome, as senators. The man
leading the procession at the right edge wears his toga
in a characteristic fashion, his arm supported in the *bal-
teus* like a sling (Vickers). Several such details, as for
example the man who holds a box and turns back
toward a companion, led Vickers to conclude that
parts of the north and south friezes of the *Ara Pacis* had
been studied by Mantegna in drawings for the
Triumph. Such works could have been known before
they were discussed in letters or published later in the
cinquecento; Vickers draws attention to the long his-
tory of building and renovation on the site of the *Ara
Pacis.* The Augustan monument could hardly have re-
mained totally undisturbed while palaces were built
and rebuilt on its site for two centuries. Though Man-
tegna's principal source for *The Captives* was no doubt
panel 91 of Trajan's Column (Blum), enough refer-
ences to the *Ara Pacis* can be found in the *Senators* en-
graving to make a convincing case that Mantegna also
knew the Augustan reliefs.

Hind observed, however, that there is no proof that
Mantegna conceived and directed the production of
the *Triumph* engravings. They may have been under-
taken independently by engravers who had seen or got
possession of some of his original drawings. The in-
completeness of the engraved set, and the differences
between the painted panels and the related engravings,
favor the latter supposition (Hind; Levenson, Ober-
huber and Sheehan).

The author of this engraving imitated Giovanni An-
tonio da Brescia's style closely in its techniques of
modeling, yet failed to achieve its density and control
of line (Levenson, Oberhuber and Sheehan). If Vic-
kers's hypothesis that Mantegna's drawings from
the *Ara Pacis* served as models for the *Senators* is cor-
rect, the engraving should be dated c. 1490–95 at the
earliest.

Exhibition: Prints of the Italian Ren., no. 193.
References: I. Blum, *Andrea Mantegna und die Antike,*
Strasbourg, 1936; Hind, 5, 23–25; Levenson,
Oberhuber and Sheehan, 216 f., 235–237; A. Blunt,
Andrea Mantegna, The Triumph of Caesar, London,
1975; M. Vickers, "Mantegna and the Ara Pacis," *The
J. Paul Getty Museum Journal,* 2 (1975), 109–120; P. W.
Lehmann, personal communication, 12/1/77.

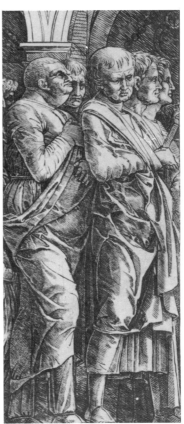

11 (detail)

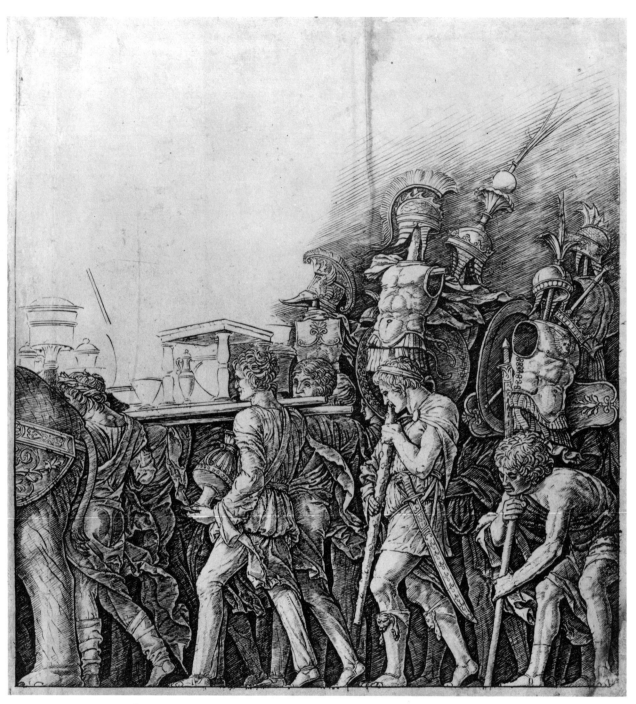

10

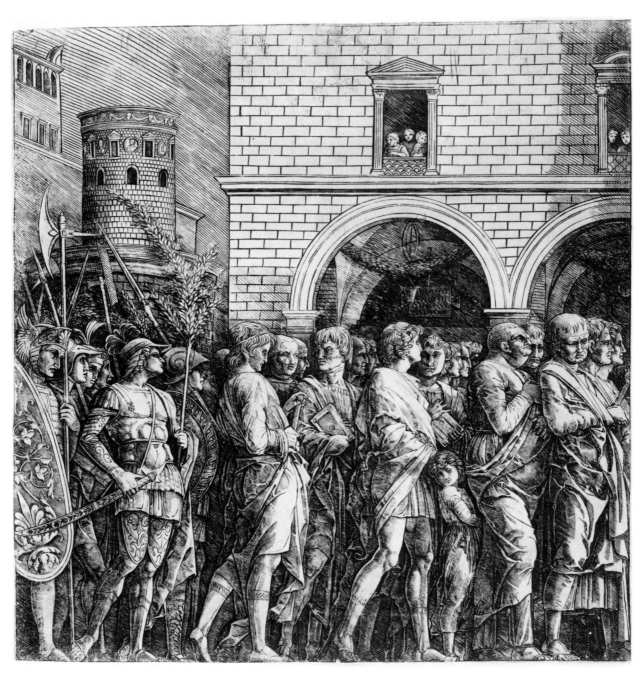

11

12 *Erato* c. 1465

Master of the E-series *Tarocchi* (Ferrara, active c. 1465)

Engraving; H. 1, 235, E.I. 14a. 17.8 × 9.9 cm.

National Gallery of Art, Ailsa Mellon Bruce Fund (B–25, 393)

13 *Euterpe* c. 1465

Master of the E-series *Tarocchi* (Ferrara, active c. 1465)

Engraving; H. 1, 236, E.I. 18a. 17.8 × 9.9 cm.

National Gallery of Art, Ailsa Mellon Bruce Fund (B–25, 397)

Erato and *Euterpe* belong to a set of 50 engravings known as *Tarocchi*. Their iconography differs from conventional *Tarocchi,* or tarot cards, which have, like modern playing cards, pip-cards and suits. The set has five groups; the two engravings discussed here belong to the second, Apollo and the Nine Muses. The four remaining groups depict Conditions of Man, Liberal Arts, Cosmic Principles and Firmaments of the Universe. It is possible that the *Tarocchi* were used in a kind of card game, as a method of philosophical instruction, or as a memory-aid. The theme of the game or lesson being communicated is the Great Chain of Being in which ladder-like interrelationships connect the lower orders of humanity—Beggar, Servant—through intermediate orders—Artisan, Merchant—and highest orders—Knight, Emperor—to God, thus enabling divine power to be transmitted downwards. Muses and Liberal Arts refer to human activities—arts and sciences—that help humanity raise itself in this spiritual order.

The E-series *Tarocchi,* to which *Erato* and *Euterpe* belong, is the earlier of the two known sets. They must have been in existence by 1467. The artist probably came from Ferrara as comparison with Francesco del Cossa's Schifanoia frescoes of 1469–70 suggest. Considering the lack of evidence that printmaking existed in Italy before the 1460s, the *Tarocchi* gain considerable interest and value as fine examples of early Italian engraving. Their "meticulous, even exquisite technique" suggests that the engraver and the designer were one and the same person, perhaps one of the artists in the Ferrarese court known to have worked on playing cards (Levenson, Oberhuber and Sheehan, 87).

Erato and Euterpe are two of the only three Muses who have their functions clearly specified in the *Tarocchi* (Levenson). Erato, the Muse of Dance on Card 14 of the series, is shown dancing, singing and playing a tambourine. She is a single figure, looming large against a somewhat arid, flat landscape bordering a river or lake, with a small hill-fortress in the right distance. On Card 18, Euterpe, the Muse of Lyric Song, leans languidly against a tree while playing the double flute. The blank disks which appear in all the Muse cards except Thalia may, according to Seznec, as quoted by Levenson, represent the celestial spheres of the Ptolemaic universe.

These engravings show the extent to which a rela-

tively accurate understanding of classical drapery had penetrated the court milieu in northern Italy as part of the growing fashion for *all'antica* style in art and decoration. Despite some unclassical reminiscences of early quattrocento court style that impart to the Muses an air of quaintness, their costumes bear a relationship to classical dress that is quite respectable for their date. These costumes are not unlike those worn by Mantegna's Muses in the *Parnassus,* finished in 1497 for Isabella d'Este's studio in the ducal palace at Mantua (cf. 14). They were doubtless referred to by Mantegna when he was canvassing available Muse imagery. The E-series Master, though obviously unable to translate his awareness of Greek costume with the correct yet free ease of assimilation that Mantegna attained (cf. 14), nevertheless managed to portray Erato and Euterpe wearing the sleeveless, double-girdled chitons worn by Muses on many sarcophagi. In the mid-century work of such central Italian painters as Filippo Lippi—who, considering his combination of courtly and modern tendencies, might have seemed a likely model for allegorical images *all'antica* like these *Taroc-*

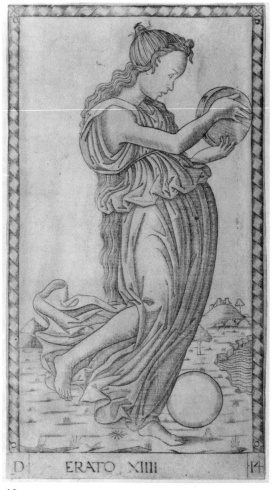

12

chi Muses—the girdled chiton is sometimes combined, less accurately than in these *Tarocchi,* with tight-fitting long sleeves (but cf. 39). Ancient sculptural examples of the costume type adapted for the *Tarocchi* Muses would not always have allowed a later artist to understand whether the chiton was supposed to be open at one side or not. The slit that shows Erato's right leg bare from the knee down as she kicks it back in the dance is a kind of compromise not found in classical art. Perhaps its presence here reflects an uncertainty that the model made inevitable.

Ex collections: George Cumberland; Royal Academy.
Exhibition: Prints of the Italian Ren., nos. 111 and 115.
References: Marie Johnson, ed., *Ancient Greek Dress* (reprint of Ethel Abrahams, *Greek Dress,* London, 1908, and Maria Evans, *Chapters on Greek Dress,* London, N.Y., 1893) Chicago, 1964; G. Fiocco, *L'arte di Andrea Mantegna,* Venice, 1959, 79f. (suggested a Paduan origin for the *Tarocchi*); Lehmann, "Parnassus," 93–98; Levenson, Oberhuber and Sheehan, 81–89 (Levenson), nos. 26 and 32.

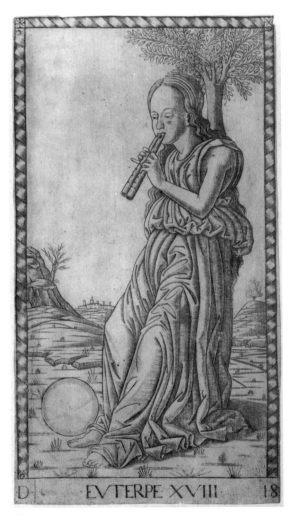

EVTERPE XVIII · 18

13

14 *Four Women Dancing (The Muses)* c. 1497
School of Andrea Mantegna, attributed to Zoan Andrea (Mantua and Milan, active c. 1475 or earlier/ 1519 or later)
Engraving; H. 5, 27, 21; B. 13, 305, 18. 24.8 × 32 cm. Museum of Fine Arts, Boston, Frances Draper Colburn Fund (M28357)

Four Women Dancing relates to the Muses in Mantegna's *Parnassus,* completed in 1497. In that painting Mars and the nude Venus, arm in arm, preside over the music of Apollo and the dancing of the nine Muses. Perched to Mars's left, Eros aims his blow pipe at Vulcan at the mouth of his cave. In the right foreground, Mercury, presented as a god of music with elongated caduceus and syrinx, rests one arm on Pegasus.

In identifying the iconological components of the painting Phyllis Lehmann concluded that Mercury and Pegasus's prominent size and important location, as well as the emphasis on the primary colors of the Gonzaga-Este coats of arms on the golden couch behind Mars and Venus, have a special astrological significance. On February 11, 1490, the date of the wedding of Isabella d'Este to Gianfrancesco Gonzaga, the planets, Mercury, Mars, and Venus were conjoined with the westernmost bright star of Pegasus within the sign of Aquarius. The *Parnassus,* the first painting commissioned by Isabella for her *studiolo,* commemorates the union of "those mortal representatives of Venus and Mars" (Lehmann, "Parnassus," 166) through whose patronage, under the influence of the planet Mercury, the arts, especially music, flourished at the Court of Mantua.

According to Lehmann, in the composition of the *Parnassus* Mantegna used late medieval iconographic types which he classicized and reinterpreted on the basis of ancient prototypes and augmented with details taken from classical literature. Evidently Mantegna derived his mythological personae for the *Parnassus* from literal antique equivalents: for example, the Venus from a Venus, the Apollo from an Apollo. Only minor adjustments were made, apparently for reasons of form or content. Lehmann discovered the source for the Muses in a well-authenticated drawing by Cyriacus of Ancona (1444) taken from an archaic frieze of dancers in Samothrace. In both extant copies of this lost drawing (one in the Bodleian manuscript, 1), the first six figures are identified as Muses.

Beginning with the third Muse from the left in the painting, but reversed and with other changes, the women dancing in this engraving are based on the *Parnassus* Muses. The fourth from the left in the painting has been omitted. The two singing women at left in the engraving correspond to the third and fourth from the right in the painting. The second figure's head has been changed from three-quarter to profile. Like her painted counterpart, the central dancer is seen from behind. The head of the right-hand figure in the engraving is seen in profile, thereby differing from the

painted Muse. Sheehan concluded from these differences that the engraving is based on a lost preparatory drawing by Mantegna (Levenson, Oberhuber and Sheehan).

Like other Mantegna School engravings, *Four Women Dancing* lacks the degree of expression, *sfumato* and delicacy and richness of detail that form criteria for autograph Mantegna prints, only seven of which exist *(Entombment of Christ, Risen Christ Between Sts. Andrew and Longinus, Bacchanal with a Wine Vat, Bacchanal with Silenus, Battle of the Sea Gods* [left and right halves], *Virgin and Child)*. Yet Zoan Andrea, to whom it has been attributed, evolved a graphic style characterized by a delicacy and flexibility of contours and modeling lines that approached Mantegna's own. In the Boston Museum's exceptional impression, a relatively early one, the fine lines, by which tonal values are carefully built up to create a relief-like effect, are well preserved. Its subtle hue of brownish ink lends unusual chromatic interest to the work. The impression of plasticity and relief recalls the marble surfaces of ancient relief sculpture that often inspired Mantegna and his followers in their engravings of the 1470s through 1490s (cf. 5, 7, 10, 11).

Zoan Andrea's technical achievement in creating a variety of surface texture can be seen in the treatment of the diaphanous outer tunic of the dancer second from left, through which the heavier folds of the chiton underneath can be glimpsed. Mantegna's knowledge of antique drapery ultimately determined the forms of the chitons worn by the two dancers on the right, one of which slips off the shoulder in response to the turns of the dance. The fluidity and grace with which Greek costume communicated the body's rhythmic movement has here been rediscovered. The engraved Muses call to mind some fifth-century dancing Nike, though there is little likelihood that Mantegna or Zoan Andrea can have seen such a prototype.

Exhibition: Prints of the Italian Ren., 198
References: A. Einstein, *The Italian Madrigal,* 2 vols., Princeton, 1949, 1, 34f., 38ff., 42ff., 52f., 93f., 104f., 110f. (music at the court of Mantua and Isabella as a patron of this art); M. Johnson, ed., *Ancient Greek Dress,* Chicago, 1964, *passim;* P. W. Lehmann, "An Antique Ornament set in a Renaissance Tower: Cyriacus of Ancona's Samothracian Nymphs and Muses," *Revue Archéologique,* 1968, 197–214; Levenson, Oberhuber and Sheehan, 197–199 (Mantegna School); 228–229, no. 85 (*Four Women Dancing,* National Gallery impressions, entry by Sheehan); Lehmann, "Parnassus", 90–115 and *passim;* Sue Welch Reed, personal communications, 1977, 1978.

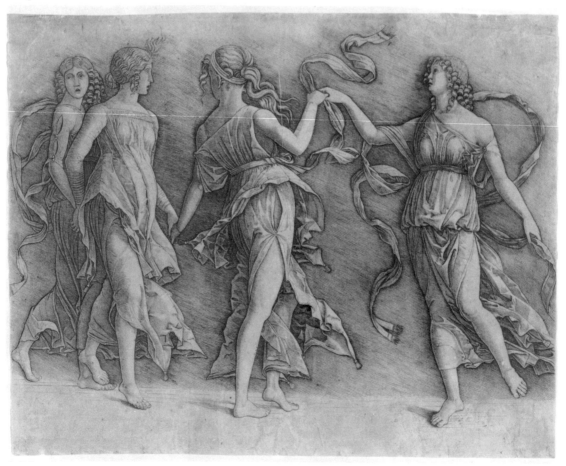

Recording and Reproducing
Antiquities

15 *Scenes from the Life of Dionysus* Second century A.D.

Rome

Marble relief, sarcophagus front; cut down. 38.5 × 150 cm.

The Art Museum, Princeton University, The John Maclean and Gertrude Magie Fund, 1949 (49.110)

The importance of sarcophagus reliefs for the transmission of Hellenistic compositional motifs, via Roman sculptors, to artists of the Renaissance can hardly be exaggerated. Bacchic sarcophagi were among those eagerly copied. Of the 385 extant Bacchic sarcophagi listed in the corpus by Matz, 40 are included in the *Census of Antique Works of Art Known to Renaissance Artists* organized by Phyllis Bober (Institute of Fine Arts; Warburg Insitute). The importance of this exceptionally interesting sarcophagus relief panel for the Renaissance is documented by the use of two of its scenes as sources for decorative motifs on the bronze San Lorenzo pulpits, Donatello's last work (begun about 1460 or earlier; finished posthumously). Held has pointed out, furthermore, that Rubens likely had recourse to the scene at left as the basis for a figure in his *Raising of the Cross* of 1609–1610 in Antwerp Cathedral (1959). Held assumed Rubens saw the sarcophagus in Rome, whereas its use by Donatello establishes a Florentine provenance. Rubens could have seen the sarcophagus in Florence in autumn, 1600, when he visited there in the retinue of Vincenzo I Gonzaga at the time of the marriage of Marie de' Medici to Henri IV of France. Yet one wonders how well he would have remembered the motif ten years later when designing *The Raising of the Cross.*

Three of the four scenes which originally decorated its face are preserved: at the right end, the child Dionysus is attended by two satyrs and two women; next, the youthful god blesses the vine; finally, the herm of Dionysus is raised by youthful worshippers. Originally a scene at the extreme right, now missing, showed some episode from the infancy of the god. The panel on the right end of the original sarcophagus has been located by Jones at Woburn Abbey, Bedfordshire: it shows a scene with two nymphs bathing the infant Dionysus (Matz, pl. 212). The left end panel, with a drunken Silenus, is in Arezzo (Matz, pl. 213). "The fact that these scenes are repeated on other ancient objects indicates that they are derived from some well-known cycle honoring the god of the vine; composition and other considerations suggest that the original series belonged to the Hellenistic period" (Jones).

Bacchanalian putto motifs appeared also on the base of Donatello's bronze *Judith* (Janson, 1, pl. 349–351). There the antique source, a sarcophagus from the Campo Santo, Pisa, has been considerably transformed. On the San Lorenzo pulpits, the Princeton sarcophagus motifs of putti raising a herm and the adoration of the infant Dionysus on a pedestal are quoted in a more straightforward manner. They occur on the friezes over the main reliefs with episodes from Christ's Passion (north or left pulpit), where there are also horse tamer motifs at the corners (cf. 47, 48). The scene of adoration of the putto on a pedestal is also to be found on the frieze below the sarcophagus on the Tomb of Francesco Sassetti in Sta. Trinita, Florence.

Whereas the San Lorenzo putto friezes may lack apparent relationship to the Christian subject matter of the main reliefs, the funerary context in which such scenes often occurred in antiquity was well known in the Renaissance and, in fact, the sarcophagus-like nature of Donatello's pulpits has often been commented upon. The San Lorenzo pulpit program has been interpreted coherently as a Renaissance revival of the early Christian tradition of twin *ambones,* one for the reading of the Gospels, the other for the Epistles (Janson; Lavin). Since Dionysian motifs like putti trampling on grapes were taken over by early Christian iconography and given new symbolic meanings, their presence was entirely appropriate in a program of early Christian revival.

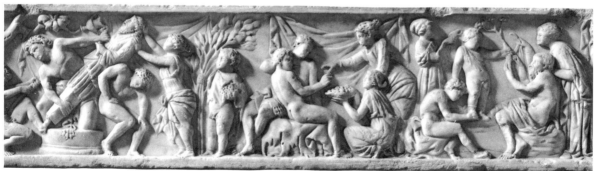

15

15 (detail)

Ex collection: Giorgio Sangiorgi; Mario Barsanti, Rome
References: L. Curtius, "Dionysischer Sarkophag,"
*Jahreshefte des Österreichischen Archäologischen Instituts in
Wien,* 36 (1946), 62–76; Janson, Donatello, 1, pl. 423 a
and b; 2, 209–218, esp. 213f., 215–216, n.7; J. S. Held,
Rubens, Selected Drawings, 2 vols., London, n.d. [1959],
1, 129, no. 76; 2, pl. 87; I. Lavin, "The Sources of
Donatello's Pulpits in San Lorenzo," *AB,* 41 (1959),
19–38; F. Jones, *Ancient Art in the Art Museum, Princeton
University,* Princeton, 1960, 62–63; E. Simon,
"Dionysischer Sarkophag in Princeton," *Römische
Mitteilungen,* 69 (1962), 136–158; R. Turcan, *Les sar-
cophages romains à représentations dionysiaques,* 1966 (Bib-
liothèque des Ecoles Françaises d'Athènes et de Rome,
210) 51, n. 2; 164; 167; 381; 384; 407; 412ff.; 415–418;
524; J. R. Martin, *Rubens: The Antwerp Altarpiece,*
N.Y., 1969, 49, fig. 34; F. Matz, *Die Dionysischen Sar-
kophage,* 3, Berlin, 1969, 354–357, no. 202 (exhaustive
description with observations on condition).

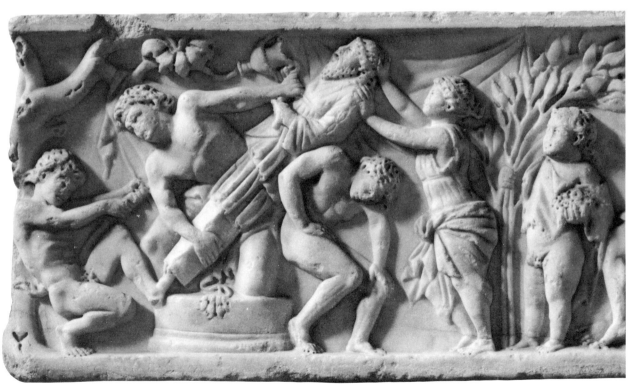

15 (detail)

16 *Study of the Throne of Nepture Relief*
c. 1419–20

Gentile da Fabriano (Fabriano, Marches, c. 1370–85/
Rome 1427)

or Antonio Pisanello (Verona? c. 1395/Rome? 1455)

Drawing; silverpoint on paper prepared with a slate
gray ground. 16.3 × 26.3 cm.

Ecole Nationale Supérieure des Beaux Arts (M.2342)

This drawing of figures from an Augustan era relief
walled into the apse of San Vitale, Ravenna (ill. De-
genhart and Schmitt, *Zeichnungen,* 235), is among the
earliest preserved studies of classical antiquities. The
relief shows three putti with fluttering cloaks, each car-
rying an attribute of Neptune; the only one specified in
the drawing is the trident carried by the putto at right.
The artist has omitted the draped empty throne of
Neptune. The drawing is related in style to a group di-
vided among the Ambrosiana, the Louvre, Rotterdam,
Haarlem (formerly) and the Uffizi. They are identified
by Degenhart and Schmitt as studies after antiquities

made by Gentile da Fabriano mostly depicting figural
motifs from sarcophagi. An alternative attribution to
Pisanello (before 1395–1455), a student of Gentile's, is
suggested by stylistic links with the younger artist's
many drawings from the antique. The Ecole des Beaux
Arts sheet is the only one showing an antique that was
not located in Rome.

The drawing's style reveals the difficulties faced by
even very advanced painters at the beginning of the
quattrocento in representing convincingly how the
body moves (cf. 47). Following the Gothic canon of
proportions in which he was trained, moreover, Gen-
tile (or Pisanello) elongates the bodies of these putti
and draws the heads much smaller in relation to the
bodies than is the case in the model. It seems to be the
variety of their poses while engaged in similar actions
that attracts the artist, along with the pleasing sensu-
ousness of the erotes' bodies. These qualities made this
subject—popular in antiquity from the Hellenistic era
on—one of the first to be revived and one of the most
frequently depicted in Renaissance art (cf. 6, 15, 17, 80
rev., 92, 119).

The relief belongs to a series, perhaps from an altar,

16

located in San Vitale during the Middle Ages but now dispersed (Louvre; Venice, Museo Archeologico; Milan, Castello; Florence, Uffizi and Bargello; and Ravenna, San Vitale and Museo Arcivescovile). In 1355, Oliviero Forzetta of Treviso thought of acquiring them for his collection of antiquities; the two reliefs now in Venice (referred to by Francesco Sansovino in 1581 as works of Praxiteles) may have that provenance. The *Throne of Neptune* relief was also copied by Amico Aspertini and engraved by Marco Dente (B. 14, 242). A Tuscan artist copied the *Throne of Saturn* relief (Venice) in the late quattrocento in a style close to the *Codex Escurialensis* (Ambrosiana, F. 237 inf., No. 1702). This drawing makes an instructive comparison to the Paris sheet: by an artist manifestly inferior to Gentile or Pisanello, it nevertheless renders the volume and weight of the putti far more successfully, demonstrating the effects of the intervening 70 years of study from nature and the antique. Some scholars have observed effects of the Ravenna reliefs in the sculpture of Donatello, but Janson discounts their theories.

Schmitt dated the *Study* to 1419–20 in view of Gentile's probable visit to Ravenna between September, 1419, when he was still in Brescia, and March, 1420, when he is recorded as having been in Fabriano. Gentile came to Rome in 1427, where he painted frescoes, later destroyed, in the Lateran Basilica. Pisanello was called to Rome to finish these decorations (1431–32). Most of the drawings after antiquities associated with these two artists date from this period (1427–31). For both artists, the impulse to study classical remains in Rome was closely bound up with the practice of recording nature with new objectivity. A keen interest in antique art was transmitted by Gentile to his pupil Jacopo Bellini, whose son Gentile, later to become the premier painter in Venice, was named after his father's teacher. Jacopo was the first north Italian artist to draw extensively from antique remains. Jacopo's son-in-law, Andrea Mantegna, probably had access to his sketchbooks.

Ex collection: Masson
References: Bober, *Aspertini,* 86; Janson, *Donatello,* 125; Degenhart and Schmitt, "Gentile da Fabriano," *passim* and esp. 110, 124 (attr. Gentile da Fabriano); Fondazione Giorgio Cini, Centro di Cultura e Civiltà, *Disegni del Pisanello e di maestri del suo tempo,* cat. A. Schmitt, Venice, 1966, no. 35 (Ambrosiana drawing by Tuscan artist of *Throne of Saturn*); Degenhart and Schmitt, *Zeichnungen,* 1:1, 235, no. 126 (attr. Gentile da Fabriano); see also 236–241 for discussion of related drawings and the antiques they illustrate.

17 *The Capitoline Wolf with Romulus and Remus*
1471–c. 1500
Sienese School
Bronze (heavy hollow cast); black-brown lacquer over reddish-brown brushed patina over scarified surface. 38 × 64.2 cm.
National Gallery of Art, Samuel H. Kress Collection, 1957 (A. 155)

This extraordinary bronze wolf reproduces a sculpture that in its role as a symbol of Rome and the Law is one of the most significant of all antique representations of animals extant. Its fidelity to the original bespeaks profound familiarity with the antique model. The features of the original have been retained with only slight differences: the shape of the wolf's body, its lean ribs standing out in contrast to the full udders, the stance with stiffened forelegs close together as if braced on the defensive, the positioning of hindlegs one slightly in front of the other. The mane is incised as overlapping flamelike shapes, continuing in a single row down the back, following the spine. A ring of curled fur frames the face and another braidlike ring of fur encircles the body behind the forelegs. In the Renaissance bronze the treatment of the fur is somewhat less abstract and more suggestive of actual texture than the stylized forms seen on the Roman model. The height of the original has been reduced by half, the length by a little less than half. This difference might result from the bushy tail, restored differently in the original, and very likely missing when the copy was made. Its thickness adds to the width of the piece and alters the contour of the wolf's haunches.

The antique original did not include Romulus and Remus, the twin founders of Rome who were rescued by a wolf after their uncle's unsuccessful attempt to drown them. The addition of the twins to the original was a Renaissance "restoration," probably following Livy's allusion to the image of the city's founders as infants being suckled by the wolf that was set up by the Ogulnii in 296 B.C. (X, 23, 11–12). Authorities now agree that the *Capitoline Wolf* was not the work to which Livy referred. The nurturing image of the wolf and suckling twins presented by the Renaissance pastiche alters that of unadulterated ferocity expressed by the *Wolf* in medieval times, when it had presided over barbarous punishments of criminals in the Lateran piazza as a symbol of Law. The immediate impetus to add the twins could have been the donation of the *Wolf* and other statues pertaining to ancient Rome to the city by Pope Sixtus IV in 1471. These sculptures, transferred from St. John Lateran, focused fresh attention on the urban significance of the Capitoline Hill. There the *Wolf* was placed over the entrance to the old Conservators' palace, where it can be seen in a drawing by Heemskerck (Hülsen and Egger, 2, pt. 2, pl. 101). These statues formed the nucleus of the Capitoline Museum, the first public collection of antiquities in Europe, and of Michelangelo's redesign of the area as

"a monumental symbol in which the haunting dream of ancient grandeur became concrete" (Ackerman, 163).

Because Pollaiuolo was the sculptor of the bronze tomb of Sixtus IV, on which he worked from 1484–93, his name has been suggested as the author of the Capitoline Romulus and Remus, that is, the twins cast as additions to the original bronze wolf. Indeed their style is not incompatible with what we know of Pollaiuolo, renowned in his time as a designer of figures in action (cf. 44). The engagingly varied yet convincing postures reveal the body's structure beneath the infant flesh and suggest life study, as practiced by Leonardo in Verrocchio's shop in the early 1470s as a basis for evolving such lifelike forms.

The Washington bronze group is a reduced version of the pastiche which combined the original bronze wolf and the twins sculpted by a Renaissance artist, perhaps Pollaiuolo. The twins in the Washington group are works of such high quality and are so faithful to the Capitoline twins that it is possible to conceive of them as cast from reduced scale models for the final figures. Thus they may be from or very close to the hand charged with responsibility for the Renaissance "restoration" of the *Wolf*. A Sienese origin was postulated for this artist because the *Wolf* had been adopted in the Middle Ages as an emblem of that city, but in Sienese representations, as pointed out by Pope-Hennessy, the *Wolf's* head turns completely back to regard the suckling twins. In this form the image derives, not from the Capitoline group, but from Roman coins.

Ex collections: Augustus the Strong, King of Poland, Elector of Saxony (c. 1730); Baron Wittinghof, Dresden (1826); Camilla Castiglioni collection, Vienna (1923); [Jacob Hirsh Antiquities, N.Y.]; Samuel H. Kress collection (1945–57).

References: C. Hülsen and H. Egger, *Die römischen Skizzenbücher von Marten van Heemskerck im Königlichen Kupferstichkabinett zu Berlin,* 2 vols., Berlin, 1913–16, reprint, Soest, Holland, 1975, 1, pt. 2, 41–42 (fol. 72); 2, pl. 101; J. Carcopino, *La Louve du Capitole,* Paris, 1925; W. S. Heckscher, *Sixtus IIII aeneas insignes statuas Romano Populo restituendas censuit,* Utrecht, 1955; personal communication, December, 1977; J. Ackerman, *The Architecture of Michelangelo,* Harmondsworth/Baltimore, 1971, 162–173 (reprint of 1961 ed.); Pope-Hennessy, *Kress,* 145, no. 531; see also 146, no. 532, and 104, no. 375; Helbig, 2, 277, no. 1454 (Simon); T. Kraus, ed., *Das römische Weltreich,* Berlin, 1967 (Propyläen Kunstgeschichte, 2) 151, no. 1.

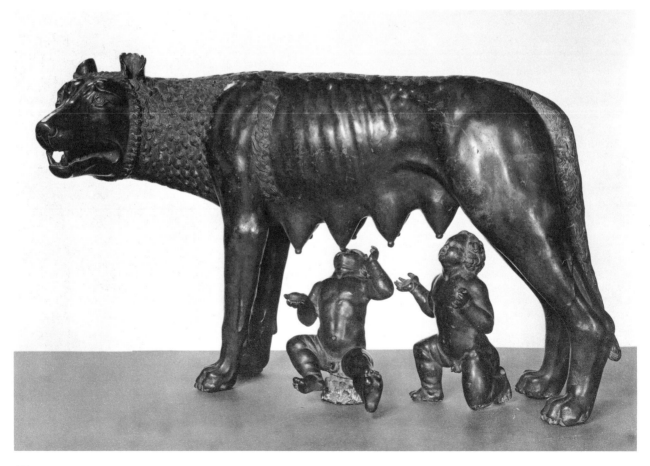

18 *Reclining Partly Nude Girl Holding a Spherical Object* c. 1501–4

Marcantonio Raimondi (Argini, near Bologna, c. 1480/ Bologna 1527–34)

Drawing; pen and brown ink. 11.2 × 16.5 cm.

The Art Museum, Princeton University (44–263)

In this drawing a partially draped reclining woman rests her weight on her left forearm against a cylindrical support, her head tilted and turned as she gazes at the ground to her left. She balances a sphere on her right thigh. The figure's body type echoes northern female nudes in its emphasis on the rounded belly, while the drapery and sandal suggest an ancient prototype. Her pose probably derives from an antique water nymph (cf. MacDougall, fig. 3) or river god. Drapery and body alike are described by many short parallel strokes with cross hatching for modeling and shadows.

A large group of figural studies, many of nudes, some clearly reflecting antique sculptures, were attributed by Oberhuber to Marcantonio Raimondi and dated to his early period, relatively unstudied by scholars. Gibbons linked this sheet and the *Adam* (52) to the group, several of which are in the Musée Bonnat, Bayonne. After his initial training, perhaps in the workshop of Francesco Francia (cf. 53, 108), Marcantonio left Bologna for Venice in 1506. Perhaps as late as 1508, he travelled via Florence to Rome, where *Mars, Venus and Cupid* (56), dated 16 December 1508, was probably made.

The meaning of the sphere held by Venus remains unexplained. The spheres at the feet of *Erato* (12) and *Euterpe* (13) are equally problematical. There is also a mysterious sphere held by a nymph-like figure in *all'antica* dress in one of a series of small allegorical paintings from the shop of Giovanni Bellini (Venice, Accademia, 72). Perhaps it is a translation into abstract form of the rim of a water jug held by an ancient river god, which, when held in pouring position facing the spectator, has a circular shape.

Ex collections: Litta; Carlo Prayer (Lugt 2044, lower r. recto, partly obliterated); Frank Jewett Mather, Jr. (Lugt supp. 1853a).
Exhibition: New York, Roerich Museum, *Exhibition of Drawings by Old Masters from the Private Collection of Professor Frank Jewett Mather, Jr.,* N.Y. 1930, no. 5 (Florentine, c. 1480).
References: J. Bean, *Les dessins italiens de la collection Bonnat,* Paris, 1960; Oberhuber, *Renaissance in Italien,* 85 and "Marcantonio Raimondi," *Albertina Informationen,* 1971, nos. 1–3, 1–4; E. B. MacDougall, "The Sleeping Nymph: Origins of a Humanist Fountain," *AB,* 57 (1975), 357–365; F. Gibbons, *Catalogue of Italian Drawings in the Art Museum, Princeton University,* 2 vols., Princeton, 1977, 1, 163, no. 505; 2, fig. 505.

19 *Study of an Antique Venus* c. 1500–1509

Marcantonio Raimondi (Argini, near Bologna, c. 1480/ Bologna 1527–34)

Drawing; pen and brown ink. 21.5 × 10.5 cm.

Private collection

This attractive drawing of an ancient statue, a marine Venus without head and lower right arm, has been attributed by Oberhuber to Marcantonio Raimondi and dated c. 1500–1505. In Becatti's study, which distinguishes among variants of the Venus, the corpus of illustrations shows that two Venuses, one in

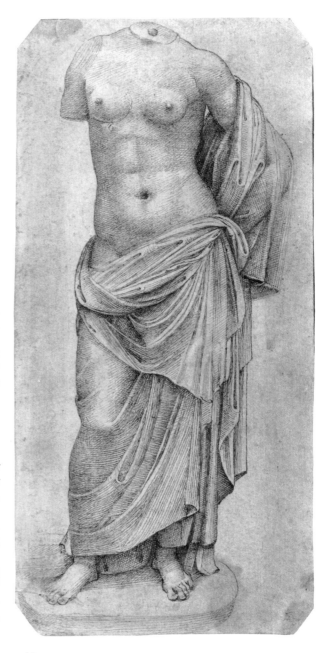

Madrid (Museo Nacional, inv. 65), the other in Berlin (inv. 276), are close in almost every detail to Marcantonio's drawing. The head, lower right arm and vase of the Madrid work are modern restorations; however, its pedestal, connected to the figure by a *puntello,* is ancient. In this case it is hard to explain why, if the Madrid figure was the antique model he used, Marcantonio did not include the pedestal. A molded pedestal base does appear next to the right foot in the drawing, thus in his model the upper part of the pedestal was lacking. The Berlin example, said to come from Florence, lacks head, lower right arm, and pedestal support. The break point of the arm is slightly higher than in the Madrid figure and more like that in Marcantonio's drawing. A drawing attributed to Fra Bartolommeo (?) in Christ Church College (Byam Shaw 56) appears to represent the same statue. It lacks any vestige of a pedestal support. Added to the differences from the Madrid Venus already noted, the evidence of the Christ Church sheet suggests that Raimondi saw the Berlin Venus in Florence, perhaps during the 1506–8 period, if its provenance can be considered valid.

In Marcantonio's drawing, the antique prototype is approached as a study in female anatomy and contrapposto. The appearance of fluidity and ease in the stance of the Berlin and Madrid Venuses is less evident in Marcantonio's version. The figure becomes heavier, as if the drapery's maze of minutely articulated folds, rendered here in their full sculptural density and weight, would overwhelm a more slender body. By studies from the antique such as this one, Marcantonio's style was transformed from the early tentative efforts shown in 18 and 52. He thereby gained the assurance in constructing contrapposto and movement that was necessary in order to capture Raphael's newly won mastery of these aspects of the figure in his engraved versions of *Lucretia* (102) and the *Massacre of the Innocents* (45). Comparing the *Venus* to these slightly later works enables us to glimpse the process through which Raimondi was able to become the transmitter of early sixteenth century Roman "corrected" antique revival style to the rest of Italy and Europe.

References (unpublished): J. J. Bernouilli, *Aphrodite,* Leipzig, 1873, 367, no. 1 (Berlin *Venus,* referred to as no. 746); J. Byam Shaw, *Drawings by Old Masters at Christ Church Oxford,* 2 vols., Oxford, 1976, 1, 49, no. 56, 2, pl. 34; G. Becatti, "Ninfe e divinità marine. Ricerche mitologiche, iconografiche e stilistiche," Università di Roma, Seminario di Archeologia, *Studi Miscellanei,* 17, Rome, 1971; 19, nos. 8, 10; K. Oberhuber, personal communication, January, 1977 (information about this drawing and its attribution to Marcantonio included opinion that the Madrid *Venus* was used by Antonio Lombardo as the model for one of his niche figures in the relief of *Vulcan's Forge* carved for Alfonso d'Este of Ferrara c. 1508; see 103, 107).

19a *Goddess of the Via Traiana*
Attributed to Pier Jacopo Alari Bonacolsi, called Antico (Mantua c. 1460/Gazzuolo 1528)

Bronze. 18.4 × 23 cm.

Staatliche Museen Preussischer Kulturbesitz, Skulpturengalerie (Inv. Nr. 2550)

The *Goddess of the Via Traiana* was listed in the 1542 inventory of Duke Federigo Gonzaga as a "figura piccola di metale che sede cum una rota in mano" and is known only in this unique example that appeared on the Florence art market in 1900. It is the only work attributed to Antico in which a figure has been adapted from an ancient coin and given three-dimensional form. Although not a literal copy, this bronze demonstrates the importance of Roman coins and medallions which, in addition to more monumental antiquities, served as models for Renaissance artists. The tutelary *Goddess of the Via Traiana* does not display the immaculate technical accomplishment and thoroughness of finish that characterize Antico's work; however, H. J. Hermann, the great early twentieth-century authority on Antico, has accepted it among the autograph bronzes.

The model is a reverse of a bronze medallion of Trajan on which a personification of the Emperor's triumph reclines on rocky ground, holding a six-spoked wheel on her raised right knee and a laurel branch in her left hand. The lively contrapposto of the model would have appealed to Renaissance artists at the beginning of the cinquecento who were made aware of the expressive potential of such movements by the evolving figure types of Leonardo and Michelangelo. In fact, Antico softens the dramatic effect of the model's contrapposto somewhat by lessening the contrary twist of the figure's hips to the right, adjusting the angle of the head to a less extreme profile, and simplifying the drapery forms. The treatment of the nude, its broad shoulders and powerful arms balancing the more voluptuous forms of the torso with a suggestion of physical power, relates to models other than the coin. It suggests the profundity with which Antico eventually absorbed the Hellenic, more specifically the Greek High Classic and fourth-century, elements implicit in at least a few Roman copies of Greek originals, and in Roman revival styles such as those which Augustus and Hadrian had promoted.

From an iconographic point of view as well, the noble forms of this seated *Goddess* are well suited to a tutelary deity whose function is one of protection and guardianship. Antico's thoughtful analysis and reevaluation of both the style and meaning of his models is suggested by this work. This is the same approach to antiquity that Legner defined as a result of his careful examination of Antico's Frankfurt *Apollo Belvedere.*

References: Hermann, "Antico," pp. 253–254, figs. 24, 25 (reverse of the coin of Trajan); Staatliche Museen zu Berlin, *Die italienischen Bildwerke der Renaissance und des Barock,* 2, W. von Bode, *Bronzestatuetten, Büsten und Gebrauchsgegenstände,* 4th ed., Berlin, Leipzig, 1930, 22, no. 100; Legner, "Anticos Apoll."

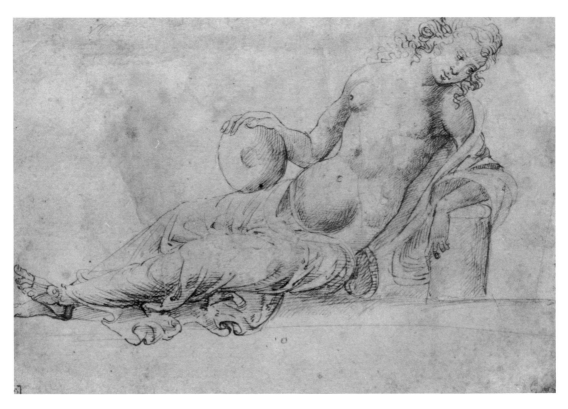

18

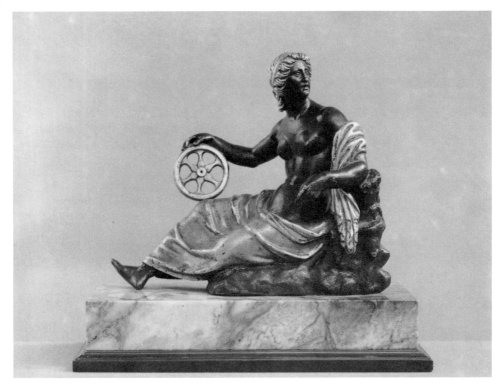

19a

20 *Imitation of a Syracusan Coin*

Giovanni dal Cavino (Padua 1500/Padua 1570)

Bronze medal (struck); brown patina. Obverse, below: ΑΘΛΑ. Reverse, above right, near rim: illegible Greek inscription. 4 cm. (diameter)

Collection of Heinz Schneider

Giovanni dal Cavino is known for his imitations of Roman coins which, apart from slight differences in technique owing to the use of different graving instruments and methods of striking, are almost indistinguishable from the originals. Known as "Paduans," his coins have been passed off as originals on many occasions, both during the Renaissance and after. Even so, it cannot be said that Cavino was merely a forger, since, at least in the beginning, his coins may very well have been made to demonstrate skill and to satisfy patrons who often asked contemporary craftsmen specifically for something "antique."

Here the model was a late fifth–early fourth-century B.C. Syracusan silver ten drachma piece by Euainetos, one of a series of Greek coins famed for their beauty and excellence of design. Winckelmann pronounced Euainetos's and Cimon's coins the ultimate in human concepts of beauty. Euainetos's coin shows on its reverse the head of Arethusa, the goddess of the freshwater spring where the first colonists of Syracuse settled. She is shown with a crown of reeds or corn stalks woven into her hair, "giving it an extra animation as it curls riotously in all directions" (Jenkins). Four dolphins surround the head with their characteristic curving and gliding movement. On the obverse is a chariot drawn by four galloping horses with a Victory flying above holding out a crown for the charioteer. Below the ground line a shield, a crested helmet, and two daggers (Cavino's misunderstanding of the greaves on the original) flank a cuirass. The Greek word beneath them, *athla,* could be taken to mean prizes in a contest or war trophies. Cavino's imitation, whether or not intended as a forgery, conveys an appreciation of the lively and elegant nature of Euainetos's design and the delicate precision of his technique, with its wonderful richness of minute detail.

It is often observed that Renaissance ideas of classical styles must have come overwhelmingly from Roman art, either the native productions of Rome, or Roman copies of Greek works. However, Cavino's pseudo-Syracusan coin illustrates the availability of at least some genuinely Greek models in the Renaissance, and of ones which represented the peak of quality in the field of numismatics.

Ex collection: [Edward R. Lubin, New York, 1970].
Exhibition: Cleveland, *Ohio Bronzes,* 82.
References: E. Kris, *Meister und Meisterwerke der Steinschneidekunst in der italienischen Renaissance,* Vienna, 1929, esp. 17–32; A. Gallatin, *Syracusan Dekadrachms of the Euainetos Type,* Cambridge, 1930, C XII-R VI, D II-R IX; Hill and Pollard, *Medals,* 75, no. 400 (medal by Master IO. F. F. adapting the same or a similar Syracusan coin); R. Hoe Lawrence, *The Paduans: Medals by Giovanni Cavino,* Chicago, 1967; F. Cessi and B. Caon, *Giovanni da Cavino,* Padua, 1969; G. K. Jenkins, *Ancient Greek Coins,* N.Y., 1972, 160–182, no. 440, 441 (ill.); C. M. Kraay, *Archaic and Classical Greek Coins,* Berkeley and Los Angeles, 1976, 218–224, 231–233, no. 815 (ill., ex. in Heberden Coin Room, Ashmolean Museum).

20 (actual size)

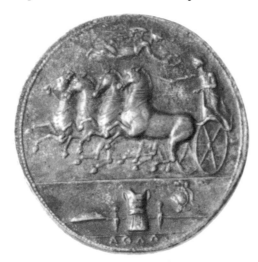

20 (obverse, enlarged)

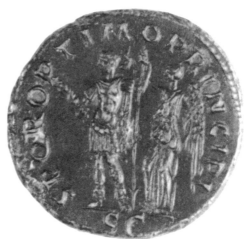

20 (reverse, enlarged)

21 *Tetradrachm* 474–450 B.C.
Sicily, Syracuse
Silver coin (Attic standard). Reverse, around:
ΣΥΡΑΚΟΣΙΟΝ
Smith College Museum of Art (1949.25)

The basic themes of the obverse and reverse of this Syracusan four drachma piece correspond to the coin imitated by Giovanni dal Cavino (20). In style, however, it may be dated one-half to three-quarters of a century earlier. On the obverse, a standing charioteer wearing a long chiton drives a quadriga, holding the reins in both hands, rather than a goad in one hand as in the dekadrachm. As in the coin copied by Cavino, a Nike flies to left above with a wreath to crown the charioteer. The reverse shows a profile of Arethusa, her hair confined in a net in back and bound by a beaded fillet. She wears a necklace and earrings. The dolphins symbolize the harbor of Ortygia, the original site of Syracuse and of Arethusa's fountain.

Exhibitions: Smith College Museum of Art, *Greek and Roman Antique Coins . . . Renaissance Books,* 1962, no. 5. (ill.).
References: B. V. Head, *Historia Numorum, A Manual of Greek Numismatics,* Oxford, 1911, 172–174; G. K. Jenkins, *Ancient Greek Coins,* N.Y., 1972, 145–182 (Sicily, fifth-fourth centuries).

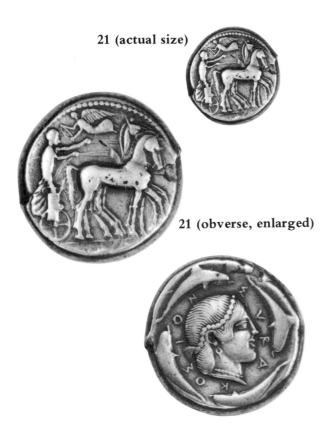

21 (actual size)

21 (obverse, enlarged)

21 (reverse, enlarged)

22 *The Fall of Phaeton and Other Sketches After the Antique* c. 1500–c. 1503
Amico Aspertini (Bologna 1475/1552)
Drawing, recto and verso; pen and brown ink, in some places over a preliminary drawing in graphite. Inscription: Trecitellio[?] n.o 10. 37.2 × 26.1 cm.
The Metropolitan Museum of Art, Rogers Fund, 1919 (19.151.6)

In the history of artists' study of the art of antiquity, Amico Aspertini occupies a very special place. His three *taccuini* or sketchbooks filled with dozens of drawings after antiquities in Rome provide an unusually full record for their dates (*Wolfegg Codex,* c. 1500–1503; *British Museum I,* 1531/2–1534; *British Museum II,* c. 1535–1540). Phyllis Bober's analysis in her magisterial *Drawings after the Antique by Amico Aspertini* has supplanted Vasari's portrayal of Aspertini as a psychologically disturbed, frenetic copyist of antiques with little discrimination of intrinsic interest or quality. Aspertini's style, though, unlike the assiduity of his study of antiquity, was not at all typical of other contemporary artists who produced corpuses of drawings of antiquities of comparable size and scope. Bober has elucidated his innate preference for scenes of action and conflict as well as the intrinsically pictorial values predominating in their presentation. His lack of interest in physical naturalism and tempermentally determined anticlassicism precluded any decisive impact on him of Raphael's Roman classicism and explains his choice of Antonine and other even later antique reliefs as models.

The Metropolitan Museum's sheet is divided into three unrelated fields. The uppermost, a band about 11 cm. high running across the top, is the most fully elaborated. It shows a section of the relief from a Phaeton sarcophagus now in the Uffizi (181) that was used by Moderno in a much less literal fashion as one source for his *Fall of Phaeton* plaquette (91), and by Michelangelo in the evolution of his Cavalieri drawings. As with Aspertini's studies of antiques collected in bound sketchbooks such as "London I," perhaps this drawing originally began on a facing folio which has since been lost, thus accounting for the cut-off forms of Phosphoros on horseback and one of the fallen horses of Phaeton's chariot. Below the first pair of counter-positioned horses is a swan, which on the sarcophagus now lacks its neck and one of its wings. The central motif of Phaeton falling from the steeply tilted chariot was restored incorrectly on the sarcophagus. Since Phaeton's left leg is a restoration, we do not know whether this drawing records the original position of Phaeton's legs, or was itself the draftsman's "restoration" of the left leg crossing behind the right. On the sarcophagus as it now stands, only one chariot wheel is represented as intact. The drawing records instead a broken axle, two fragments of broken wheels at either end, and a faintly sketched-in fragment of a third wheel on the ground, below the axle and the nearby horse's tail. The horse's head and the elderly man

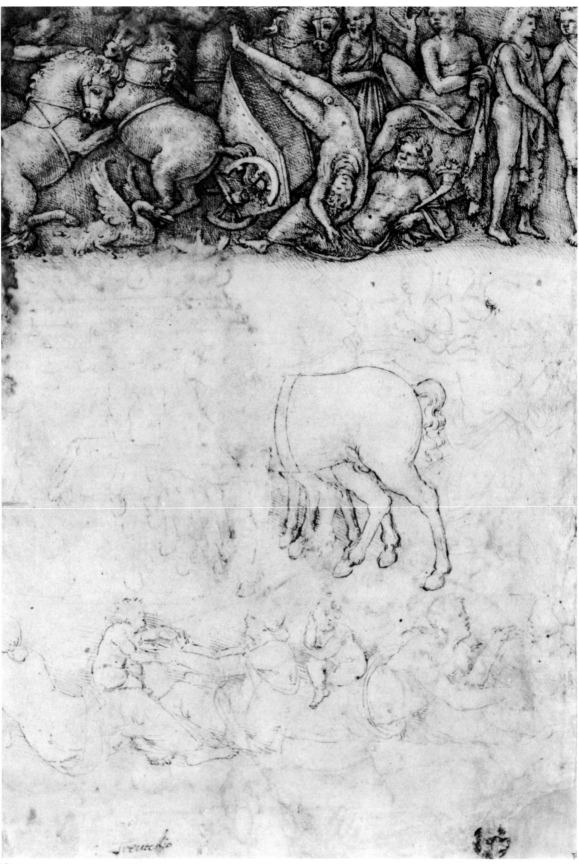

22

above Phaeton are easily recognizable in the relief. The figure next to the elderly man does not follow the corresponding figure on the sarcophagus, but has been modeled on the popular Diomedes type known from Lorenzo de' Medici's intaglio or the *Felix Gem* (8). Below this figure and the falling Phaeton is a River God, and, on the right, the scene of Helios entrusting his chariot to Phaeton. In this uppermost section of the drawing a relief-like effect typical of Aspertini's *Wolfegg Codex* drawings is achieved by a dense texture of parallel and cross-hatched lines. This is employed for the background, with little interior modeling defining details of the figures' anatomies. Here and there the paper shows through to provide highlights.

A large area in the middle of the sheet, about 14 cm. high, is given over to a scene copied from a larger-scale relief showing an imperial triumph. The group has been lightly sketched in graphite and partly gone over with ink in the hindquarters of the foreground horse and some of the other horses' legs. To the right of the group of four horses is a chariot bearing an emperor in triumph who raises his right arm. Behind him on the chariot is a winged Victory. Three figures walk beside the chariot. The foremost, partially draped, raises his right arm in a gesture similar to the emperor's. This drawing undoubtedly records the relief showing the Triumph of Titus in his quadriga inside the arch erected in his honor after A.D. 81.

The lowermost band, about 7 cm. high, shows four Nereids or Nymphs, one seen from behind in the popular "Letto di Policleto" pose (ill. Gombrich, *Norm and Form,* fig. 173), with two putti. The Nereid near the center who stretches out her arms toward the putto perched on her companion's knee is probably not from a sarcophagus relief but is instead a study from life. These figures are lightly sketched in ink with some indication of the background relief plane in rapid, rather piecemeal, parallel hatching. Interior modeling lines and indications of the shapes of hair and drapery are minimal.

The three parallel bands of drawings on the sheet differ in style and degree of completion. First there is a completely worked-out rendering of a relief in which both precision of form and a three-dimensional effect are sought. In the middle, the unfinished drawing from Titus's Arch would probably have resembled the Phaeton relief drawing if finished. Below, the drawing of the Nereids has a freedom and playful spontaneity about it that indicates copying intermingled with fantasy.

The sheet has been assigned the date 1500–1503 because of its close relationship of style to Aspertini's *Wolfegg Codex* drawings, dated by Bober to this period.

Ex collection: E. J. Poynter, 1919 (Lugt 874).
References (unpublished): Bober, *Aspertini,* 9f., 17–22 (Aspertini's *Wolfegg Codex,* style and relationship to antique sources); G. A. Mansuelli, *Galleria degli Uffizi, Le Sculture,* pt. 1, Rome, 1958, 232, no. 251 (Phaeton sarcophagus).

23 *Head of Julius Caesar* c. 1530–40
Parmigianino (Parma 1503/Casalmaggiore 1540)
Drawing; pen and brown ink, brown wash on off-white paper, traces of red chalk and touches of white heightening. Inscription in pen, lower left corner: L davinci. 8.6 × 7 cm.
Museum of Art, Rhode Island School of Design, Gift of Mrs. Gustav Radeke (20.517)

In this handsome drawing Parmigianino studies a Roman marble portrait head. The rounded cranium, sparse hair, squared jaw and cleft chin, but especially the characteristic wrinkles on the neck, have identified the model as a head of Julius Caesar. Other studies were made by Parmigianino of this same head from different angles (Windsor 0580, profile, slightly averted; 2279, old copy of a Parmigianino drawing of the head in pure profile). None has the elaboration with wash and the white heightening of this example, suggesting perhaps that the artist preferred this aspect of the portrait.

The drawing is given a sculptural sense by the dark shadowing along the left contour. Unlike most quattrocento drawings of antique sculpture, the eyes are left blank. Thus it is clear that a marble statue, not a person, is represented. This sheet and several others related to it in style were once attributed to Leonardo, which explains the inscription "L davinci."

Ex collection: William Isaak Hooft (Lugt 2631).
Exhibitions: Rhode Island School of Design, Museum of Art, *Italian Drawings from The Museum's Collection,* 17 March–16 April 1961, no. 34; *First Maniera,* no. 39 (Susan E. Strauber).
Reference: A. E. Popham, *Catalogue of the Drawings of Parmigianino,* 3 vols., New Haven/London, 1971, 1, 195, no. 646; 242, o.c. 52; 3, pl. 445.

23

24 *Flora Farnese*　　Second half of 16th century
Italy, Florence
Bronze (heavy hollow cast); dark brown lacquer worn in places to chocolate-brown natural patina. 36.2 × 15.2 cm.
Private collection

The practice of making reductions in bronze of famous antique marbles which were themselves versions of bronze originals was an important aspect of antique revival. As Renaissance collectors and artists well knew, the ancient Romans were avid collectors of just such replicas.

Often these Renaissance reductions in bronze exhibit changes from the original models, whether in the form of restorations (see 61) or of "improvements". Their creators take the occasion to comment in some way on the original models. The making of replicas in which the antique is reproduced without alteration hardly ever occurs during the first half of the sixteenth century. Later, the shift from artistic interpretation of an antique to what was conceived as archaeologically correct transcription indicates that antiquity was beginning to be viewed as an era distinct and even remote from the Renaissance. During the sixteenth century, the process of "distancing" by which the Renaissance learned to think of itself once and for all as separate from the antique past accelerated.

The *Flora Farnese* is a reduced replica of the colossally scaled marble (3.42 m.) dating from the second or third century, found in 1540 in the Baths of Caracalla (now Naples). It shows a mature woman wearing clinging, almost "wet", drapery clasped on her left shoulder but leaving the other shoulder bare. This small bronze, dating at the earliest to the mid sixteenth century and viewed by some scholars as belonging to the seventeenth century, at first appears to replicate the model rather closely, but on further inspection, many personal touches that preserve an individual artist's perceptions of antiquity reveal themselves. The head is a restoration of the Renaissance or Baroque artist; the one now on the marble statue is of plaster. *Flora*'s hair is parted in the middle and drawn back symmetrically in waves held by an encircling fillet in a typical Hellenistic hairstyle. The strong and supple column of her neck alludes to the strength and grandeur projected by the colossal marble figure and helps encapsulate these qualities in the small bronze. She stands in a relaxed contrapposto with weight carried on her right leg, the intended position of the foot obscured by a casting flaw. The mid-stride pose of the marble is thus quieted; instead of interpreting the figure as holding out a bunch of flowers (the restoration we see today, apparently dating from the intervention of Carlo Albacini [1797]), the artist has raised the left forearm and cocked the wrist so that the back of the hand faces out, shielding the victory wreath held close to the body as if in quiet anticipation of crowning its recipient.

The *Flora*'s less literal, more spontaneous spirit of imitation can be appreciated by comparing the work to both contemporary Renaissance and eighteenth-century versions of the antique Flora. Wixom drew attention to the difference in character between this bronze and the *Flora Farnese* bronzes Giacomo Zoffoli made after a model by Pacetti (1773; examples in Ashmolean, Saltram Park, Devon and Schloss Woelitz), which indicated the major role played by contemporary taste in the art of restoration or reconstruction. Compared to the slightly taller late-sixteenth-century variant in Vienna (Planiscig no. 244, fig. 244), which Planiscig associated with Pietro da Barga's production of bronze antique replicas, this statuette has more life and vitality, and emphasizes to a greater degree both the monumentality and the voluptuousness of the prototype. The systematization of drapery folds is less uniform, and the modeling looser, more fluid and subtle. The woman's serene amplitude combined with her naturalness and ease of stance links the style of this piece to early Baroque approaches to antique revival, as seen also in the drawings from the Marcus Aurelius arch (27–29).

Ex collections: [Volpi, Rome, 1907]; Lord Cavendish Bentinck; [J. J. Klejman, New York].
Exhibitions: Detroit, *Decorative Arts* (no. 281: Italian, Florence, 2nd half of sixteenth century); Cleveland, *Ohio Bronzes,* no. 154 (Wixom); California Palace of the Legion of Honor, *The Triumph of Humanism,* San Francisco, 1977–78.
References: A. Ruesch, *Guida Illustrata del Museo Nazionale di Napoli,* Naples, 1911, 71–72, no. 242 (6409) (Flora Farnese); L. Planiscig, *Die Bronzeplastiken,* v. 4 of J. Schlosser, ed., *Publikationen aus den Sammlungen für Plastik und Kunstgewerbe,* Vienna, Kunsthistorisches Museum, 1924.

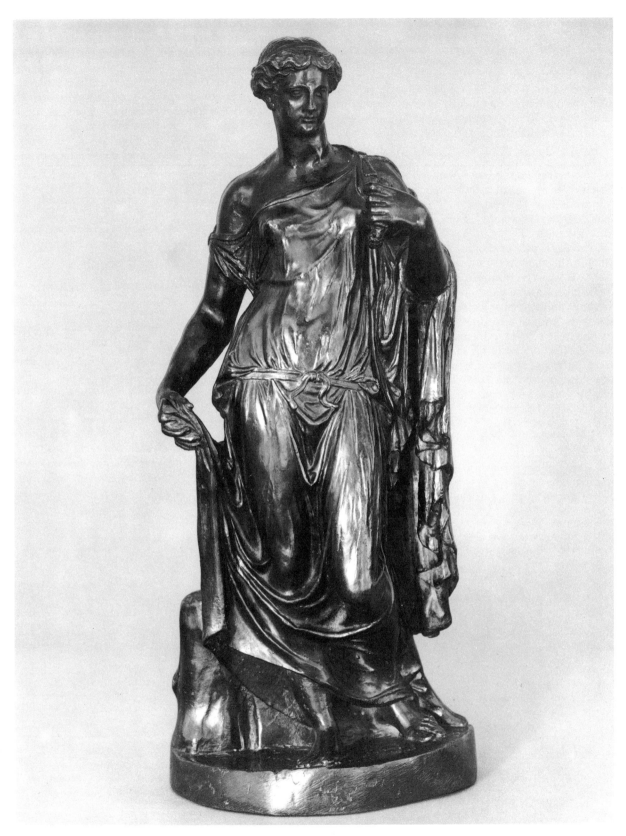

24

25 *Roman Soldiers in Combat with Dacians, after a Relief from the Arch of Constantine* 1553

Nicholas Beatrizet (Lunéville? 1507/Rome after 1565)

Engraving; B. 15, 266, 94. Signature: NB [monogram]. Inscription: Tabula marmorea, pugnae Dacicae: ex diruto Traiani, ut putatur, arcu, in Constantini cognomento Magni; qua spectat Aventinum; ornatus caussa; Romae, translata/Antonij Lafrerij Sequani formis Romae 1553. 28.8 × 45 cm.

Davison Art Center, Wesleyan University (40.D1.14)

In this rare engraving, Nicholas Beatrizet, a printmaker from northeastern France who came to Rome around 1540, recorded a section of the great Trajanic frieze, probably originally located in the Forum of Trajan. The frieze was cut into sections for use in the Arch of Constantine (A.D. 315). This scene appears in the attic story, on the eastern short side of the arch. Trajan's troops, recognizable by their crested helmets, chain mail armor and the long shield marked with wings and lightning bolts, are shown in a rout of the Dacians (wars of A.D. 101–102 and 105–107). Originally this section was immediately to the left of the famous section of the frieze in which Trajan himself appears on horseback at the head of his victorious troops (also on the Arch of Constantine). The man whose body is cut off by the right edge of the engraving is actually the vexillum bearer who accompanies Trajan.

Beatrizet's engraving provides clear evidence of the considerable advances in the study and absorption of Roman monumental reliefs by 1553, the date of the engraving. The uses to which such motifs of battle had been put during the first half of the cinquecento have been well described by Gombrich. The clarity of the engraving and its emphasis on details of musculature, costume and texture bring to light subtle aspects of the relief. It has somewhat the character of a schematic diagram, unusually strong in this brilliant impression in which the light-dark contrasts are exaggerated. They almost seem to presage modern compositional analyses of battle reliefs in which the Romans are outlined in red and the barbarians in black (Hamberg).

The engraving's date is of interest as it coincides with the beginning of Antonio Lafreri's joint partnership with Salamanca. Lafreri, also a native of France, is named as publisher of the engraving in its inscription. The engraving was included among the hundreds of prints in the collection known (jfter 1573) as *Speculum romanae magnificentiae*. These representations of Roman architecture and sculpture, like present-day collections of photographs or slides, formed a repository of images recording the major sights of Rome, enabling the traveller to refresh his memory of the eternal city.

Ex collection: George W. Davison, 1940.
References: C. Huelsen, "Das Speculum Romanae Magnificentiae des Antonio Lafreri," *Collectanea variae doctrinae Leoni S. Olschki,* Munich, 1921; P. G. Hamberg, *Studies in Roman Imperial Art,* Copenhagen, 1945; A. Giuliano, *Arco di Costantino,* Milan, 1955, fig. 6, right half; E. H. Gombrich, "The Style *'all'antica':* Imitation and Assimilation," *Norm and Form: Studies in the Art of the Renaissance,* London, 1966 (first published 1963); L. R. McGinniss with H. Mitchell, *Catalogue of the Earl of Crawford's "Speculum Romanae Magnificentiae" now in the Avery Architectural Library,* N.Y., 1976, 3–8, no. 541.

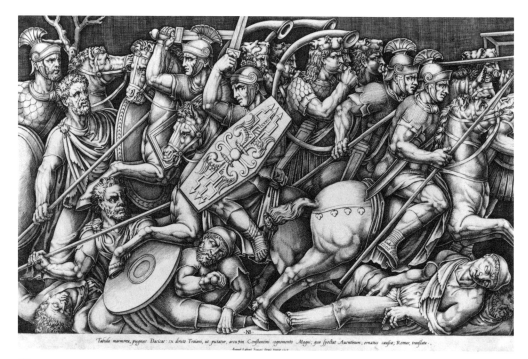

Tabula marmorea, pugnae Dacicae: ex diruto Traiani, ut putatur, arcu in Constantini cognomento Magni; qua spectat Aventinum; ornatus caussa; Romae, translata.

26 *Four Studies of an Antique Female Torso*
 c. 1550

Girolamo da Carpi (Ferrara 1501/Ferrara 1556)

Drawing; pen and brown ink. Inscription, lower center: Raffaelle di Urbino. 28.4 × 19.7 cm.

The Art Museum, Princeton University (48.560)

Girolamo da Carpi probably saw the statue copied in this drawing during his stay in Rome between 1549 and 1554 (Gibbons). The antique studied here has been identified as a Hellenistic torso of Venus similar to one in the Louvre (Olson; Reinach).

The attribution of this drawing to Carpi has gained wide acceptance. Carpi's interest in antiquity revived Mantegna's fusion of archaeology and art in north Italy during the previous century. His "refined and graphi-cally precise drawings after ancient statues" (Gibbons) are remarkable for their fluid subtlety of line in the service of careful recording. Closely related drawings by Carpi which show a similar style in the copying of antique sculpture are in the Uffizi and in Turin (Bertini).

Ex collections: Thomas Banks (Lugt 2423); Dan Fellows Platt (Lugt supp. 750a and 2066b).
References: S. Reinach, *Répertoire de la statuaire grecque et romaine,* Paris, 1913, 4, 199, no. 8; A. Bertini, *I disegni italiani della Biblioteca Reale di Torino,* Rome, 1958, 183; R. J. M. Olson, "The Fulfillment of an Ideal: Two Drawings by Girolamo da Carpi," *Record of the Art Museum, Princeton University,* 32, no. 2 (1973), 16–27; Gibbons, *Princeton Drawings,* 55–56, no. 149.

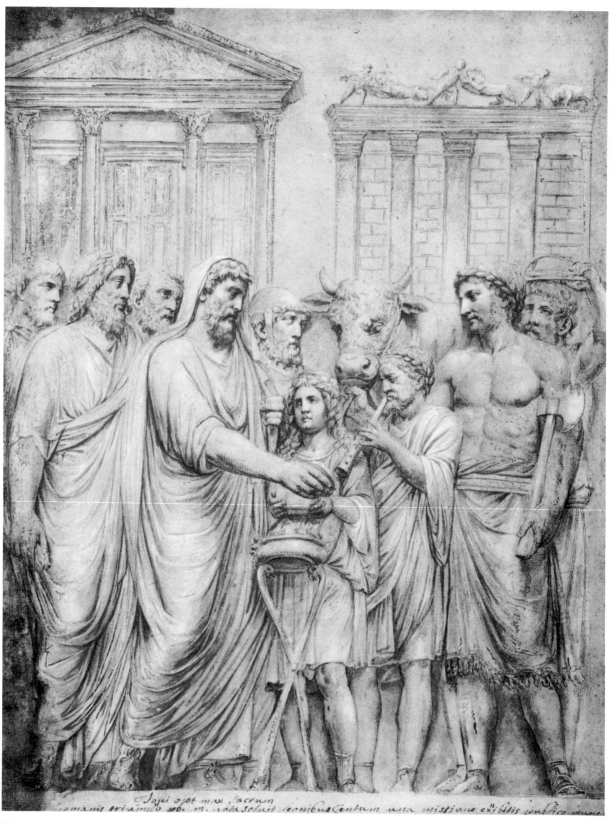

Iovi opt max Sacrum
camanis triamuro vo. m. vota soluit leonibus Centum uena missione exibitis publico numine

27

27 *Sacrifice of Marcus Aurelius before the Capitol* c. 1620–40

Italy

Drawing; pen and medium brown ink, brush and light brown washes on white paper, heightened with white, scattered remains of oxydized pigment. Inscription below ground line: Jovi opt max sacrum/[illegible] Germanis triumpHo po.m. vota solvit leonibus centum una missione exHibitis publico munere. 49 × 37 cm.

Museum of Fine Arts, Boston, Department of Classical Art; Bequest of Benjamin Rowland, Jr. (1974:168)

This and the following two drawings reproduce reliefs probably from an arch of Marcus Aurelius that celebrated his triumphs over the Germans (A.D. 174) and Sarmatians (A.D. 176). Although the arch itself is now destroyed the reliefs have been in the Palazzo dei Conservatori since 1515. Eight other panels from the arch are incorporated into the Arch of Constantine.

In the center of the *Sacrifice* drawing is a tripod behind which the *camillus* stands holding an open box of incense. To his left the Emperor, his head veiled, offers the sacrifice. He is followed by three men. The strongly individualized head immediately behind the Emperor's probably portrays the *Praefectus praetorio* M. Bassaeus Rufus, while the figure shown in full next to the Emperor is not an actual person but rather the personification of the Senate (Stuart Jones). Next to the *camillus* a lute-player holds his instrument close to the boy's ear. To his right an assistant holds an axe, and behind him is a man carrying a pan on his head. Most of the personages wear laurel wreaths. The head of the sacrificial bull stands out prominently behind the *camillus* and flute-player. The sacrifice takes place before the Temple of Jupiter Capitolinus, represented at the left with four instead of six columns, and a building with five pilasters, probably part of the sanctuary enclosure. The relief panel on which the drawing is based includes the temple's pedimental sculpture—Jupiter, with his eagle, seated between Juno and Minerva, Mercury, Sol rising in his chariot on the right, and Luna descending on the left. These figures do not appear in the drawing but sculptural groups above the architrave of the building on the right are clearly represented. The severe breakage which the relief had sustained, resulting in a great many losses to the figures, is shown in Cod. Vat. Lat. 3439 (*Codex Ursinus*), made between 1564/5 and 1569/70 (ill. Stuart Jones, fig. 1). The date of the relief's restoration, 1595, provides a terminus post quem for our drawing.

In their approach this drawing and the two following (part of a set of five that includes two other triumphal reliefs) differ from both quattrocento and cinquecento studies of antiques (cf. 16, 19, 22, 23, 26, 47). The impetus for copying antique sculpture had first shifted from an artistic to an archaeological one; now, at the beginning of the seventeenth century, some artists once again aimed to tap the vital energies underlying the antique types, and could see them afresh, in a newly unconstrained fashion (cf. 24). The reliefs are copied in a way that infuses them with life as well as recording their appearance. Unlike most earlier copies of antiquities, these drawings are made as finished products, not as part of a study or personal record (cf. 19, 22, 23) or even to contribute to a stock of workshop patterns as was true of Ghirlandaio's lost sketchbook or the *Codex Escurialensis*. They display a high degree of finish in which the delicate brushed modeling and white heightening help to communicate the sculptural values.

Their style, moreover, is unlike that of any of the artists (Heemskerck [48], Bandinelli, Francisco d'Ollanda, Pirro Ligorio, for example) who drew antiquities in Rome in the 1530s–50s. It is more painterly than the work of these artists, with softer outlines and an absence of such standard graphic techniques as parallel or cross hatching. The same three scenes (see 28, 29) were copied by d'Ollanda in 1539–40 (fol. 25 bis), and though also executed in washes and without hatching lines d'Ollanda's renderings lack the fully worked out sculptural modeling and the air of grave dignity conferred on the scenes by this artist.

Working within an overall antiquarian purpose, this artist has yet managed to bring the stone figures alive rather than rendering them "correctly" as marble surfaces. One senses his strongly sympathetic response to antiquity, one that led him to imbue an ostensibly objective record with the stamp of an individual interpretation.

The style of the *Sacrifice of Marcus Aurelius before the Capitol* establishes a context that relates chronologically to Cassiano Dal Pozzo's project to form a *Museum Chartaceum* as a corpus of antique sculpture, by commissioning several artists, Poussin among them, to copy all the antique sculpture in the Rome area (1620–57). When complete, Cassiano's collection (in its present form divided between Windsor Castle and the British Museum) numbered well over 1300 drawings. Its drawings of the *Marcus Aurelius Sacrificing* relief (Windsor 8257) and the *Submission of the Germans* (Windsor 8256) were made by an artist whom Vermeule identified as the most outstanding from the viewpoint of clarity and fidelity to the antique of any who worked for Dal Pozzo. The style of Windsor 8256 (Vermeule, 1956, fig. 10) is similar to our drawing but not identical. The modeling is neither so detailed nor so sensitive; the expressions on the faces have not undergone that sympathetic process of "humanization" that removes them from their stone models, so typical of this artist. The Master of Windsor 8256 tends to elongate limbs and extremities, while our artist shows an opposite preference for chunkier proportions.

One artist who worked for Cassiano was Pietro da Cortona, who came to Rome as a young man in 1613. There is a drawing of the *Sacrifice of Marcus Aurelius* relief in a sketchbook (Toronto) that includes drawings by Pietro, which in its handling of the scene is extremely close to the present composition. The similar-

ity is such that the Toronto sketchbook drawing could represent an earlier stage of this much more finished rendering.

Note: the following information applies as well to 28 and 29.

Ex collection: Prof. Benjamin Rowland, Cambridge, Mass.

References: F. d'Ollanda, *Os Desenhos das Antigualhas . . . 1539–40,* facsim. ed., E. Tormo, Madrid, 1940, 25 bis, 116–118; H. Stuart Jones, *A Catalogue of the Ancient Sculptures preserved in the Municipal Collections of Rome, Sculptures of the Palazzo dei Conservatori,* Rome, 1926, reprint, 1968, 22–26, nos. 4, 7; 27–29, no. 10 (with bibliog. on reliefs and lists of their Renaissance representations; note that Windsor, vol. 2, 8258 is said to depict the *Triumph of Marcus Aurelius* [p. 26], but see below); C. C. Vermeule, "The Dal Pozzo-Albani Drawings of Classical Antiquities, Notes on their Content and Arrangement," *AB,* 38 (1956), 31–46 (Windsor 8258 is the early Antonine triumphal relief showing *Hadrian Received by Roma,* Stuart Jones no. 12, p. 39); idem, "The Dal Pozzo-Albani Drawings of Classical Antiquities in the British Museum," *Transactions of the American Philosophical Society,* n. s. 50, pt. 5 (1960), 3–38, esp. p. 22 (Vol. 1, fol. 166, no. 194 shows this scene with the left hands of the *camillus,* flute player and *victimarius* unrestored. The present drawings 27–29 (then still in the Rowland collection) are considered closer to the style of Windsor 8256–58 than to Pietro da Cortona's drawing of the *Sacrifice* in the Toronto sketchbook); G. Brett, "A Seventeenth Century Sketchbook," *Royal Ontario Museum, Bulletin of the Division of Art and Archaeology,* 26 (1957), 4–10, pl. 2B; E. Mandowsky and C. Mitchell, *Pirro Ligorio's Roman Antiquities,* London, 1963 (Studies of the Warburg Institute, 28), *passim* and 140 (date of *Codex Ursinus*); Berlin, Staatliche Museen der Stiftung Preussischer Kulturbesitz, Kupferstichkabinett, *Zeichner sehen die Antike,* February–April, 1967, 71–73, no. 47 (Pietro da Cortona drawing after scenes from the column of Trajan).

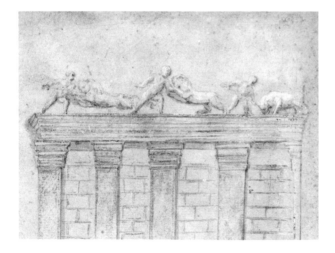

27 (detail)

28 *Triumph of Marcus Aurelius* c. 1620–40
Italy

Drawing; pen and medium brown ink, brush and light brown washes on white paper, heightened with white, scattered remains of oxydized pigment. Inscription below ground line: Trumphus germanicus M. Aurelij/contra Germanos rebus feliciter gestis marco manis sarmatis vandalis quandis devictis panno [illegible]/liberata triutomphat Campidolio. 48 × 36 cm.

Museum of Fine Arts, Boston, Department of Classical Art; Bequest of Benjamin Rowland, Jr. (1974:167)

The emperor is shown at the left in a chariot drawn by four horses. He is bareheaded, dressed in tunic and mantle, and in his right hand he holds a roll (restored incorrectly, replacing an original laurel branch). Behind his head is a Victory who originally was in the act of crowning him with a wreath. In the background is a pedimented temple with a single door visible through two center columns. Between the chariot and a trumpeter walks the *lictor proximus* who looks up at Marcus Aurelius. The chariot is decorated with reliefs of Neptune with his trident, seen from behind (see 7, 8), Juno enthroned and Minerva, wearing a helmet and holding a shield. Two other Victories decorate the chariot lower down and there are lion heads at the end of the chariot pole (between the second and third horses) and over the axle-box (at left behind the horse's tail.)

Like 27 and 29, this drawing is a thoroughly finished composition. The use of white in modeling the horses' musculature and bony structure calls attention to the breadth and ease of draftsmanship as well as to details like the bulging veins of the horse in the foreground. The white heightening also serves to define the several planes of the relief. On the emperor and the Victory the highlights are more impressionistic and painterly in style. The spatial arrangement of the relief has been accurately preserved. Yet here again the artist has imparted to the figures a psychological vitality, a "presence," that is not part of the sculptured relief.

In analyzing the *Museum Chartaceum,* Vermeule noted the surprising absence of any representation of this relief. It was apparently the only Conservatori triumphal relief known since the Renaissance that was not included. This omission seems inexplicable given Cassiano Dal Pozzo's thoroughness and his demonstrated knowledge of extant Roman antiquities; perhaps that sheet, which probably corresponded in style to Windsor 8256 and 8257, has become separated from the collection. The present set of five drawings is much larger in format than most of the *Museum* sheets, though possibly inspired by Cassiano's example and identical to his project in intention. They seem rather to have been done for another patron whose antiquarian interests were matched or exceeded by opulent tastes.

Note: see 27 for provenance and references.

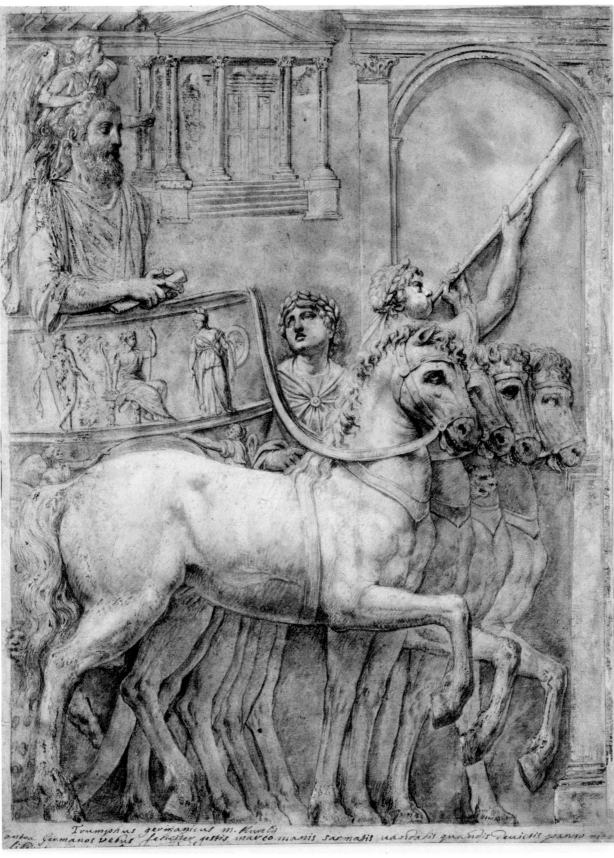

Triumphus germanicus m. Aurelii
contra germanos rebus feliciter gestis marco manis sarmatis uandalis quandis deuictis
lib...

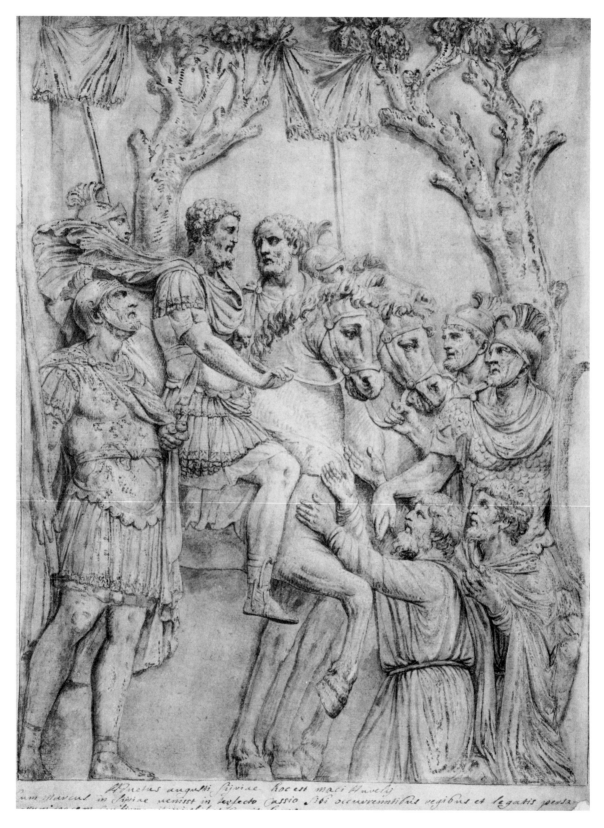

Augustus augusti filiviae hoc est mati Havelij
um marcus in filiviae nemisst in prefecto Cassio Bti occurrentibus regibus et legatis persa—

29

29 *Submission of the Germans to Marcus Aurelius*
c. 1620–40

Italy

Drawing; pen and medium brown ink, brush and light brown washes on white paper, heightened with white, scattered remains of oxydized pigment. Inscription below ground line: Advetus augusti Syriae hoc est maci Aurelij/Cum Marcus in Sijriae venisst in perfecto Cassio Sibi occurvenntibus regibus et legatis persa-/rum pacem confirmavit xiphil. es capitolinus. 48.5 × 37 cm.

Museum of Fine Arts, Boston, Department of Classical Art; Bequest of Benjamin Rowland, Jr. (1974:166)

Marcus Aurelius on horseback in military dress receives the submission of the Germans, as shown by his gesture. On his left a companion of high rank (Bassaeus Rufus?) turns to speak to him while a soldier holds his horse. In the left foreground stands an officer of the Praetorian guard, fully armed, wearing a cuirass and long military cloak.

Like the *Sacrifice* relief, this panel had suffered many losses, shown in Cod. Vat. Lat. 3439, fol. 73 (Stuart Jones, fig. 2). The draftsman of that codex, whose figure style and rendering of heads and expressions is inferior to these later drawings, nevertheless understood how the Emperor's leg and arm ought to have been restored, as indicated by his inclusion of the break-points and contact marks that are clues to the correct restoration. The design of this panel was popular in the Renaissance and can be found in the ciborium of Sixtus IV (1475–80, Vatican *Grotte*).

Note: see 27 for provenance and references.

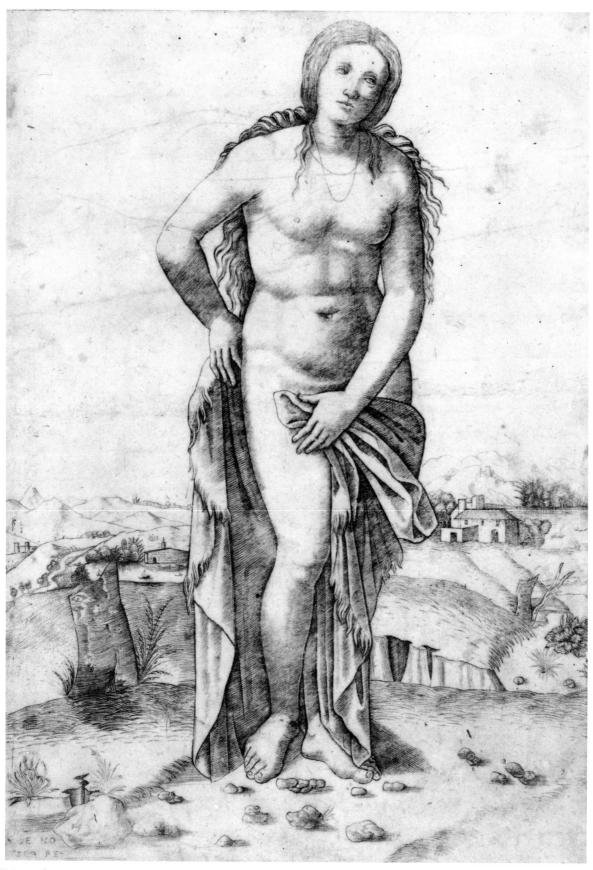

37 (supplement). Giovanni Antonio da Brescia. *Venus: after the Antique,* c. 1513. Engraving; H. 5, 41, 14. Inscription at lower left: ROME NOVITER REPERTVM. Signature, below, center: IO.AN.BRIXIAS. The Art Institute of Chicago.

The Figure in Repose and Action

30 *An Athlete Making a Libation* Second half of the 5th century B.C.

Argive, after Polykleitos

Bronze; eyes inlaid in silver and nipples in copper; hair finely chiselled; dark green patina with areas of gray-green. 21 cm.

Musée du Louvre, Département des Antiquités grecques et romaines (Br 183)

The major works of Polykleitos, the most important sculptor of the High Classic period in Greece next to Pheidias, are known only through copies, of which *An Athlete Making a Libation* is one of the finest. Furtwängler's opinion that it originated in the immediate circle of Polykleitos and not many years after the original life-sized prototype was made has won wide acceptance. Such closeness in time to the original is an important aspect of this rare work, although in the Renaissance many more antique bronze versions of this and related prototypes existed than have survived today. The fundamental differences between a small-scale bronze and a full-sized marble version of the same life-sized bronze prototype may be studied by comparison with 31.

Furtwängler pointed out that the fully developed forms of this body correspond to those of the *Doryphoros* and the *Diadoumenos,* the two best known Polykleitan types, and not to the more adolescent, boyish forms of some of his other athletes. The body's weight rests on the right leg, allowing the relaxed knee and foot to come slightly forward. The position of each arm corresponds symmetrically to its opposing leg. The right hand, held with the thumb drawn in, must once have held a patera; the left an attribute formed like a staff. The beautifully worked head is bent and tilted in the direction of the carrying leg and toward the action being performed. "The whole body is included within a fine curve that rises from the un-weighted leg, and its structure is molded and balanced down to the last detail. . . . The sculptural construction of the body simultaneously makes clear the action that draws the head and the right hand holding the bowl into relation with one another. The statuette epitomizes the harmonious concord of all physical and mental forces in the shape of an athletically formed youth at the height of Greek Classicism" (Lullies, 61).

Renaissance works like 35 and Tullio Lombardo's life-sized marble *Adam* (Metropolitan Museum) suggest that Polykleitan types exerted much influence during the quattrocento and early cinquecento. Fourth-century and later Hellenistic types, those invented for example by Lysippos (fl. second half of the 4th century B.C.), such as that furnishing the inspiration for 32, were particularly influential at the beginning of the sixteenth century (cf. 34 and 59). They had appealed as well though to an earlier artist like Ghiberti, since their sinuousness was also in keeping with the International Gothic style that had formed his taste (see Ghiberti's *Samson,* Krautheimer, vol. 2, pl. 127b).

Ex collection: France, Royal collections.
References: A. Furtwängler, *Masterpieces of Greek Sculpture,* ed. E. Sellers, N.Y., 1895, 279; Musée du Louvre, *Les bronzes antiques,* cat. by A. de Ridder, Paris, 1913, 27–28, 50, fig. 24; R. Lullies and M. Hermer, *Greek Sculpture,* London, 1957, 61, pl. 181; C. C. Vermeule, *Polykleitos,* Boston, 1969, 13; R. Krautheimer, with T. Krautheimer-Hess, *Lorenzo Ghiberti*[2], Princeton, 1970, 2 vols.; P. Zanker, *Klassizistische Statuen,* Mainz, 1974, 4–5.

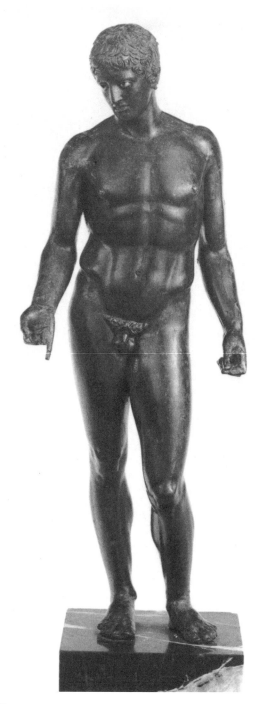

30

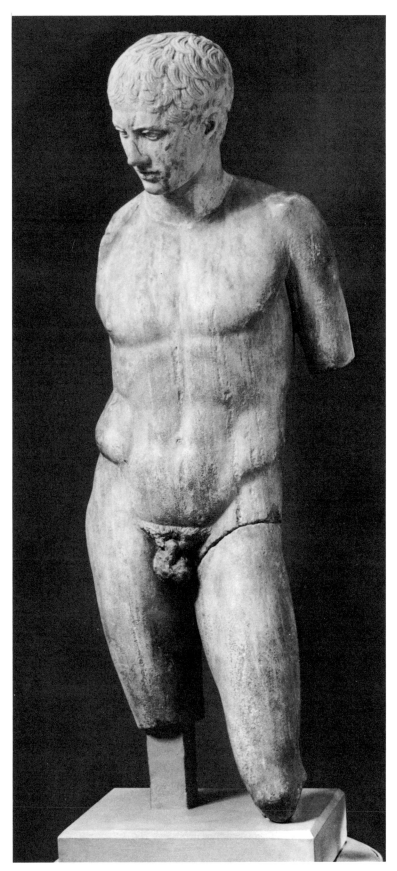

31

31 *Athlete* Reign of Tiberius, A.D. 14–37(?)
Roman, after Polykleitos
Fine-grained white marble. 130 cm.
The Wellesley College Museum, Gift of Hannah
Parker Kimball, 1904 (1904.1)

This life-sized marble figure of a full-grown slender youth, lacking the right arm, left forearm and legs below the knees, stands with his weight concentrated on the right leg. A slightly curving central axis leads from the chin to the genitals. The flesh is vigorously, yet abstractly, modeled. There is a question as to whether the head, lowered and turned to the figure's right, originally belonged to the body. Tests carried out in 1942 showed that the pieces originated in the same quarry or locality.

Comparison with the more than twenty-four replicas belonging to the same type allows one to reconstruct to some extent the position of the missing limbs. The right shoulder is brought forward and the forearm was probably slightly raised. The left forearm was originally lowered and held relatively close to the body. The feet were aligned in roughly the same plane. Carl Blümel, who first reconstructed its type, called it the "discophoros" or discus-carrier after an example in the Palazzo Torlonia, Rome (n. 76), in which a discus, thought to be original, was held in the left hand. Recently Zanker pointed out the uncertainty of the "discophoros" terminology and renewed the old suggestion that these works portray a Hermes who held a caduceus in the left hand. He claimed that the Louvre *Athlete Making a Libation* (30) is the only copy in which the position of the left hand is shown correctly, and that the missing attribute had a caduceus-like shape.

Blümel dated the type of this *Athlete* prior to the *Doryphoros* in the evolution of Polykleitos's art (followed by Arias, Steuben, Lorenz, Zanker). He argued that the clear contrast between tensed and relaxed muscles, fully worked out in the *Doryphoros,* was not yet altogether resolved. Vermeule, considering the curve of the axis through the body (even more pronounced in 30), and the narrowness of its torso compared to the *Doryphoros* (which is not true of 30), placed it later, in the first half of the 430s. With regard to the dating of the Wellesley copy, Lauter grouped it with the *Doryphoros* of the Braccio Nuovo as works from the same late Augustan or Tiberian workshop. In both, the linear locks of hair lie so close to the skull as to be almost without volume. The two exemplars also share the same manner of forming the eyes and a characteristic gradual transition from facial to cranial planes.

"Even in its present condition the Wellesley *Athlete* reveals much of Polykleitos: his stress on the compact volume of the figure with its earthbound weight emphasized by the horizontal divisions of the anatomy; the masterful ponderation, already classical in its measured balance; the vigor and clarity of the modeling; and the rendering of the youthful athletic male body in terms of an ideal pattern" (Shell and McAndrew).

Ex collections: Rome, Palazzo Odescalchi; Ottorino Paternoster; Pietro Barocchi.
References: C. Blümel, *Der Diskosträger Polyklets,* Berlin, Leipzig, 1930 (Archaelogische Gesellschaft zu Berlin, Winckelmannsprogramm, 90); Helbig, 1, no. 117 (H. von Steuben); C. Shell and J. McAndrew, *Catalogue of European and American Sculpture and Painting at Wellesley College,* 2nd ed., Wellesley, 1964, 22–25; P. E. Arias, *Policleto,* Milan, 1964, 15–17, 134–135; H. Lauter, *Zur Chronologie römischer Kopien nach Originalen des V. Jahrhunderts,* Inaugural Dissertation, Rheinische Friedrich-Wilhelms-Universität, Bonn, 1966, 74; C. C. Vermeule, *Polykleitos,* Boston, 1969, 13; T. Lorenz, *Polyklet,* Wiesbaden, 1972, 18; P. Zanker, *Klassizistische Statuen,* Mainz, 1974, 4–5.

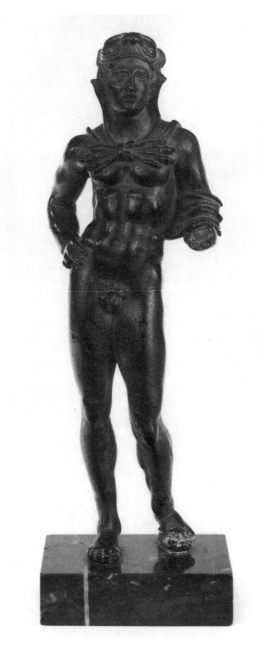

32 *Hercules Standing at Rest* Late 3rd–early 2nd century B.C.

Etruscan

Bronze; black patina. 24 cm.

Collection of James Coats, Courtesy of Yale University Art Gallery

Hercules, nude, stands with his weight on his right foot (restored from above ankle), right hand on hip. His left hand, extended, once held something, perhaps an apple or a bow, but not, apparently, a club. He wears the lion skin as a headdress, his face framed by the jaws of the lion, its paws tied across his chest. Orig-

inally a separately cast additional piece attached to the lion skin hung down from the figure's left arm.

The figurine is a votive bronze of the kind found in excavations of the Latin colony of Carseoli (Carsòli), founded 298 B.C. in the Abruzzi. Several of these votive bronzes followed Greek types, including a nude Hercules, wearing a lion skin "that hangs, napkin-like, over his outstretched left forearm." A piece similar to this bronze shows Hercules wearing the lion's mask as a hood, with the forepaws knotted around the hero's neck and the rest of the skin wrapped around his left arm (Florence, Museo Archeologico, Richardson, pl. XLVIIa). In the Coats bronze the archaic bearded Hercules of Polykleitan proportions has been replaced by an elongated lean and sinewy figure based on a Lysippan prototype and posed in a pronounced swinging contrapposto that became characteristic of Etruscan art. In the last two centuries of the Roman Republic, striding or lunging Hercules figures related to this type became the commonest of all votive figures, found in Spain and Gaul as well as central Italy.

This bronze, while clearly belonging to the class of Etruscan votive statuettes, is an uncommonly fine example, showing greater concern for and competence in rendering anatomy than was found in Etruria in the Classical period. A closely parallel piece exists in the Badisches Landesmuseum, Karlsruhe (Mitten). The back view is especially beautiful, showing an S-curve rising from the left heel through the right hip, compensated for by the raised left shoulder and echoed by the counter curve in the lion skin's spine. Michelangelo's known interest in Etruscan art suggests the possibility of his familiarity with statuettes like this one in which the Lysippan exaggerated contrapposto is adapted to a native Italic style. Such a work might have figured among the sources for his lost Hercules of 1492–94.

Ex collection: Kervorkian Foundation.
References (unpublished): Bieber, *Hellenistic Sc.,* 31–32 (Lysippan canon); E. H. Richardson, *The Etruscans, Their Art and Civilization*[2], Chicago and London, 1976, 158–159; Yale University Art Gallery file on the *Hercules,* information supplied by D. Mitten; conversation with Susan Matheson, Associate Curator of Ancient Art, Yale University Art Gallery.

33 *Nude Man Standing beside a High Pedestal*
 c. 1475–c. 1510

Bartolomeo Montagna (Near Brescia or Vicenza
c. 1450/Vicenza 1523)

Drawing; brush and black pigment on faded blue-gray
paper, heightened with cream white. Inscription in pen
and brown ink, lower center: 21; lower right: vene.
40 × 25.8 cm.

The Pierpont Morgan Library, New York, Gift of a
Trustee (1974.1)

Renaissance study of the male nude in repose in
which a live model is posed after the antique could
hardly be better illustrated than by this supremely
beautiful drawing. The youth's athletic build is muscu-
lar. His bony shoulders, hands and feet, and his sinewy
neck are probably based upon an individual model.
The technique of the drawing is deliberate and
finished, with the forms of the nude built up in care-
fully modulated areas of short parallel strokes. Greater
relief is added by the heightening, with strongest ef-
fects in the elaborately articulated, complex folds of the
drapery. The multiple twists, hooks and cul-de-sacs
testify to the effect of Verrocchio shop drapery studies
on north Italian artists after the mid to late 1480s when
Verrocchio's presence in Venice was felt.

The grapes spilling over the top of the wand or thyr-
sus, with a palm attached, were noted by Bean and
Stampfle as having Dionysiac associations hard to re-
concile with the "ascetic severity" of the figure, which,
indeed, reminds one more of a Venetian Saint Sebas-
tian than of a Bacchus figure. The antique cross-legged
stance that the pose re-creates, however, was probably
most frequently encountered on Bacchic sarcophagi,
though with the arm corresponding to the crossed leg
raised and bent at the elbow, with the hand resting on
the head. In the drawing the concentration of expres-
sion and feeling in the face leads one to postulate a
single figure rather than a sarcophagus relief as a pro-
totype. In fact, so many aspects of the pose and overall
elegiac mood are shared with *Hercules Resting after the
Fight with the Lion* (93) that a common source is not out
of the question, despite the fact that the musculature of
Hercules is richer and more detailed, as befits a deified
hero.

The *Nude Man Standing beside a High Pedestal* is as-
cribed to Montagna because of the figure's re-
semblance to St. Sebastian in the artist's *Madonna and
Saints* in Bergamo (Accademia Carrara, ill. Puppi, pl.
17). Its style may also be linked to the *Standing Figure of
a Woman* exhibited at Burlington House (1930, no. 180)
whose monumental sculptural presence combined
with pensive gravity in an out-of-doors setting are
reminiscent of the Morgan sheet.

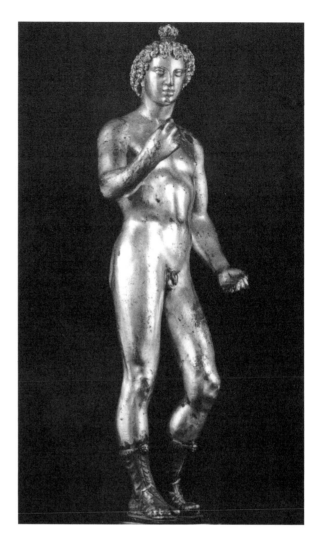

34

Ex collections: Count Erizza Minervi; private collection,
New York.
Exhibitions: Bean and Stampfle, *N. Y. Collections,* I, no.
14; The Pierpont Morgan Library, *Gifts in Honor of the
Fiftieth Anniversary,* N. Y., 1974, 42–43; Los Angeles
County Museum of Art, *Old Master Drawings from
American Collections,* April 29–June 13, 1976, cat. by E.
Feinblatt, no. 38.
References: Royal Academy, Burlington House, *Italian
Drawings,* London, 1930, 50, no. 180, pl. cliii; L. Puppi,
Bartolomeo Montagna, Venice, 1962, pl. 17; Pierpont
Morgan Library, *Seventeenth Report to the Fellows of
the Pierpont Morgan Library, 1972–1974,* ed. C. Rys-
kamp, N. Y., 1976, 145, 174, pl. 13.

34 *Paris* or *Hercules* 16th century

North Italy

Gilt bronze, silvered boots. 17.7 cm.

Museum of Art, Rhode Island School of Design, Gift of Mrs. Murray S. Danforth (73.079)

Like the Louvre *Athlete* (30) this small bronze represents an athletically built nude standing man. The figure has been conceived as a study in contrapposto and symmetry in Pliny's sense of balanced proportion. The weight is carried on the right leg, with hip thrust out, balanced by the lowered left hip and arm. The lowering of the relaxed left thigh prompts the raised right hand and the turn of the head to the figure's right.

The body's proportions are more slender and less foursquare than in the bronze version of Polykleitos's *Athlete Making a Libation* (30) and the distribution of weight on one leg is less pronounced, with the relaxed leg carrying some of the body's weight. The quality of repose is thereby enlivened by a hint of ongoing movement. This aspect of the statuette suggests that the artist knew a Lysippan figure with a more sinuous contrapposto, perhaps a *Hercules* something like the *Hercules Standing at Rest* (32). The sculptor has achieved a pleasing supple flow in the modeling of the lithe torso, where the lack of emphasis on strongly-patterned anatomical divisions such as the inguinal boundary and sternum also recalls Lysippan rather than Polykleitan ideal types (cf. also 31). One could legitimately ask whether knowledge of Mannerist works would not have been a necessary precondition for a style of such smoothly flowing planar articulations. In this case the statuette's date ought to be advanced to later in the century (Holderbaum).

A beautiful life-sized bronze statue of a nude youth with both arms uplifted in prayer (Staatliche Museen, East Berlin), possibly the *Adorante* by one of Lysippos's sons, Boedas, recorded by Pliny (*Nat. Hist.* 34, 73), is documented as having been brought to Venice from Rhodes in the summer or early autumn of 1503. It was later recognized by Lorenzo da Pavia, Pietro Aretino and Enea Vico, all extremely well-informed connoisseurs, as one of the greatest antique bronzes extant. In the stance of that extraordinary work (Bieber, fig. 93), the ankles are close together, the weight is borne mainly on one leg but also slightly on the other, and the symmetries are worked out so as to generate a current or flow of movement up through the body. The *Adorante's* ponderation and remarkable suppleness, achieved through lifelike and subtle modeling (praised in lascivious terms by Aretino, see Perry, 207), raise the question whether the sculptor of the present bronze might have seen it. There are, to be sure, obvious differences in the poses: the positioning of the arms as well as the absence in the Renaissance work of the true Lysippan canon embodied in the Berlin bronze. Another possible prototype, also not reproduced literally, is the source reproduced in the Lubin Collection *Narcissus* or *Bacchus* (Bober, Fig. 8).

The gestures of the statuette imply missing attributes. If the figure held the apples of the Hesperides then Hercules is represented. But if the figure is a Paris, accompanied originally by statuettes of Minerva, Juno and Venus to form a *Judgment of Paris* group, the left hand could have held an apple and the right hand a ring in a fashion similar to Antico's *Paris* (89; though unlike 89 a standing rather than a seated pose has been chosen). The topknot could then be explained as an exaggeration of the hairstyle worn by Antico's *Paris*. The statuette may equally well have been made quite independently of Antico's work, especially if the iconography of Paris with apple and ring was at some point widespread. In any case, the figure's topknot ought to be considered a reflection of the luxuriant one on the *Apollo Belvedere* (cf. 53, 55).

Ex collection: Mrs. Murray Danforth, 1973.
References: Bieber, *Hellenistic Sc.,* 39f.; P. Bober, "The Census of Antique Works of Art Known to Renaissance Artists," *Acts of the 20th International Congress of History of Art, The Renaissance and Mannerism,* Princeton, 1963, 82–89; L. Franzoni, *Verona: La Galleria Bevilacqua,* Milan [1970], 111–123 and notes; C. M. Brown, "Giovanni Bellini and Art Collecting," *BM,* 114 (1972), 404; M. Perry, "A Greek Bronze in Renaissance Venice," *BM,* 117 (1975), 204–211; J. Holderbaum, personal communication, April, 1978.

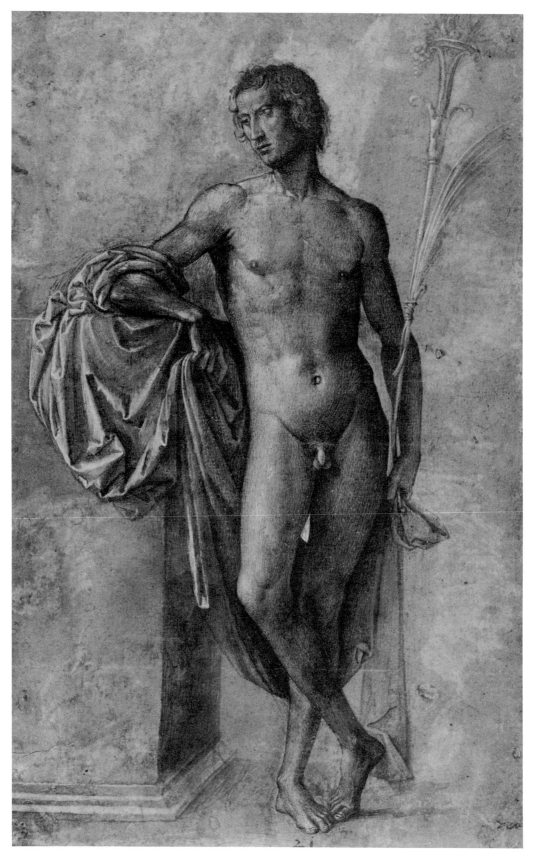

33

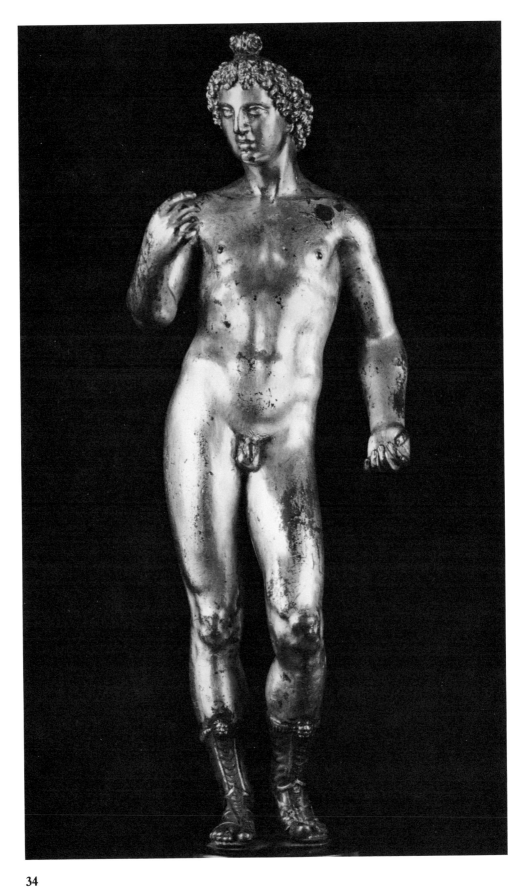

35 *Man with an Arrow* c. 1508(?)

Benedetto Montagna (Vicenza c. 1480/1555–58)

Engraving; H. 5, 180, 15(II/III). Signature on cartellino: Benedeto Montagna. 21.3 × 14.7 cm.

The Art Institute of Chicago, Mr. and Mrs. Potter Palmer Collection (1956.1035 R8950)

In their study of the ideal human figure, some artists continued to rely on Polykleitan types even after 1500, despite the by then widespread influence of more active Hellenistic types such as the *Apollo Belvedere*. Montagna's engraving, probably intended to represent Apollo, demonstrates the importance of Tullio Lombardo's *Adam* (Metropolitan Museum) in promoting this continuing interest. The body's smooth, hard surfaces tend to suggest marble rather than flesh: note the sharply defined planes that sometimes meet in angular ridges, as along the shin bones, and abstractly handled anatomical features, as in the torso. The head especially, with its thick curls and tilt to one side imparting a dreamy and somewhat melancholy expression, points to the *Adam* as a source. The figure's contrapposto, however, is more animated than the *Adam*'s, the engaged hip being given a rounder contour and greater outward thrust (cf. 34). The unnaturally elevated lines connecting the neck to the shoulders seem to be derived from Dürer's and Jacopo de' Barbari's female nudes (see 37a). Dürer's engraved works are believed to have provided Benedetto with his major source of technical knowledge as an engraver (Sheehan); this engraving demonstrates the relationship by its use of curved modeling lines for the nude and crisp, convoluted drapery folds on either side.

Compared to his father's drawing of a *Nude Man Standing Beside a High Pedestal* (33), Benedetto's Apollo betrays its alienation from the late quattrocento practice of close observation of nature. The *Man with an Arrow* does not appear to include the features of a posed model; all its forms were discovered in other works of art. The resulting image of a man, while embodying Classic proportions and symmetry, appears somewhat drily classicistic when confronted with the slightly earlier ideal type (33) in which an ancient prototype is blended with the features of a living model.

Ex collection: Mr. and Mrs. Potter Palmer, 1956.
References: Hind, 5, 180, 15; J. Sheehan, "Benedetto Montagna," a summary of the artist's career, in Levenson, Oberhuber and Sheehan, 307–311.

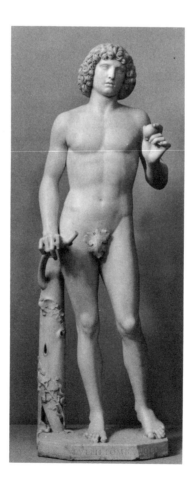

35 (supplement)
Tullio Lombardo
Adam, c. 1490–93
Carrara marble.
The Metropolitan Museum
of Art, New York.

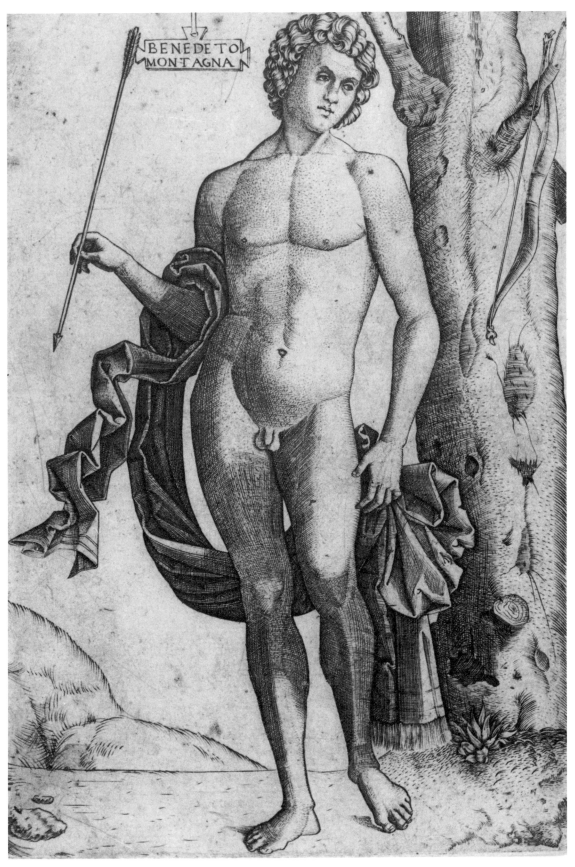

35

36 *Aphrodite* 125–100 B.C.

Hellenistic

Bronze (hollow cast?); pupils of eyes and lower ribbon binding hair originally silvered, lips originally inlaid with copper; shiny, dark green patina. 47 × 24 cm.

Museum of Art, Rhode Island School of Design, Museum Appropriation and Special Gifts (26.117)

At least some masterpieces of Greek sculpture described by ancient writers were available to the Renaissance in the form of bronze statuettes. Pliny's account of Praxiteles mentions an *Aphrodite Pseliumene* (putting on a bracelet or necklace; *Nat. Hist.*, 34, 69). This beautiful bronze Aphrodite, probably a late-second-century B.C. adaptation of a fourth-century B.C. prototype, is shown in the act of tying a fillet around her hair (the position of her left arm, restored from just below the shoulder, is probably incorrect). It could easily have been associated in the Renaissance with the Praxitelean *Aphrodite,* as it is today. The female nude with both arms uplifted was also commonly associated with one of the most famous paintings of antiquity, Apelles' *Venus Anadyomene* or Venus rising from the sea.

The high quality of this relatively large statuette allows it to communicate to a great extent the proportions, pose and sensuous surface modeling of the life-sized bronze original. In this respect it is comparable to the bronze Polykleitan *Athlete Making a Libation* (30). The combination of clear structural articulation and sensuous fluidity found in this *Aphrodite* was highly valued by artists of the High Renaissance. In its stance the effects of the body's weight borne on the right foot (incorrectly restored with the heel slightly raised) are clearly articulated in the upward and outward thrust of the right hip and the raised left shoulder. At the same time "the surface modeling of the torso achieves extraordinary nuances of sensuous detail, approaching that visible in the Aphrodite from Cyrene" (Mitten, 68).

Although the provenance of the Providence bronze is unclear, it may have come from Pompeii or Herculaneum, in which case this particular work would not have been known to Renaissance artists. The type has survived in at least four other bronzes, so that Renaissance artists may well have been familiar with it in some form. The interest of Venetian sculptors in antique Venus prototypes began with Antonio Rizzo (active from 1465 or before, d. c. 1500) and Tullio Lombardo (see 37a, 38). Influence of late Hellenistic types with upraised arms and wearing drapery that slips off the body appears in Venice as early as c. 1507. It is reflected in Marcantonio Raimondi's *Grammatica* (B. 383), probably engraved while the artist was still there. Riccio's design for the *Venus Chastising Cupid* plaquette (41) also presupposes a Venus *Pseliumene* or *Anadyomene.*

Ex collections: Prince Belosselski-Belosorski, Leningrad; Dr. von Frey, Vienna.

Exhibitions: Detroit, Detroit Institute of Arts, *An Exhibition of Small Bronzes of the Ancient World,* March 23–May 18, 1947; Smith College Museum of Art, *Pompeiana,* November 18–December 15, 1948.

Reference: Museum of Art, Rhode Island School of Design, *Classical Bronzes,* cat. by D. G. Mitten, Providence, 1975, 66–76, no. 20.

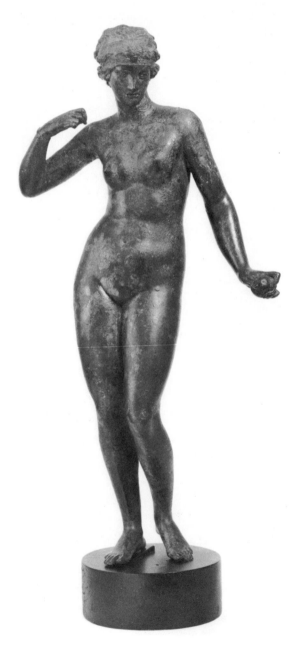

36

37 *Venus* c. 1480–1500

Attributed to Andrea Riccio (Padua 1470–75/
Padua 1532)

Bronze (hollow cast); brown patina. 26 × 8.4 ×
5.7 cm.

Ashmolean Museum, Oxford (Fortnum 411)

Renaissance knowledge of the fame in antiquity of
Praxiteles' Cnidean *Venus* was acquired through
Pliny's account of its great beauty (*Nat. Hist.* 36,
20–22) and Lucian's sharply observed description of
the radiance and lifelike, expressive quality of the
statue's face (*Imagines*, 6). Both authors note the
work's unique nudity. The purity of conception and
technical finesse of this Renaissance *Venus*, as shown
for example in the exquisitely worked details of the
hair, face and drapery, reveal the mind and hand of a
master of the first rank. He would not have been un-
aware of these literary references to one of the most
formally and psychologically powerful of all antique
sculptures.

At the end of the fifteenth century, the number of
works in marble from which an idea of Praxiteles'
goddess might be gleaned seems to have been small,
and those were of a quality far removed from the orig-
inal. The Capitoline and Medici Venuses were not yet
known. The partially draped Venus type, known from
antiques like the fragment illustrated in Giovanni An-
tonio da Brescia's engraving H. 5, 41, 14 (see 37 suppl.)
was obviously closely related. At least one example of
the nude *Venus pudica* type must have existed in Rome,
however, since, in his only drawing to record a free-
standing statue rather than a relief, Gentile da Fabriano
depicted it (Degenhart and Schmitt, *Zeichnungen*, 1,
245, no. 134, ill. 3, pl. 177a). One marble of the par-
tially draped type was known to sculptors at the be-
ginning of the sixteenth century: the so-called *Venus
Felix*, well over six feet tall. In it the Praxitelean type
had been converted into a portrait, traditionally iden-
tified as Faustina the Younger (Helbig, 1, 241). The
Venus Felix, possibly owned by Julius II while still a
cardinal, and displayed in the Vatican Belvedere by
1510, was known in north Italy through Antico's
bronze replica (most elaborate exemplar in Vienna,
Kunsthistorisches Museum) and, later, through draw-
ings like Amico Aspertini's (London I, f. 15r).

Small-scale bronzes like the Metropolitan Museum's
late Hellenistic Cnidean *Aphrodite* (No. 12173, h. 20⅜
in., ill. Bieber, figs. 26 and 27) were more numerous
and would more easily have served as models for a
work like the Ashmolean bronze. A similar Venus
with left arm raised slightly is shown on a shelf in Car-
paccio's *St. Augustine in His Study* (Venice, Scuola di S.
Giorgio degli Schiavoni, ill. *EWA*, 3, pl. 71).

The Ashmolean *Venus*, like Antico's *Venus Felix*, is
partially clad, with elegant drapery around the legs. Its
slender figure is closely akin to Antonio Rizzo's life-
sized marble *Eve* (Venice, Palazzo Ducale), itself an
austere quattrocento version of a *Venus pudica* (via

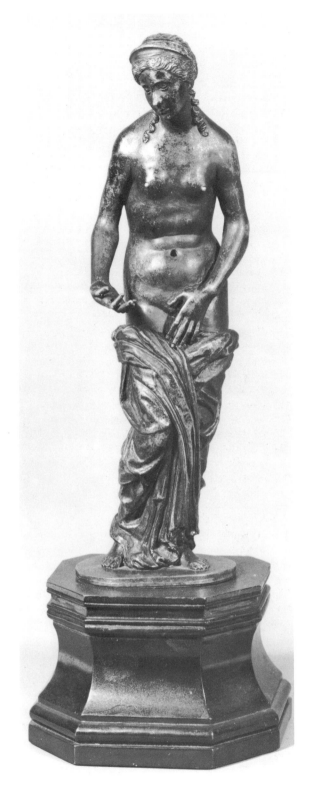

37

Jacopo Bellini's drawing [British Museum sketchbook,
fol. 43] ?). Rizzo's *Eve* (c. 1480–85) had established this
type as the ideal female nude in Venice. Later, under
the influence of Jacopo de' Barbari's and Dürer's en-

gravings beginning in the 1490s (49, 51), the nude took on greater amplitude with unnaturally sloping shoulders (37a).

The present *Venus* shares with the *Venus Felix* the twin corkscrew curls, one falling on each shoulder, often found in north Italian *all'antica* images of ideal beauty (38, 68). However, they differ in that the left hand of the Ashmolean *Venus*, instead of holding drapery, covers the body in what has frequently been interpreted as an instinctive gesture of modesty invented by Praxiteles for the marble destined for Cnidos. In the *Venus Felix*, the pronounced turn of the head, with glance focused outside itself as if the goddess had been interrupted by an intruder, is characteristic of post-Praxitelean versions of the Cnidean *Venus* such as the Capitoline and Medici Venuses. This feature of later versions of Praxiteles' work has often been criticized for depriving the image of its divine dignity and lending it a kind of coyness. In the bronze, on the other hand, Venus's gaze is directed down and to her right, in a manner that recalls Polykleitan *Athletes* (30, 31). The statue's outline and attitude thus become more self-contained, thereby recapturing something of the original model's serenity and detachment. The freshness of conception evident in the work's individualistic approach to an antique model suggests a relatively early date, perhaps pre-1490.

The open right hand was no doubt intended to hold an attribute. A statuette closely related in its origin to this *Venus* (formerly Pierpont Morgan coll.) holds an apple in the lowered right hand. The face, despite a strong generic resemblance of the head, as in the hair and fillet, to Bartolommeo Bellano's *Europa* (Florence, Museo Nazionale; ill. Amsterdam, Rijksmuseum, *Meesters van het brons*, fig. 32), evidently records a live model rather than an antique. *Venus* was once attributed to Bellano, Riccio's teacher (Bode), but it now seems more reasonable to give it to Riccio himself as an early work, in which Bellano's experimental naturalism has been transformed into "classical naturalism" by means of a deepened understanding of ancient models. Hermann postulated an unnamed artist close to Antico in his investigation of antique models as the artist of this statuette and grouped a number of related bronzes under the general rubric of Padua or Venice at the turn of the sixteenth century.

Ex collections: [Dealer, Bologna, 1851]; C. D. E. Fortnum, 1899.
References: Bode, 1, 22, 36 (attrib. Bellano); W. von Bode, *Bronzes of the Renaissance,* cat. of the collection of J. Pierpont Morgan, 1, Paris, 1910, XIII, no. 23, pl. XX, tentative attr. to Bellano of a variant of the Ashmolean *Venus* ("Many partially draped examples of this little bronze exist; the best is in the Ashmolean Museum"); H. Stuart Jones, *A Catalogue of the Ancient Sculptures Preserved in the Municipal Collections of Rome, The Sculptures of the Musei Capitolini,* Oxford, 1912, 182–184 (Capitoline *Venus*); W. von Bode, *Die italienischen Bronzestatuetten der Renaissance*[2], Berlin, 1922, 27 (as Bellano?), pl. 19; Berlin, Staatliche Museen, *Die italienischen Bildwerke der Renaissance und des Barock, 2, Bronzestatuetten, Büsten und Gebrauchsgegenstände,* cat. by W. von Bode, Berlin, Leipzig, 1930, 12, no. 50. Bode catalogues a bronze Venus, h. 24.4 cm., nearly identical to the Ashmolean *Venus* except that the right arm is raised. The Ashmolean and Pierpont Morgan examples are named and an antique *Venus,* Venice, Museo Archeologico inv. 61, is suggested as a likely antique source for this Renaissance statuette type (G. Pellegrini, *Descrizione della sezione classica del R. Museo archeologico di Venezia,* plate vol. only published, Venice, Schio, 1911, pl. LIX (ill.); C. Anti, *Il Regio Museo Archeologico,* Rome, 1930, 153). This antique, though it combines the *Venus pudica* and partially draped types as the statuettes do (though its alien third-century B.C. head differs somewhat from theirs) did not enter the Venetian collection before the 1586 Grimani bequest (Anti). Its uncertain whereabouts prior to that time, very likely in Rome during the early years of the century at least, renders its candidacy as the Bellano-Riccio model in this case rather weak; Hind, 6, pl. 536 (ill. of Giovanni Antonio da Brescia's *Venus*); Bober, *Aspertini,* 60 (Aspertini drawing of *Venus Felix*); Pope-Hennessy, *IRS,* 347f. (Antico, *Venus Felix*); Bieber, *Hellenistic Sc.,* 19f. (Praxiteles' Cnidean *Venus* and related types, especially fig. 26, Metropolitan bronze statuette); Helbig, 1, 149, no. 207 (Cnidean *Venus,* H. von Steuben), 186, no. 241 (*Venus with the Head of Faustina the Younger*); Brummer, *Statue Court,* 122–127.

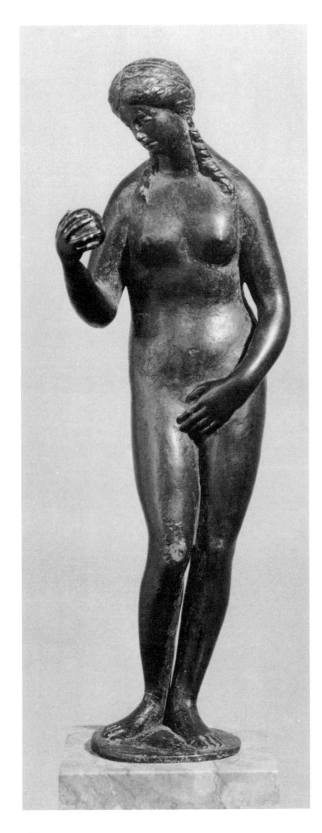

37a

37a *Venus* First half of 16th century

Venice

Bronze, partly gilt. 26.1 cm.

Staatliche Museen Preussischer Kulturbesitz, Skulpturengalerie (Inv. Nr. 2395)

The *Venus* from Berlin, like the one from the Ashmolean, stands in a pose related to the antique *Venus pudica*. She gazes intently at the sphere held in her right hand, as if it were a mirror. Her hair is stylized as a heavy cap over which incised lines inscribe a standard Hellenistic hairstyle, with the two corkscrew curls (see 37, 38) reminiscent of marine Venuses.

Life-sized marble figures of Eve holding an apple, also based on antique Venus prototypes, by Antonio Rizzo (Venice, Palazzo Ducale) and Tullio Lombardo (Venice, formerly Church of Santi Giovanni e Paolo, Vendramin monument; now lost) spawned this figure type, in which the apple now became an object of contemplation, the attribute of an allegorized Venus. Some of these antique-derived forms were imbued with Christian meaning (see 38); other allegories referred to secular themes like *Vanitas*.

The statuette of *Chastity* attributed to Bartolommeo Bellano (Basel, Kunstgewerbe Museum, Bode, pl. 19) is close to this *Venus* and may have provided its model. But the later artist, in bringing the legs and heels together and placing the feet at oblique angles, gives to the figure a sustained, slowly-rising curve that lightens her stately proportions and helps generate the subsidiary curves of the arms and head. *Venus's* face betrays a girlishness and sweetness that suggests certain of Jacopo de' Barbari's faces as possible sources and, more generally, Venice as the probable area of origin. One could imagine this *Venus* as an early work by Antonio Lombardo, or as closely related to one. The approach to antiquity in the work is too generalized and too greatly influenced by Venetian contemporary *all'antica* types to be a product of Antico's classicism (cf. 68, 89).

The type of allegorized Venus exemplified here eventually became *Venus-Vanitas,* as employed for example in the paintings of northerners like Jan Gossaert (known as Mabuse). In his Rovigo *Venus,* Gossaert combines the Chastity-Prudence associations of the Bellano statuette with a paradoxical and erotic image in which the still-life of Mars's discarded armor and Cupid's arrows alludes both to the Triumph and the Vanity of Love.

Ex collection: Von Sallet, Berlin.
References: W. von Bode, *Die italienischen Bronzestatuetten der Renaissance*[2], Berlin, 1922; Berlin, Staatliche Museen, *Die italienischen Bildwerke der Renaissance und des Barock,* 2, W. von Bode, *Bronzestatuetten, Büsten und Gebrauchsgegenstände*[4], Berlin, 1930, 22, no. 102.

38 *Venus Prudentia* or *Caritas* 1500–1520

Attributed to Tullio Lombardo (Venice? c. 1455/ Venice 1532)

Gilt bronze (hollow cast). 18.3 cm.

The Cleveland Museum of Art, John L. Severance Fund (48.171)

During the late 1480s Tullio Lombardo became a leader in the Venetian antique revival. He seems to have gained a clearer idea of the variety of antique styles and sculptural types than most contemporary artists. Having familiarized himself with the multiple antique sources transmitted by the work of Jacopo Bellini and Andrea Mantegna as a youth in Padua, he attempted re-creations in a number of Hellenistic and Roman modes. At the same time, Tullio's awareness of High Classic art is evident from his use of Polykleitos's *Doryphoros* as a basis for his most famous work, the *Adam* from the Vendramin Tomb (Metropolitan Musem). The *Doryphoros* was famous in the literary sources not only as a canon of ideal beauty but also as the first fully classical treatment of contrapposto. In Tullio's marble *Adam,* carved between 1490 and 1493, he adopted this stance as the one best befitting an image of human perfection in which the ideas of Adam as the first man and Christ the Savior of mankind were fused. The *Adam* is a study of the male body in equilibrium, rendered with the kind of consciousness of the issues posed and resolved by its classical source that makes the result appear neo-classical. It represents the culmination of two independent strands of development, the first being the quattrocento study of contrapposto, in which the weight displacements and axes through the figure remained predominantly two-dimensional, and the second, the Venetian antique revival. Because of its geographical position and cultural and mercantile connections, a much stronger interest in and awareness of the Greek component in antique art existed in Venice than elsewhere in Italy.

Comparable analysis of statics, or the balance of opposing weights, is applied to the female body in this bronze statuette, although the sinuously curving right hip and slight torsion to the body's right allow the figure greater animation than the *Adam.* If not directly from Tullio's hand, the *Venus* is wholly dependent on his ideas and approach. No single antique Venus type, such as a *Venus pudica* (cf. 37, 37a), has served as a model. Instead, a generalized interpretation of various antique Venuses stands behind it (cf. 19, 36). A long, small-breasted torso like that of 36 is combined with positions of the arms and hands that Tullio, familiar as he was with some exemplar, might have derived from the *Doryphoros.*

Here Venus is presented as an allegory of Virtue. Perhaps Charity rather than Prudence was intended. The crown (Charity was often presented as the Queen of Virtues) and flaming lamp held in the left hand were attributes linked to Charity in Venice. These associations stand behind Titian's image of "Sacred Love." Another attribute was once held in the figure's right hand. The luxurious mass of hair pulled back in parallel waves was familiar from a number of Hellenistic and Roman female head types (cf. 68, 107). Its arrangement in two symmetrical locks falling on the shoulders recalls images of Venus in the context of marine iconography. The tilted head, with large, expressive eyes, Hellenic nose and parted lips was a combination pioneered by Tullio in two *Double Portraits all'antica* of the 1490s (Cà d'Oro and Vienna). They impart a dreamy, distracted expression to the face (cf. 68 and detail of 118). The sensuous, individualized quality of the head contrasts with the somewhat more abstract body in a way reminiscent of the *Adam.*

Weihrauch tentatively attributed this beautiful bronze to Tullio on the basis of similarities to other works given to him. Tullio's documented connections with sculpture in bronze do not offer much support to the notion that he worked in the medium very frequently. His brother Antonio, on the other hand, made the model for a life-sized bronze *Madonna and Child* for the altar of a memorial chapel to Cardinal Zen in St. Mark's (1501–6). Antonio's style in bronze of 1512 is wonderfully documented by his *Allegory of Peace* (107). The *Venus Caritas,* with its simultaneous hint of girlish awkwardness and sensuous charm, is from a later period than that represented by Tullio's *Adam* or the stately and grave Ashmolean *Venus* (37).

Ex collections: J. P. Heseltine, London; Dr. Ernö Wittmann, Budapest; [R. Stora & Co., New York, 1948].

Exhibitions: Columbus Gallery of Fine Arts, *The Renaissance Image of Man and the World,* Columbus, Ohio, 1961 (no catalogue); Cleveland, *Ohio Bronzes,* 109.

Reference: Weihrauch, *Bronzestatuetten,* 129, fig. 145 (Tullio Lombardo [?]).

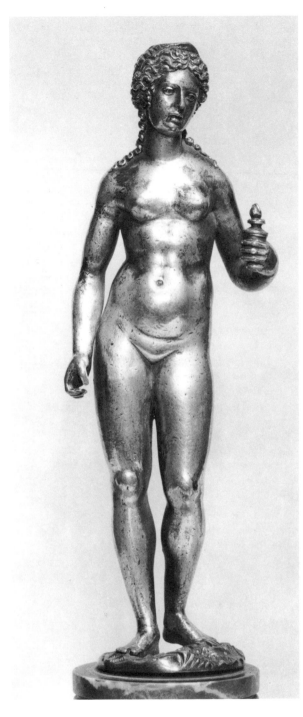

38

39 *A Female Figure* Second half of 15th century
Circle of Filippo Lippi (Florence c. 1406/Spoleto 1469)
Drawing; pen and brown ink, wash, on blue paper, heightened with white. 25.2 × 11.5 cm.
Fogg Art Museum, Harvard University, Cambridge, Gift of the Honorable and Mrs. Robert Woods Bliss (1936.118)

Filippo Lippi was one of the first painters in the Italian quattrocento to adopt a mode of costume *all'antica*. Lippi's influence is apparent in this drawing of a classically draped female figure pointing upward and standing beside a garland-covered sarcophagus (cf. 33). The head corresponds closely with his wide faces and their large eyes (found, for example, in the *Coronation of the Virgin*, Florence, Uffizi, ill. with detail, *EWA*, IX, pl. 142).

A sleeveless chiton is fastened at the left shoulder and belted high under the breasts, following a fashion not established in antique dress before the fourth century B.C. A loose overlapping fold at the neckline reproduces a detail characteristic of many antique female figures. The chiton should have been extended below the mantle's lower edge, where the figure's legs and bare feet are only tentatively suggested by faint outlines and schematic parallel hatching. This suggests that the basic forms of Greek costume are not completely understood, although they are rendered more accurately than, for example, in the *Tarocchi Muses* by the E-series Master (12, 13). The artist is not only interested in recording elements of antique costume but also explores drapery as a potentially powerful means of plastic expression, as Donatello had done in major sculptural works beginning in the 1420s.

Assuming the sheet was made in Florence, the technique of white highlights used in the drawing can only be judged as tentative in comparison to the systematic exploration of chiaroscural values in drapery studies emanating from Verrocchio's workshop in the 1470s. A date for the Fogg study somewhat earlier, perhaps the mid 1460s or earlier, thus seems feasible. Berenson dated it as early as c. 1440. Agnes Mongan preferred to locate the drawing in north Italy (Ferrara), because the blue paper is not especially characteristic of Florence. Attribution to a particular Emilian artist has not been attempted.

Ex collection: Henry Oppenheimer.
Exhibitions: London, Royal Academy of Arts, Burlington House, "Exhibition of Italian Art, 1200–1900," 1930, no. 433 (tentatively attr. to Filippo Lippi); Lawrence University, *Drawing Before 1800*, Jan. 7–Feb. 21, 1968, no. 2.
References: B. Berenson, *The Drawings of the Florentine Painters*, 3 vols., Chicago, 1938, 2, 156, no. 1384A; 3, fig. 170 (attr. to Filippo Lippi); Mongan and Sachs, *Fogg Drawings*, 1, 10, no. 9; 2, fig. 10.

40 *Madonna and Child* c. 1527

Jacopo Tatti, called Sansovino (Florence 1486/Venice 1570)

Bronze (hollow cast); black lacquer patina worn to natural brown patina on some extremities. Signature across front of base: IACOBVS SANSOV. 47.6 cm.

The Cleveland Museum of Art, John L. Severance Fund (51.316)

Antique ideals of beauty began to influence representations of the Madonna in more easily recognizable fashion by the early fifteenth century. About a hundred years later the use of antique prototypes became even more direct, and images of the Virgin in marble then assumed a deliberately neoclassic appearance (Andrea Sansovino's *Virgin and Child with St. Anne,* Rome, S. Agostino, 1512).

Jacopo (Tatti) Sansovino entered the workshop of Andrea Sansovino in 1502, and in 1505–6 he followed his teacher, whose name he had assumed, to Rome. His *Madonna del Parto* (S. Agostino, 1518–20) continued the trend toward neoclassicism. The head was perhaps based on a portrait of Agrippina (Pope-Hennessy); Wixom associated it with a gem like the lapis lazuli head of Livia reused on the Herimann crucifix in Cologne (Cleveland, *Ohio Bronzes*) but Sansovino more probably would have used a monumental prototype, at least for the marble group.

This bronze Madonna stands in an understated contrapposto pose of utmost fluidity and naturalness, her weight borne on her hidden left leg. Her right leg, bent at the knee, forms a support for the Christ Child. A veil covers the back of her head. In front her wavy hair is parted in the middle and drawn back, with two locks falling forward across her shoulders in a style familiar from a number of phases of antique art. A heavy mantle is fastened to her long-sleeved chiton by two round fibulae, one corner pulled forward over her left hip, the other gathered beneath her right wrist. She holds the Christ Child with both hands as he blesses; both mother and child look to the left.

The bronze closely resembles the marble *Virgin and Child* of c. 1527 carved for the tomb of Gelasio Nichesola in Verona cathedral. Wixom disputes the idea that the bronze derives from the marble (Weihrauch) because the nature of the signature, lacking in many variants, and the high quality of the work's facture indicate its primacy. De Liphart had suggested (1922) that the wax model for the bronze was the *modello* for the marble statuette (Cleveland, *Ohio Bronzes*). There are too many differences, however, to permit this interpretation. The greater softness and sensitivity of the bronze is a predictable result of the malleable medium. Weihrauch correctly interpreted the work as Sansovino's response, upon arriving in Venice, to Donatello's monumental bronze *Madonna and Child* and *Saint Justina* on the high altar of the Santo, Padua (1446–50), works of "unaccustomed quiescence" and "lyric subtlety" (Janson) that mark an unusually classical moment in Donatello's oeuvre.

Ex collections: The Hermitage, Leningrad; Baron Heinrich Thyssen-Bornemiza, Lugano; [Adolph Loewi, Los Angeles, 1951].

Exhibitions: Cleveland, *The Venetian Tradition,* 1956, no. 80; Wildenstein, *Italian Heritage,* no. 48; E. P. Pillsbury, *Florence and the Arts: Five Centuries of Patronage, Florentine Art in Cleveland Collections,* Cleveland, 1971, no. 35; Cleveland, *Ohio Bronzes,* 112 (Wixom entry includes list of variants and basic bibliography).

References: H. R. Weihrauch, *Studien zum bildnerischen Werke des Jacopo Sansovino,* Strassburg, 1935, 34–35; Janson, *Donatello,* 183; Pope-Hennessy, *High Renaissance and Baroque,* 2, plates 48, 49; 3, 51–52.

41 *Venus Chastising Cupid* c. 1515–32

Andrea Riccio (Padua 1470–75/1532)

Bronze plaquette; clear lacquer over bright yellow-brown bronze with traces of brushed red-brown patination in center. 10.6 × 8.1 cm.

National Gallery of Art, Samuel H. Kress Collection, 1951 (A. 410 133B)

Toward the end of the first decade of the cinquecento, the female nude regarded as an ideal form became more animated. Increasing incorporation of movement into a standing figure corresponded with artists' growing mastery of the animated poses of late Hellenistic art. This change is apparent in the two representations of *Lucretia* (102, 103), as well as in Riccio's *Venus Chastising Cupid*.

In this small relief the subtle, sensitive modeling of the torso, limbs, and head of Venus reveal Riccio's study from nature. Riccio's strong yet fluent and graceful composition condenses the inherent grandeur of the statuesque nude Venus within the small scale of the plaquette medium without loss of classical monumentality. Presumably because of the sense of mastery demonstrated in this work, scholars have dated *Venus Chastising Cupid* late in Riccio's career. On the other hand, the closeness of Venus's pose to that of Titian's nude *Lucretia* (Hampton Court Palace), often dated c. 1520, but possibly a decade or so earlier, might suggest instead a date of 1510–20 for the plaquette.

The antique type that inspired the pose for Venus, whose right arm is sharply bent in an interrupted mo-

tion of striking Cupid, seems to have been a late Hellenistic version of the *Aphrodite Pseliumene* (see 36), in which the goddess lifts her right hand to the back of her head, allowing her mantle to glide off her shoulders, with a swinging contrapposto animating the body (example in Louvre, ill. in Bieber, *Hellenistic Sc.,* fig. 609). The two-figure composition might have been suggested to Riccio by a group like the *Aphrodite Anadyomene and Triton* in Dresden in which, despite the fragmentary state of the torso, Venus clearly lifts her right arm up and back in exactly the position of the arm on Riccio's Venus. The fishtailed Triton at lower right occupies a position analogous to Cupid's (ill. Lullies, figs. 43, 44). Pope-Hennessy called attention to a related plaquette, *Venus Forging the Arrows of Cupid* (National Gallery, Kress no. 211), in which the stance of Venus, although also derived from an antique model, is less animated than in the *Venus Chastising Cupid* plaquette. Maclagan had noted that Pomponius Gauricus, in *De sculptura* (1504), referred to a *Venus Chastising Cupid* by Pyrgoteles, the nickname of Giorgio Lascaris, a sculptor of Greek origin who worked with the Lombardi on Santa Maria dei Miracoli (cited by Pope-Hennessy).

Ex collections: Aynard, Lyons (sale Paris, December 1–4, 1913, no. 200); Gustave Dreyfus Collection; heirs of Dreyfus, 1914–33; [Duveen, 1933–45]; Samuel H. Kress Collection, 1945–51.

References: R. Lullies, *Die kauernde Aphrodite,* Munich, 1954; Pope-Hennessy, *Kress,* 63, no. 209, fig. 106; P. Gauricus, *De sculptura,* ed. A. Chastel and R. Klein, Geneva/Paris, 1969, 46, no. 36, 47, 254–255 and no. 28.

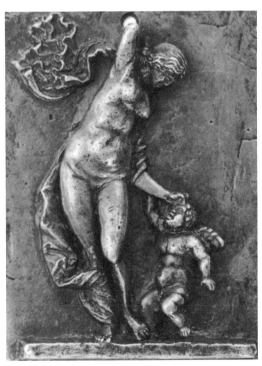

41

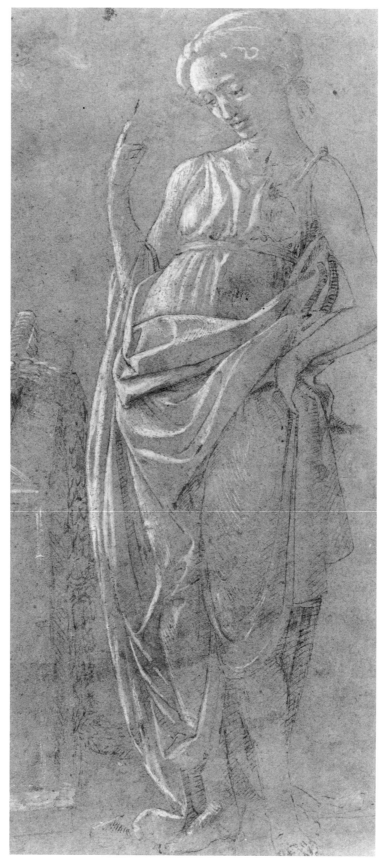

39

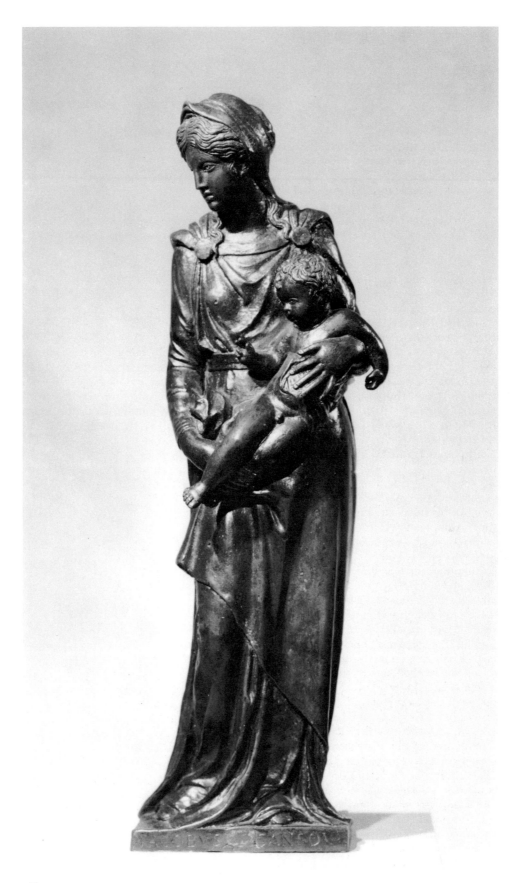

40

42 *Crouching Venus* Mid-16th century
Italy, Venice or Padua
Bronze (heavy hollow cast); brown, reddish-brown, and brassy-brown natural patina with traces of dark brown lacquer. 15.9 cm.
Private collection

This *Venus* exemplifies the practice, which became more popular as the sixteenth century advanced, of translating large-scale antique prototypes into small bronze replicas (see 24). Often the marbles copied were themselves replicas of bronzes. Ancient Roman marble copies of Greek bronzes generally transmitted only the broader aspects of anatomy and pose to Renaissance and later copyists, and so these aspects were a major part of what Renaissance artists had to work with in their distillations of antique figural inventions. Replicas such as the *Crouching Venus* played an important role in dispersing familiarity with the repertory of Hellenistic types that had been preserved by the ancient Romans, since by the later sixteenth century they were eagerly sought by collectors throughout Europe.

The prototype for the *Crouching Venus* is the mid-third-century B.C. bronze by Doidalsas of Bithnyia which was known through Roman copies in marble. Pliny's mention of Doidalsas's *Aphrodite Bathing Herself,* located in the portico of Octavia in Rome, could have been interpreted in the Renaissance as a reference to this work. Famous copies, noted by Wixom (Cleveland, *Ohio Bronzes,* 107), are from Hadrian's Villa (now in the Museo delle Terme, Rome) and from Vienna (now in the Louvre). In 1501–3, Leonardo had adapted this type in his initial drawings for the *Leda;* by mid-century Aldrovandi referred to an antique belonging to the type as a "Leda." Marcantonio Raimondi engraved a profile view of the statue with a restored Cupid alighting on a pedestal behind Venus (B. 14, 235, 313), and followers of Giovanni Bologna were responsible for numerous statuettes based on it. The figure's successful incorporation of forthright yet graceful movement within an essentially still and self-contained pose must have impressed Leonardo and the other creators of High Renaissance style. During the 1480–1505 period he worked out a newly energetic contrapposto stance later known as the *figura serpentinata,* that extended displacement and compensation into three dimensions. This new approach to contrapposto, as distinct from earlier less animated symmetry—exemplified by the *Doryphoros,* by Polykleitos's subsequent *Athletes* (30, 31), and by their Renaissance reincarnations like Donatello's bronze *David* and Tullio Lombardo's *Adam*—was one of the great reconquests of classical art in the Renaissance (Shearman). Its evolution parallels the history of the treatment of the figure in classical sculpture itself.

The cast, though slightly flawed and with metal repairs on the nose, chin and neck, "is a remarkable reflection of the wax original, including the accidental gashes, and there are few tooled corrections in the de-

tails" (Wixom, *Ohio Bronzes,*). For technical reasons the *Crouching Venus* has been linked to the circle of Danese Cattaneo (1509–73) or Alessandro Vittoria (1525–1608) in Venice. In that city the same antique prototype is reflected in the center nymph, seated on the antique fountain, who shrinks from the sight of Actaeon in Titian's *Diana and Actaeon* (Edinburgh, National Gallery, on loan from the Duke of Sutherland.)

Ex collections: Private collection, London, 1967; [Alfred Spero, London].
Exhibition: Cleveland, *Ohio Bronzes,* 107.
References: Bieber, *Hellenistic Sc.,* 82–97, Figs. 290–295; J. Shearman, *Mannerism,* Baltimore, 1967, 83; Sotheby & Co., *Catalogue of Italian Maiolica . . . , Metalwork . . . , Works of Art . . . ,* sale cat., London, July 13, 1967, lot 136; M. Winner, in *Zeichner Sehen die Antike, Europäische Handzeichnungen 1450–1800,* Berlin-Dahlem, Kupferstichkabinett, Feb.–Apr. 1967, 107; D. Summers, "Maniera and Movement: the *Figura Serpentinata,*" *AQ,* 35 (1972), 269–301; A. H. Allison, "Antique Sources of Leonardo's *Leda,*" *AB,* 56 (1974), 375–384 (identifies exemplar studied by Leonardo as the *Venus Kneeling on a Tortoise* in the Prado, thought to have been in the collection of the Massimi family in Rome c. 1500, since a work corresponding to it was described as belonging to them in the *Antiquarie prospetiche romano* [by Bramante?] of around that time).

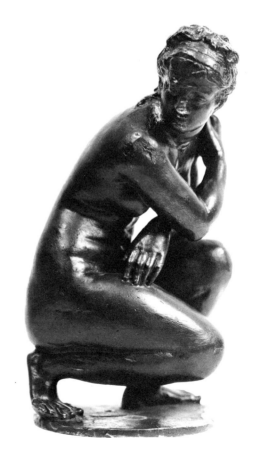

43 *Two Studies of the Crouching Venus*
 c. 1525–35

Circle of Fra Bartolommeo (Florence 1472/Pian di Mugnone 1517)

Drawing; natural black chalk and black crayon on gray paper. Inscription, upper left (by a later hand): Sarto. 19.7 × 28.4 cm.

Fogg Art Museum, Harvard University, Cambridge, Massachusetts, Bequest of Charles Alexander Loeser (1932:141 recto)

The Doidalsas *Crouching Venus* is studied from two viewpoints in this Florentine drawing by an artist associated with the Mannerism of the third and fourth decades of the sixteenth century. In the figure of Venus on the left of the sheet, it is evident that the style of Michelangelo's sculpture has influenced the way in which ancient prototypes were seen. Curves which are merely hinted at in the outline of the figure's back as rendered in the Roman copy (cf. 42) are here exaggerated, while the folds of flesh in the abdomen and the taut swelling thigh suggest knowledge of the female Medici Chapel Allegories. This emphasis on the contour of breasts and abdomen is so important to the art-

ist that he omits the *Venus's* left hand, essential to the carefully constructed system of diagonal balances in the antique prototype. The right arm crossing the chest seems derived as much from Michelangelo's *Victory* (Palazzo Vecchio) as from the Doidalsas *Venus* with its less heroic proportions. Even the foot with its long, curling toes that, unlike the ancient example, does not support the statue's weight, recalls the influence of Michelangelo. These echoes, in their turn, reveal the original impact on Michelangelo of antiques like this one, constructed with dynamic symmetry and diagonally opposing axes. Doidalsas's *Venus* may well have served as one of Michelangelo's sources for the treatment of abdomen and thighs in the Medici Chapel Allegories, and for the crossed arm of the *Victory*.

In the figure of Venus on the right, the statue is studied from a three-quarter frontal view with head in profile. Here there is the same Michelangelesque treatment of form. But the arm, instead of being bent at right angles and drawn across the body as seen in the left-hand study (a motif that finds echoes in many later sixteenth-century figure compositions) is instead extended. The hand was cut off, along with the left knee, presumably when the sheet was trimmed along the right edge.

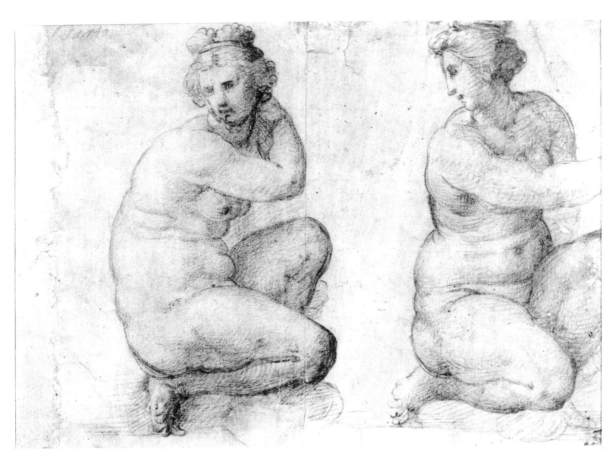

Ruth Kennedy believed this to be an autograph drawing by Fra Bartolommeo, datable to his Roman visit of 1514, based probably on the version of Doidalsas's *Venus* in the Palazzo Farnese (now Naples, Archeological Museum), in which the artist re-asserted the necessity of studies from the nude. The evident Michelangelesque influence, Kennedy thought, could derive from the Sistine Ceiling, or statues for the tomb of Pope Julius II executed prior to Fra Bartolommeo's Roman visit.

Exhibition: Smith College Museum of Art, *Italian Drawings, 1330–1780,* Dec. 1–20, 1941, exhibition catalogue by Ruth W. Kennedy, no. 24.
References: Mongan and Sachs, *Fogg Drawings,* 1, 50, no. 61; 2, fig. 53; R. Lullies, *Die kauernde Aphrodite.* Munich, 1954 (plates 5–7, 9–11).

44 *Battle of the Nudes* c. 1469–78

Antonio Pollaiuolo (Florence 1431–32/Rome 1498)

Engraving; H. 1, 191, D.I. Inscription on cartellino: · OPVS · · ANTONII · POLLA/IOLI · FLORENT/ TINI. 40.7 × 58 cm. (irregular)

Yale University Art Gallery, Maitland F. Griggs, B.A., 1896, Fund (1951.9.18)

The study of antique representations of the nude body in action as a means of learning functional anatomy as well as mastering a repertory of harmonious and natural movements goes back at least as far as Gentile da Fabriano's and Pisanello's drawings of the later 1420s. Pisanello's *Dioscure* (Ambrosiana) reflects the beginnings of this kind of study in the quattrocento: the outlines of the pose and the detailed modeling of

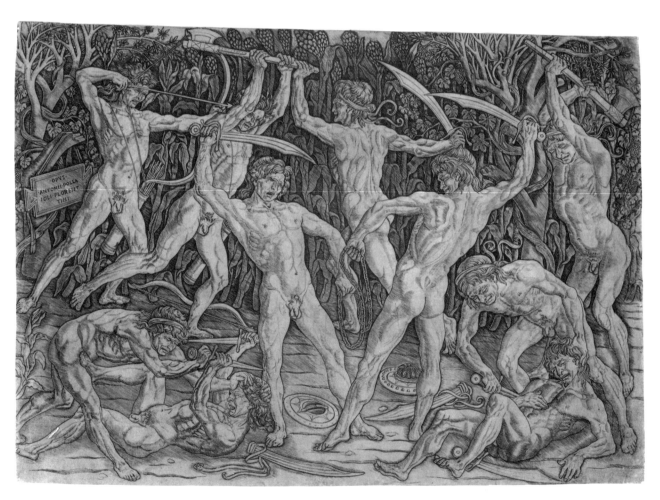

the torso musculature are carefully rendered, though the body appears weightless and the gesture lacks force (ill. Degenhart and Schmitt, fig. 81). The later *Dioscure* drawn by a follower of Fra Angelico or Filippo Lippi (47), while admittedly more graceful, still fails to represent accurately the underlying muscular function that makes possible such a movement. Antonio Pollaiuolo's *Battle of the Nudes,* a print that in the fifteenth century was unique because of its large size and the monumental scale as well as the nudity of its figures, has been considered a landmark in artistic anatomy ever since Vasari commented on that aspect of it. Many, though not all, of the muscles are drawn accurately, which in itself is an advance; yet it is primarily Pollaiuolo's use of flickering patches of light and shade in his unusually varied engraving technique that lends the bodies a sense of great energy, and creates the conviction in the observer that their movements are indeed possible if not naturalistic. This effect was largely absent in earlier representations of the nude in action.

Ten nude men fight each other with swords, daggers, axes and a strung bow. They are arranged in two rows in front of a field of dense stalks of maize with grapevines at either end. Attempts to explain the print as illustrating some episode from classical history or literature have foundered, usually because none of the proposed subjects sufficiently explains all elements of the iconography. Colin Eisler's interpretation, elaborating on the old idea of Kristeller and Bartsch that the men are gladiators, is the most satisfactory (quoted by Fusco in Levenson, Oberhuber and Sheehan). He believes that the battle represents a funerary ritual that originated in ancient Tuscany, Etruria, and was adopted by the Romans. The print revives the Roman practice of depicting such combats, which were held upon the deaths of prominent men, originally in public places and later in sacred settings. The funerary context—in this case possibly the death of Giuliano de' Medici, who was killed in the Pazzi conspiracy (1478)—supplies a symbolic meaning for the maize and grapes, alluding to Christ's sacrifice on the cross and its liturgical re-enactment in the taking of the bread and wine of Holy Communion. Such a context would account for the monumental size of the plate, for the prominence of Pollaiuolo's signature on the cartellino, and for many of the design's iconographic components. The survival and even renewal of Medici fortunes after a disaster, a persistent theme in the family's propagandistic iconography, is apparently alluded to in the "withered tree from which a new branch springs" imagery in the background. A dating of the engraving to the 1460s becomes possible if an allusion to the death of Cosimo il Vecchio (1464) or Piero il Gottoso (1469) was intended. *Hercules and the Giants,* an engraving close to the *Battle of the Nudes* made from a design by Pollaiuolo that has been dated persuasively to the early 1470s at latest (Anderson), might have represented funerary games on the occasion of Cosimo's or Piero's death. The figure types in the *Battle,* broader than those of the *Hercules* and of Pollaiuolo's paintings

of the 1460s, are thus probably later. A date in the 1470s for the engraving is also suggested by its use of pyramidal shapes, those formed, for instance, by the pairs of nudes struggling on the ground at left and right and by the two principal combatants holding a chain at the center of the composition (cf. London, *St. Sebastian*).

In designing his figures, Pollaiuolo was drawing on prototypes from antique art but altered them according to observations from nature. Yet, as has been noted in the case of other artists, it is difficult to establish specific sources even when a surviving antique is known to have existed in quattrocento Florence. In a recent study Laurie Fusco found that the figure shooting an arrow was adapted from a female archer reaching back for an arrow in a quiver on her back on a Niobid sarcophagus (Robert, 3:3, 312–13). The archer in the identical stance but seen from a different viewpoint appears as Hercules in Pollaiuolo's *Hercules and Deianiera* (Yale Art Gallery). Fusco compared the central warrior seen from the rear to a figure lunging with a spear on Meleager sarcophagi, but there is only a very general resemblance, restricted to the striding position of the legs. Hercules sarcophagi were apparently consulted for the two figures with axes, at the right (*Hercules and the Hydra,* Robert, 3:1, 103, 104 [Uffizi], 105–6, 107 [formerly Boboli gardens] 113, 128 [Florence, S. Pancrazio] and 109) and left (*Hercules carrying the Erymanthean Boar,* Robert, 3:1, 106, 116). This latter figure's dependence on a carrying and running pose rather than on one of striking, reveals the way in which Pollaiuolo often altered the behavioral context of his poses while retaining their visual configurations. The influence of the Monte Cavallo *Dioscuri* in the Renaissance, more pervasive than is sometimes realized (see 47, 48), is borne out by Fusco's observation that the poses of the central paired combatants were based on them. The interlocked arrangement of the figures, which overlap or at least touch, is a revival of an antique mode of composition, as is the principle of "pivotal presentation" (Fusco, 77) whereby figures in essentially the same pose are seen from varying angles.

Part of the difficulty of proving ancient sources is the occurrence in antiquity of identical, or nearly identical, figural motifs in various media, dating from different eras. This is true for example of the axe-wielding figure on the right, which resembles not only the Hercules on a sarcophagus (Fusco), but also, as Vickers observes, resembles the axe-wielder on a fragment of a pot by the Niobid painter (Berlin, Staatliche Museen, 2403). The impressive array of connections between the nude figures, their poses and weapons, and the rendering of anatomical details, in the *Hercules and the Twelve Giants* and in vases by the mid-fifth-century B.C. Niobid painter strongly suggests that Pollaiuolo may indeed have had access to a volute- or calyx-crater by this artist or by one of his followers.

But Pollaiuolo does not copy his painted or carved models exactly. He alters the figure on the basis of ob-

served detail, in a manner similar to Montagna's use of the prototype in 33. The archer on the left in the *Battle*, for example, lifts his right elbow in a distinctive manner that combines the motif of the Niobid reaching for an arrow with the artist's personal observation of archers.

Another unprecedented feature of the engraving is its display of ferocity, especially in the combatants' faces. This appears neither in Roman sarcophagi reliefs nor on Greek fifth-century pots. It has recently been suggested that the violence had its source in Etruscan battle painting (François tomb, Museo Torlonia; Dresden, *Dialoge*).

References: Robert, *Sarkophagreliefs,* 3:1, 3:2, 3:3; Degenhart and Schmitt, "Gentile da Fabriano"; L. Armstrong Anderson, "Copies of Pollaiuolo's Battling Nudes," *AQ,* 31 (1968), 155–167; Dresden, *Dialoge,* 31, no. 19; Levenson, Oberhuber and Sheehan, 63–65, "Antonio Pollaiuolo," and no. 13, *Battle of the Nudes,* 66–80 (L. S. Fusco); M. Vickers, "A Greek Source for Antonio Pollaiuolo's *Battle of the Nudes* and *Hercules and the Twelve Giants,*" *AB,* 59 (1977), 182–187.

45 *Massacre of the Innocents* c. 1509–10

Marcantonio Raimondi, after a design by Raphael (Argini, near Bologna, c. 1480/Bologna 1527–34)

Engraving; B. 14, 19, 18(I); P. 6, 76, 17.
28.3 × 43.4 cm.

Museum of Fine Arts, Boston, Harvey D. Parker Collection (P 1217)

Toward the end of Raphael's stay in Florence (c. 1504–08), he did many studies of the nude in action inspired by the painting and sculpture of Pollaiuolo, Leonardo and Michelangelo. Michelangelo's cartoon for the *Battle of Cascina* ("Bathers") intended for the Hall of the Great Council in the Palazzo della Signoria (1504–06), furnished numerous examples of vigorously active nudes. Since the styles of these Florentine artists were based in varying degrees upon study of the antique, Raphael absorbed *all'antica* figural types from them indirectly. His immediate sympathetic response to classical art during this period is attested to by drawings like the Ashmolean *Three Musicians,* directly inspired by an ancient relief or cameo.

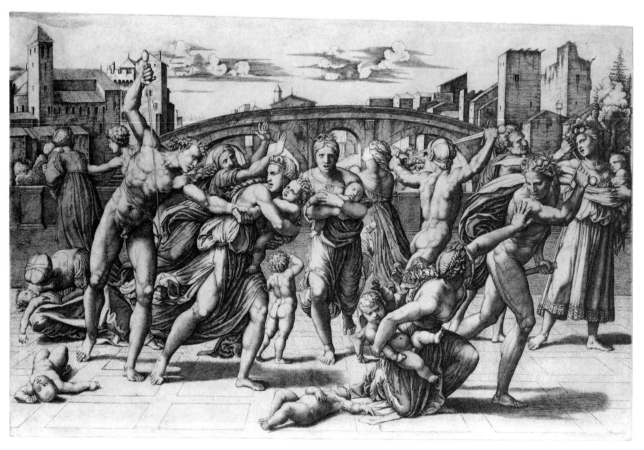

45

Once in Rome his approach to antiquity became both more direct and more profound, as shown by such drawings as his studies of the Pantheon (Uffizi) and his use of antique prototypes like the Casa Sassi torso, in designing the ceiling panels for the Stanza della Segnatura (Becatti, Lehmann). Raphael's appreciation of the classical monuments in Rome is recorded in a few surviving drawings and in his use of recognizable antique motifs in the Vatican Stanze compositions and other paintings. It is perhaps most clearly recorded in engravings like Marcantonio's *Standard-Bearer* (B. 14, 189, 481), based on Raphael's study of the *Torso Belvedere* and his *Two Muses* (B. 14, 159, 317). These engravings spread Raphael's classicism throughout Italy and the north. His version of antique revival was to become the definitive one for the cinquecento.

The *Massacre of the Innocents,* though seemingly not based on specific antiques, demonstrates Raphael's incorporation of agonistic motifs, derived ultimately from battle sarcophagi and monumental Roman reliefs via Michelangelo's *Battle of Cascina,* into the representation of a scene whose violence and brutality are rare in his work. Comparison with Pollaiuolo's *Battle of the Nudes* (44) shows the extent to which the new classicism depended on an increased mastery of functional anatomy. This was due largely to the work of Leonardo and Michelangelo at the end of the quattrocento and to the greatly intensified study of antique art during the same period.

The pen and ink drawing *Five Nude Men* (B. M. 1895-9-15-624) has often been linked with this engraving. It includes a version—later used for the nude executioner seen from behind in the *Massacre*—of a figure in Michelangelo's *Cascina* cartoon. The engraving is datable 1510–11 on the evidence of two further studies which include figures destined for the *Astronomy* and *Judgment of Solomon* on the ceiling of the Stanza della Segnatura (1509). Vasari's reference to the engraving as among the earliest by Marcantonio after Raphael (V, 411) supports such a date. Its immediate popularity produced many copies, as well as its use in Araldi's ceiling in the Convento di S. Paolo, Parma. Some authorities believed this version of the *Massacre of the Innocents,* with the small pine tree in the upper right corner, to be a copy of a version lacking the tree (B. 14, 21, 20).

Ex collections: H. F. Sewall (mark on verso, Lugt 1309); A. Firmin-Didot (mark on verso, Lugt 119); Louis Galichon (mark on verso, Lugt 1060).
Exhibition: Fogg, *Rome and Venice,* no. 12 (Lawrence Nees).
References: Oberhuber, *Renaissance in Italien,* 96–97, no. 133; A. Forlani Tempesti, "The Drawings," in *Raphael,* N.Y., Reynal and Co., [1969], 354ff.; G. Becatti, "Raphael and Antiquity," ibid., 508–517; Brown-RISD, *First Maniera,* 89, no. 96 (John Quarrier: Emory University impression); Lehmann, "Parnassus," 90n.; K. Oberhuber, *Raphaels Zeichnungen,* v. 9, Berlin, 1973, 24 and fig. 8.

46 *Battle Scene with Horses and Men* c. 1517(?)
Domenico Campagnola (Venice 1500/Padua 1564)
Drawing; pen and ink on white paper. Inscription, lower center (in 16th-century hand): Campagnola. 21.2 × 31.9 cm.
The Art Institute of Chicago, The Leonora Hall Gurley Memorial Collection (1922.16 R 28/7)

In the Renaissance, the importance of battle scenes as subjects prompted frequent recourse to battle or battle-related sarcophagi (e.g. Niobid) for individual combatants and interlocked fighting groups. They supplied answers to the problem of conveying the speed and energy of battle in a clear and legible fashion. As in this drawing, battle sarcophagi were often not copied literally but stimulated variations on their standard repertory of motifs, such as the falling riders or the sword-wielding soldier who dominates the left third of the composition.

Whereas Pollaiuolo's battle involved men only (44), early sixteenth-century battles such as Leonardo's *Battle of Anghiari* or the *Battle of Constantine at the Milvian Bridge* entrusted to Raphael's workshop after his death (Vatican, Sala di Costantino) were complex affairs in which the movements of horses and men had to be successfully integrated. Campagnola's drawing relates to his engraved *Battle of Nude Men* (1517; H. 5, 211, #4). This is connected in turn, in its use of a major diagonal compositional axis, to Titian's *Passage of the Red Sea* engraving (c. 1514–15; P. 6, 223, 4).

Titian offered to paint a battle piece in the *Sala del Maggior Consiglio* of the Palazzo Ducale in Venice as early as 1513; the offer was accepted but the painting remained unfinished until 1538. Domenico Campagnola's preoccupation with battle subjects might have been touched off by Titian's earliest sketches for this project. An accurate copy in the Uffizi shows that in this painting, the *Battle of Cadore,* Titian's concern to render the forms as completely as possible in space took precedence over the conflicting intention to render the battle's pace and fury. This order of priorities was reversed by Campagnola in his engraving: "Using classical compositional formulas and deforming the shapes of the men and horses to increase the sense of movement and excitement, he created a haunting scene of confusion and turmoil; the individual figures and episodes are submerged in the general darkness, while the flickering light here and there picks out an arm, a face, a thigh, a muscular back, or the anguished form of a fallen horse" (Oberhuber, 431).

Something of the process of definition and selection that culminates in Campagnola's powerful achievement in the graphic medium is traceable in this drawing. The even lighting and the lack of any atmospheric space indicate that a sculptured relief provided the basis for this strongly expressive work. The uppermost boundary formed by a nearly isocephalic line of heads and shields suggests the narrow oblong format of a relief. The landscape background of Campagnola's en-

graved *Battle,* in which trees provide a forest backdrop for the mysteriously illuminated action, has been omitted. In its place, diagonal cross-hatching above the heads suggests a background plane pushing up from behind and crowding the furious shapes into an even more compact, dense mass. Placing antique sources in the service of so personal an expressive style links Campagnola's methods with such contemporaries as the young Rosso and Parmigianino and thus with the styles of early Mannerism.

Ex collections: F. Abbott (Lugt 970), recto; Sir Peter Lely (Lugt 2092), recto; Gurley, recto (not in Lugt) and verso (Lugt 1230b).

Exhibition: The Art Institute of Chicago, *The Leonora Hall Gurley Collection of Drawings,* 1922, Early Italian, no. 4.

References: H. Tietze and E. Tietze-Conrat, *The Drawings of the Venetian Painters in the 15th and 16th Centuries,* 2 vols., N.Y., 1944, no. 451; E. Gombrich, "The Style *all'antica:* Imitation and Assimilation," *Norm and Form: Studies in the Art of the Renaissance,* London, 1966, 122–128 (battle scenes in *Sala di Costantino,* Vatican); Levenson, Oberhuber and Sheehan, 141–147 ("Domenico Campagnola") and 428–431, no. 156 (Oberhuber); M. Muraro and D. Rosand, *Tiziano e la silografia veneziana del Cinquecento,* Venice, Fondazione Cini, 1976, 81–83, no. 8B.

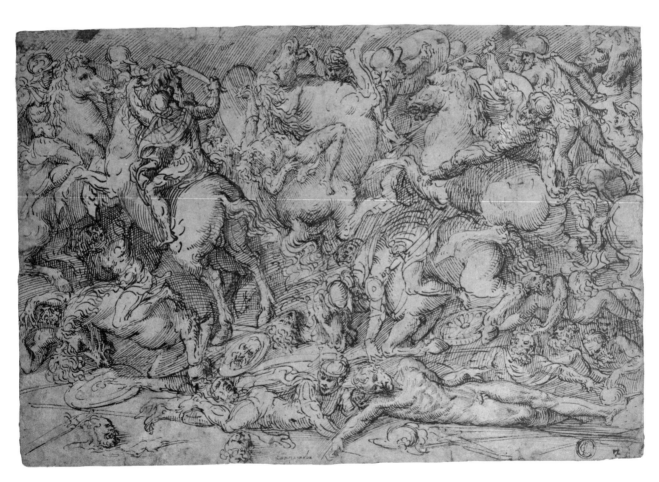

The Sixteenth-century Canon

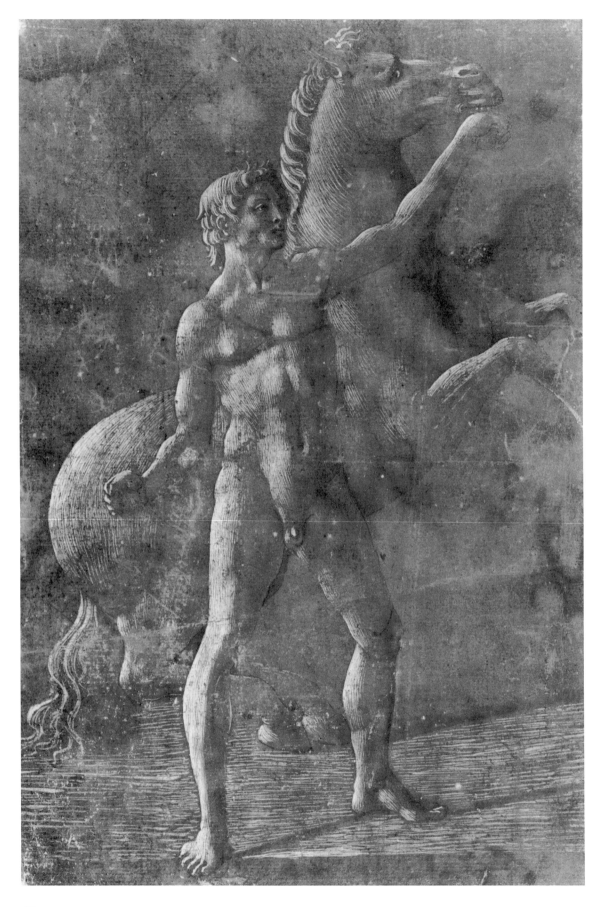

47

47 *Nude Youth Holding a Rearing Horse* c. 1450
Studio of Filippo Lippi (Florence c. 1406/Spoleto 1469)
Drawing; metal point on blue prepared surface, heightened with white. 36 × 24.7 cm.
The British Museum (Pp. 1–18)

Throughout the Middle Ages only a few major works of Roman sculpture remained on view and were widely known. Among them were two colossal groups of *Dioscuri* or *Horse Tamers,* each over eighteen feet high, located on the Quirinal hill, known as Monte Cavallo for these gigantic but fragmentary rearing horses. With cuirassed torsos as supports, they towered over a field of rubble that had once been Caracalla's Temple of Serapis and the Baths of Constantine. Their high marble bases, immured in a "great bastion of brick", were inscribed, probably c. A.D. 450, OPUS FIDIAE and OPUS PRAXITELIS ("Opus Fidiae" is visible in 48). One medieval attitude to such remains is expressed in *De mirabilibus urbis Romae* (c. 1200) by Gregorius, an English canon lawyer who travelled to Rome. He repeated the popular tradition that Pheidias and Praxiteles were two philosophers or fortune-tellers, commemorated with these statues by the Emporer Tiberius. The nakedness of the figures symbolized the truth of their prophecies; their twin steeds, the agility of their wits. This belief demonstrates how, during the Middle Ages, nudity was viewed symbolically rather than appreciated esthetically.

The *Horse Tamers* were among the most frequently drawn Roman antiquities. This drawing, which depicts the left-hand group, belongs to the earliest phase of this activity and can be dated c. 1450 (Degenhart and Schmitt). Its frontal viewpoint is similar but not identical to Pisanello's drawing of the same figure in the Ambrosiana. Pisanello's study, however, makes no claim to "finish" but confronts the complexity of the figure in an attempt to record accurately both the motif and its style. He reproduced the rigid schematization of the torso musculature and the exact position of the left hand, but had difficulties with the foreshortened right arm. The heroic proportions of the colossus have been attenuated according to the Gothic canon.

The present drawing, by contrast, is "a very free adaptation". (Bober). The forelegs (missing from the left-hand horse before the restoration ordered by Sixtus V in 1548) have been restored. The youth's position combines aspects of both colossi. The motif of a powerful nude figure in action is not studied in analytical fashion but adapted to a fundamentally decorative purpose. Though the drawing is more "presentable" than Pisanello's—with complexities of pose and style masked—comparison to 48 shows that neither the structure nor the functioning of the *Horse Tamer*'s anatomy has yet been understood. The drawing's elaborate thorough technique provides an attractive decorative pattern of feathery strokes rhythmically built up on the blue prepared paper. Degenhart has pointed out the close similarity of the figure's head to Fra Angelico's Perugia polyptych, and therefore associates the drawing with that master.

Ex collection: Payne Knight bequest, 1824.
References: E. R. Curtius, *European Literature and the Latin Middle Ages,* N.Y., 1963, 405f.; A. E. Popham and P. Pouncey, *Italian Drawings in the Dept. of Prints and Drawings in the British Museum,* 1, London, 1950, 91–92, no. 152; Bober, *Aspertini,* 72; B. Rowland, Jr., "Montecavallo Revisted," *AQ,* 30 (1967), 143–152; Degenhart and Schmitt, *Zeichnungen,* 1:2, 449–450, no. 373.

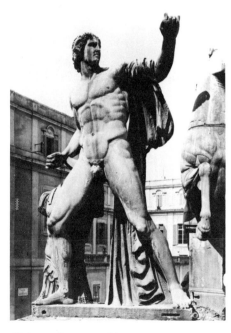

47 (supplement A)

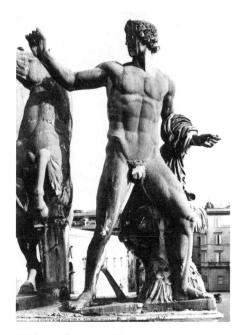

47 (supplement B)

Roman. *Dioscuri,* c. 330 A.D.(?) Rome, Quirinal Hill

48 *The Horse Tamers of Monte Cavallo* c. 1533

Martin van Heemskerck (Heemskerk 1498/Haarlem 1574)

Drawing; pen and brown ink. 23.5 × 25.2 cm. (irregular)

Private collection

The Dioscuri—Castor the horse tamer and Polydeuces or Pollux, the master of boxing—were, according to Homer, the sons of Leda and Tyndareos. The ideal types of bravery and dexterity in fighting in antiquity, they were worshipped from early times among the tribes of Italy. The Senate often met in the temple erected to them in Rome near the Forum (484 B.C.) in gratitude for their assistance at the battle of Lake Regillus. In recognition of their special significance to Rome, statues of the Dioscuri (heavily restored antiques) flank the stairway leading up to the Campidoglio.

The appearance of the *Dioscuri* on Monte Cavallo before their renovation and re-installation in 1548 is best preserved by this drawing (compare 47). It is executed in Heemskerck's unmistakable style: a firm outline with hatching in strokes of variegated thickness for modeling and texture. Heemskerck uses cross-hatching only sparingly to reinforce dark shading. The sketch, like all his drawings, was done *in situ,* yet is executed with great authority and finish. This fragment fills a gap in the Berlin sketchbook where such complete views of the groups have always been missing. Despite the loss of the upper corners, the representation of the Dioscuri and their mounts is complete, as is that of one of the Constantinian statues formerly

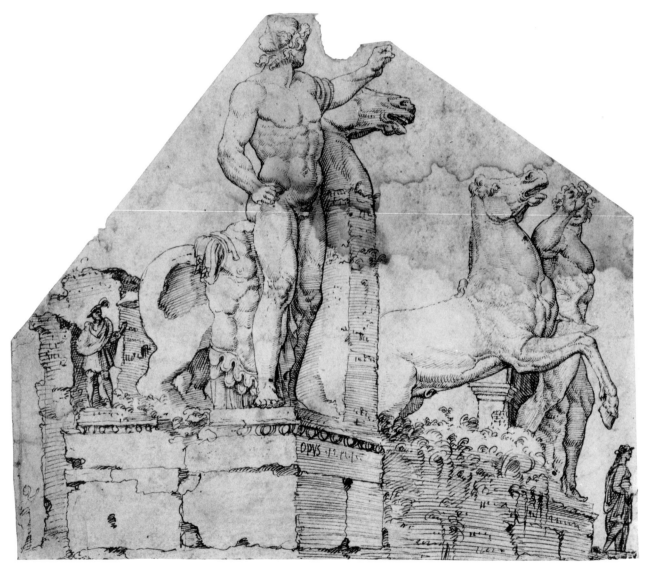

48

on the spot at the right (later transferred to the Capitoline Hill). At the extreme left, on the same level as the colossal groups, appears a small figure wearing a plumed hat and dashing cloak of the style made fashionable by Charles V, the emperor whose triumphal entry into Rome Heemskerck had helped prepare. The small scale of the figure in comparison to the *Dioscuri* helps to convey the otherwise unimaginable magnitude of the nudes, whose actual relationship to human height has been increased from a factor of three to a factor of four. This exaggeration in the disparity of scale looks ahead to Hendrick Goltzius's engravings (55, 100) where it is evident that the colossal achievements of antique art began to place an increasingly oppressive, academically administered, burden on artists.

Compared to Pisanello's study in the Ambrosiana and 47, the *Dioscuri* and their horses as drawn by Heemskerck have become convincing sculptural masses in which the bodies of both men and animals are understood organically. Yet in marked contrast to the earlier views, they are reproduced as though they were stone rather than flesh. Heemskerck conveys a sense of the weight, the authority and the nobility of these forms. His perception of them allows the intrinsic power and vitality of the original invention lying behind the late antique works to emerge from the repeated process of replication that can deaden the Quirinal sculptures and deprive them of persuasiveness to the modern eye.

Through Heemskerck's evocation, we can better understand how in the Renaissance the *Dioscuri* could have been associated with Pheidias (see entry for 47). This tradition, on its face somewhat absurd, may actually have received support from Cyriacus of Ancona after his visits to Athens in 1436 and 1447, since he made drawings of the west pediment of the Parthenon that served as a precious record of its sculpture (now lost). We know from seventeenth-century drawings by Jacques Carrey that in the contest between Athena and Poseidon depicted in the west pediment, the nude figure of Poseidon stood in an active stance, possibly in relation to a rearing, fiery horse, as did his opponent Athena (ill. Langlotz). This pose seems to have been repeated in the right hand Dioscure. Also, the figures of Athena and Poseidon were symmetrically opposed in a manner that must have been well known in antiquity and widely associated with Pheidias. In a number of particulars the *Dioscuri* resemble these Parthenon sculptures; thus the late antique inscription associating one of them with Pheidias, added, according to Curtins, by lovers of pagan art to preserve the sculpture from destruction, may also have recorded an ancient tradition.

Ex collection: [Dealer, England].
References: E. Langlotz, *Phidiasprobleme,* Frankfurt on the Main, 1947, pl. 2; B. Rowland, Jr., "Montecavallo Revisited," *AQ,* 30 (1967), 143–152 (relationship of the Heemskerck drawing to the colossal *Dioscuri*).

49 *Apollo and Diana* c. 1503–4

Jacopo de' Barbari (Venice? c. 1460–70/Malines, or Brussels?, by 1516)

Engraving; H. 5, 153, 14. 16 × 10 cm.

National Gallery of Art, Rosenwald Collection (B-3,496)

Jacopo de' Barbari is famous as the first Italian Renaissance artist of note to travel to Germany and the Netherlands, where he worked for such patrons as Emperor Maximilian I and Frederick the Wise, Elector of Saxony. His print *Apollo and Diana* was one of the earliest engravings to reflect the impact of the *Apollo Belvedere*. It was made c. 1503–4 during Barbari's middle period (1501–5) when the artist was probably in his late thirties or forties. It is signed with Barbari's standard signature, a caduceus in the upper left.

Following late antique and medieval precedent, Barbari depicts the god and goddess as planetary deities. "Apollo, god of the sun, advances over the crystalline sphere of the stars, while the moon-goddess Diana, accompanied by her stag, disappears behind it" (Leven-

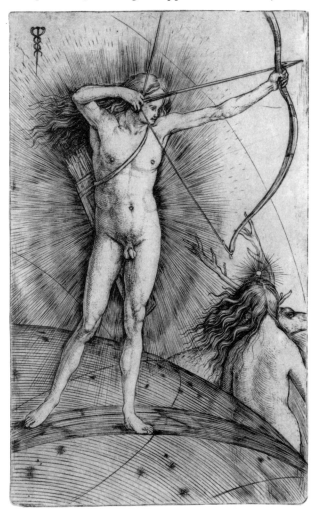

49

son, 368). There is little likelihood that Barbari knew the Roman work at first hand. However, drawings of the *Apollo* in its unrestored state, such as the one in the *Codex Escurialensis,* fol. 53, were circulating as early as the 1490s (cf. 53). Barbari worked from a drawing showing the *Apollo* from a viewpoint further to the right, such as *Escurialensis,* fol. 64, which emphasizes the openness of the figure's stance and its potential for motion.

In transforming the *Apollo Belvedere*'s expectant stride into the specific action of shooting an arrow, Barbari reverses the relationship between the position of the arms and the weight-bearing function of the legs. Although the figure's left arm is outstretched like the *Apollo Belvedere*'s, here it reaches straight out and slightly up, bracing the bow against the counterpull of the string. This arm differs from the model in that it corresponds to the weight-bearing, not the free, leg. These changes show that although he was aware of the identity of the Roman work as a *pharetratus,* or quiver-bearing, Apollo, as it was referred to by Giovanni Francesco Pico della Mirandola in 1512, Barbari's main interest did not lie in reconstructing the original appearance of the antique work. On the contrary, he has freely adapted the open, half-striding stance to an action understandable in physical terms. This is analogous to contemporary restorations of the *Torso Belvedere,* like 57.

Following some such reasoning as this, Levenson understandably linked the figure to the even more energetic bowman of Pollaiuolo's *Battle of the Nudes* (44), a source which Barbari combined with the *Apollo Belvedere.* Compared to Pollaiuolo's bowman, however, Barbari's figure loses all semblance of convincing physical action, and our attention is then drawn to the essentially decorative aspect of the print. This good impression allows us to form some idea of the brilliance of Jacopo de' Barbari's technique and his importance in Italian engraving of the early cinquecento.

Ex collection: British Museum duplicate.
Exhibition: Prints of the Italian Ren., no. 264.
Reference: Levenson, Oberhuber and Sheehan, 368, no. 141b (entry by J. A. Levenson).

50 *Poynter Apollo* c. 1501–3

Albrecht Dürer (Nuremberg 21 May 1471/6 April 1528)
Drawing; pen, brown and dark brown inks on pale brownish-gray paper; Winkler 262; Strauss 1501/8. Inscription (by a later hand): AD [monogram]. 21.8 × 14.6 cm.
The Metropolitan Museum of Art, Gift of Mrs. William H. Osborn, 1963 (63.212)

The ancient idea that human figures of ideal beauty ought to follow a canon of proportions was freed in the Renaissance from its exclusively schematic service to harmonistic cosmology. Beginning with the art and writings of Ghiberti, it was fused with the ancient Greek idea of *symmetria* as commensurability "calculated according to the appearances which are presented to the eyes," as Diodorus Siculus wrote (Pollitt). In 1523, Dürer wrote of a meeting with Jacopo de' Barbari, which took place in Nuremberg around 1500, during which Jacopo showed him figures constructed according to a proportional system. Dürer's account (Levenson, "Barbari") vividly conveys the artist's frustration when Barbari refused to explain the system to him, and states unequivocally that at this point he started reading Vitruvius in order to figure it out for himself.

Two of Dürer's earliest preserved constructions of the male figure record this experience by representing the body according to Vitruvian proportions, with the length of the head equal to one-eighth and the face one-tenth of the body's height. These proportion studies are the London *Apollo and Diana* and the *Poynter Apollo.*

Together with the 1504 *Adam* (Morgan Library) and the engraved *Adam and Eve,* also of 1504 (51), they demonstrate how at this stage Dürer's image of ideal male beauty was constructed according to a proportion system that was both arithmetic and geometric—based on the square, trapezoid and circle, as well as aliquot fractions. Moreover, figures in poses derived from the *Apollo Belvedere* were used in the evolution of the system. As there is no record that Dürer visited Rome, and since his documented preoccupation with proportion construction dates from a period when the artist was known to be in Nuremberg, scholars have concluded that Dürer's knowledge of the *Apollo Belvedere* depended on drawings. At first, Dürer was unaware of the identity of the antique as an Apollo with quiver and bow (Panofsky). In some early drawings the end of the quiver does not show. The support-stump with its snake (added to the figure by Roman copyists) could apply equally well to an "Apollo Medicus," the subject of one of Dürer's even earlier constructed drawings (Berlin, W. 263).

Many researchers agree that Jacopo de' Barbari's engraving of *Apollo and Diana* (49) is a source that Dürer studied. Yet Dürer's London Apollo is much closer in its stance to the *Apollo Belvedere* than Barbari's

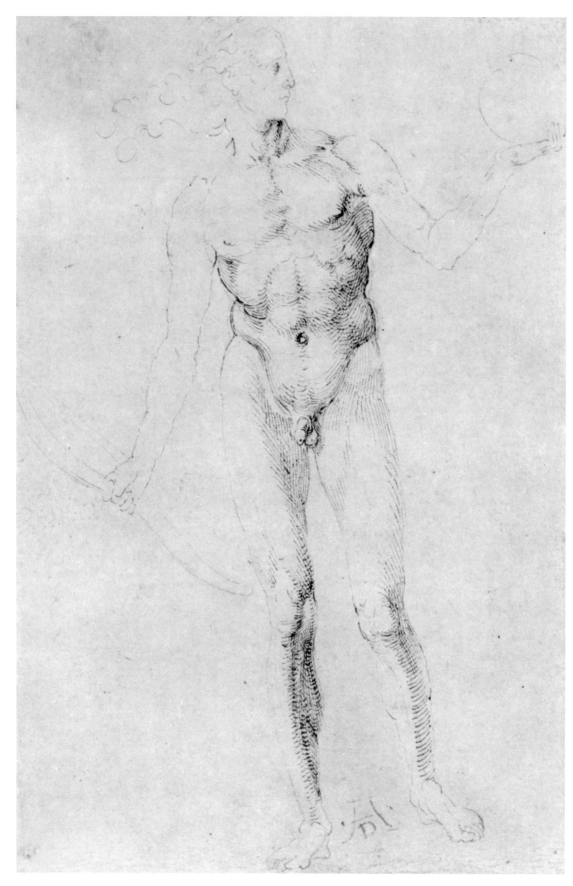

50

Apollo. The antique's symmetrical relationship between engaged leg and raised arm, relaxed, retracted leg and right arm brought close to the side, is rendered more correctly. It appears that Dürer had before him, in addition to Barbari's print, a drawing like *Codex Escurialensis* fol. 64r (which lacks the quiver), showing the frontal view; Winner has suggested the *Standing Nude with the Torch* in the Musée Bonnat (Bean, cat. 225). By presenting the figure frontally with head in pure profile, Dürer combined two of the *Apollo Belvedere*'s most frequently represented aspects, as did Antico, especially in his second bronze based on the antique work (Venice, Cà d'Oro).

In the *Poynter Apollo* the short, feathery strokes of the figure's outline, uncharacteristically tentative, can be interpreted as evidence that the sheet is a tracing by Dürer of his own *Apollo and Diana*. Dürer purposely made certain changes in the Apollo figure: from the waist upwards, the *Poynter Apollo* leans more steeply to the left, which "corrects" the stiffness of the London drawing (*Dürer in America*). The modeling, in a darker ink, gives prominence to the musculature of the torso, as if the sculptural qualities of the forms were being explored. The slight narrowing of the body at the waist and hips was perhaps intended to restore some of the rhythmical movement of the antique prototype that, in the London drawing, had been sacrificed to the rigors of Dürer's construction schema. The long flowing hair, the disk and bow, an attribute more appropriate to a classicized Apollo than the scepter in the London drawing, were executed freehand.

Ex collections: Thomas Banks; Lavinia (Mrs. Edward) Forster; Ambrose Poynter; E. J. Poynter; Johnston L. Redmond; Mrs. William H. Osborn.
Exhibitions: London, Burlington Fine Arts Club, *Exhibition of Early German Art,* 1906, no. 5; N.Y., Metropolitan Museum of Art, *Fiftieth Anniversary,* 1920; N.Y. World's Fair, *Masterpieces of Art,* 1939, no. 95; N.Y., The Pierpont Morgan Library, *Drawings and Prints by Albrecht Dürer,* 1955, p. 9; *Dürer in America,* 39–41, no. VII (entry by Jay A. Levenson).
References: E. Panofsky, "Dürer and Classical Antiquity," *Meaning in the Visual Arts,* Garden City, N.Y., 1955, 236–292, esp. 249ff.; E. Panofsky, *The Life and Art of Albrecht Dürer,* Princeton, 1955 (one vol. ed.), 261ff.; J. Bean, *Les dessins italiens de la collection Bonnat,* Paris, 1960; Pollitt, *Art of Greece,* 19–20; Winner, "Apollo Belvedere," 189; Levenson, Oberhuber and Sheehan, 344–345 (Levenson, biography of Barbari).

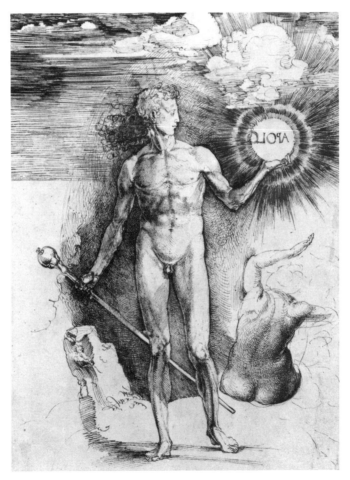

50 (supplement)
Albrecht Dürer
Apollo and Diana,
1501–3
Pen. W. 261.
The British Museum,
London.

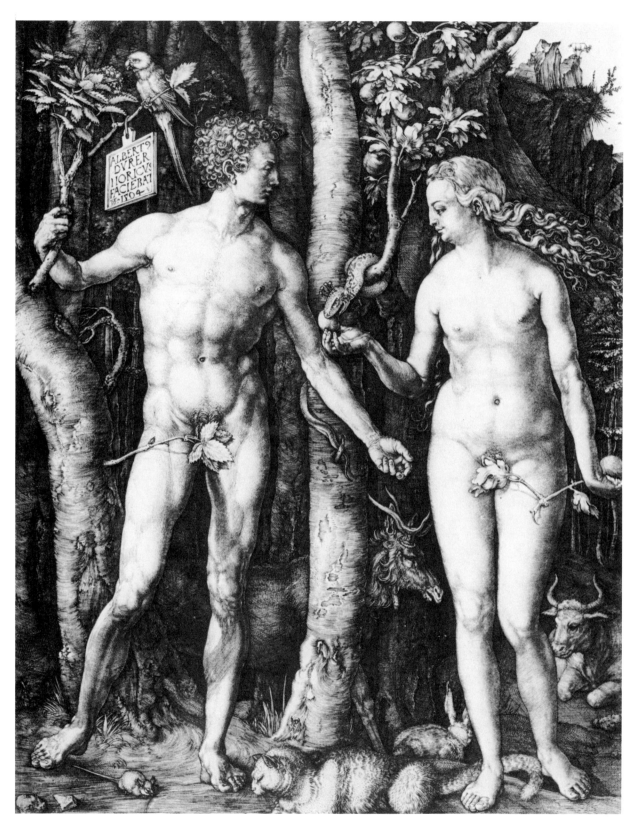

51

51 *Adam and Eve* 1504

Albrecht Dürer (Nuremberg 21 May 1471/6 April 1528)

Engraving: B. 7, 13, 1; Meder 69, 1 (II/III,a). Inscription on cartellino: Albert[us]/Dürer/Noricus/Faciebat/AD [monogram] 1504. 25 × 19.2 cm.

Yale University Art Gallery, the Fritz Achelis Memorial Collection, Gift of Frederic George Achelis, B.A. 1907; reacquired 1972 with Henry J. Heinz II, B.A. 1931, Everett V. Meeks, B.A. 1901, and Stephen Carlton Clark, B.A. 1903, Funds (1925:29)

The figures of Adam and Eve in this engraving are Dürer's ideal nudes, as perfect as possible both in proportions and pose. They reveal the impact on Dürer of the classical tradition, as mediated by Italian quattrocento artists. They also show Dürer's fascination with contrapposto, the "constructed equilibrium" (Panofsky) that clearly articulates the body's forms in both active and passive states, and its association in his mind with ideal proportions. At first Dürer planned to present the ideal nudes in two separate engravings. His decision to place the male and female together in one image could have been inspired by Barbari's *Apollo and Diana* (49). What Panofsky called "the diptych-like character" of the engraving reflects this genesis from two originally independent conceptions.

The translation of what were originally Apollo and Venus types into an Adam and Eve was possibly inspired by Dürer's experience ten years earlier. In 1494, during his first stay in Venice, he would have encountered the tradition of presenting current ideals of classically perfect bodies as nude life-sized sculptures of

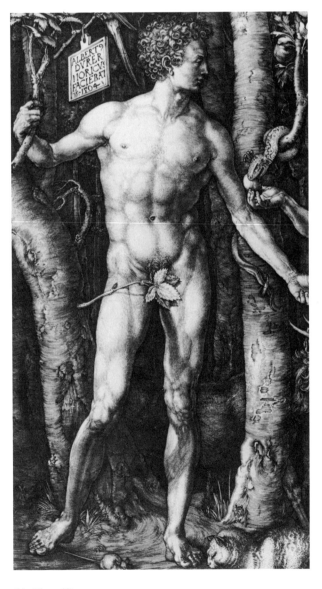

51 (detail)

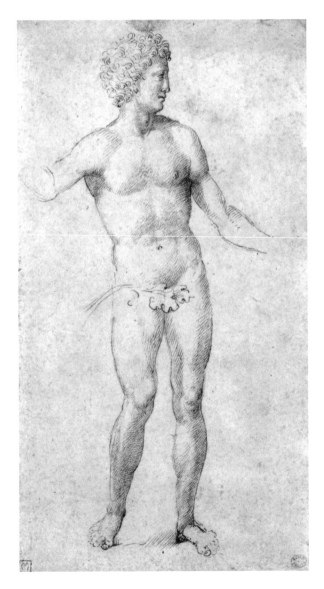

52

Adam and Eve. Like Dürer's engraved figures, Antonio Rizzo's and Tullio Lombardo's statues of *Adam* and *Eve* were based on antique prototypes such as a *Venus pudica*, the *Doryphoros* and an Apollo of the Mazarin type.

"Both figures, superbly modelled, are aligned on one standing plane and set out against the penumbral darkness of a thicket" (Panofsky). Dürer's choice of such a background was a reference to Pollaiuolo's *Battle of the Nudes* (44) which simultaneously paid tribute to and challenged the Florentine master. Like Pollaiuolo, Dürer calls attention to his signature. It hangs on a tree behind and to the left of Adam, on a branch where a parrot, symbolizing the virgin birth of Christ, perches very near Adam's head. For the first time in Dürer's career the signature includes a Latin inscription—worded like Pollaiuolo's and contrasting his pride as a Florentine to Dürer's as a citizen of Nuremberg.

"The self-contained, classical poses of the two figures and the necessity of keeping them completely frontal for a clear display of their proportions precluded a dramatic handling of the action" (Talbot, *Dürer in America*), which might otherwise have been expected in a portrayal of the Fall of Man, an inherently dramatic central episode in the epic of Salvation. Dürer compensated for this de-emphasis on the narrative potentiality of the scene by presenting instead a pervasive and detailed symbolism. Adam grasps a mountain ash, the Tree of Life, standing in contrast to the forbidden fig; the parrot opposes the diabolical serpent whose guile lures Adam and Eve to their downfall. As Adam reaches forward to grasp the fatal fruit, his situation is symbolized by the mouse at his feet, unaware that the cat is about to spring.

The need to bring the original static Apollo-Adam into active relationship with Eve in the engraving caused Dürer to move the free leg further to the side (cf. 50). The greater tilt of Adam's chest in comparison with the London drawing is anticipated by the Poynter sheet. The evolution of the ideal classicized female type in Dürer's work is not documented by many surviving drawings, but here too Jacopo de' Barbari's engravings seem to have played an important role. Yet Dürer ultimately went beyond Barbari's nudes in the illusion of three-dimensionality and in anatomical articulation, as suggested by a constructed *Nude Woman with a Staff in Ottawa* (W. 265; *Dürer in America*, VIII) which directly anticipates both the Morgan Eve and the final engraving.

This rich impression preserves Dürer's varied and subtle technique, the faded paper contibuting an attractive pearly tone to the highlights on the nudes.

References: E. Panofsky, *The Life and Art of Albrecht Dürer*, Princeton, 1955 (one vol. ed.), 85–87; *Dürer in America*, 50–52 (Morgan drawing), 131–132 (engraving, *Adam and Eve*); Langemeyer and Schleier, *Bilder nach Bildern*, 130–131, no. 104.

52 *Adam, after Dürer* c. 1504

Marcantonio Raimondi (Argini, near Bologna, c. 1480/ Bologna 1527–34)
Drawing; pen and brown ink. 19.2 × 10.5 cm.
The Art Museum, Princeton University (45–47)

In his engravings of 1504–8, Marcantonio demonstrated increasing sophistication and skill in his adaptation of landscape motifs and graphic techniques from woodcuts by Dürer. Vasari (5, 405) records that on arriving in Venice in 1506, Marcantonio bought Dürer's woodcut series of the *Life of the Virgin* and began to duplicate them, but his awareness of Dürer's graphic work need not have been confined to the post-1506 years. The style of this drawing of Dürer's engraved *Adam* (51) resembles the Princeton *Reclining Partly Nude Girl* (18) and the Musée Bonnat drawings (cat. nos. 225–237) and others in a group whose stylistic coherence has been defined by K. Oberhuber (Gibbons).

Marcantonio concentrates here on modeling the torso and legs in groups and chains of closely parallel lines, omitting the hands and most of the forearms. Adam's half-stride, with the body's weight borne completely on the left foot, is not organically correct, and makes the figure seem off balance. Marcantonio's only tentative grasp of the *Apollo Belvedere*'s anatomy—on which Dürer's engraving is based—is apparent in the Bonnat *Man Holding a Torch* (Bean, no. 225) that Winner linked to the *Apollo Belvedere*. A feeling for solidity and weight, as well as greater ease of draughtsmanship, is evident in 19, made a few years later.

Ex collections: Litta; Carlo Prayer (Lugt 2044, lower right recto); Frank Jewett Mather, Jr. (Lugt 1853a, lower left recto).
Exhibition: New York, Roerich Museum, *Exhibition of Drawings by Old Masters from the Private Collection of Professor Frank Jewett Mather, Jr.*, 1930, no. 10 (North Italian, c. 1500).
References: J. Bean, *Les dessins italiens de la collection Bonnat*, Paris, 1960, nos. 225–237, esp. 225; Winner, "Apollo Belvedere," 186 (*Man Holding a Torch*, ill.), 189 (discussed in relation to other views of the statue); Fogg, *Rome and Venice*, nos. 1–8 (Suzanne Folds: Marcantonio's early engravings); F. Gibbons, *Catalogue of Italian Drawings in the Art Museum, Princeton University*, 2 vols., Princeton, 1977, 164, no. 506 (cf. also no. 505).

53 *Apollo Belvedere* c. 1509–10

Circle of Francesco Raiboloni, called Francia (Bologna before 1453/Bologna 1517)

Drawing; brush with blue ink on paper prepared with blue ground, heightened with white. Inscription on plinth (by a later hand): p. perusin [Pietro Perugino]; upper right (later): 47; near bottom edge (recent): 1475. 25.6 × 17.2 cm.

Staatliche Museen Preussischer Kulturbesitz, Kupferstichkabinett (KdZ. 26135)

This drawing shows the *Apollo Belvedere* before Giovanni Montorsoli furnished the hands and placed a bow in the left hand (1532–33). Since there is no sign of the niche in which the *Apollo* was installed (probably by 1511), the drawing must date to the period after its transfer from the Garden of S. Pietro in Vincoli to the Belvedere garden at the Vatican (1503–9). The statue is seen in profile, the viewpoint originally perceived as its main aspect.

The god appears suddenly, walking before the spectator from right to left and extending the left arm, which probably held the bow, as can be concluded from the quiver on his back. In his right hand he held the laurel branch, fragments of which remain on the tree trunk of the copy. It represents the means of purification of repentant sinners, while the bow threatens to punish the evildoers. The head, despite the cheeks being too smooth and the hairbow being too luxurious in the copy, is beautiful, with its finely shaped large eyes, haughty mouth, and noble profile. Particularly when seen from the side to which it turns, the expression of proud aloofness, eternal purity, and disdain of all base and vile sinners is wonderfully rendered. The movement suggests a sudden epiphany of the god (Bieber, 63).

It was Winner who noted the similarities between this drawing and a group of drawings usually attributed to Francia, including 108. A myriad of small strokes of blue pigment are laid down in a dense texture following the figure's contours. Contrast with the pale body tones lends the image dramatic relief. The white is employed in masterful fashion for highlights; the chlamys and sandalled feet are executed with precision. These areas are carefully contrasted with adjoin-

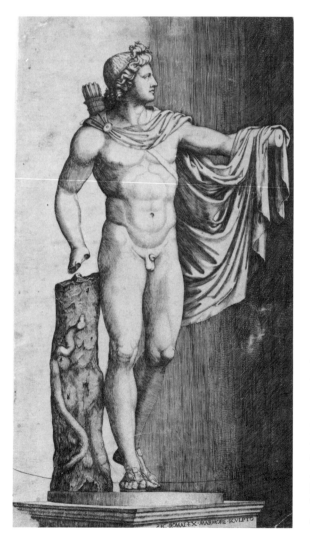

53 (supplement)
Marcantonio Raimondi
The Apollo Belvedere,
 c. 1509–10
Engraving; B. 14, 249, 331.
Inscription below:
ƧIC. ROMAE, EX.
MARMORE.
SCVLPTO.
The Metropolitan Museum
of Art, New York.

ing values to render the figure as unusually sculptural and solid in appearance. The effect is of white marble gleaming against a velvety background. The freshness and immediacy of confrontation with the actual sculpture come through strongly. The statue itself, rather than another drawing, must have been depicted. Yet the drawing's status as a work of art in its own right, far from being a dry copy, is immediately apparent. It exudes the sense of life and vigor that emanated from the antique *Apollo* as seen by artists of this period.

The fact that Francia never visited Rome weakens the attribution (Winner). One might hypothesize that a student of Francia's, schooled in his technique, made the drawing. Marcantonio Raimondi (see 18, 19, 45) is a possibility. The drawing is close to Marcantonio's engraving of the *Apollo Belvedere* (B. 14, 249, 330; 53 suppl.) which represents the statue from exactly the same viewpoint as this drawing and is identical to it in most details. Although the engraving omits the strut connecting the right wrist to the adjacent thigh and exaggerates the musculature of the arms and torso, the drawing could very well have served as the model for it. The presence of the strut in this drawing and two others, despite its absence in the well-known *Codex Escurialensis* view (folio 53), proves that Montorsoli cut off the antique's arm at the elbow in the course of his restoration (Winner). Shortly after World War II the Montorsoli hands were removed and the statue now stands once again in fragmentary form (see 55 suppl.).

Ex collection: Private collection, Munich, 1967.
Exhibitions: Berlin, Staatliche Museen der Stiftung Preussischer Kulturbesitz, Kupferstichkabinett, *Zeichner sehen die Antike,* Feb.-Apr. 1967 (not in catalogue); Berlin, Staatliche Museen Preussischer Kulturbesitz, *Vom späten Mittelalter bis zum Jacques Louis David, neuerworbene und neubestimmte Zeichnungen im Berliner Kupferstichkabinett,* 1973, no. 51 (M. Winner).
References: Beiber, *Hellenistic Sc.,* 63; Helbig, 1, 170–172, no. 226 (W. Fuchs); Winner, "Apollo Belvedere," *passim* and esp. 190–199; Brummer, *Statue Court,* 50ff.

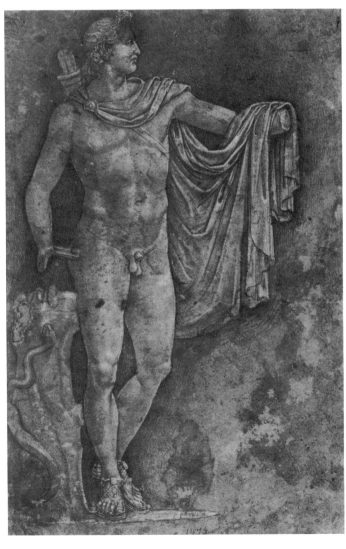

CARMINA

Appofita Pafquillo anno. M.D.xiij.

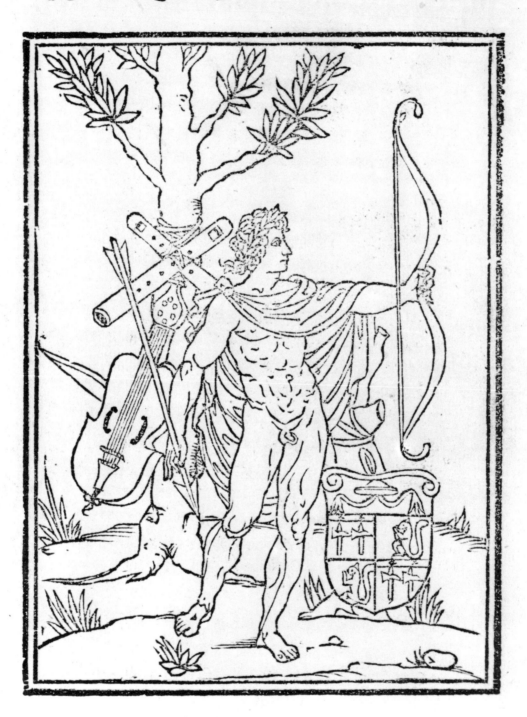

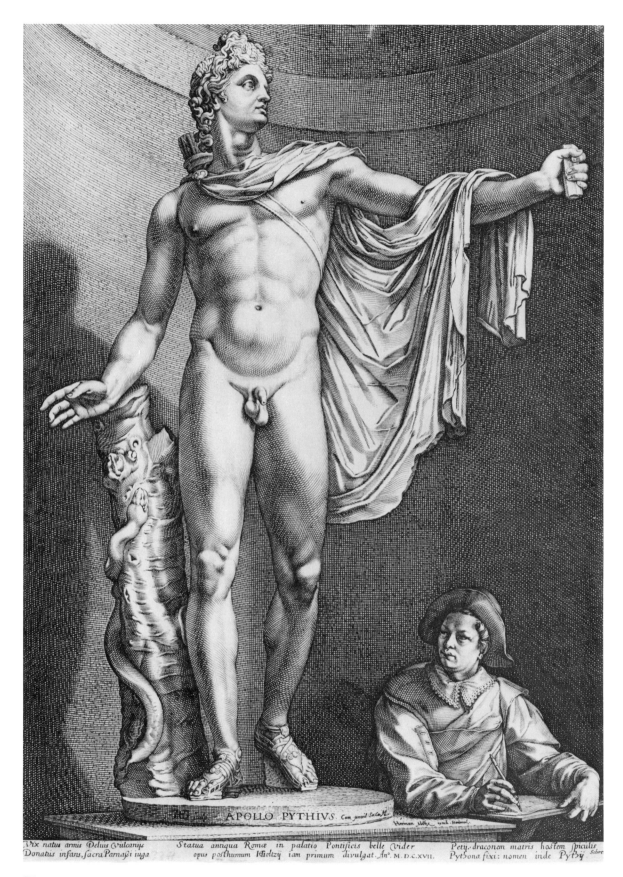

APOLLO PYTHIVS. *Cum privil: Sa:Ca:M*.

Vix natus armis Delius Vulcanijs *Statua antiqua Romæ in palatio Pontificis belle Vider* *Petij. draconem matris hostem spiculis*
Donatis infans, sacra Parnasi iuga *opus posthumum Iscioltzij iam primum divulgat. An°. M.D.C.XVII.* *Pythona fixi: nomen inde Pythij* Schre

55

54 *Carmina apposita Pasquillo anno M.D.xiij* 1513

Pasquino (pseudonym)

Printed book; quarto; Rome, Etienne Guillery and Ercole Nani(?). Woodcut on title-page. Brown morocco. 20.3 × 14.3 cm.

Houghton Library, Harvard University, Gift of Philip Hofer (Typ 525.13.674)

"Pasquillo" and "Pasquino" are nicknames for a fragmentary Menelaus and Patroclus group discovered in 1501 and placed outside the Palazzo Carafa (later Pal. Braschi, now Orsini) in Rome, where it remains today. Each year, as part of the celebration of the feast of St. Mark, the work was decked out in outlandish costume. Verses satirizing ecclesiastical dignitaries and current events ("Pasquinades") were plastered over it and the adjoining walls, as is shown in an engraving published by Lafreri (ill. Mortimer, I, no. 247). Its absurd appearance when thus employed (referred to in the engraving's inscription: "Io non son (como paio) un Babbuino") is in dramatic contrast to the high esteem in which it was held by Michelangelo among others (Fagiolo).

The satirical verses were first printed in 1509. In 1513, when the verses in this volume were collected, the statue was dressed up as Apollo to celebrate the accession to the papacy of Giovanni de' Medici, whose reputation as patron of literature, especially poetry, was encouraging to local poetasters.

The title page illustrates not the *Pasquino* but the *Apollo Belvedere,* with right and left forearm (missing in the original; see 53) restored by the engraver: the left hand holds a bow, as in the Montorsoli restoration of 1532/3, and an outsized arrow. The position of the right arm is changed, making it stand out rather stiffly from the body. The support-stump has been removed and the chlamys greatly enlarged. The statue's weight has been shifted from the right to the left leg (Mortimer), its musculature has been exaggerated, especially in the legs, and its contrapposto simplified. As in Dürer's London *Apollo* the frontal and profile views have been combined. The publication at such a relatively early date of these alterations to the *Apollo Belvedere* suggests that a process of speculative restoration, quite apart from any actual commission to restore the work, must have been relatively widespread.

Ex collections: Victor Masséna, Prince d'Essling (arms on covers, monogram on spine); Philip Hofer.
References: E. Rodocanachi, *La première Renaissance, Rome au temps de Jules II et de Léon X,* Paris, 1912, 153–155; M. Fagiolo, *Pasquino e le pasquinate,* Milan, 1957, xvii; D. S. Chambers, *Cardinal Bainbridge in the Court of Rome 1509 to 1514,* Oxford, 1965, 120–125; Mortimer, II, 525–526, no. 361; ill. (same copy).

55 *Apollo Belvedere* c. 1592

Hendrick Goltzius (Mühlbrecht, near Venlo, 1558/Haarlem 1617)

Engraving; Hirschmann 147; Hollstein 8, 33, 147. Inscription on pedestal: HG Sculp. APOLLO PYTHIUS Cum privil. Sa. Ca. M.; on base: Herman Adolfz. excud. Haerlemens.; in margin below, center: Statue antiqua in palatio Pontificis belle vider/ opus posthumum HGoltij iam primum divulgat. An° M.D.C.XVII.; at right and left: Vix natus armis Delius Vulcanijs/Donatus infans, sacra Parnassi iuga/Petij. draconem matris hostem spiculis/Pythona fixi: nomen inde Pythij. Schrevel. 41.2 × 29.3 cm.

The Metropolitan Museum of Art, Elisha Whittlesey Collection, the Elisha Whittlesey Fund, 1949 (49.97.687)

Hendrick Goltzius had a curious career. He spent his first twenty working years as a printmaker and draughtsman and took up painting only sometime after 1600. He is known for spreading the extreme Mannerism of Bartolomaeus Spranger (99) through a half dozen engravings directly after Spranger's drawings and many more in his style. Goltzius was originally introduced to Spranger's style around 1583 by his friend and fellow artist in Haarlem, Carel van Mander, who, like Vasari, is now known and esteemed more for his compilation of artists' biographies, the *Schilderboek* (1604), than for his own painted work.

Goltzius is also known for his virtuosity. Stechow points out that "the oldest evaluations of Goltzius's art stress his unrivalled position as the greatest virtuoso among the engravers of all time" (Broeder, 9). Six prints of 1593/94 which depict the Life of the Virgin and are known as the "master prints" imitate the styles of Dürer, Lucas van Leyden and several Italian artists. Van Mander praises them at length: " . . . it is most amazing that engravers who thought themselves great experts on the style and technique of those masters were also deceived by this. All of which shows the power of favor and disfavor, as well as of prejudice among men; for in this way, several people who tried to disparage or depreciate Goltzius's art, unwittingly put him above the best old masters and above himself."

In 1590/91 Goltzius made a relatively short trip to Italy following in the footsteps of such Netherlanders of the earlier part of the century as Bernard van Orley, Jan Gossaert, Jan van Scorel and Martin van Heemskerck. Heemskerck was considered the arch-Romanist and had worked closely with Goltzius's own teacher Dirck Volckertsz. Coornhert. His contemporaries Spranger and van Mander had also preceded him in this journey, which had by late in the cinquecento begun to be regarded as a matter of course in a young artist's training.

In Rome Goltzius made many drawings, presumably a larger number than the fifty-four still extant in a so-called "Roman Portfolio" sold, perhaps by Goltzius himself, to the Emperor Rudolf II in 1612 (Reznicek). Most of these are of antique sculpture, including the *Laocoon,* the *Torso Belvedere* and the *Ariadne* known as "Cleopatra". Three were later issued in engravings: the *Farnese Hercules* (100), the *Hercules and Telephos* and the *Apollo Belvedere.*

One Goltzius drawing of the *Apollo Belvedere* is known (Reznicek, no. 208); the present engraving surely derives from it and shows the same point of view. The drawing lacks the figure of the artist sketching and the detailed rendition of musculature and drapery. Doubtless a more detailed intermediate drawing served to prepare the engraving.

Goltzius's drawing and engraving show the restoration carried out by Montorsoli in 1532/33 which raised the tree trunk and supplied both the hands. Comparison with 53 and with Marcantonio's *Apollo Belvedere* engraving (see 53 suppl.) demonstrates the change from High Renaissance to Mannerism that had taken place in the seventy or so years between the two renditions. The Goltzius engraving is nearly three times as large as the Marcantonio. Goltzius chose the angle that provides the widest spread of the arms. This angle, depicted from a low viewpoint, maximizes the dramatic potential of the sculpture. In comparison to the looming marble, the artist sketching in the background looks small, vulnerable and ordinary. There is a distinct note of humor in the contrast, which adds to the print's overall elegance and panache.

This engraving, along with the *Farnese Hercules* (100) and the *Hercules and Telephos,* was not published until shortly after the artist's death in 1617. However, Reznicek (419), and Strauss following him, believe the plates were cut in 1592, not long after Goltzius's return to Haarlem from Italy. Reznicek (201f.) thought that Goltzius's drawings after antique sculpture were made specifically for a series of engravings intended to improve the quality of engravings after antiquities—at that time very low. These three would thus have been left unpublished pending completion of the project. Whatever the intention, no others were ever produced. The three prints have Latin verses in the lower margin by Theodore Schrevelius, rector of the Latin School of Leiden.

Exhibition: Museum of Art, University of Connecticut, *Hendrick Goltzius and the Printmakers of Haarlem,* Apr. 22–May 21, 1972, cat. by F. Den Broeder, with preface by W. Stechow, 48, no. 30.

References: O. Hirschmann, *Verzeichnis des graphischen Werks von Hendrick Goltzius,* Leipzig, 1921, no. 147; F. W. H. Hollstein, *Dutch and Flemish Etchings, Engravings and Woodcuts,* Amsterdam 1948–, vol. 8 (Goltzius, Heemskerck); Reznicek, *Goltzius Zeichnungen,* 1, 201f.,

326, no. 208, 419; C. Van Mander, *Schilderboek,* in W. Stechow, ed., *Northern Renaissance Art, 1400–1600, Sources and Documents,* Englewood Cliffs, 1966, "Hendrick Goltzius," 55; Brummer, *Statue Court,* 50, 71; Dresden, *Dialoge,* 49, no. 53; W. L. Strauss, ed., *Hendrick Goltzius, 1558–1617, The Complete Engravings and Woodcuts,* 2 vols., New York, 1977, 2, 566, no. 314 (with ill.).

—*Suzanne Boorsch*

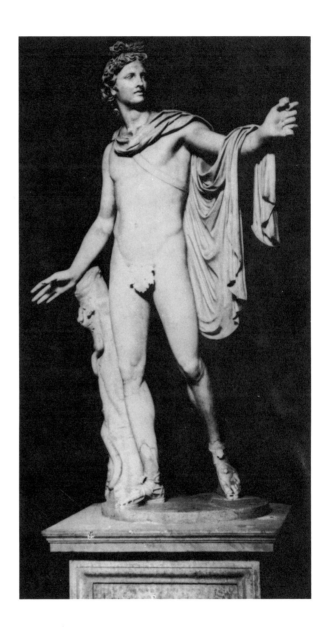

55 (supplement). Roman. *Apollo Belvedere,* 2nd century A.D. (?) (copy after 4th century B.C.? bronze by Leochares, active c. 363–330 B.C.). Marble. Rome, Vatican Museum.

56 *Mars, Venus and Cupid* 1508

Marcantonio Raimondi (Argini, near Bologna, c. 1480/ Bologna 1527–34)

Engraving; B. 14, 137, 345. Signature: MAF [monogram]. Inscription at edge below axe: 1508 16D [16 December]. 30.4 × 21.4 cm.

Yale University Art Gallery, Gift of the Associates in Fine Arts (1941.183)

The figure style of *Mars, Venus and Cupid* contrasts with Marcantonio's earlier drawings (18, 19, 52) and engravings. It represents the stage in the artist's apprehension of antique figural types and poses before he came under Raphael's influence. The engraving, dated 16 December 1508, shows Marcantonio's own classical taste and aspirations. This advanced taste, combined with earlier technical advances, enabled him to find,

for the engraving of Raphael's *Lucretia* (102), an effective technique for translating the plasticity and *gravitas* of Raphael's composition into the print medium.

The figure of Mars in the *Mars, Venus and Cupid* is the earliest dated attempt to reconstruct the *Torso Belvedere,* an antique owned by the Colonna family in Rome at least from c. 1432. Marcantonio must have gained access to the Palazzo Colonna, near the Quirinal Hill, in order to draw the torso for this engraving. A belief grew up that the torso was not discovered until the reign of Pope Julius II (1503–13), probably because "its stylistic influence did not come to the fore until Michelangelo's creativity had opened men's eyes to what its powerfully modelled Hellenistic body could convey" (Bober). This occurred in the period beginning in 1508 when Michelangelo was working on the Sistine Ceiling. There the pose of one of the *Ignudi* incorporated the torsion of the *Torso Belvedere,*

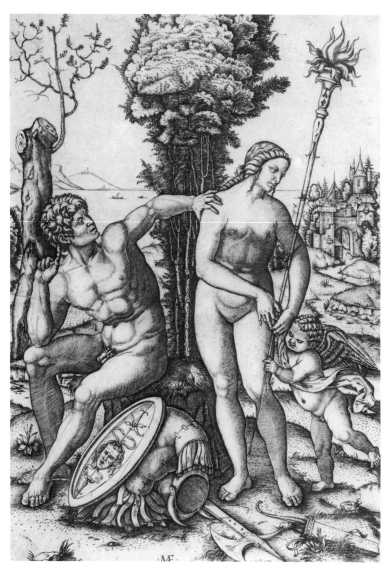

prompting other artists' serious study of that antique fragment. Marcantonio's engraving does not seem to have depended on the Sistine ceiling figure, however. Instead it reflects the *Torso*'s influence on those few connoisseurs of the ancient marbles in Rome whose knowledge of the *Torso* pre-dated Michelangelo's use of it. The date inscribed on the engraving of *Mars, Venus and Cupid* permits this assumption.

The exact date of Marcantonio's arrival in Rome is not known, but he is known to have been there by 1510 and some authorities have stated that he went from Venice to Rome around 1508. Earlier scholars assumed Marcantonio's source for this engraving was a drawing of the *Torso Belvedere* by another artist. Its accuracy and freshness, like that of the Berlin *Apollo Belvedere* (53), testifies instead to first-hand knowledge of the *Torso*. If this inference is correct, the engraving's date of 16 December 1508 provides a *terminus ad quem* for Marcantonio's arrival in Rome.

The source for the Venus and Cupid in the engraving may be a relief showing a nude woman leading a child by the hand on the Tomb of Doge Giovanni Mocenigo in the church of Santi Giovanni e Paolo, Venice, probably carved by Tullio Lombardo with his brother Antonio's assistance (ill. Pope-Hennessy, *IRS*, pl. 137). This relief is related to a woodcut illustrating a scene of liturgy *all'antica* in the *Hypnerotomachia Poliphili* (Pozzi-Ciapponi). Venetian experiences thus remained fresh in Marcantonio's mind. The two (or three) cognate images may have sprung from a common source in antique relief sculpture. If, on the other hand, the Mocenigo tomb relief did serve as a source for this engraving, the date in its inscription could be interpreted as a *terminus ad quem* for the sculpture.

Exhibition: Busch-Reisinger Museum, Harvard, *Dürer and the Decorative Tradition*, March 4–April 3, 1971.
References: H. Delaborde, *Marc-Antoine Raimondi*, Paris 1888, 164–165, no. 119; R. Kautsch, "Michelangelos Zeichnung zu Marcantons Mars, Venus und Amor," *Repertorium f. Kunstwissenschaft*, 22 (1899), 183–187 (earliest mention that Marcantonio's engraving was a reconstruction of the *Torso Belvedere*); F. Saxl, "A Scene from the *Hypnerotomachia* in a painting by Garofalo, *J Warb*, 1 (1937–38), 169–171 (analysis of the *Hypnerotomachia* illustration in relation to classical sources); F. Saxl, "Pagan Sacrifice in the Italian Renaissance," *J Warb*, 2 (1938–39), 346–367; esp. 360–362 (further discussion of *Hypnerotomachia* engravings); Bober, *Aspertini*, 19; Ladendorf, *Antikenstudium*, 31ff; G. Pozzi and L. Ciapponi, eds., Francesco Colonna, *Hypnerotomachia Poliphili*, 2 vols., Padua, 1964, 1, 248; 2, 183 (nude woman leading a child on Giovanni Mocenigo tomb relief likened to *Hypnerotomachia Poliphili* engraving illustrating memorial service for "Valeria loved by all"); Brummer, *Statue Court*, 142–152 (on *Torso Belvedere*); Fogg, *Rome and Venice*, nos. 1–6 (entries by Suzanne Folds; Marcantonio's early engraving style).

57 *Hercules Shooting at the Stymphalian Birds*
c. 1500–1525
Vettore Gambello, called Camelio (c. 1455–60/Venice 1537)
Bronze mounted on rock; dark brown, almost black, patina. 24.8 cm.
The Metropolitan Museum of Art, Gift of C. Ruxton Love, Jr., 1964 (64.304.2)

In the early sixteenth century artists often attempted to reconstruct the original pose or action of fragmentary remains. Many drawings and sculptures give evidence of artists' theories about the position of the arms in the *Laocoon* (61), the *Apollo Belvedere* (49–51), and of the *Torso Belvedere* (see Brummer). This bronze presents one reconstruction of the *Torso*. Yet the famous fragment remained unrestored throughout the Renaissance.

Unlike the Mars in Marcantonio's engraving (56), in which the twist arises from the relatively simple action of turning, in this bronze the sculptor visualizes the torsion as necessitated by the physical act of shooting a bow. Note that the actual forms of the musculature, even the area around the collarbone and tendons of the neck, are rendered in a similar manner in both 56 and the bronze *Hercules Shooting at the Stymphalian Birds*, and that both closely resemble the actual torso.

The torso's identification as a Hercules goes back to a commentary, attributed to Cyriacus of Ancona, dealing with the statue's inscription. All the reconstructions except Marcantonio's (56) present the statue as Hercules. The attribution of this bronze to Camelio is based on its resemblance to the taut, muscular figures with similar facial types and proportions but more impressionistic modeling, in the Cà d'Oro relief of the *Battle of the Giants*. This relief was originally part of Camelio's funerary monument in the church of the Carità, Venice. *The Battle of the Giants* is not only signed "O. VICTOR CAMELIUS" but is also a work of substantial size (38.2 × 56 cm.), thus offering a better touchstone around which to group works by Camelio than is provided by the reverse of his self-portrait medal (84 rev.). Langenskiöld compared the *Hercules* to the so-called *Hercules assessato*, another bronze reconstruction of the *Torso Belvedere* from a slightly earlier date, at Brunswick. He found the present bronze to be better proportioned and modeled with greater assurance and a clearer grasp of anatomy. It not only demonstrates the way in which Renaissance artists learned anatomy from antique works but also communicates the artist's understanding of the inherent expressiveness of the heroic torso.

Ex collection: Walter von Pannwitz, Berlin.
Exhibitions: Metropolitan, *Northern Italy 1440–1540,* no. 22.
References: Bode, 3, pl. 237 (attr. Antico); O. von Falke and W. von Pannwitz, *Die Kunstsammlung von Pannwitz,* 2: *Skulpturen und Kunstgewerbe,* Munich, 1925, 2, no. 15, pl. 36; E. Langenskiöld, "Torso di Belvedere," *Acta Archaeologia,* 1 (1930), 121–146; A.

Andrén, *Il Torso del Belvedere,* Lund, 1952 (Institutum Romanum Regni Sueciae, Opuscula Archaeologica, 7), 1–45, esp. 11ff. (Pannwitz *Hercules* is no. 4, p. 12); Ladendorf, *Antikenstudium,* 31ff.; Pope-Hennessy, "Statuettes," 22–23 (Camelio); Brummer, *Statue Court,* 142–152 (up-to-date information and bibliography on *Torso Belvedere);* R. Stone, personal communication, December, 1977.

On exhibit
Gallery 57
Case C

57

58 *Torso*

Late Hellenistic or Roman

Terra cotta; molded in two pieces and joined. 9.2 × 4.7 × 2.8 cm.

Collection of Phyllis Williams Lehmann

What remains of this terra cotta is the nude torso of a muscular man leaning strongly toward his left. The front and back of the hollow body were made in a two-part mold and joined along the sides. The missing head was molded separately and joined to the body before baking, probably with a film of the same wet clay used to make the figure. Possibly other missing parts were also separately molded (Higgins). Some of the modeling of the torso was reinforced by tooling, notably with the *linea alba* on the upper abdomen and the spinal furrow. In its original state the figure would have been gilded or painted, but no trace of color remains.

The figure stood with its weight on the right leg. The right arm hung down, although its precise position is not certain. The left arm was somewhat raised at the shoulder, but this arm also may have hung down; the muscles at the top of the shoulder do not seem to be as sharply contracted as they should be if the arm were raised high, as in a dance. It seems more likely that the figure was supported on its left side by a prop under the armpit, although no certain scar from any element can be discerned. An unexplained strip of clay on the back of the left shoulder may have been connected with such a missing part.

It has been suggested that this torso was part of the figure of a satyr, but such a mature, athletic torso leaning heavily to one side immediately recalls a type of Herakles who stands at rest with his club, cushioned by the lionskin, supporting him under his left arm. These figures echo a famous work by Lysippos which was widely copied and adapted, in all sizes and all media, throughout the Hellenistic and Roman worlds (Johnson; Vermeule). The present figurine may imitate a Hellenistic interpretation of the original of the fourth century B.C. The front and back of the torso do not seem perfectly harmonious, as they should if the statuette follows a masterwork. The modeling of the front of the body is rather linear and almost patterned, while the back is richly worked in undulating masses. A similarly undigested style has been noted elsewhere in a marble copy of a male figure presumed to have been of the second century B.C. (Ridgway), and it seems possible that this dichotomy may duplicate the stylistic uncertainty of some Hellenistic sculptures, rather than that of scattered later copyists.

Whether or not the figure represents Herakles, it surely reflects, if at some distance, the style of Lysippos. Although it is not known where this piece was found, its style and its clay show it to be a product of the workshops of Smyrna on the coast of Asia Minor. During the first century B.C. and the first century A.D.,

these establishments made a specialty of clay figurines of strongly sculptural appearance. The backs of the figures were worked in as much detail as the fronts, a rare occurrence in other centers of manufacture. The statuettes were usually gilded, giving the appearance of new bronze figurines, and were often small scale imitations or adaptations of famous sculptures. Works by Polykleitos and Lysippos can be recognized, and Herakles is frequently represented (Besques; Higgins).

It is not known whether terra cottas from Smyrna have ever been found west of Greece, and in any case, it is extremely unlikely that any of them came to the attention of any artist during the Renaissance. The coroplasts of Smyrna, however, catered to the widespread appetite for replicas which has left Italy strewn with similarly inspired sculpture which was often similarly truncated when it was discovered.

References (unpublished): F. P. Johnson, *Lysippos,* Durham (North Carolina), 1928, 197–212; R. A. Higgins, *Greek Terracottas,* London, 1967, 110–112; S. Besques, *Catalogue raisonné des figurines et reliefs en terre-cuite, grecs, étrusques et romains,* 3, Paris, 1972, 153–156; B. S. Ridgway, *Classical Sculpture: Catalogue of the Classical Collection, Museum of Art, Rhode Island School of Design,* Providence, 1972, no. 25; C. C. Vermeule, "The Weary Herakles of Lysippos," *AJA,* 79 (1975), 323–332.

—*Elsbeth Dusenbery*

59 *Apollo or Hercules* c. 1500–1530
Tuscany or Central Italy
Coarse-grained Italian marble. 116.1 cm.
Yale University Art Gallery, Gift of Gallery Associates
(1961.26)

When it was acquired this life-sized torso was thought to be antique. Since then a consensus has gradually arisen that the work is not antique but belongs instead to the Italian sixteenth-century Renaissance. The pose is a pronounced contrapposto, with the right hip, corresponding to the weight-bearing leg, thrust out. The left hip is lower and the left thigh brought forward and turned slightly outward. The sinuous S-curve described by the hip and upper torso recalls fourth-century prototypes rather than the more solid ponderation of Polykleitan works (cf. 30, 31).

The rather massive right arm is held close to the body. It rests against a mass of cascading parallel waves which resemble liquid as carved in stone. It is difficult, however, to identify this passage or associate it with any particular material. If it were part of a lion skin, for example, the statue would be identifiable as a Hercules but the texture does not resemble a lion skin. The rippling waves stop short at the hip and do not continue behind the arm, where an undifferentiated section of the marble creates further uncertainty about what is being represented.

The diagonal strap across the chest is not attached to a quiver, but once might have been before the damage to the area above the left hip was sustained. In back, a voluminous cascade of drapery falls from the top of the right shoulder, ending in a tube-like roll on one side and a series of zigzag folds on the other. The large loss at the left hip obscures the resolution of this drapery. The damage near the right shoulder likewise makes impossible any logical connection between the drapery in back and the graceful swath that curves forward around the right shoulder.

There is a curious contrast between the anatomical knowledge and technical skill evident in the carving of the torso on the one hand, and the inconsistent, botched character of the carving in the drapery on the other. Though the gathers of the material around the right shoulder are gracefully arranged, the garment itself is not functional nor can it derive directly from any antique prototype.

There is no way of knowing whether or not this torso was once a complete figure, but its pastiche-like quality suggests that it was created as a fragment under the spell of antique fragments like the *Torso Belvedere* or the *Narcissus* torso restored as a *Bacchus and Ampelos* by Giovanni Caccini in the late sixteenth century (Uffizi). If we suppose that the figure was originally whole, several questions arise. The neck has been smoothed down and a dowel hole inserted, apparently to hold a replacement head. What then happened to that head? And why was the left shoulder, by contrast, left rough? If, on the other hand, we think of the work as a pseudo-antique fragment, fewer questions of this

sort arise. Its awkwardnesses are more understandable as a result of haste and, perhaps, an undiscriminating market. The dowel hole might have been inserted relatively recently by a dealer intending to restore the piece as an antique. The normal wear on the surface possibly resulting from exposure to the out-of-doors, may be accompanied by intentional minor damages to make the work look antique.

The torso's style relates to the beginning of Mannerist sculpture. The hipshot stance, the fluid curve, the detailed rendering of musculature, the undulation of the ribs and soft protruding lower abdomen, all recall Michelangelo. The boyish softness of the flesh brings to mind the *Bacchus* of 1496–97. Another work that might have served as a source was Michelangelo's lost *Hercules* of 1492–94. One theory about what that *Hercules* may have looked like stems from a Rubens drawing in the Louvre. A second source of information is a Du Cerceau sketch of a fountain by Primaticcio which possibly had incorporated the *Hercules* (Paris, Petit Palais), and a third is a seventeenth-century engraving of the statue as it stood in the Jardin de l'Etang, Fontainebleau (Joannides). The *Hercules* apparently imitated the crossed-leg motif of the Belvedere *"Mercury"* (Uffizi) and the *Farnese Hercules* type—known from small-scale replicas from c. 1500—in a pastiche of well-known Hellenistic, especially Lysippan, sources. If his *Hercules* did in fact employ the cross-legged motif from the *"Mercury"*, Michelangelo must have known that work from a replica or a drawing since it did not come to Florence until 1550. The animation of the present torso, with its incipient spiral and diagonal opposition of the shoulder to the hip axis, reveal an attempt to move beyond fifteenth-century modes of contrapposto. In this it resembles the wax model in the Casa Buonarroti that de Tolnay associated with Michelangelo's *Hercules*.

The Hercules was owned by the Strozzi family in Florence until 1529 when the family's agent, Agostino Dini, apparently sold it to Giovanni Battista della Palla, the agent of François I, who sent the statue to France in 1530 or 31. Though knowledge of the *Hercules'* history in France is scanty, Henri IV seems to have transported it to Fontainebleau for the Jardin de l'Etang. There a new base was made for it, probably in 1594 after Henri IV had come to the throne. Hence the years when its impact could have been significant on the sculptor of our torso can be narrowed down to the period from 1503 (before which its fame may not have been great) to 1530/31. This span of years coincides with the time framework suggested by the torso's style.

Ex collection:[Arcade Gallery, London, 1961].
References (unpublished): Mansuelli, *Uffizi,* 50–51, no. 27 (Belvedere *"Mercury"*), 147, no. 117 (*"Narcissus"* torso reconstructed as *Bacchus and Ampelos* [or *Dionysus and a Satyr*]); C. de Tolnay, "L'Hercule de Michel-Ange à Fontainebleau," *GBA*, 6. per., 64 (1964), 125–140; S. A. Nodelman, personal communication, 1968; Yale University Art Gallery file, opinion of C. C. Vermeule (Mannerist sculpture—one of the Windsor

Great Park sculptures by Francavilla?) 1974; K. Weil Garris, personal communication, November 1976 (Mid-sixteenth-century Mannerist, shows influence of Michelangelo, work made in haste); E. Pillsbury, personal communication, February 1977 (early to mid-sixteenth-century Mannerist, before Giovanni Bologna); P. Joannides, "Michelangelo's Lost Hercules," *BM*, 119 (1977), 550–554 (summarizes recent literature and proposes specific cross-legged type for the *Hercules*).

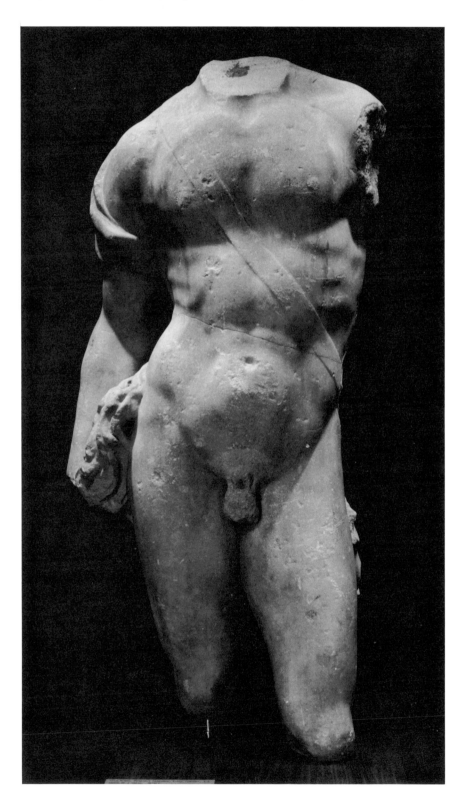

60 *Laocoon* c. 1520–25

Marco Dente, called Marco da Ravenna (Active 1515/1527)

Engraving; B. 14, 268, 353; P. 6, 70, 47. Signature: MRCVS RAVĒNAS. Inscription: LAOCHOON [and] ROMAE IN PALATIO PONT IN LOCO QVI VVLGO DICITUR BELVIDERE. 47.8 × 33 cm.

Museum of Fine Arts, Boston, Harvey D. Parker Collection (P1331)

This engraving of the Laocoon group conveys the intense excitement that accompanied the discovery of antiquities in Rome during the papacies of Julius II (1503–13) and Leo X (1513–21). It is often referred to as a completely accurate transcription of the fragmentary form in which the group appeared when discovered in 1506. The right arms of Laocoon and his dying younger son are shown broken off at the shoulder, with fingers missing from the right hand of the elder son at right. The snakes' coils linking Laocoon to his younger son are also missing. The head of the snake that bites Laocoon's hip has been elaborated according to the engraver's fantasy, however (Vergara Caffarelli).

The discovery of the *Laocoon* created an immediate sensation among the members of Rome's artistic and cultural elite. Pope Julius II sent Giuliano da Sangallo to examine the work. Giuliano took with him his son Francesco, a boy of eleven, as well as Michelangelo, then in Rome to work on the pope's tomb. Sixty-one years later Francesco wrote in a letter:

We went down to where the statues were: suddenly my father said, "That's the *Laocoon* Pliny talks about!" They were excavating the hole to get the statue out; the moment we saw it, we started to draw, all the time talking about antique works, discussing the ones in Florence as well. (Italian original quoted by Brummer.)

The passage in Pliny that Giuliano da Sangallo and others immediately recalled described how the *Laocoon* exemplified a work of art created by more than one person (in this case Hagesandros, Polydoros, and

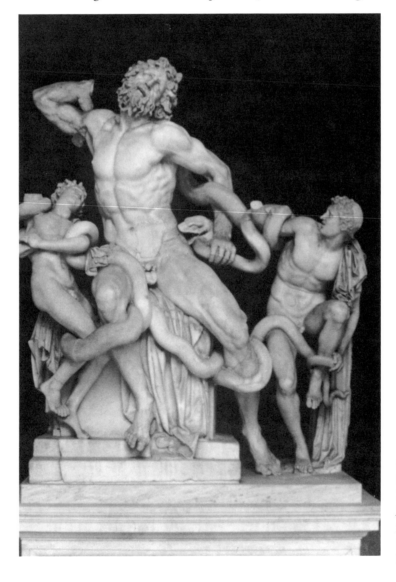

60 (supplement)
Late Hellenistic or Roman
Laocoon, 2nd century B.C.–1st century A.D.
Marble.
Rome, Vatican Museum.

Athenodoros of Rhodes), to the detriment of individual fame (*Nat. Hist.*, 36, 37). The pope acquired the sculpture on 23 March 1506; by 1 July it had been set up in the newly created statue court in the Belvedere. The engraving shows the group after it had been mounted on a pedestal (Brummer).

The graphic medium's potential for rendering the hardness of marble surfaces, its planes that are at once spatially defined and chiaroscural, its creation of "a rhythmic pattern on the surface dissolving the suffering in a final harmony" (Tolnay), are brilliantly realized by Marco Dente in this engraving. The Boston Museum's impression, though worn, was made when the plate was relatively new and preserves much of the print's original strong plasticity and vigor of modeled contrasts.

Ex collection: H. F. Sewall (mark on verso, Lugt 1309).
Exhibition: Fogg, *Rome and Venice*, no. 34 (entry: John Spike).

References: Thode, 13–16, no. 35; Ladendorf, *Antikenstudium*, 37–40; A. Prandi, "La fortuna del Laocoonte dalla sua scoperta nelle Terme di Tito," *Rivista dell'Istituto Nazionale d'Archeologia e Storia dell'Arte,* n.s. 3 (1954), 78–107; E. Vergara Caffarelli, "Studio per la restituzione del Laocoonte," *ibid.,* 29–69; Bober, *Aspertini,* 61–62 (list of drawings and engravings of Laocoon, unrestored and restored; drawing by Filippino Lippi for the fresco in the entrance hall of the Medici Villa at Poggio a Caiano, Uffizi inv. 169, is not included since the date of Lippi's death, 18 April 1504, precludes his having known the famous Laocoon group, which thus cannot have been among his sources for this composition [see P. Halm, "Das unvollendete Fresko des Filippino Lippi in Poggio a Caiano," *Mitt Flor,* 3, pt. 6 (1931), 393–427]); Magi, *Laocoonte, passim;* Bieber, *Hellenistic Sc.,* 134–135; P. H. von Blanckenhagen, "Laokoon, Sperlonga und Vergil," *Archäologischer Anzeiger,* 3 (1969), 256–275; Brummer, *Statue Court,* 75–119.

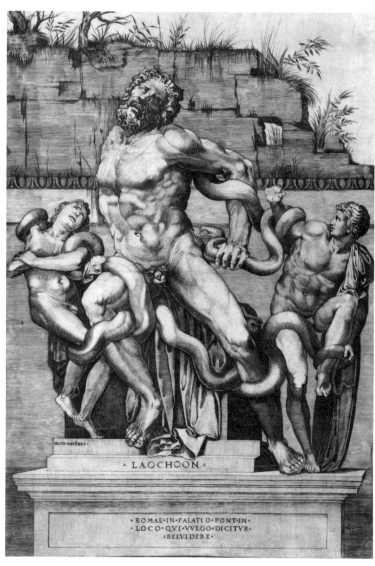

61 *Laocoon* c. 1510–50

Italy, Florence or Rome

Bronze (heavy hollow cast) with hand-hammered surface; brown patina with traces of black paint. 31 cm.

Private collection

This fine bronze is a reduced replica of the Vatican *Laocoon*. No general agreement exists as to whether the Vatican group, variously dated between the second century B.C. and the Augustan era (27 B.C.–A.D. 14), or possibly somewhat later, is itself an original or a copy. If it is a copy, the original on which it is based may have included only the priest and his younger son (von Blanckenhagen). In the bronze, Laocoon's right arm is raised, bent at right angles at the elbow by the effort to extricate himself from the serpent. This gesture breaks the diagonal set in motion by his left leg and, in continuing the direction of the younger son's arm, implies a more self-contained contour for the group than in Giovanni Montorsoli's terra-cotta restoration (1532–33). The many subsequent campaigns of restoration and reinstallation of the *Laocoon,* beginning with that of Cornacchini (1725–27), followed Montorsoli's solution to the problem of the missing right arm—almost fully extended and following the diagonal of the left thigh. Montorsoli's restoration was removed so that Primaticcio could make a bronze cast of the original for François I (Louvre, Gallerie Mollien, inv. 819, commissioned 1540). Judging by Beatrizet's engraving (B. 15, 264, 90, omitting the son's arm) Montorsoli's restorations seem to have been re-adapted later. Analysis of the muscles of Laocoon's back shows that the figure could never have been intended to hold that position; its greater overt drama, however, appealed to Mannerist and eighteenth century taste. In 1905, Laocoon's original right arm, completely flexed and with remains of the snake coiled around it at the shoulder and wrist, was discovered in Rome by Pollak. This arm was reattached to the body during the 1957–60 restoration by Magi, in which traces of adhesives were also removed.

The practice of making bronze replicas of classical antiquities is recorded as early as the end of the first decade of the sixteenth century. Soon after Jacopo Sansovino arrived in Rome, Bramante had a number of artists make wax models of the *Laocoon* and asked Raphael to judge which was the best. Sansovino's entry won the contest, was cast in bronze (now lost) and later highly valued by collectors (Vasari, 7, 489–90; cf. 40). These models were not simply copies but interpretations of the original, in which solutions were suggested for the missing parts.

A marble relief of *Vulcan's Forge* by Antonio Lombardo, made for Alfonso d'Este of Ferrara around 1508, is commonly regarded as one of the earliest reflections of artists' knowledge of the *Laocoon*. It showed Vulcan's arm in a flexed position similar to the elder priest's in the original (Pollak). A figure disappearing behind Vulcan corresponds in its similarly flexed elbow to the arm of the younger son in a position now thought to be the original one. Hence the Renaissance anticipated the twentieth century's discovery of the correct solution to the problem of Laocoon's arm. Perhaps Sansovino's model had also shown the flexed position.

Other sixteenth-century drawings, engravings and sculptures testify to the existence by the 1540s of at least four schools of thought on the correct restoration of the priest's arm: flexed (Sansovino?; Antonio Lombardo); almost fully extended (Montorsoli), and two intermediate possibilities. In one, the forearm is parallel to the inclination of Laocoon's head (the post-1540 "non finito" arm traditionally ascribed to Michelangelo and attached to the statue's base at the back). Baccio Bandinelli, in his full-scale marble version of the group commissioned by Leo X (1520–25) had already realized that Laocoon's arm had to be bent. He made the forearm vertical and angled the upper arm sharply back. The present bronze shows a variant of the Michelangelesque arm attached to the torso at a steeper angle. Yet another bronze of approximately the same dimensions, in the Museo Nazionale, Florence, also incorporates the Michelangelesque arm (ill. Magi, pl. 14, 1). The relationship of these two bronzes to Montorsoli's and Michelangelo's solutions to the restoration problems does not necessarily imply a post-1533 or post-1540 date. Since Michelangelo is known to have begun study of the *Laocoon* in 1506, his idea arose at least as early as Bandinelli's, and may have been the source followed in the version shown here and the one in the Museo Nazionale.

References: L. Pollak, "Der rechte Arm des Laokoon," *Römische Mitteilungen,* 20 (1905), 277 f.; G. De Nicola, "Notes on the Museo Nazionale of Florence, II," *BM,* 29 (1916), 363–373 (bronze replica of *Laocoon* made for Cardinal Ferdinando de' Medici by Pietro da Barga, with arm following Montorsoli's restoration); A. Prandi, "La fortuna del Laocoonte dalla sua scoperta nelle Terme di Tito," *Rivista dell'Istituto Nazionale d'Archeologia e Storia dell'Arte,* n.s. 3 (1954), 78–107; G. Jacopi, "Gli autori del Laocoonte a la loro cronologia," *Archeologia Classica,* 10 (1958), 160–163; S. Howard, "On the Reconstruction of the Vatican Laocoon Group," *AJA,* 63 (1959), 365–369; Magi, *Laocoonte, passim;* M. Bieber, *Laocoon, the Influence of the Group since its Rediscovery,* Detroit, 1967; P. H. von Blanckenhagen, "Laokoon, Sperlonga und Vergil," *Archäologischer Anzeiger,* 3 (1969), 256–275; Brummer, *Statue Court,* 75–119; C. M. Havelock, *Hellenistic Art,* London, 1971, 149–150; W. Oechslin, "Il Laocoonte o del restauro delle statue antiche," *Paragone,* 25, no. 287 (1974), 3–29 (bibliography in footnotes).

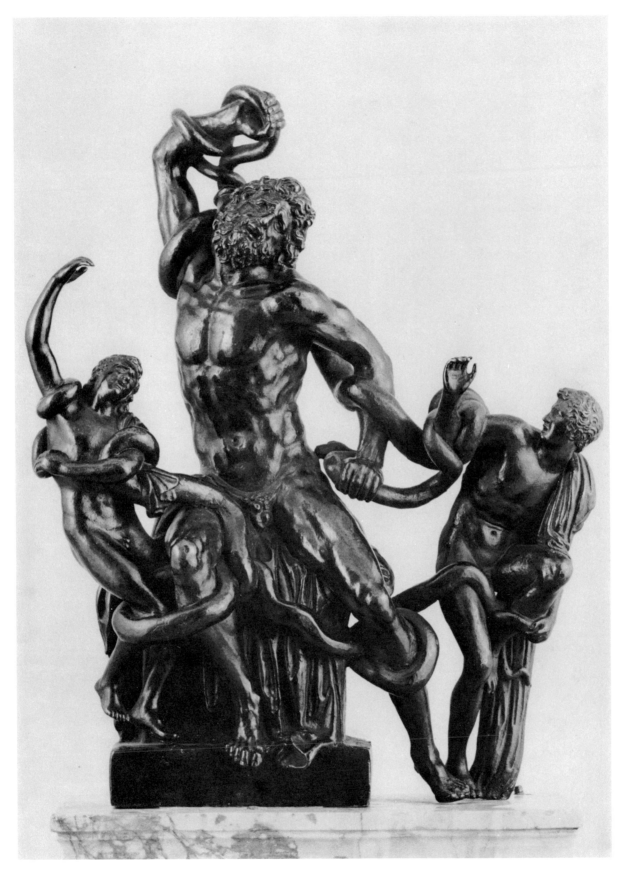

61

62 *Study of Laocoon* c. 1515–50
Central Italy
Drawing; red chalk. 18.1 × 9.4 cm.
Private collection

This red chalk drawing of the elder priest in the *Laocoon* group records the artist's careful study of the torso's musculature and the contrasting diagonal axes of hips and shoulders that underlie the figure's writhing movement. The anatomy of this unusually strong body struggling against superior force becomes in the sixteenth century a vehicle for the expression of pathos. It is rendered here with carefully graded modeling that avoids extremes of highlight and shadow in favor of accurate description of the groups of intercostal and abdominal muscles.

The viewpoint chosen for the drawing is ambiguous. Laocoon's left side, hip and thigh are shown from slightly to the right. Far more of that side is visible than when the sculpture is viewed frontally. Yet the relatively complete rendering of the torso's right side suggests that a viewpoint further to the observer's left was also incorporated. The torso's breadth thus appears greater in relation to its length than is true in the antique work. The tilt of the head has been increased to add to the expressiveness of contrasting angles, and the hair has been simplified, possibly to avoid the necessity of deep shadows that would disrupt the drawing's narrow range of values.

Laocoon as rendered here is far more fragmentary than the actual antique: his legs and left arm have been cut off close to the points at which the snake twines around them. On the other hand, parts of the upper arm have been added, albeit very faintly, to the breakpoint at the right shoulder. Perhaps the fragmentary nature of the *Torso Belvedere* has influenced the artist in this conception of the *Laocoon* in which the figure has been so dramatically reduced.

Ex collections: [Alister Mathews, Bournemouth(?)].
(Unpublished)

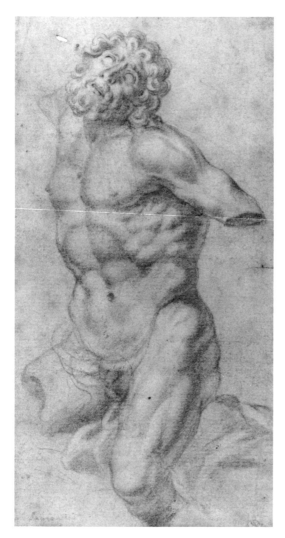

62

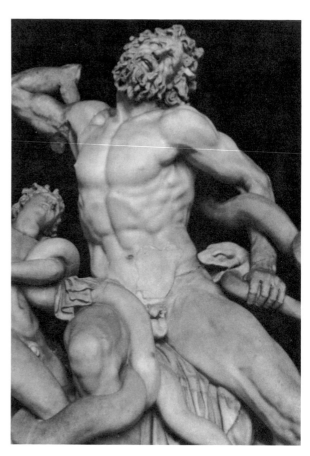

62 (supplement). Late Hellenistic or Roman. *Laocoon* (detail), 2nd century B.C. Marble. Rome, Vatican Museum.

63 *The Flagellation of Christ* c. 1506–25

Moderno, Galeazzo Mondella? (North Italy, Verona?, active c. 1500, in Rome by 1506?)

Bronze plaquette (solid cast); blackish-brown lacquer with natural brown patina where rubbed on Christ and Flagellator. 15.4 × 11.2 cm.

Private collection

This relief belongs to a series of reduced versions, possibly from Moderno's own model, of the original signed silver parcel-gilt example in Vienna, one of the great masterpieces among Italian plaquettes. In it Christ is tied to a central column with his right arm bent over his head and his left arm behind his back. On the left a horseman, whose horse's head and mane recall those of the Cleveland *Fall of Phaeton* (91) attributed to Moderno, repeats with upraised, bent arm the motif of Christ's arm. High round arches receding on each side, like those in an engraving by Giovanni Antonio da Brescia dated 1509 but brought into conformity with Bramantesque architectural style, suggest a vast hall. Some variants, like this example, show the arches on the right broken, an allusion to the Old Order destroyed by Christ; in others the arches are intact.

The dynamism of Moderno's composition shows his links with stylistic developments in Rome during 1509–17. Dating the piece to this period is consistent with the plaquette's place in the series of signed Moderno reliefs. We know from remarks made in 1549 by the Portuguese painter, Francisco Hollanda, that Moderno was active as a medal engraver in Rome in the first half of the sixteenth century.

It is often noted that the figure of Christ is dependent on Laocoon, and the right-hand flagellator on one of the Quirinal *Dioscuri* (see 48). Alternatively, Planiscig saw the source for the flagellators as a statue in the Palazzo Medici-Madama courtyard, known through a Heemskerck drawing. Pope-Hennessy felt that Marco Dente's engraving of c.1520 (60) could have provided Moderno with knowledge of the *Laocoon,* and further that Marcantonio's *Massacre of the Innocents* (45) could have supplied the other major figures. On the other hand, the achievement of fully realized three-dimensionality within so small a format can be interpreted as suggesting first-hand knowledge of the antique sculptures in Rome. Such familiarity would also help to explain the more skillful composition and rendering of dynamic figural movement evident in the *Flagellation* as compared to Moderno's earlier plaquettes, like *Hercules and the Oxen of Geryon* that was adapted for one side of an inkstand (124). Pope-Hennessy associated this shift in style with a conversion from the style of Mantegna to that of Marcantonio. However, such a conversion was unlikely to involve so profound a mastery of the antique sources had it been effected solely through the study of engravings.

Moderno's Christ contributed an important idea to contemporary reconstructions of the *Laocoon.* The position of his right arm is close to the position favored by Michelangelo as the correct one for Laocoon's arm (see 61), a reconstruction somewhat different from that actually put into effect by Montorsoli in 1532–3.

The idea of deriving a figure of Christ in the flagellation scene from *Laocoon* was a powerful invention in complete harmony with the artistic environment in Rome. Moderno likens the passion of the suffering priest, who is sacrificed to ensure the survival of the Trojan race, to the expiatory suffering of Christ. In so doing he demonstrates the way in which a Renaissance artist could employ a highly expressive late Hellenistic style to endow a representation of a Christian subject with intense emotional power.

Ex collection: [Michael Hall Fine Arts, to 1977].
References: L. Planiscig, *Die Bronzeplastiken* (Vienna, Kunsthistorisches Museum) Vienna, 1924, nos. 408, 410; Magi, *Laocoonte,* 46–50, pl. XLIX; Pope-Hennessy, *Plaquette,* 69–71; Pope-Hennessy, *Kress,* no. 134; Brummer, *Statue Court,* 111–113; Cleveland, *Ohio Bronzes,* 33, 34 (*Flagellation* plaquettes owned by Cleveland Museum and Heinz Schneider, entry by William Wixom).

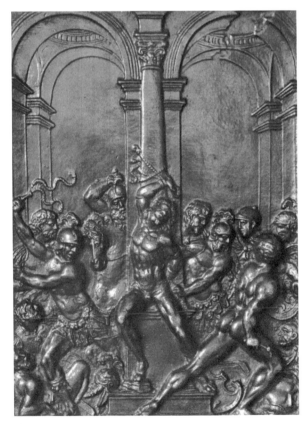

63

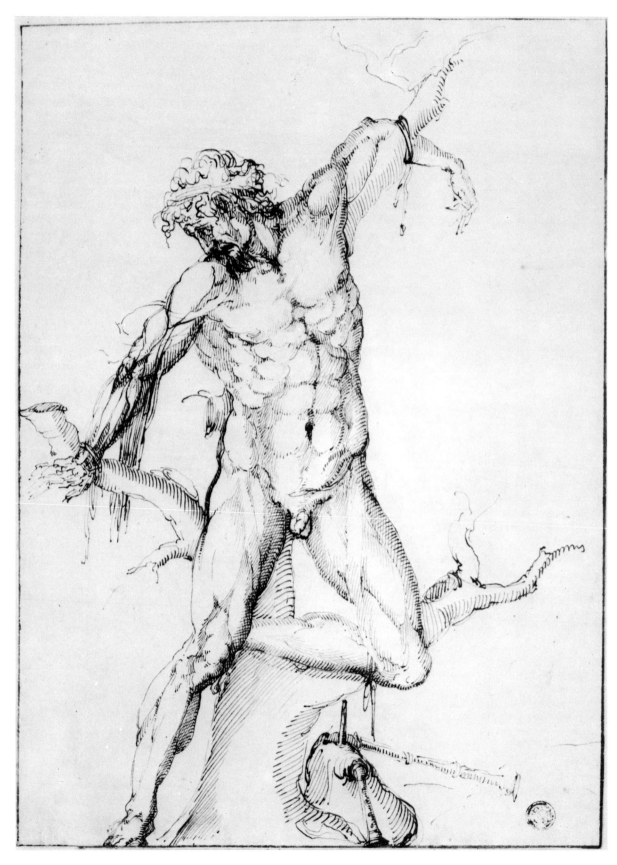

64

64 *Marsyas* c. 1520–c. 1530

Circle of Baccio Bandinelli (Florence 1493/Florence 1560)

or Benvenuto Cellini (Florence 1500/Florence 1571)

Drawing; pen and dark brown ink. 28.4 × 20.5 cm.

The Art Institute of Chicago, The Leonora Hall Gurley Memorial Collection (1922.16 R/28)

The story of Marsyas, told by Ovid (*Metamorphoses,* 6, 382–400) and others, became popular in the Renaissance and was illustrated by many paintings such as Raphael's on the ceiling of the Stanza della Segnatura. There Raphael turned to the well-known sculptural type in which Marsyas is tied to a tree with both hands above his head, his body rigidly compressed into a vertical, stressing his powerlessness in the face of Apollo's revenge.

In this drawing Marsyas is presented in a pose divorced from the tradition one would expect in a Renaissance presentation of the scene. His physique is not at all that of a satyr. Instead it has much in common with Baccio Bandinelli's marble version of the *Laocoon.* Indeed, when reversed, a preparatory drawing attributed to Bandinelli in the Uffizi (ill. Prandi, fig. 6) provides an almost exact model for the Chicago *Marsyas.* Both drawings show the heroically-proportioned torso, curving along the same central axis, with a similar expansion and twist of the upper torso. The musculature is similarly schematized in the two compositions and reflects the same basic conception of underlying shapes. The join of the upward-reaching arm to the shoulder and the contours of the extended legs and torso are also alike. Both heads are inclined in a direction opposite that of the torso; in the Chicago drawing Marsyas's head differs from Laocoon's in being turned to allow the figure to stare aghast at his flayed arm. The curving branches of the dead tree correspond to the coiling bodies of snakes. The satyr's left knee, bent in a position favored by some artists for Laocoon's right arm, relates to a less familiar Laocoon composition, known from a manuscript tradition, in which the priest is shown with arms outstretched, partially kneeling on an altar.

Baldwin has pointed out the logic of choosing as a model for a depiction of Marsyas's punishment a well-known episode in which a mortal dies horribly to propitiate a god's wrath. Yet other, more authentic, antique sources for a flayed Marsyas were obviously available to the artist. His rejection of them points to the power of the spell cast over both artists and patrons by Michelangelesque-Hellenistic muscular exaggerations of torso and shoulders. By the 1520s, heroic anatomies in stressed or contorted poses had become metaphors for anguish. Renaissance artists, moreover, interpreted the Marsyas episode in a Neoplatonic sense as "a tragic ordeal of purification by which the ugliness of the outward man was thrown off and the beauty of his inward self revealed" (Wind). Marsyas, thus en-dowed with the nobility of Laocoon, could reflect an exalted visual prototype in preference to a more authentic one. Something of this same process informs the depiction of Marsyas in a painting recently attributed to Michelangelo Anselmi (Brown).

The clearly defined planes articulated in short, slightly curving parallel strokes suggest the hand of a sculptor. It is not known whether the drawing was a project for a sculpture or painting, or was simply an invention exploring this unusual possibility for adapting the physique and pose of Laocoon. Uncertainties of draftsmanship would seem to exclude the hand of Bandinelli himself.

Ex collections: Dr. William Ogle; Leonora Hall Gurley, 1922.

References: A. Prandi, "La fortuna del Laocoonte dalla sua scoperta nelle Terme di Tito," *Rivista dell'Istituto Nazionale d'Archeologia e Storia dell'Arte,* n.s. 3 (1954), 78–107; E. Wind, *Pagan Mysteries in the Renaissance²,* N.Y. 1968 (paper), "The Flaying of Marsyas," 171–176; E. Winternitz, *Musical Instruments and their Symbolism in Western Art,* London, 1967, "The Curse of Pallas Athena," 150ff.; R. Baldwin, "Marsyas," notes for a catalogue entry on the drawing, 1976, unpubl., Art Institute of Chicago, Dept. of Drawings and Prints; D. A. Brown, "An Apollo and Marsyas by Anselmi," *Antologia di Belle Arti,* 1 (1977), 2–6.

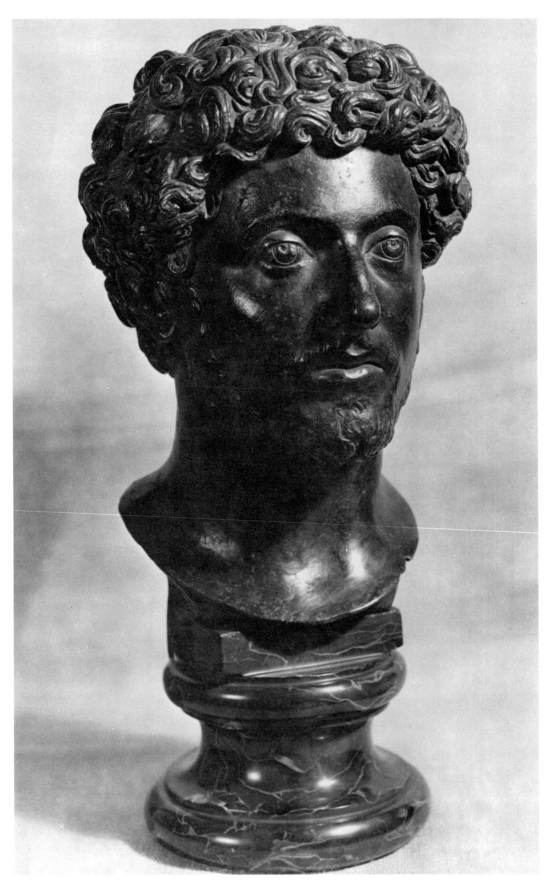

79 (supplement). Italian. *Head of Marcus Aurelius,* late 16th century (?) Bronze, Fogg Art Museum, Harvard University.

Portraiture

65 *Portrait of a Young Man* c. A.D. 140
Eastern Roman Empire, early Antonine period
Marble. 32 × 25.4 × 28 cm.

Wellesley College Museum, Given by Mrs. Albert M. Steinert in memory of her daughter Kathryn '28 (64.19)

In Greece and Asia Minor the age of the Antonines (A.D. 138–192) was one of great material wealth and was the last period of unbroken peace before civil wars and barbarian inroads disturbed the northeastern and eastern frontiers. It was a period of great activity in the production of art, both public and private. This head of an unknown aristocratic youth from Asia Minor reflects the high quality in the productions of Eastern Roman Imperial ateliers at the time (also shown by 66).

The luxuriant mass of curly hair recalls heads identified by C. C. Vermeule as Aelius Caesar (d. 137), the father of Lucius Verus. The prototype of the head in Corinth may have been created during the last year of Hadrian's reign, when Aelius was adopted by Hadrian and designated Caesar shortly before his premature death and the death of the Emperor. On the other hand, the curls of the Wellesley head, though carved with the undercutting and deep drilling that are hallmarks of the Antonine style, may echo a version of the hairstyle of Antinous, Hadrian's favorite, whose image had been widely propagated in the preceding decade. Unlike the distracted and pensive look of Antinous's portraits, however, are the pronounced turn of this head to the side and the directness of the gaze toward some external target, a feature originally accentuated by painted pupil and iris. This implied communication with something outside the work itself, and the psychic drama of the shadowed eye sockets, juxtaposed with the sensuous luxury and textural illusionism of the abundant curls, would have appealed to High Renaissance and Mannerist artists. Related devices in the portraiture of the early cinquecento in Venice suggest at least a general familiarity with such ancient techniques of rendering the illusion of an actual living presence.

Ex collection: Mathias Komor.
References: C. C. Vermeule, *Roman Imperial Art in Asia Minor,* Cambridge, 1968, 264, 274, 296; E. Vermeule and C. C. Vermeule, "Antiquities at Wellesley," *Archaeology,* 25, no. 4 (1972), 282.

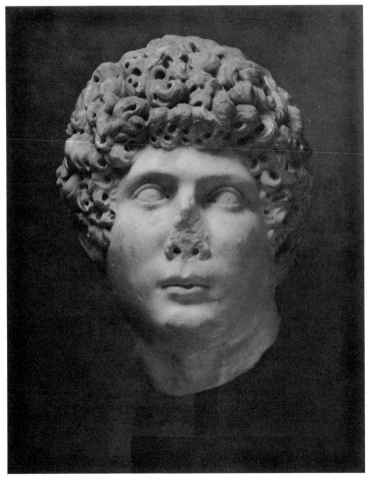

65

66 *Portrait of an Antonine Lady* A.D. 138–192

Eastern Roman Empire(?), Antonine period

Bronze (cast in two pieces); eyes originally inlaid(?); light and dark green patina on head. 54 × 46.9 × 34 cm.

Worcester Art Museum, in part from the Sarah C. Garver Fund (1966.67)

Large ancient bronzes are rare principally because so many of them have been melted down for the intrinsic value of the metal. Renaissance inventories often mention antique bronzes but checking such references is hampered by the general and often abbreviated terms in which they are written. Though a fair number of listed works were no doubt contemporary rather than ancient as claimed, it still seems likely that in the Renaissance many ancient bronzes were known that have not survived into the present day. One which was so venerated that it was carefully preserved from the tenth century on is the *Capitoline Wolf,* the original model of our 17. The present portrait was not excavated until modern times, but works with a similar beauty and delicacy surely were available to Renaissance sculptors.

The portrait is of a mature young woman, possibly Julia Domna, the wife of Septimius Severus, d. A.D. 217 (Lehmann), her hair centrally parted and arranged in the front in carefully combed waves. In the back it is gathered into a knot which in this example is minutely detailed. The hair-style resembles Julia Domna's early portrait type, as seen on coins issued from 193–196. This hair-style and the inclusion in the bust of a raised hand beneath the himation have also been interpreted as linking the work chronologically to the reign of Faustina the Younger, the wife of Marcus Aurelius (d. A.D. 175). The modeling of the head and the highly individualized expression of the face demonstrate "a sensitivity unexcelled in Roman portraiture" (Teitz). Though perhaps made only a few years later than the

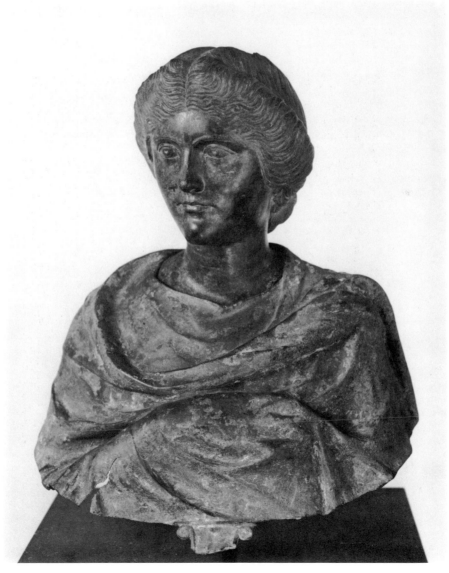

66

Wellesley *Portrait of a Young Man* (65), the Worcester portrait seems introverted and subdued in comparison. The differences between these two portraits result in part from the distinct artistic personalities of the sculptors who produced them and from the differing places of origin, material used, and subjects portrayed.

Provenance: said to have been found in southwestern Anatolia.
Exhibition: "Master Bronzes from the Classical World," Fogg, St. Louis, Los Angeles, 4 December 1967–30 June 1968, cat. by David G. Mitten and Suzannah F. Doeringer, Mainz on Rhine, 1967 (entry by Richard S. Teitz), 240–241, no. 233.
References: R. Calza, "Giulia Domna," *EAA,* 3 (1960), 922–924; R. S. Teitz, "A Bronze Bust of an Antonine Lady", paper delivered at College Art Association meeting, Jan. 27, 1967; Worcester Art Museum, *Annual Report,* 1967, x–xi, xv (ill. on cover); C. C. Vermeule, "Classical Bronzes in three American Museums," *BM,* 110 (1968), 167; Worcester Art Museum, *Handbook,* 1973, 30; P. W. Lehmann, personal communication, April, 1978.

67 *Portrait Bust of a Boy* Mid-3rd century A.D.
Rome
Marble. 52 cm.
The Cleveland Museum of Art, Purchase from the J. H. Wade Fund (51.288)

The bust portrays a child of three or four wearing a tunic with belt knotted and a thick cord across his left shoulder. The cord is possibly the badge of a youth union of which the imperial princes used to be *Princeps Juventatis.* A bust of a boy in the Wellesley College Museum also wears a diagonal strap over the shoulder and a high belt (1924.22).

The head seems almost too large for the slender neck, expressing the child's early age and vulnerability. The soft flesh, full cheeks, delicate, small nose, and childlike mouth, are highly illusionistic. Fragility is communicated by an uncanny effect of transparency, by means of which the sculptor seems to show the skull close beneath the skin of the forehead and crown of the head. Shallow curved lines are engraved directly on the head without textural differentiation. This luminous and compelling image of childhood, which

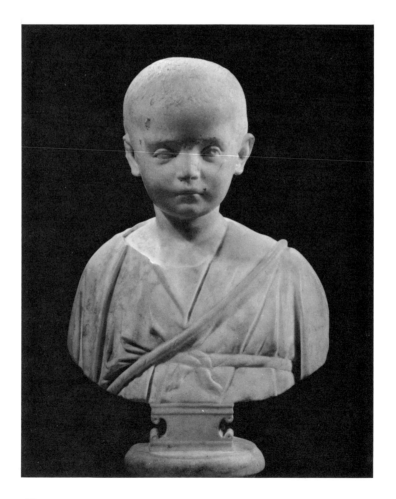

at the same time summarizes essential features of an individual face, would have appealed to such Renaissance sculptors as Desiderio da Settignano and Antonio Rossellino. In their portraits of children, as for example Desiderio's *Portrait Bust of a Boy* (National Gallery of Art, Mellon Coll., c. 1460), comparable skill in marble cutting as well as sensitivity of conception is evident. But unlike such portraits, the Cleveland *Boy*, as is typical of late antique portrait busts, is hollowed out at the back, has a curved lower edge, and stands on its own pedestal.

Ex collections: Count Raffaele de Sarzana, Rome; [Giuseppe Cellini, Rome].
References: S. A. Wunderlich, "A Roman Portrait Bust of a Child," *Cleveland Museum of Art Bulletin,* 38 (1951), 219–221; M. Bieber, Comments on the bust, 11/12/51, unpublished, Cleveland Museum of Art, Department of Ancient Art; Cleveland Museum of Art, *Classical Art Handbook,* Cleveland, 1961, pl. 21; I. Lavin, "On the Sources and Meaning of the Renaissance Portrait Bust," *AQ,* 33 (1970), 207–226, esp. 208; Arielle Kozloff (Associate Curator, Department of Ancient Art, Cleveland Museum of Art), personal communication, December, 1977.

68 *Cleopatra* c. 1519–20

Pier Jacopo Alari Bonacolsi, called Antico (Mantua c. 1460/Gazzuolo 1528)

Bronze, partly gilt; brown patina. 54.5 cm.

Museum of Fine Arts, Boston, William Francis Warden Fund (64.2174)

Plutarch described Cleopatra thus:

For her beauty, as we are told, was in itself not altogether incomparable, nor such as to strike those who saw her; but converse with her had an irresistible charm, and her presence combined with the persuasiveness of her discourse and the character which was somehow diffused about her behavior towards others, had something stimulating about it. There was sweetness also in the tones of her voice . . . (*Antony,* XXVII, 2)

The Egyptian Queen is portrayed here with sumptuous, richly-waved hair, parted in the middle, pulled back on the sides, and with two long corkscrew curls falling along her neck to her chest. She wears a crown ornamented with five fleurs-de-lis. This must be interpreted as two crowns—one a plain band and the other a delicate circlet of fleurs-de-lis superimposed over it—if the identification of this bust with "una donna

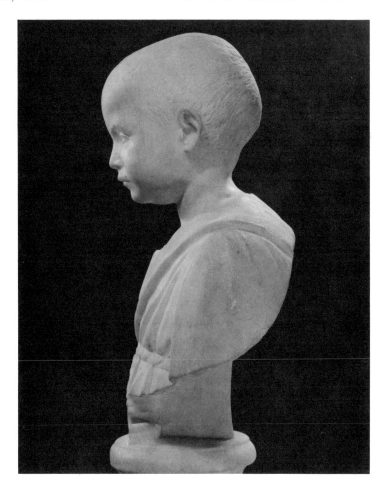

67

con due corone" in the Gonzaga inventory of 1627 (Hermann, 219) is to make sense.

Instead of an inscription the bust has, as an identifying emblem, a small snake in relief on the pedestal. Details like the incised irises and indented pupils (formerly filled with lapis lazuli or some other semiprecious stone), the gilding of the crown and shoulder clasps (now worn away), and the earrings (now lost), characterize the kind of precious, meticulously-crafted object that so delighted Antico's patrons.

A tetradrachm possibly from Antioch has portraits of Cleopatra and Antony, inscribed with their respective names, on the obverse and reverse (Richter). She appears there in profile, with emphatic aquiline nose, boldly modeled chin, and a characteristic hairstyle with individual corkscrew curls falling forward over her forehead. If such a model was available to Antico, he interpreted the likeness only in the most general terms. The long neck, strong nose and chin, heavy-lidded eyes and richly curled hair that covers much of the forehead in this bust are recognizable, nevertheless, as features inherent in Cleopatra's authentic coin portraits. They have been transformed from a Semitic into a distinctly Hellenic image which softens and sweetens the queen's erotic power and the charismatic force of her personality. It communicates instead in elegiac tones the pathos of her ultimate fate referred to also by the emblematic asp. One might recall that a famous antique *Sleeping Ariadne,* installed in the Vatican Belvedere sculpture court in 1512, was at that time believed to represent the dying Cleopatra. Isabella d'Este owned a bronze replica of this work (Brown).

It is assumed that Antico used an antique bust as a model for the *Cleopatra*. Like this presumed Roman model, the *Cleopatra* is a true bust, rounded at the bottom, hollowed out at the back, and set up on a base. This form was not used for Renaissance portraits of contemporaries before the sixteenth century (Lavin). An early first-century bust in the British Museum nicknamed "Clytie" (no. 1874) that represents Antonia, daughter of Mark Antony and Octavia, oddly enough shares several features with *Cleopatra*.

Closely cognate bronze busts by Antico are the *Bacchus* and *Ariadne* in Vienna, of Este provenance. The *Cleopatra* should be dated somewhat earlier than these, given the greater abstraction and remoteness of the

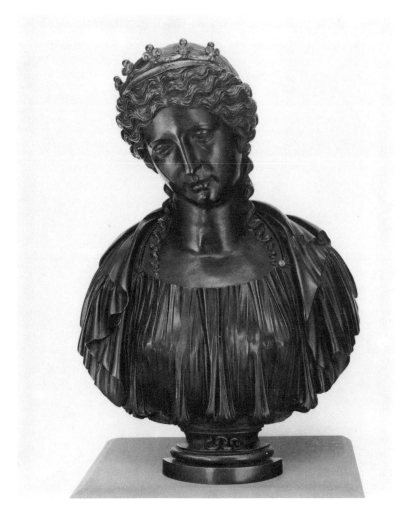

68

Vienna busts. The *Cleopatra*'s more enigmatic and dreamy expression goes back to Venetian art of the first years of the cinquecento (Antonio Lombardo's *Zen Madonna* and the paintings of Giorgione and Titian).

Ex collections: Gonzaga family, 1627 (?); Estate of Julius Goldschmidt.

References: Hermann, "Antico," 211–12 (1519 letter from Antico to Isabella d'Este concerning bronze heads); 219; Museum of Fine Arts, Boston, *Annual Report,* 1964; *Connaissance des Arts,* no. 163, Sept., 1965, 72 (ill.); Richter, *Portraits,* 1, 13f.; 3, 269 and fig. 1859; Legner, "Anticos Apoll," *passim* (up-to-date discussion of Antico's technique and approach to antique sources); I. Lavin, "On the Sources and Meaning of the Renaissance Portrait Bust, *AQ,* 33 (1970), 207–226 (general background); C. M. Brown, " 'Lo Insaciabile Desiderio nostro de Cose Antique': New Documents on Isabella d'Este's Collection of Antiquities" in Cecil H. Clough, ed., *Cultural Aspects of the Italian Renaissance,* Manchester, 1976, 324–353, and "The Grotta of Isabella d'Este," *GBA,* 6th period, 89 (1977), 155–171.

69 *Menander* c. 1510–30

Circle of Antico? (Mantua, first half of 16th century)

Bronze bust (heavy hollow cast), eyes inlaid with silver, dark brown lacquer worn in places to natural brown patina. 51 cm.

The Walters Art Gallery, Baltimore (27.419)

The recent discovery of an inscription on a miniature bronze bust in the Getty Museum identifying its subject as Menander (Ashmole) supports the notion that this lifesize bust also represents the Athenian comic dramatist (c. 342/1–293/2 B.C.). Studnickza's 1918 identification of this popular type, of which more ancient exemplars have survived than any other, as Menander, is thereby corroborated. Menander's popularity with Roman theatergoers explains this ubiquity. His plots and skillfully drawn characters served as models for Plautus and Terence. Even Ovid thought him worthy of immortality.

The portrait of Menander, Richter suggested, should show "a sensitive person, between 40 and 50 years of age, clean-shaven, with . . . an oval face, a high

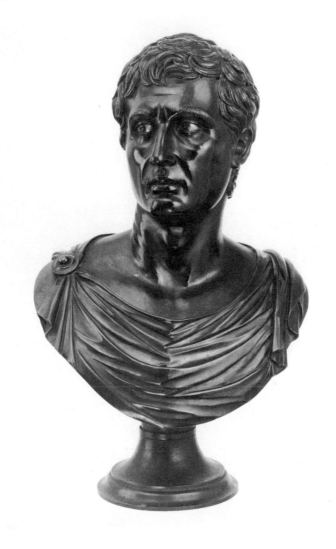

forehead that bulges out in its lower part, lean cheeks, finely curving lips, a thin, straight nose slightly curving below the bridge, a small, round, rather prominent chin with a pronounced groove between it and the lower lip, and a slender neck with a prominent Adam's apple." In the Walters example the fairly short-cropped, thick hair is arranged in overlapping layers of wavy locks. In the center of the forehead, two curls lie horizontal and two are directed downwards. Over the temples are similar but longer locks that descend as far as the ears, but leave them uncovered. At the back, at the base of the skull, is a marked indentation, below which another layer of curly waves clings to the neck. This image corresponds with what is said of Menander's appearance in literary sources, viz. that he was effeminate and delicate. The close relationship between this Renaissance bust and the ancient Menander type is immediately apparent when it is compared with any of the most characteristic and well-preserved examples adduced by Richter, such as those in the Museum of Fine Arts, Boston (no. 97.288), and the Dumbarton Oaks collection, Washington, D.C. (no. 46.2). The Walters *Menander*'s close correspondence in all major identifying features leaves no doubt that this ancient type is being faithfully followed. To judge by the sixteenth-century drawings Richter reproduces, this image was recognized in the Renaissance as Menander, though later some writers began to identify it as Virgil.

A connection between the Walters *Menander* and the work of Antico was first suggested by Michael Hall (1970). It is extremely close in size to *Cleopatra* (68). Like it, the pupils were once small bits of precious stone. However, the surface is harder and dryer in feeling. The rendering of the drapery as connected flat facets suggests a concern with abstraction of surface that is perhaps more typical of the later sixteenth century (Holderbaum). The bust should be compared to the *Antoninus Pius* (Metropolitan Museum), generally accepted as a work by Antico, with which it shares an austerity and lack of sensuousness quite unlike the *Paris* (89) or the *Cleopatra* (68). These latter works are examples of Antico's transformational powers rather than replicas or reproductions. In them, emotive content and mood, derived from antique literature as well as art, evoke an image of the classical past as distant and irrecoverable, as well as beautiful.

Ex collection: Henry Walters, 1927.
References: Richter, *Portraits*, 2, 229 ff.; B. Ashmole, "Menander: An Inscribed Bust," *AJA*, 77 (1973), 61, pls. 11, 12; E.P. Bowron, Curator of Renaissance and Baroque Art, Walters Art Gallery, letter (9/6/77); J. Holderbaum, personal communication, April 1978.

70 *T. Livius duobus libris auctus,* ed. Lucas Panaetius 3 May 1520
Livy (Padua 5 B.C./Rome A.D. 17)
Printed book; folio; Venice, Melchiorre Sessa and Pietro de' Ravani. Woodcut portrait on title-page; 31 woodcuts in text. Contemporary limp vellum, two pairs of ties removed. Ms. notes in several hands. Signature on portrait block and 4 text blocks: .Z.a. [Zoan Andrea]. Inscription on arch in portrait: VERA. TITI. LIVII. EFFIGIES. 31.9 × 22.8 cm.
Houghton Library, Harvard University (Typ.525.20.526F)

This edition of two books of Livy's *Ab urbe condita libri*, printed with Florus's *Epitomes* and Leonardo Bruni's *De primo bello punico*, has on its title page a wonderfully modeled engraved portrait of Livy by Zoan Andrea. The portrait is based on a carved memorial tablet (dating possibly as late as c. 1300) on the exterior of the *Salone*, on the Palazzo della Ragione in Padua. The tablet was believed to be a true image of Livy, owing to a misreading of its inscription, which was first discovered between 1318 and 1324 (this inscription is given on leaf b10r). "The fact that humanist Padua failed to note that the epitaph bore also the surname Halys and indicated that this Livius was a freedman, naturally shows the still primitive stage of antiquarian studies" (Weiss, 21). In his engraving Zoan Andrea has faithfully translated the relief (itself a version of an illusionistic Roman funerary relief) into two-dimensional form. It shows a half-length portrait of the Roman historian seemingly set back behind a windowlike frame on the ledge of which he rests his book.

Although the facial features, costume of a medieval jurist and pose of the relief were closely followed in the engraving, there are a few minor variations. The turn of the head changes it from a frontal to a three-quarter view; the size of the left hand has been exaggerated; and the architectural framework has been elaborated to form an inscribed classical aedicule with a shell-topped niche. Zoan Andrea makes the likeness more specific by rendering the face in greater detail, changing the angle of the head and focusing the glance. The desired effect is a portrait of Livy from life, and by presenting him as a "living presence", antiquity itself is in turn brought to life. The use of the funerary relief prototype, as Phyllis Lehmann showed, has special significance for the Renaissance revival of antiquity. The manner in which Livy holds the book that rests on the imaginary window ledge parallel to the picture plane had become canonical in Venetian portraits by

this date. The dependence of Zoan Andrea's engraved portrait of Livy on a Gothic relief which in turn reproduced an ancient funerary portrait type points to the importance of the type's survival as a major source of this widespread convention in Renaissance painted portraiture.

The portrait block was re-used in a Vittore de' Ravani edition of 1535.

References: V. Masséna Essling, *Etudes sur l'art de la gravure sur bois à Venise,* pt. 1, v. 1, Florence/Paris, 1907, 51–4, no. 41; P. W. Lehmann [Phyllis Williams], "Two Roman Reliefs in Renaissance Disguise," *JWarb,* 4–5 (1941–1942), 47–66; C. G. Mor, *Il Palazzo della Ragione di Padova,* Venice, 1964, 42 (and n. 39); figs. 31, 63 (relief of Titus Livius Halys); Weiss, *Discovery of Antiquity,* 21; Mortimer, I, no. 261, 377–80.

71 *Helen of Troy*

Style of Domenico Poggini (Florence 1520/Rome 1590)

Bronze medal (struck). Obverse, around: ΕΛΕΝΗ ΛΗΔΑΙΑ ΣΓΑΠΤΗΣ ΒΑΣΤΛΙΣΣΑ. Reverse, around: ΑΚΑΘΑΡΤΟΣ ΚΓΙΣΙΣ. 4.8 cm. (diameter)

Bowdoin College Museum of Art (Brunswick, Maine), Molinari Collection (1966.104.12)

In this imaginary portrait of Helen of Troy, her elaborate hair style and imposing mien stem perhaps from an imperial portrait, while the treatment of her chiton harks back to a generalized *all'antica* mode created at the end of the quattrocento in north Italy. The Judgment of Paris is on the reverse, with Mercury shown flying over the heads of the three goddesses to hand the apple to Paris, while Cupid shoots an arrow at him. In the foreground a river god reclines; in the background is Troy (cf. 89, 90). The style is academically "correct": anatomy, volumes and space are convincingly rendered. At the same time, the forms are appropriately delicate for the miniature scale and are fashioned with the technical competence expected of a medallist at the mid-sixteenth-century court of the Medici. Poggini, to whom Hill attributed this medal, served for nearly twenty years in this post.

The medal reflects mid-century academicism in its approach to antique revival (cf. 26). The sense of experimentation that can be felt in works like Pisanello's *Horse Tamer,* or, among objects treated here, in 5–7, 9, 37, 49 and 86, for example, has now given way to a more automatic reliance on a generally accepted classical language. The sense that antique forms are opening up new horizons for lifelike anatomical description (as with 16, 38, 41, and 44) or contributing to powerful new modes of expression (60, 63, and 64), is now part of the past. One has the feeling that the artist approaches antique art somewhat indirectly through prior Renaissance manifestations.

Ex collection: Molinari.
References: G. F. Hill, "Notes on Italian Medals, XXIII," *BM,* 30 (1917), 197f., pl. I, D; A. Norris and I. Weber, *Medals and Plaquettes from the Molinari Collection at Bowdoin College,* Brunswick, Maine, 1976, 24–25, no. 50.

72 *Denarius of Augustus* 19–16 or 15 B.C.

Spain, Uncertain Mint (Colonia Patricia?)

Silver coin. Obverse, down left and up right: CAESAR AVGVSTVS. Reverse, in field, left and right: [10] V TON

Collection of Phyllis Williams Lehmann

Coins such as this silver denarius of Augustus must have been common in the Renaissance. At Mantua in 1355 Petrarch, one of the first to collect Roman coins, presented the Emperor Charles IV with a collection which included a coin of Augustus. The profile portrait on the obverse shows Augustus's characteristic facial features and hairstyle. This may be compared with the more refined portrait of him on the Renaissance *Augustus* plaquette (73), possibly based on an ancient carved gem.

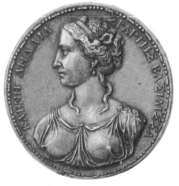

71 (obverse)

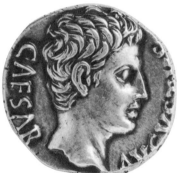

72 (obverse)

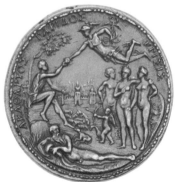

71 (reverse)

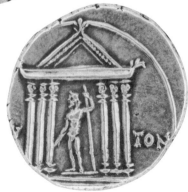

72 (reverse)

On the reverse of the coin there is a hexastyle temple with pediment and eagle on its apex, on a podium of three steps (only two appear on this example). Jupiter, holding a thunderbolt in his right hand and a long scepter in his left, stands in the center of the temple. The building is the temple of Jupiter Tonans near the Capitol, which Augustus dedicated in acknowledgment of his escape from lightning during his Cantabrian expedition in 22 B.C. (Suetonius, *Augustus*, 29, 91).

Exhibition: Smith College Museum of Art, *Greek and Roman Antique Coins . . . Renaissance Books,* 1962, no. 84 (ill.).
References: G. F. Hill, "Classical Influence on the Italian Medal," *BM,* 18 (1911), 259–260; Mattingly, *BMCI,* 64, no. 15.

73 *Augustus* Late 15th century.
Italy, Florence

Bronze plaquette (irregular oval); silvery-black chemical patina over scarified surface of dark reddish-brown bronze. 4.6 × 3.1 cm.

National Gallery of Art, Samuel H. Kress Collection, 1951 (A 328.51B)

In the fifteenth and sixteenth centuries Roman imperial portraiture enjoyed great popularity among humanists and artists. The collecting of imperial coinage had begun at least as early as Petrarch's time. By 1440–1464, the period of the cardinalate of Pietro Barbo, excavations beneath street level in projects like

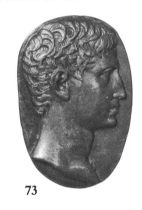

73

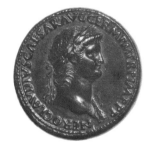

74 (obverse) **74 (reverse)**

Eugenius IV's rehabilitation of the Pantheon and its piazza had begun to turn up increasing numbers of ancient coins and gems. Ancient types began to be revived on medals (see 80), plaquettes, and in as important a large-scale program as the new bronze doors for St. Peter's that were commissioned from Filarete by Eugenius and installed in August 1445. The great collections of Cardinal Pietro Barbo (later Pope Paul II) and Cardinal Francesco Gonzaga contained large numbers of these objects.

This relief with a profile of the young Augustus belongs to a group of anonymous plaquettes molded or adapted from classical gems. The irregular shape of the plaquette, Augustus's profile and hairstyle, and the undulating lower outline of the bust are close to the design of a yellow glass cameo in the British Museum (Vollenweider, pl. 156, 8, 9). The cameo is about half the size of the plaquette and the proportion of height to width is the same in the two objects. Bange suggested another gem, in Naples, as its source.

Ex collections: Charles Timbal (?), 1871; Gustave Dreyfus, c. 1871–1914; Heirs of Gustave Dreyfus, 1914–33; [Duveen, N.Y., 1933–45]; Samuel H. Kress, 1945–57.
References: Bange, 24, no. 181; R. W. Kennedy, "The Contribution of Martin V to the Rebuilding of Rome, 1420–1431," *Smith College Studies in History,* 44 (1964), 27–39; Pope-Hennessy, *Kress,* 78, no. 269; M.-L. Vollenweider, *Die Porträtgemmen der Römischen Republik,* Mainz on Rhine, 1972, 101, entry for pl. 156, nos. 8, 9.

74 *Sestertius of Nero* A.D. 64–66
Italy, Rome

Bronze coin. Obverse, around: NERO CLAVDIVS CAESAR AVG GERM P M TR P IMP P P. Reverse, in field: S C. In exergue: DECVRSIO

Fogg Art Museum, Harvard University, Cambridge, Massachusetts (1972.225)

On the obverse of this coin a laureate bust of the Emperor Nero (r. A.D. 54–68), facing right, is encircled with an inscription typical of Nero's undated sestertii in the period from 64 to 66 A.D. On the reverse, Nero is pictured on horseback accompanied by another horseman. A coin belonging to this same series ("Decursio S.C.") inspired Giovanni dal Cavino's imitation Nero sestertius from the Bowdoin College Museum (75).

References: Mattingly, *BMCI,* 227, no. 146; R. R. Holloway, *The Frederick M. Watkins Collection of Coins,* Cambridge, Mass., 1973, 148, no. 152.

75 *Imitation of a Nero Sestertius*

Giovanni dal Cavino (Padua 1500/Padua 1570)

Bronze medal (struck). Obverse, around: NERO CLAVD CAESAR AVG GER P M TR P IMP PP. Reverse, in field: S. C. In exergue: DECVRSIO. 3.5 cm. (diameter)

Bowdoin College Museum of Art (Brunswick, Maine), Molinari Collection (1966.108.9)

This "Roman sestertius" exemplifies the imitations of imperial coins struck by Giovanni dal Cavino with the help of his son, Vincenzo, and associate, Alessandro Bassiano. One hundred twenty-two of Cavino's dies are preserved in the Bibliothèque Nationale in Paris. His skill was such that only the most painstaking examination of the minutiae of lettering and edges suffices to show that his coins are not authentic antiques. As a result of the feverish pitch that collection of Greek (see 20) and Roman coins had reached by the middle of the fifteenth century (collectors often complained of their scarcity—Weiss), Cavino's imitations enjoyed a success that eclipsed the fame of his other, non-imitative, medals.

On this coin a laureate head of the Emperor Nero (r. A.D. 54–68) decorates the obverse. The reverse shows Nero on horseback with a spear, followed by a horseman holding a banner. The obverse and reverse appear to derive from two different Roman sestertii belonging to Mattingly's "Decursio S. C." types E1 and E2 (see 74). This same inscription (Mattingly, type *a,* p. 218), which differs only in one small detail from the Fogg's Nero sestertius (74), surrounded the head of Nero on many undated sestertii of the period A.D. 64–66.

The use of ancient coins as sources became common in the Renaissance. An early instance is the border of Filarete's bronze doors for St. Peter's (commissioned in 1433 and installed in 1445). Here there is a portrait of the Emperor Nero derived from his likeness on his coinage. Filarete's relief of the *Martyrdom of St. Peter* on these doors was also based on images on reverses of Neronian coins. Enlarged versions of Roman coins were often carved on doorways of the fronts of churches or palaces during the later quattrocento and early cinquecento (for example, the Palazzo Thiene, Verona, c. 1502).

At the same time, coins formed the basis for antiquarian research into portrait traditions, and supplemented ancient literature as sources for Roman history and culture, leading to the earliest systematic investigations of ancient numismatics like the *Illustrium imagines* by Andrea Fulvio (1517), which provided an iconographic repertory of the famous Romans.

References: L. Forrer, *A Biographical Dictionary of Medallists,* 8 vols., London, 1904–30, 1, 368; Mattingly, *BMCI,* 218 (varieties of legends), 226–228 (types E1 and E2), pl. 42, no. 4; Hill and Pollard, *Medals,* 73 (Giovanni dal Cavino, biography and bibliography), 75, no. 403 (a Nero "sestertius" with same obverse, different reverse); Weiss, *Discovery of Antiquity,* ch. 12, "The Study of Ancient Numismatics," 167–179; A. Norris and I. Weber, *Medals and Plaquettes from the Molinari Collection at Bowdoin College,* 24–25, no. 50; (and see references for cat. no. 20).

75 (obverse)

76 *"Head of the Emperor Vitellius"* Second half of 16th century

Attributed to Jacopo Robusti, called Tintoretto (Venice 1518/Venice 1594)

Drawing; black chalk heightened with white on oatmeal paper. Inscription, lower right: Testa di Vitellio Cavata dal Rilievó. 40.6 × 27.8 cm.

Ian Woodner Family Collection

This drawing records a masterpiece of second-century portraiture (now in the Museo Archeologico, Venice, inv. 141) that was excavated in Rome and became part of the Grimani family's donation of art works to the city of Venice. When the bust was first shown in 1523 at the Palazzo Ducale in Venice it caused a sensation among collectors and artists alike. Then as now the bust clearly ranked high among surviving three-dimensional Roman portraits in the brilliance of its evocation of an individual, fully characterized both psychologically and physically. It deserves to be numbered among the specific antique works known to the sixteenth century that helped to inspire the birth of Baroque style.

Beginning in the 1540s, Tintoretto and his workshop associates made more than fifteen drawings of a

76

cast of this bust which Tintoretto himself owned (as recorded in the will of his son Domenico; now Padua, University Museum). Only three are retained as autograph in the *Corpus Graphicum* volume on Tintoretto's drawings by Rossi (Munich; Ecole des Beaux Arts; formerly Boymans-van Beuningen). Tintoretto's interest in the head is demonstrated by his use of it as a model in the *Supper in the House of the Pharisee* (Escorial, 15). His fascination with the antique's power of description and expression is documented in these drawings. Here the flicker of light and shadow records the subtle modulation of planes in the original, and the broad impressionistic use of the chalk captures its fleeting, instantaneous quality.

In 1930, Anti published a re-evaluation of the traditional identification of the antique head as Vitellius, an identification which by then was recognized as arbitrary. Careful analysis of the work's style suggested instead a Hadrianic date (A.D. 117–138). Zadoks-Josephus Jitta recently pointed out that the incised pupils allow a dating to the latter part of that period, c. 130. Traversari agreed with Anti's dating of the piece but rejected his proposal that the man portrayed was the high official pictured with Hadrian on the Arch of Constantine Hadrianic medallions. Wegner's belief that the bust was a Renaissance forgery has been vigorously contested by Traversari and others on the valid grounds that in 1523, the date of the bust's public display, no Italian sculptor could have carved such a head. As a solution to the dilemma posed by contradictory dating indications, Meller's recent suggestion that the head is original but was retouched by Simone Bianco (active 1512–1553), sculptor of an impressive marble portrait *all'antica* in Stockholm (Meller, fig. 7), deserves consideration.

Exhibition: William H. Schab Gallery, N.Y., *Woodner Collection I: A Selection of Old Master Drawings,* N.Y., London, 1971, no. 31 (ill.).
References: C. Anti, *Il Regio Museo Archeologico nel Palazzo Reale di Venezia,* Rome, 1930, 135; M. Wegner, "Antikenfälschung der Renaissance," *Bericht über den VI. Internationalen Kongress für Archäologie,* Berlin, 21–26 August 1939, Berlin, 1940 (Archäologisches Institut des Deutschen Reiches), 147f.; B. Candida, *I calchi rinascimentali della collezione Mantova Benavides nel Museo del Liviano a Padova,* Padua, 1967, 39–42, fig. 8 (plaster cast of 'Vitellius' bust owned by Tintoretto), and review by E. Schwarzenberg, *Gnomon,* 42 (1970), 611; G. Traversari, *Museo Archeologico di Venezia, I Ritratti,* Rome, 1968 (Cataloghi dei Musei e Gallerie d'Italia), 63–64, no. 43, pls. 44a–c; A. N. Zadoks-Josephus Jitta, "A Creative Misunderstanding," *Nederlands Kunsthistorisch Jaarboek,* 23 (1972), 3–12, esp. p. 5; P. Rossi, *I disegni di Jacopo Tintoretto,* Florence, 1975, (Corpus Graphicum, 1) no. 31; P. Meller, "Marmi e bronzi di Simone Bianco," *Mitt Flor,* 21, no. 2 (1977), 202; bibliog. in nn. 21, 22.

77 *Sestertius of Trajan* A.D. 103–111
Italy, Rome

Coin, orichalcum. Obverse, around: IMP. CAES. NERVAE TRAIANO AVG. GER. DAC. P.M. TR. P. COS. V. P.P. Reverse, around: S. P. Q. R. OPTIMO PRINCIPI. In exergue: S.C.
Smith College, Classics Department

With the advent of programs that included Roman imperial portraits, such as Mantegna's ceiling of the Camera degli Sposi in the Ducal Palace at Mantua (1465–74), Roman coins gained importance as the major source for the portrait traditions. The Renaissance acquired a thorough knowledge of imperial iconography long before accurate portrait traditions were discovered for personages of the Roman Republic or Greek antiquity.

A portrait of Trajan appears on the obverse of this sestertius and on the reverse the emperor is shown bareheaded, in military dress, holding a thunderbolt and a spear, and being crowned by a standing Victory who holds a palm branch. The legend encircling Trajan's portrait typifies this emperor's legends, and is longer than those generally used by previous emperors. This change necessitated the small, neat, closely-spaced lettering that often marks the coins of Trajan. The coin can be dated A.D. 103–111 from "Cos. V." in the inscription. Trajan became consul for the fifth time in 103, and only once more, in 112.

Exhibition: Smith College Museum of Art, *Greek and Roman Antique Coins . . . Renaissance Books,* 1962, no. 93 (ill.).
Reference: R. Reece, *Roman Coins,* London, 1970, 85–86.

77 (obverse)

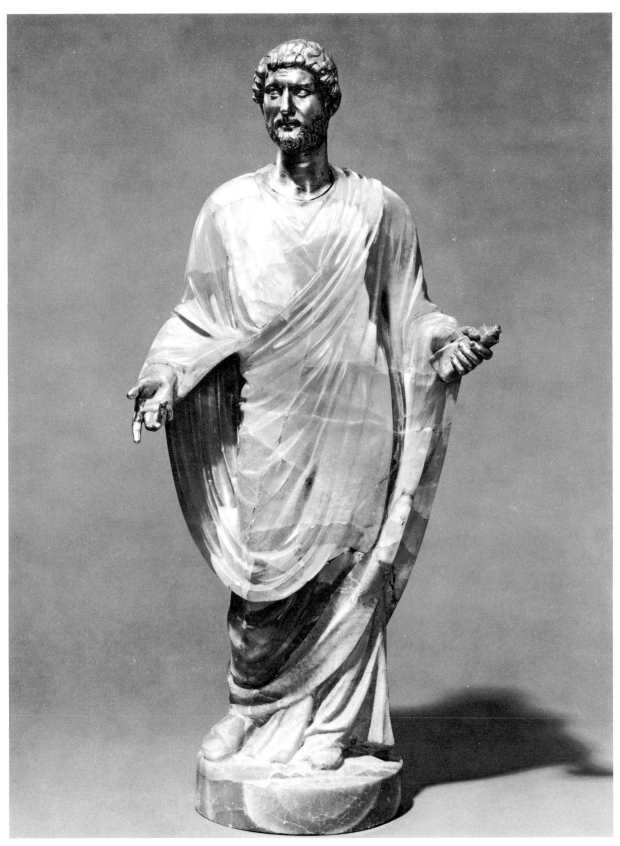

78

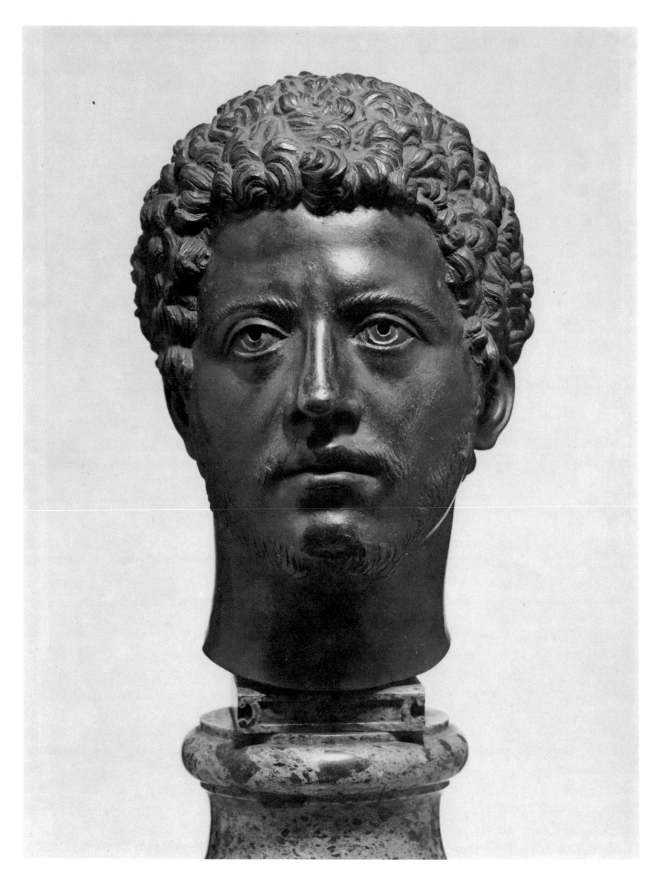

79

78 *The Emperor Hadrian* 4th century (body), c. 1550 (head and hands)
Rome and Central Italy
Calcite crystal, gilt bronze head and hands. 57.2 cm.
Museum of Fine Arts, Boston, Gift of the Class of the Museum of Fine Arts, Mrs. Charles Devens, Chairman, May 10, 1972 (1972.354)

The major fifteenth-century collections of antiquities in Rome contained fragments like the *Torso Belvedere,* the torso in the Casa Sassi courtyard, and the Martinori *Bacchus* then in the collection of the Santacroce family. Beginning with the restorations of the *Apollo Belvedere* and the *Laocoon* carried out by Giovanni Montorsoli in 1532–33, however, the projects to restore or otherwise complete antique fragments became common. Many well-known compositions in collections like that of the Uffizi are the result of such campaigns (Giovanni Caccini's *Bacchus and Ampelos* constructed around a Hellenistic *Narcissus* torso, for example; or Cellini's restoration of an antique torso as a *Ganymede* in 1545–47 [Florence, Museo Nazionale]).

The Boston Museum's *Hadrian* is a sixteenth-century restoration in which the togate body of an emperor has been fitted with a bronze head of Hadrian and hands in an orator's pose, the left holding a book-scroll. The fluid, linear treatment of the drapery suggests a fourth-century date: the head is based on a marble portrait bust. The head and hands in the original antique version were very possibly of metal or a contrasting stone like porphyry. In the present version the delicate luminosity of the partially translucent crystal of the figure's body is complemented by the highly reflective gilt bronze. The fact that this complementary contrast was retained in the "completion" of this work suggests the capacity of the sixteenth-century antiquarian movement to combine the utmost esthetic sensitivity with scholarly correctness. The statuette as reconstituted is an object of great decorative elegance that well suited the Mannerist taste of mid century as well as gratifying its antiquarian interests.

Ex collection: [Heim Gallery, London].
Reference: S. Drysdale, *Christian Science Monitor,* Friday, July 1, 1972, p. 10, col 3 (ill.).

79 *Roman Emperor (Lucius Verus?)* c. 1520–50
Italy
Bronze (hollow cast); dark brown lacquer worn in places to reddish-brown natural patina. 23.7 cm.
The Walters Art Gallery, Baltimore (27.240)

This head probably depends on a life-sized Roman marble portrait of the young Marcus Aurelius (A.D. 121–180) or Lucius Verus (A.D. 130–169), co-emperors of Rome from 161 to 169. The abundant hair curling over the temples and forehead and the mustache and beard are features common to both. The eyebrows, given prominence by chiseled strokes, and the full, parted lips with upper lip slightly overshot, tend, however, to suggest an identification with Lucius Verus. In comparison to the portrait of Lucius Verus in the Vatican Sala dei Busti (no. 886), however, the hair does not fall as low on the forehead, coming to just above the eyebrows. The beard and mustache are not as abundant and exuberantly curly as they are on another portrait with a reputed Egyptian provenance commonly identified as Lucius Verus, which it otherwise resembles (Cleveland).

Yet the face of the Walters bronze differs in even more respects from types of the youthful Marcus Aurelius such as those from Lansdowne House and Tarragona (Wegner, plate 16). Comparison with another Renaissance bronze portrait of a Roman emperor identified as a youthful Marcus Aurelius (Fogg) differentiates this bronze further from Marcus types: its expression is more spiritualized than the rather stolid look of the Fogg *Marcus.* The face has been flattened out. The rich textural effects with which virtuoso marble cutting undoubtedly had endowed the hair of the antique model (cf. 65) were not reproduced, whereas in the *Marcus* this aspect has been successfully imitated despite technical difficulties.

Ex collections: Harding, 1916; Henry Walters.
Exhibition: The Metropolitan Museum of Art, *The Italian Renaissance,* 1923, no. 78.
References: The American Magazine of Art, 29, no. 10 (1936), 660; M. Wegner, *Die Herrscherbildnisse in antoninischer Zeit,* Berlin, 1939 (Deutsches Archäologisches Institut, Das römische Herrscherbild, pt. 2, v. 4), pls. 15, 16, 18, 40, 42; Worcester Art Museum, *Roman Portraits,* April 6–May 14, 1961, cat. by Michael Milkovich, no. 23 (Cleveland Lucius Verus); Wildenstein and Co., *Gods and Heroes, Baroque Images of Antiquity,* October 30, 1968–January 2, 1969, cat. by Eunice Williams, no. 64 (Fogg Marcus Aurelius); C. M. Brown, "'Lo Insaciabile Desiderio nostro de cose Antique': New Documents on Isabella d'Este's Collection of Antiquities," in C. H. Clough, ed., *Cultural Aspects of the Italian Renaissance, Essays in Honour of Paul Oskar Kristeller,* Manchester, N.Y., 1976, 329 (an antique Lucius Verus owned by Isabella d'Este—a possible model); S. A. Nodelman, personal communication, January 1978 (problems in ascertaining genuine antique Lucius Verus types).

80 *The Emperor Caracalla* 1466

Attributed to Giovanni di Pasqualino Boldù (Venice?, active 1454–77)

Bronze medal. Obverse, around: ANTONINVS · PIVS · AUGUSTVS · Reverse, above: IO · SON · FINE. Below: · M · CCCC · LXVI · 8.9 cm. (diameter)

Museum of Fine Arts, Boston, Gift of Mr. and Mrs. Cornelius C. Vermeule III (59.557)

This medal shows a profile bust of the youthful emperor Caracalla (r. A.D. 211–217) facing left, laureate. The prominent folds of the cloak wrapped closely around his throat may allude to the nickname "Caracalla," derived from the style of cloak he favored. Comparison with an identically inscribed denarius of Caracalla of A.D. 206 shows that the direction of the bust, which normally faces right, has been reversed (*Roman Imperial Coinage,* 225, no. 83b, ill. pl. 12, 3). Hill suggested that the artist may have worked from the impression in reverse of a coin. Yet the profile suggests Caracalla's portraiture in marble rather than his coin portraits. The puffy cheeks, heavy lids, full mouth and nascent double chin recall, for example, Caracalla's portrait on the Arch of the Argentarii in Rome.

This medal is always categorized as "attributed to Boldù" because of an earlier appearance of its reverse, with a different inscription, on a self-portrait medal of Boldù dated 1458. Scholars since Hill have nonetheless observed that the style of the head differs from Boldù's and that the true diameter of the reverse is smaller than that of the obverse. As often noted, the presence of the same composition on the reverse of this medal only indicates that its artist had access to the Boldù medal. Middeldorf extended these doubts to the medal's date, but it is difficult to know why an erroneous date need have been included on the reverse. No alternative artist has been proposed.

The nude youth on the reverse of the medal seated on a rock, his head in his hands, is the artist himself, despairingly contemplating death, represented by both

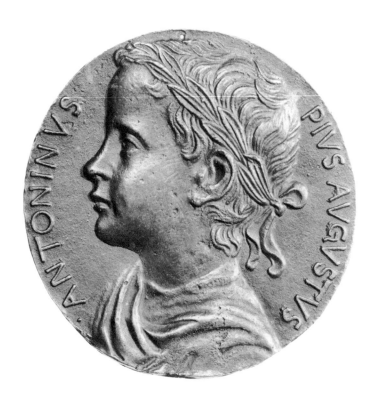

80 (obverse)

the skull and the putto. The putto as a death symbol derives ultimately, by way of an earlier medal by Pietro da Fano (Hill, 407), from Roman funerary genii. The seated youth was also doubtless inspired by an antique sculptural prototype. Janson showed the importance of Boldù's reverse as the earliest appearance in Renaissance iconography of this popular "putto with the death's head" conceit. Its striking contrast between the putto, the very image of youth and vitality, and the "cold, empty shell of man's thought and sensibility against which it rests" (Janson, 429) was an intellectually appealing antithesis that developed on its own as a separate *memento mori* formula. The other major element likewise developed independently: a seated man contemplating a skull. The inscription "Io son fine" (I am finished) that has been added to the reverse of this medal clarifies the meaning of the allegory which, as Janson argued, was often misunderstood by contemporaries, who preferred to extract single elements from it rather than to reproduce it whole.

One reappearance of the composition as a whole exemplifies the circular process that sometimes characterized the Renaissance discovery and use of antique motifs. In Apianus's *Inscriptiones sacrosanctae vetustatis* (cf. 3) H. W. Janson and J. Seznec, working independently, found the Boldù design on p. ccclxxxv. The caption identifies it as an antique lead relief found in Styria (Austria) in 1500! Thus an image that was based in the first place on a combination of (as yet unspecified) antique reliefs by 1534 had become the equivalent of an "antique."

References: Hill, *Corpus,* no. 423, pl. 80; H. Mattingly and E. A. Sydenham, *The Roman Imperial Coinage,* 4, pt. 1, *Pertinax to Geta,* London, 1936; H. W. Janson, "The Putto with the Death's Head," *AB,* 19 (1937), 423–449; J. Seznec, "Youth, Innocence and Death," *JWarb,* 1 (1937–38), 298–303; U. Middeldorf and O. Goetz, *Medals and Plaquettes from the Sigmund Morgenroth Collection,* Chicago, 1953, no. 54; C. C. Vermeule, *European Art and the Classical Past,* Cambridge, Mass., 1964, 54, 136; Salton Coll., no. 18; Hill and Pollard, *Medals,* 30, no. 143.

80 (reverse)

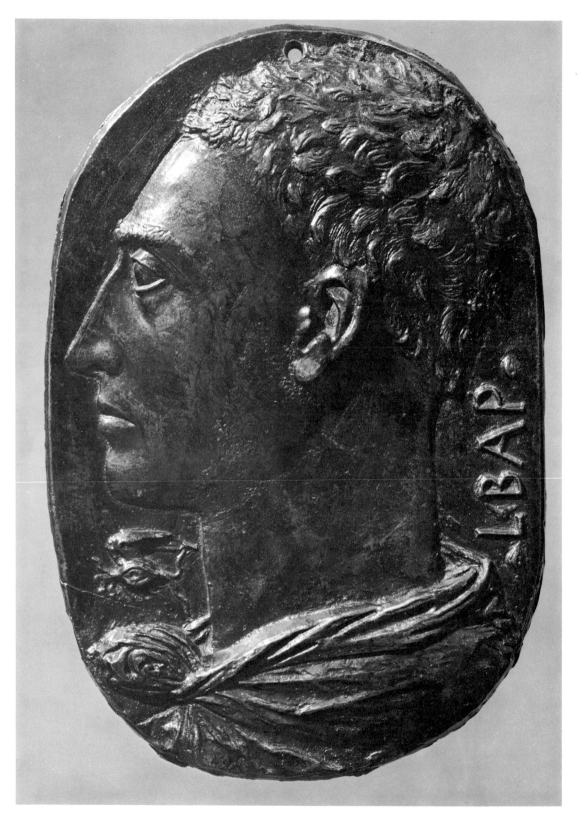

81

81 *Self-portrait* c. 1434

Leon Battista Alberti (Genoa 18 February 1404/Rome shortly before 25 April 1472)

Bronze plaque in low relief (irregular oval); dark brown lacquer over dark reddish-brown bronze, traces of old wax. Signature, vertical, on right edge: .L.BAP. 20.1 × 13.5 cm.

National Gallery of Art, Samuel H. Kress Collection, 1951 (A–278.1B)

This relief shows the bust of a clean-shaven man about 30 years old with "noble, forceful head" (Hill, *Portrait Medals,* 30) and flame-shaped curls that recall antique bronzes. To the right, parallel to the line of the neck, is the abbreviated signature in revived Roman lettering with stops formed by human eyes. Two winged human eyes appear between the chin and the knotted ends of the cloak. The winged eye seems to have been Alberti's personal device or *impresa,* on whose meaning there is no general agreement, although a connection to his work in optics is likely.

Alberti's self-portrait, like his theory of art and his architectural practice, aimed to incorporate antique art not simply by external imitation but by virtue of a thorough grasp of the principles underlying its forms. In this fashion the moderns would not only equal but surpass the ancients, as Brunelleschi had already done in building the dome of Florence Cathedral. In 1436, at the end of a two-year period in Florence, Alberti recorded his amazement and wonder at Florentine artists' achievements, praising Brunelleschi specifically for a feat of technical prowess that the ancients could not even have imagined. A description of Alberti as a practicing artist, in an anonymous fifteenth-century *Vita,* perhaps written by himself, stresses his ability as a portraitist:

He used to invite his friends with whom he had continual discussions about letters and learning; he would dictate his works to them as they wrote, and meanwhile paint their portrait or model them in wax. In Venice he did the heads of friends in Florence months or a year after he had seen them. . . . He did his own head and portrait, so that from a painted and modelled likeness he should be more readily known to visitors who had not met him.

Cristoforo Landino, a close friend of Alberti's, wrote that he worked in painting, sculpture, engraving and casting; although there is no documentary evidence in support of the attribution of this plaque to Alberti's own hand, there seems little reason to doubt it.

The long oval face shown in the plaque, with the bridge of its long straight nose continuous with the sloping plane of the forehead, its lips set at a slight downward angle, squared-off chin and large, slightly bulging eye with heavy upper and well-defined lower lids is a good likeness of Alberti's appearance as recorded on a medal by Matteo de' Pasti (Hill, *Corpus,* 39, no. 161) and a drawing on the flyleaf of a manuscript in Rome (Grayson).

The sharply incised contours and clearly defined planes of the plaque recall the work of ancient gem carvers, "those who on seals extract the features of a hidden face by excision" (Alberti). Badt suggested as a source an amethyst portraying one of Agrippa's sons caricatured as a satyr. In any case "the general point of reference in Republican and Augustan gems" (Pope-Hennessy) is correct. A sardonyx cameo by the same gem engraver, Epitynchanos, who carved the amethyst noted as a possible source by Badt (British Museum, Vollenweider, pl. 88, 4) is in many ways as close to Alberti's style on the plaque, and would not have presented, as the amethyst does, the puzzling feature of satyr's ears on an aristocratic portrait.

Ex collections: Charles Timbal (?), 1871; Gustave Dreyfus, c. 1871–1914; Heirs of Gustave Dreyfus, 1914–33; [Duveen, New York, 1933–45]; Samuel H. Kress, 1945–51.
Exhibition: Union centrale des arts décoratifs, Paris, 1865, no. 1132.
References: G. F. Hill, *Portrait Medals of Italian Artists of the Renaissance,* London, 1912, 29–31; Hill, *Corpus,* 5–6, no. 16; K. Badt, "Drei plastische Arbeiten von Leone Battista Alberti," *Mitt Flor,* 8 (1958), 78–87; Pope-Hennessy, *Kress,* 7, no. 1; M.-L. Vollenweider, *Die Steinschneidekunst und ihre Künstler in spätrepublikanischer und augusteischer Zeit,* Baden-Baden, 1966, 112, pl. 88 (both amethyst of Agrippa's son and B. M. cameo); C. Grayson, ed., *Leon Battista Alberti On Painting and On Sculpture,* London, 1972, 143–154 (appendix on Alberti's work in painting and sculpture, includes "Vita anonima" and ill. of possible Alberti self-portrait in pen).

82 *Sigismondo Malatesta* 1450(?)

Matteo de' Pasti (Venice, active 1441/Rimini 1467–68)

Bronze medal. Obverse, around: SIGISMVNDVS PANDULFVS . MALATESTA . PAN . F . Reverse, around: CASTELLVM . SISMVNDVM . ARIMINENSE . M . CCCC . XLV . 8.2 cm. (diameter)

Collection of Mr. and Mrs. Mark Salton

Matteo de' Pasti, a major fifteenth-century medallist, a known architect and the designer of this medal, was also reportedly a miniaturist, sculptor and painter, although none of his works in the other media has survived. His medals reveal him to be a thoughtful and skillful portraitist (see entry for 83). After leaving the service of Lionello d'Este of Ferrara, he became a courtier of Sigismondo Malatesta in Rimini in 1446.

Matteo made a series of over 15 medals of Sigismondo, most of them unsigned. Hill speculated that Matteo's signature was dropped from these medals because he did not personally supervise the casting. The obverse of this medal shows a bust of Sigismondo wearing armor over chain mail and facing left. Though this medal bears the date 1446, it must have been made at least a few years later, judging by Sigismondo's obviously greater age in comparison to earlier medals of the series (e.g. Hill, *Corpus*, no. 174). The date 1446 appears on many of the medals and probably refers to the completion of the Rocca or castle of Rimini, in which Sigismondo took great pride and which is pictured on many of the reverses in this series, including that of the present medal. This striking portrayal of a castle, with its numerous tiny points of reflected light glinting on the crenellations and the lush surrounding fields, was justly considered by Hill the finest architectural design on a medal.

Matteo worked closely with the architect Leon Battista Alberti on S. Francesco in Rimini (the "tempio Malatestiano"), becoming superintendent of the works after Alberti's departure in 1450. He made a medal of Alberti which is less classical in style than Alberti's self-portrait plaque (81).

Saxl long ago pointed out the close relationship between the court of Malatesta, Cyriacus of Ancona, and the revival of interest in Greek literature and visual art at mid-century. A key connection in this context was Matteo's ownership of an original manuscript of Cyriacus, who had visited Rimini in 1449. Malatesta's unusual dedication in Greek to God and to the *polis* of Rimini on two marble slabs on the exterior of S. Francesco was recently determined by Campana to be based on a record by Cyriacus of the inscription on an ancient temple of Castor and Pollux in Naples. The Greek text was inscribed and interpreted by Lorenzo Valla (1442–48) in a letter which appears in the Garrett copy of Giovanni Marcanova's *Antiquitates* (4) on fol. 204 r-v (published with commentary by Campana).

Provenance: said to have been found at Verucchio, near the Rocca Malatestiana.

References: Hill, *Corpus,* 42, no. 186; Saxl, "Classical Inscription," 35–37; A. Campana, "Ciriaco d'Ancona e Lorenzo bvellab; sull'iscrizione greca del tempio dei Dioscuri a Napoli," *Archeologia classica,* 35–36, 1973–74 (1975), 84–102; M. Aronberg Lavin, "Discussion: the Antique Source for the Tempio Malatestiano's Greek Inscriptions," *AB,* 59 (1977), 421–422.

82 (reverse)

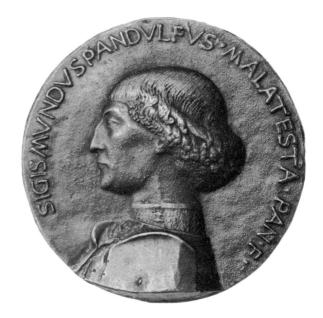

82 (obverse)

83 *Guarino da Verona* c. 1446

Matteo de' Pasti (Venice, active 1441/Rimini 1467–68)

Bronze medal; natural dark brown patina. Obverse, around: GVARINVS VERONENSIS. Reverse, around: .MATTHEVS DE PASTIS F. 9.5 cm. (diameter)

The Metropolitan Museum of Art, Rogers Fund, 1963 (63.187)

In 1446, close to the time when this medal was made, Flavio Biondo congratulated Lionello d'Este on having placed his portrait and name on coins, after the fashion of the Roman emperors. Medals were a form of antique revival particularly well suited to the fifteenth-century celebration of an individual's *Virtù*. They combined portable likenesses with personal emblematic devices and accompanying mottoes in permanent, though small-scale, memorials commemorating individuals of wealth and power or military, intellectual or artistic distinction. Discrepancies between Renaissance medallic portraiture and the imperial world currency of the Roman empire, "authorized and guaranteed by the emperor's image and superscription" (Hill, "Classical Influence," 260) were ignored.

Unlike imperial coinage, Renaissance medallic portraits recognized persons who were neither rulers nor their consorts, such as the humanist and educator Guarino Guarini from Verona (1374–1460). The classically draped portrait bust of Guarino on the obverse of this medal communicates his intellectual and moral power incisively. The image on the reverse, a nude male figure with mace and shield atop a two-tiered fountain in a flowery meadow, the whole surrounded by a laurel wreath, was an allegory of virtue. The portrait of Guarino on this medal has always amazed and delighted connoisseurs with its condensation of so much bristling energy into so small a compass. Hill called it Matteo de' Pasti's most powerful work (*Corpus*, 34). The medal has won universal acclaim as a superior example of quattrocento medallic art.

The Venetian patrician Paolo Zane enabled Guarino, the son of a blacksmith, to study Greek in Constantinople under the Byzantine Manuel Chrysoloras during 1403–8, thereby launching his career as a scholar, translator, teacher and educational reformer. He was to become one of the most influential humanists of the fifteenth century. Guarino was the first to stress the learning of Greek as essential to humanistic study. The intellectual and political accomplishment of many of his students, men like Francesco Barbaro, Leonardo Giustiniani, Giorgio da Trebizond, Vittorino da Feltre, Bartolommeo Fazio and Tito Vespasiano Strozzi, themselves leading teachers and humanists during the first half of the century, reflected their teacher's extraordinary moral and pedagogical powers. Guarino founded his famous school first at Venice (1414–18), which he helped establish as a leading center for Greek

studies in Italy, before moving to Verona (1419) and finally settling in Ferrara (1429), where he became the tutor of Lionello d'Este, the very model of the learned prince and enlightened patron. Matteo de' Pasti worked for Lionello in Ferrara during the years just prior to his entering the service of Sigismondo Malatesta of Rimini (see 82).

Ex collections: Richard Norton; Sigmund Morgenroth.
Exhibitions: San Francisco, M. H. De Young Memorial Museum, 1958; Oakland, Mills College Art Gallery, 1958; Houston, Museum of Fine Arts, *The Lively Arts of the Renaissance,* 1960, no. 126; Detroit, *Decorative Arts,* no. 287; Metropolitan, *Northern Italy 1440–1540,* no. 52.
References: G. F. Hill, "Classical Influence on the Italian Medal," *BM,* 18 (1911), 259–268, esp. 260; G. Bertini, *Guarino da Verona fra letterati e cortigiani a Ferrara,* Geneva, 1921; Hill, *Corpus,* 38, no. 158.

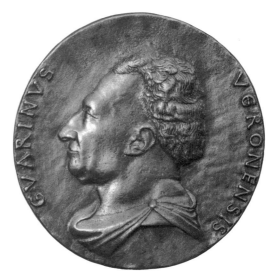

83 (obverse)

83 (reverse)

84 *Vettor Gambello* 1508

Vettore Gambello, called Camelio (c. 1455–60/Venice 1537)

Bronze medal (struck from engraved dies); traces of dark red lacquer (flaked and rubbed away) over bright yellow bronze. Obverse, around: VICTOR CAMELIVS SVI IPSIVS EFFIGIATOR MD VIII. Reverse, above: FAVE FOR[tuna]. Below: SACRIF [icio]. 3.7 cm. (diameter)

National Gallery of Art, Samuel H. Kress Collection, 1951 (A–885.148A)

Vettore di Antonio Gambello, known as Camelio and designated as such on this self-portrait medal, was a Venetian medallist, die-engraver, jeweler and maker of armor, first mentioned as master of the dies in the Venetian mint in 1484. From 1513, he worked as an engraver in the papal mint, returning to Venice in 1516 or 1517. In 1506 he cast a medal of Pope Julius II, but an earlier papal portrait of Sixtus IV attests to his presence in Rome sometime between 1471 and 1484.

His profile self-portrait on the obverse of this medal combines the naturalism of quattrocento portraiture with an awareness of antique portrait types and styles that does not seem to have been confined to the study of classical coins. As a result the living presence of the artist is captured with unusual vivacity and strength. Camelio defines himself as a Roman *redivivus* by the theme of his reverse, a sacrifice scene freely adapted from an antique model. Here he shows his inventiveness in the construction of a flawless composition based on his study of sarcophagi and imperial Roman reliefs, probably begun during his first Roman visit. The artist's virtuosity is displayed by the arrangement of the figures in a harmonious counterpoint of poses and gestures, seemingly unconstrained by the miniature dimensions of the medal.

Ex collections: Charles Timbal (?); Gustave Dreyfus, c. 1871–1914; Heirs of Gustave Dreyfus, 1914–33; [Duveen, New York]; Samuel H. Kress, 1945–51.
References: Pope-Hennessy, "Statuettes," 23; Hill and Pollard, *Medals,* 31, 148.

84 (obverse) **84 (reverse)**

85 *Head of a Woman* c. 1490–95

Attributed to Tullio Lombardo (Venice c. 1455/Venice 1532)

Bronze bust (hollow cast); brown patina with traces of black lacquer. 14.5 × 14.4 × 10.5 cm.

Smith College Museum of Art (1960.44)

The Smith College *Head of a Woman* has been connected to a group of bronze female heads with Praxitelean hairstyles and animated facial expressions. These busts end at shoulder level, often with an asymmetrical cut. Most wear generalized classicizing drapery. They are attributed or linked to Tullio Lombardo because of a resemblance to two marble double portraits, in Venice (Cà d'Oro, c. 1490–93; signed "TVLLIVS LOMBARDVS F.") and Vienna (Kunsthistorisches Museum, c. 1496–1500). Bode's contention that a signed marble head in the Venetian Palazzo Ducale serves as the basis for this group's attribution appears to be without foundation (1907, I, 38). The other examples are in Berlin, the Wallace collection, and (two) the Museo Estense, Modena. The Smith College head differs from them in being less an adaptation of a Praxitelean head and more a contemporary portrait. The hair lies closer to the head and is encircled by a thin fillet with a rosette in the center of the forehead. The drapery is not classicizing but consists of thin material closely gathered at the round, low neckline by a plain band. Only the technique of forming the eyes and the shapes of nose and mouth specifically recall the antique. These differences suggest a date somewhat earlier than that of the other bronze heads, which are today more often attributed to Antonio than to Tullio Lombardo (see 107 and works cited below). The latter may reasonably be connected to the genesis of the *Peace* (107), whereas the Smith College head remains linked stylistically to the Cà d'Oro portrait of the 1490s.

As a portraitist Tullio was among the first Renaissance artists to be fully aware of the importance of the precise angle of the head. The tilt of its axis to one side, slightly backward or forward, and the turn of the face to the left or right, play a decisive role in creating psychological animation. His ability to utilize such devices effectively probably derived in the first instance from study of Hellenistic sculpture and its formulas for pathos. As a result, his securely attributed portrait heads convey a vivid illusion of interior life, and, since they are double portraits, of the couple's ongoing relationship. Some shared moment seems suddenly interrupted by the artist; this is especially true of the Vienna portrait. This impression anticipates such well-known examples in painted portraiture as Raphael's *Thomaso Inghirami* of c. 1510–11 (version in Isabella Stewart Gardner Museum, Boston).

Tullio also achieves new intensity of facial expression by concentrating attention on the eyes. In many figures and busts by the artist the eyes are emphasized and framed by an abundance of curly hair (for exam-

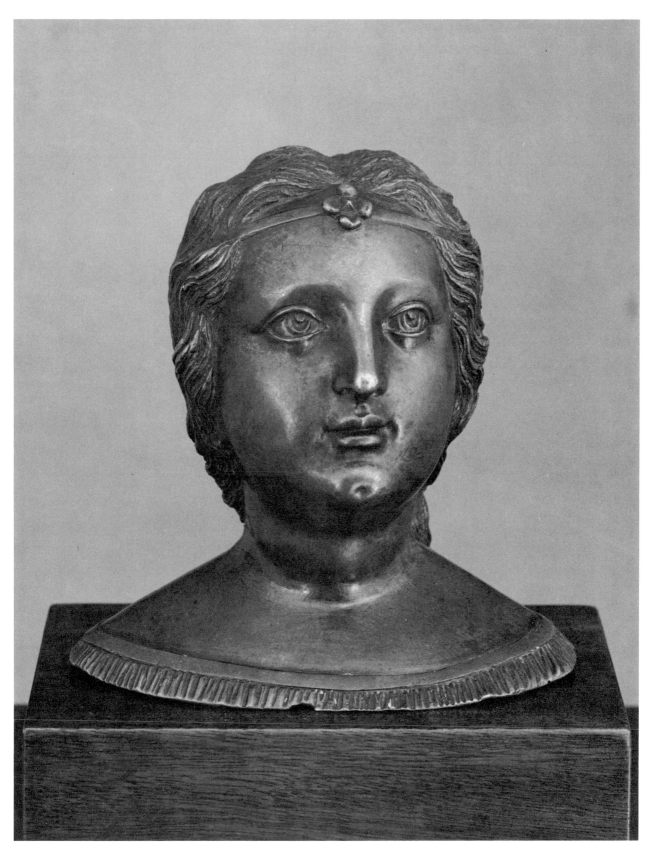

85

ple, the *Adam,* Metropolitan Museum). The effect contrasts sharply with the abstracting simplification of the head that approaches pure ovoid volume, practiced by earlier masters like Laurana. The eyes themselves are often carved or modeled with incised irises and half-moon accents in the pupils, as seen in the Smith College head; sometimes, in the marble heads, they are inset with dark stone. This characteristic technique of carving the eye may have been adapted by Tullio from Antonine or Severan heads similar to the one that served as a model for the Renaissance sculptor of 79. It serves to sharpen the focus of the glance, and draws attention to the decisive role played by the eyes in creating an illusion of life. Tullio's intention to simultaneously classicize and animate the head is fully revealed by his combination of an antique Roman mode of shaping the eye, a Hellenistic hairstyle, and the slightly parted lips seen in this head, also characteristic of his style. In this his artistic concerns can be seen to be identical with those of other major artists of the High Renaissance, men like Leonardo, Michelangelo and Raphael.

The Smith head exemplifies Renaissance sculptors' consideration of the viewing angle in the creation of their works. When viewed from the front at eye level, as in several published photographs, its appearance is somewhat heavy and coarse. But when seen from slightly below, as it would have been displayed on a shelf or a ledge above wainscoting surrounding a room, the head recovers its original liveliness and delicacy.

Ex collections: Frederick Spitzer, Paris; [Galerie Julius Böhler, Munich].
Exhibitions: Galerie Julius Böhler, *Meisterwerke alter Kunst,* Munich 1958, cat. 94; Smith College Museum of Art, *A Sculpture Collection for Smith College,* Northampton, May 15–June 5, 1963; Smith College, *Renaissance Bronzes,* cat. 14.
References: R. O. Parks, "Unpublished Works and Recent Acquisitions," *Smith College Museum of Art Bulletin,* 40 (1960), 13; Pope-Hennessy, "Statuettes," 22 (Antonio Lombardo suggested as author of both Modena heads); M. G. Ciardi Dupre, *Small Renaissance Bronzes,* trans. B. Ross, London, N.Y., etc., 1970, 79, 58–59 (illus.) (Modena heads); Weihrauch, *Bronzestatuetten,* 128 (accepts Pope-Hennessy's attribution of Modena heads to Antonio Lombardo and adds the Berlin version to Antonio's oeuvre).

86 *Diva Julia*

Pier Jacopo Alari Bonacolsi, called Antico (Mantua c. 1460/Gazzuolo 1528)

Bronze medal (solid cast); natural brown patina. Signature on ground line: ANTICVS. Obverse, around: DIVAI . IVLIA . PRIMVM . FELIX. Reverse, around battle scene: DVBIA . FORTV[n]A. 3.7 cm. (diameter)

The Cleveland Museum of Art, Gift of Cyril Humphris (71.139)

This medal shows Antico's skill in small-scale portraiture, suggesting his artistic origins lay in the shop of a goldsmith. The golden girdle he made for Antonia del Balzo to give as a present in 1487 also indicates such training. Antico's mastery of the incisive, analytic art of medallic portraiture testifies to his study of antique coins, medallions and gems, undertaken before the artist ever went to Rome. The resources of the great collection of antique gems amassed by Cardinal Francesco Gonzaga would very likely have been made available to him as a Gonzaga court artist.

The identification of the Julia on the obverse of this medal is uncertain. It cannot be Giulia Gonzaga, the daughter of Lodovico of Bozzolo, since she was only 15 when Antico died (Wixom). The psychological penetration shown by this profile image, no more than 2.7 cm. high, is impressive. The battle scene on the reverse of the medal is a masterpiece of controlled condensation of forms. It swells with dynamic energy without seeming to crowd the tiny area. Understandably, this design has been called Antico's finest medallic reverse (Wixom). There is a trophy of military arms in the exergue below. The inscription above in classical squared capitals with the Stoic motto, and the pearled border catching glints of light in its numerous facets, repeat features of the obverse.

Ex collection: [Cyril Humphris, London].
Exhibition: Cleveland, *Ohio Bronzes,* no. 60 (Wixom).
Reference: Hill and Pollard, *Medals,* 19, no. 73.

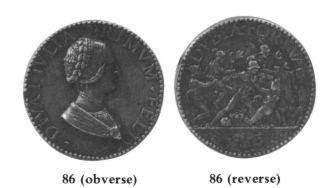

86 (obverse) **86 (reverse)**

87 *Portrait of Pope Adrian VI* 1522–23

Marcantonio Raimondi (Argini, near Bologna, c. 1480/ Bologna 1527–34)

Engraving; B. 14, 368, 494; P. 6, 40, 273. Signature near intersection of circular frame with vertical frame at right: MF [monogram]. Inscription: .ADRIANVS . SEXT . P . MAX . 8.4 × 5.1 cm.

Collection of Henri Zerner

This fine impression of Marcantonio's portrait of Pope Adrian VI in the *all'antica* mode belongs to a set of three in which Popes Leo X and Clement VII were also portrayed, according to a format chosen for papal engraved portraits beginning with Pius II (Aeneas Sylvius Piccolomini, r. 1458–64). Pius reigned during a time when the efforts of popes to make the ancient splendors of Rome accessible and to improve its modern urban environment began to be associated with aggrandizement of papal political power. Roman imperial coins of the type with profile busts of emperors on their obverses, encircled by succinct inscriptions, were thus doubtless the source for this portrait series (cf. 74 and 77). Marcantonio also engraved a series of twelve imperial portraits in similar form but larger, which included Julius Caesar, Claudius, Nero and Galba, as well as three Flavians (B. 501–512).

In Marcantonio's engraving, Adrian's features and expression and the modeling of his face are identical to a painted portrait of the pope in the Uffizi (Rodocanachi, pl. 2). Perhaps one was based on the other. This likeness is not incompatible with the painting showing the pope in a three-quarter view attributed to Jan van Scorel in Utrecht (Rodocanachi, pl. 3). But it is quite unlike two of the medallic portraits shown in Rodocanachi's plate 5 (center and lower right corner). Contemporaries might have appreciated the irony involved in the use of a manner evoking the classical past to portray a Dutch pope, Adriaan Floriszc Boeyens, who had little interest in or understanding of art and in fact actively opposed antique revival because of the glorification of pagan works associated with it.

Ex collections: Dr. F. A. Lieberg; [Knoedler's, 1958].
References: H. Delaborde, *Marc-Antoine Raimondi,* Paris [1888], 250–252, no. 229; E. Rodocanachi, *Histoire de Rome, Les Pontificats d'Adrien VI et de Clement VII,* Paris, 1933 (ills. and pp. 52–53; n. 1, p. 53—Adrian's portraits); Mortimer, I, 10–11, no. 9 (letter to Adrian imploring him to come to Rome after his election as pope; entry has bibliography on Adrian and his portraits).

87

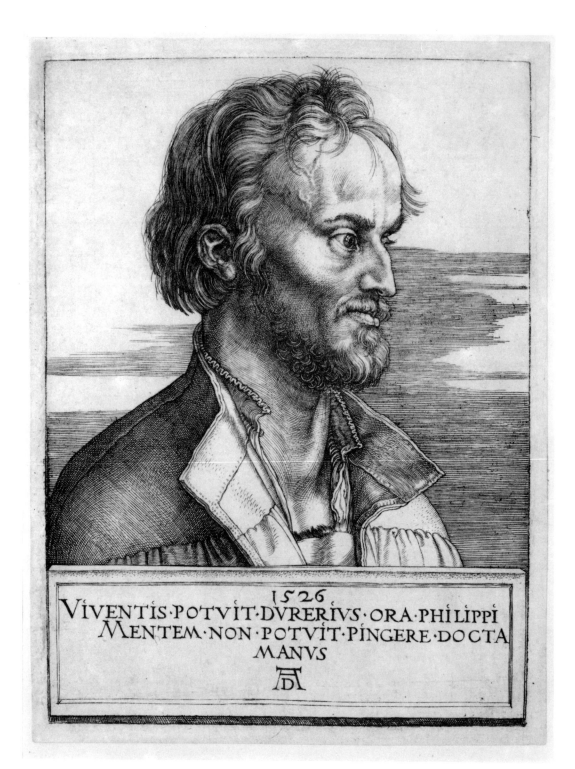

1526
VIVENTIS·POTVIT·DVRERIVS·ORA·PHILIPPI
MENTEM·NON·POTVIT·PINGERE·DOCTA
MANVS

88

88 *Philip Melanchthon* 1526

Albrecht Dürer (Nuremberg 21 May 1471/6 April 1528)

Engraving; Meder 104a. Signature: AD[monogram]. Inscription: VIVENTIS . POTVIT . DURERIVS . ORA . PHILIPPI/MENTEM . NON . POTVIT . PINGERE . DOCTA/MANVS. 17.5 × 12.8 cm.

Museum of Fine Arts, Boston, Stephen Bullard Memorial Fund (68.238)

Dürer's portrait of Philip Melanchthon was the last in a series of six engraved portraits created between 1519 and 1526. All share the feature of an "engraved tablet" that appears to be "carved" with a Latin inscription in regular squared Roman lettering. In all but one of these portraits (the Erasmus) the tablet is presented as a three-dimensional stone slab on the outermost plane, separating the onlooker from the otherwise highly naturalistic image of the sitter. As Panofsky noted, this device reflected Roman funerary monuments that were widely scattered throughout Europe. The collection of Roman inscriptions from extant monuments was well advanced by the time of Dürer's second visit to Italy (1505–January 1507). Thus this specific form chosen for engraved portraits ought to be interpreted as Dürer's version of the portrait *all'antica*, a genre that had arisen in Venice in Tullio Lombardo's sculpture and Giorgione's paintings.

The subject's personality and achievements were well suited to this mode of portraiture, since Melanchthon's career was one which actively advanced "antique revival" in Europe. He was a professor of Greek and Germany's leading pedagogue. The inscription on his tablet has been translated: "Dürer was able to depict the features of the living Philip [although] his skilled hand was unable to depict his mind" (de Grummond). "Mentem" could also be translated "soul." The reflection of a window in Melanchthon's eye apparently alluded to the eye as the "window of the soul." The emphasis on the word *"viventis"* beginning the inscription, and on other forms of the Latin word *"vivus"* in the inscriptions of the other engraved portraits, is twofold. It alludes to conventional formulae of Roman funerary inscriptions, in which the fact of the tomb's having been made during the lifetime of its recipient or that of its donor is recorded. A second and more all-embracing meaning refers to the immortality conferred on the sitter by the portrait itself, through the artist's skill in imitating nature (de Grummond).

Ex collections: Vincent Mayer; Tomás Harris, London.
Exhibition: Museum of Fine Arts, Boston, *Albrecht Dürer, Master Printmaker,* November 17, 1971–January 16, 1972, no. 217.
References: Dürer in America, no. 78; N. T. de Grummond, "VV and Related Inscriptions in Giorgione, Titian and Dürer," *AB,* 57 (1975), 346–356, esp. 355.

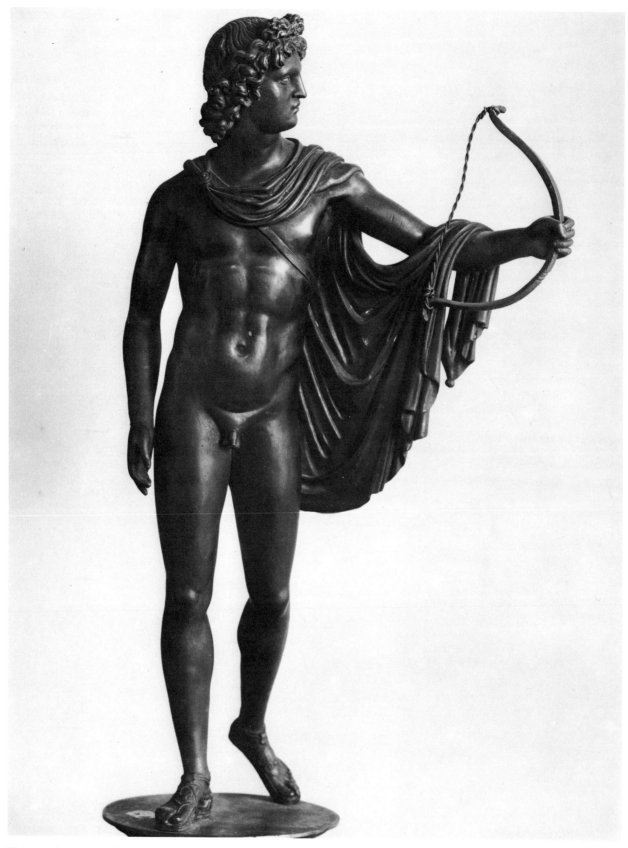

89 (supplement). Pier Jacopo Alari Bonacolsi, called Antico. *Apollo Belvedere,* c. 1519 or earlier. Bronze (hollow cast); partly gilt and silvered; dark brown patina, patches of black lacquer. Bow not original. Cà d'Oro, Venice.

Antique Subjects and their Transformations: Myth, History, Pastoral; Fantasy and Allegories <u>all'antica</u>

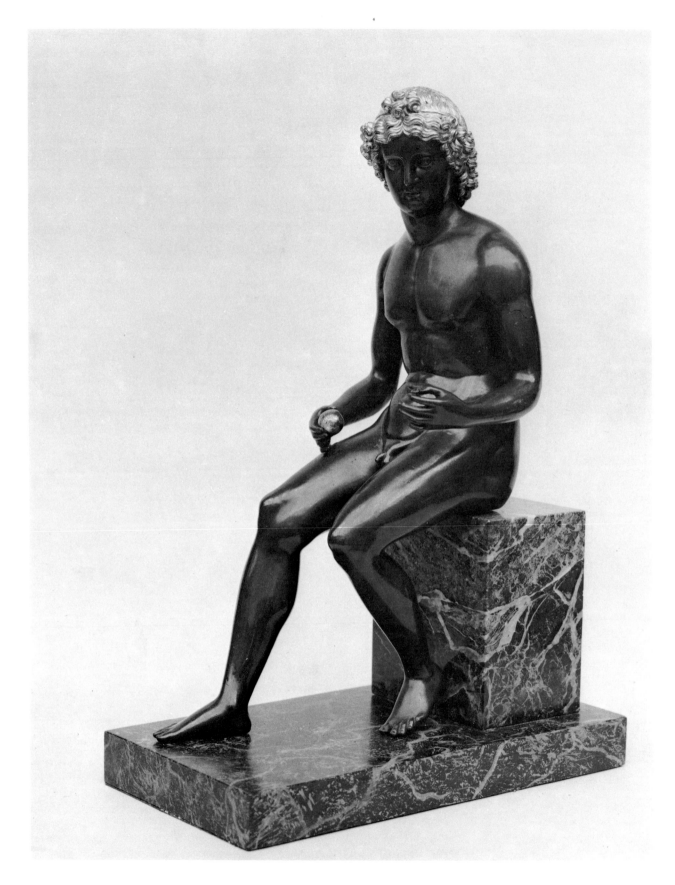

89

89 *Paris* 1490–1500

Pier Jacopo Alari Bonacolsi, called Antico (Mantua c. 1460/Gazzuolo 1528)

Bronze (hollow cast), partly gilt and silvered; thin deep brown, almost black, patina. 37.1 cm.

The Metropolitan Museum of Art, Edith Perry Chapman Fund, 1955 (55.93)

Discovered in 1955, this unusual representation of a nude, seated Paris, so far a unicum, is a work of immense charm. The extreme delicacy and refinement of each aspect of composition and technique are in every way characteristic of Antico (Phillips). Paris holds the golden apple and the ring he is about to offer Venus as tokens of his choice of her as the most beautiful of the goddesses (cf. 90). Raggio speculated that the ring, not mentioned in the classical sources, had reference to the marriage of a particular couple for whom the statue was made as a gift. Perhaps originally there were three bronze figures of Hera, Athena and Aphrodite to complete the group.

The firmness and smoothness of its modeling creates taut contours describing a form of utmost self-containment and stillness. The proportions and facial features look back to Hellenistic or Roman Greek revival styles. The serene yet slightly melancholy expression of self-absorbed composure reflects the mood of nostalgia that entered antique revival style in sculpture in the work of Antonio Rizzo and Tullio Lombardo at about the same time (38). The sense of being outside or abstracted from time, and the elegance of elaboration and finish bring to mind such paradigmatic pieces by Antico as the *Apollo Belvedere* (1519?, Cà d'Oro; 89 suppl.), the *Venus Felix* (Vienna), or the *Cleopatra* (Boston; 68). The somewhat earlier moment in the artist's development may account for a stronger sense of emotion in the face of Paris. The use of parcel-gilding and silvering in the re-creation of an antique bronze was itself an aspect of antique revival, since many literary sources spoke of the ancients' "golden statues" (Legner).

Antique seated Paris types were shown either clothed or, if nude, wearing the Phrygian cap that was his usual attribute. One exception was a completely nude Paris seated on a high support (Reinach). This work, subsequently destroyed, was illustrated by an engraving in a volume of F. A. Gori's *Museum Florentinum* (1740). Aside from these two features of the Florentine *Paris,* there seems to have been nothing in common between its style and proportions and those of Antico's bronze figure.

Ex collection: [Tozzi, 1955].
Exhibitions: Wildenstein, *The Italian Heritage,* no. 45 (O. Raggio); Metropolitan, *Northern Italy 1440–1540,* no. 24.
References: S. Reinach, *Répertoire de la statuaire grecque et romaine,* 1, Paris, 1930, 490, pl. 828; J. Goldsmith Phillips, "Recent Accessions of European Sculpture," *Bull. Met. Museum,* n.s., 15 (1956), 150; Legner, "Anticos Apoll." 108 and nn.

90 *The Judgment of Paris* c. 1517

Marcantonio Raimondi, after e design by Raphael (Argini, near Bologna, c. 1480/Bologna 1527–34)

Engraving; B. 14, 106, 245; P. 6, 25, 137. Inscription: RAPH. VRBI. IVEN. [and] SORDENT. PRAE FORMA INGENIVM. VIRTVS. REGNA. AVRVM. 29.5 × 43.7 cm.

Yale University Art Gallery, Gift of Edward B. Greene, Yale, 1900 (1928.123)

Marcantonio's *Judgment of Paris* is a famous example of transformation of motifs from ancient sarcophagi in a High Renaissance composition. In 1896 Loewy demonstrated that two sarcophagi known in early sixteenth-century Rome were drawn upon. One, often copied, is now incorporated into the wall of the Villa Medici; the other is walled into the facade of the Casino of the Villa Pamphili. Knowing these sources helps to show how Raphael "improved on" the antique reliefs that inspired him. Paris's pose is based on the Medici sarcophagus; his nudity on the Villa Pamphili example. In Raphael's design, Paris becomes at once more dynamic and more heroically proportioned. The simultaneous twist and contraction of the torso, and its exaggerated musculature, recall the *Torso Belvedere.* The use of this animated pose, when combined with the seated pose and characteristic Phrygian cap derived from the sarcophagi, gives Paris greater predominance in the overall composition. The increased roles of gesture and pose in expressing dramatic action are what one would expect from an artist who had recently completed the Sistine tapestry designs.

No artist studied the antiquities in Rome with greater depth of understanding than Raphael. His design for this engraving nevertheless implies that he found the sarcophagi models to be somewhat lacking in narrative intelligibility. What needed clearer expression was the implication of Paris's choice of Venus over Minerva, the goddess of wisdom, and Juno, the goddess of domestic stability: the inevitable end result, the climax of violence and tragedy that was the Trojan War. A more explicit connection between human acts and Olympian presences characterizes the style of Raphael's narrative.

To the right of Paris stand the three goddesses: Juno with her peacock, Venus with Eros, and Minerva with her shield and helmet lying on the ground nearby. The goddesses are not adapted from either sarcophagus. They derive in a general sense from Hellenistic free-standing nudes and relate to Raphael's compositional studies, e.g. for nudes in the Loggia of Psyche in the Villa Farnesina. This relationship helps to suggest a date of c. 1517 for the print, and contradicts Vasari's implication that it was made by Marcantonio soon after arriving in Rome (Vasari, 5, 411).

Among figures on the Villa Pamphili sarcophagus Raphael was drawn to the motif of the seated nymph seen from behind, whose graceful turning motion generates the directional flow from left to right. In the engraving the nymph with the jar at left is based on this

figure and, like her source, turns back into the picture space as if speaking to her companions. From the Medici sarcophagus come the two standing nymphs at the left and, though greatly transformed, the group of two reclining river gods with a seated nymph who turns to gaze pensively out at the onlooker. The latter group especially, because Manet adapted it in his *Déjeuner sur l'Herbe*, reveals the enduring influence of this popular sarcophagus.

Such freedom in the employment of motifs from antique relief sculpture suggests Raphael's fully mature approach to the art of antiquity. Raphael's early native classicism, which permeated works like *The Three Graces* with an atmosphere of lyrical serenity, was supplanted, after his first six years in Rome, by a style that incorporated Hellenistic Baroque twice over: through study of antiques like the *Torso Belvedere* and the *Laocoon,* and as seen in Michelangelo's own translation of it into High Renaissance style.

Ex collections: Hawkins; Alfred Morrison.

Exhibitions: Detroit Institute of Arts, *Master Prints from Yale Collections,* Mar. 18–May 4, 1952; *First Maniera,* no. 99 (John Quarrier); Vassar College Art Gallery, *Italian Renaissance Paintings, Drawings and Prints,* Sept. 20–Dec. 15, 1974.

References: C. Hülsen, *Das Skizzenbuch des Giovannantonio Dosio im Staatlichen Kupferstichkabinett zu Berlin,* Berlin, 1933, 6, no. 20; Bober, *Aspertini,* 68f. (list of Renaissance drawings of the Villa Medici sarcophagus); G. Becatti, "Raphael and Antiquity," *Raphael,* N.Y., Reynal and Co., 1969, 515f.; Lehmann, "Parnassus," 73–75; 75, n. 33 (Venus on Pamphili sarcophagus as source for Mantegna's Venus in the *Parnassus;* bibliog. on use of this sarcophagus by Marcantonio, Agostino Veneziano); Fogg, *Rome and Venice,* no. 19 (Lawrence Nees).

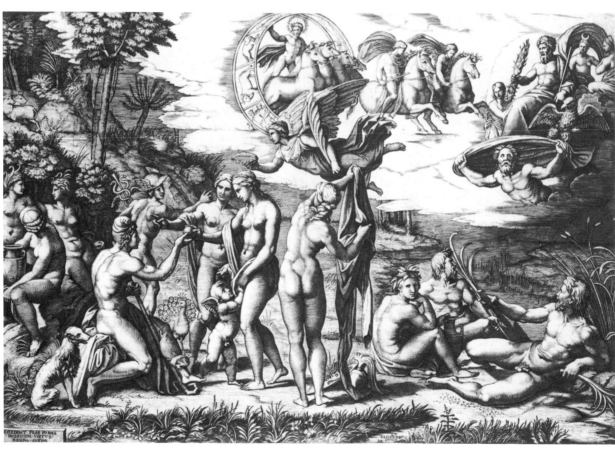

91 *The Fall of Phaeton* or *Death of Hippolytus*
After 1506

Moderno, Galeazzo Mondella? (North Italy, Verona?, active c. 1500, in Rome by 1506?)

Bronze (solid cast); dark brown, nearly black, patina. 10.2 cm. (diameter)

The Cleveland Museum of Art, Purchase from the Lawrence Hitchcock Fund (69.17)

The scene on this plaquette is based on a second-century A.D. Phaeton sarcophagus that was in Sta. Maria d'Aracoeli, Rome, during the Renaissance (now Uffizi, cf. 22). The arc-shaped organization of the group on the plaquette echoes a similar line of force in the Roman relief, whose composition in turn was based, according to Mansuelli, on a pictorial source.

Recognition of the plaquette's connection to this sarcophagus relief gave rise to the identification of the subject as the Fall of Phaeton. In the myth, Phaeton tried to drive the chariot of the sun but, unable to control the horses, nearly set Earth on fire. Killed by a thunderbolt from Jupiter, he fell into the River Eridanus (Po). On the plaquette, the nude youth has fallen from his chariot at the left. The death of Hippolytus was suggested as an alternative (Pope-Hennessy); in that case the waves would not be the Eridanus but the sea. Variants show a landscape with hillocks and trees or a palace in the background (Victoria and Albert; Berlin).

Wixom drew attention to the brilliance of this plaquette's composition. With exemplary inventiveness, Moderno varied the attitudes of the horses within the narrow scope allowed by so small a circle. He was able to make of their shapes and that of Phaeton,

moreover, a dynamic oval whose surging energy epitomizes the cosmic force that the youth so presumptuously challenged. Details like the horses' agitated streaming manes and tails break up the surface into numerous small curving ridges, thereby heightening the sense of an impetuous headlong plunge.

Ost has recently made the interesting suggestion that Moderno's immediate source was a cartoon of the Fall of Phaeton by Leonardo, reported by Francesco Scanelli in 1657 as in the collection of the Grand Duke of Tuscany. This would explain the unusual dynamism of the lines of force interrelating the horses and their relationship to the surging waves. Leonardo, in Ost's view, had designed the engraved cameo with the Fall of Phaeton (Pitti) formerly considered antique, whose forms are close to those in Moderno's plaquette as well as to Leonardo's designs for equestrian monuments and his *Battle of Anghiari* cartoon. Michelangelo, in evolving the motif of Phaeton's fall in his drawings of this subject for Tommaso Cavalieri (final version, Windsor, Royal Library, 12766r), would thus have been familiar with Leonardo's cartoon as well as with the antique Phaeton sarcophagus, also studied by Aspertini (22).

Ex collections: Georges Chalandon, Paris; [Drey Gallery, New York, 1969].
Exhibition: Cleveland, *Ohio Bronzes,* 47 (Wixom).
References: Mansuelli, *Uffizi,* 232–233, no. 251 (with list of Renaissance drawings, not including Aspertini's, no. 20) and ill.; Pope-Hennessy, *Kress,* 49–50, no. 160; F. Hartt, *Michelangelo Drawings,* N.Y., 1970, 250–251, nos. 355–358; H. Ost, *Leonardo-Studien,* Berlin, N.Y., 1975, 110–122 (Pitti *Phaeton* cameo, design attributed to Leonardo); 122–128 (Leonardo's *Fall of Phaeton* cartoon and Moderno's plaquette); figs. 95–118.

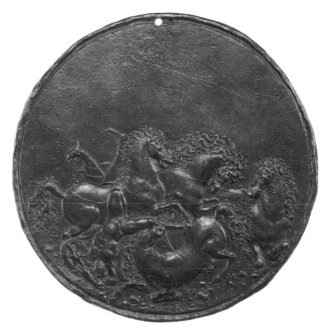

91

92 *Hercules Strangling the Serpents* c. 1510(?)

Attributed to Moderno, Galeazzo Mondella? (North Italy, Verona?, active c. 1500, in Rome by 1506?)

Bronze plaquette; dark red-brown lacquer (partially flaked) over bright yellow-brown bronze. 9 × 7.6 cm.

National Gallery of Art, Samuel H. Kress Collection, 1951 (A.467.190B)

Hercules was represented frequently by Moderno (see 124). This plaquette shows an episode in which the infant Hercules reveals his godlike nature by strangling two serpents which had attacked him in his cradle. The forms of his body and cloak, with their elastic contours and economical, incisive modeling, express the young god's exuberant strength in a manner typical of Moderno's style (cf. 63).

Courajod stated that the composition was derived from "une médaille de Samos." By this was meant the early-fourth-century B.C. tridrachm with Hercules strangling a pair of serpents on the obverse (Barron, pl. XXII, 1c, 1e), though this coin type, which was shared by other cities like Rhodes and Knidos, showed the infant Hercules kneeling rather than walking.

Pope-Hennessy, agreeing with previous scholars' attribution of the plaquette to Moderno, located its geographic source in Mantua. A generic relationship to Mantegna's putti and their derivatives may be observed by comparison with 5 and 6. The suave self-confidence with which the body's forms and striding contrapposto are handled suggests a date for the plaquette around the end of the first or beginning of the second decade of the sixteenth century.

References: L. Courajod, *L'Imitation et la contrefaçon des objets d'art antiques au XVe et au XVIe siècle,* Paris, 1887 (extracted from *GBA*); Pope-Hennessy, *Kress,* no. 177; J. P. Barron, *The Silver Coins of Samos,* London, 1966, 113.

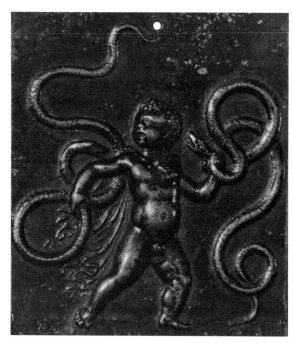

92

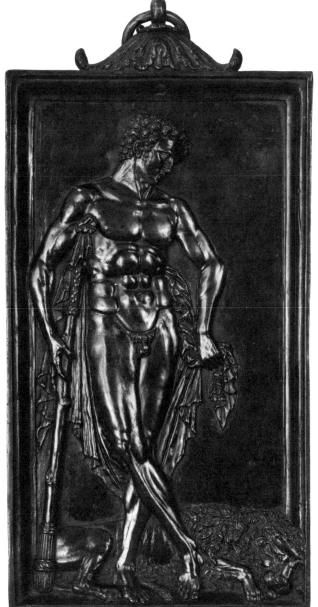

93

93 *Hercules Resting after the Fight with the Lion*
1500–1510

Pier Jacopo Alari Bonacolsi, called Antico (Mantua c. 1460/Gazzuolo 1528)

Bronze relief; brown patina. 25.4 × 14.6 cm.

The Museum of Fine Arts, Houston, Edith A. and Percy S. Straus Collection (44–582)

Mantegna's extraordinary knowledge of antique art and culture, and his ingenuity in drawing on a wide variety of media and styles (cf. 5–7, 10, 11, 14), created a climate for Mantuan art from the 1460s on that nurtured both antiquarian expertise and creative freedom in the artistic use of antique sources. Antico, more than any other artist, profited from this climate. He first worked for Federico Gonzaga (1440–84) and Gianfrancesco Gonzaga di Ròdigo (1443–96), sons of Mantegna's great patron Lodovico Gonzaga. Gianfrancesco was Lord of Bozzolo. On his death in 1496 the inventory of his art works included antiques and numerous bronzes. Many of these were the re-creations of Graeco-Roman "table-top" bronzes that Antico was to make famous, including versions of such famous antiques as the equestrian statue of Marcus Aurelius and the Quirinal *Horse Tamers*. Already secure in his reputation as a connoisseur of antiques, Antico was sent to Rome in early 1497 by Gianfrancesco Gonzaga (1466–1519), probably to locate antiquities for his wife Isabella d'Este's *studiolo*. This period in Rome was no doubt of great importance for Antico's study of the antique. But it may not have been his first visit there, as he seems to have been a practicing artist as early as 1490, the date of a letter of Antonia da Balzo calling him "her sculptor."

Hercules Resting is the only autograph Antico relief in America, and one of his only seven known extant reliefs. Its rectangular format differentiates it from the five circular reliefs of scenes from the life of Hercules (32.1–32.7 cm. diameter) with which it is otherwise closely linked.★ Hercules was hated by Juno because he had been born of the mortal princess Alcmene, fathered by Jupiter. Juno brought about the trials endured by Hercules, including his enslavement to Eurystheus, King of Argos. Slaying the lion in the Nemean forest was one of the twelve labors assigned Hercules by Eurystheus as a condition of his freedom. The roundels all depict Hercules' labors or feats; the Straus plaque, instead, portrays him at rest after slaying the Nemean lion.

The depiction of Hercules in the Straus relief is closely related to the abstracted and schematized treatment of anatomy in the circular reliefs, which may in turn draw on late antique prototypes such as the third century *Hercules with the Erymanthian Boar* on the facade of St. Mark's, Venice. In both subject and style the Straus relief is more relaxed. The moment of reflection portrayed marks the boundary between young manhood and middle age, when Hercules begins to wear the lion skin stripped from the dead beast now lying at his feet as if asleep (Planiscig). His youth and strength are shown in their full radiance, in this moment that seems briefly to escape the inevitability of change. Antico has organized the relief with utmost sensitivity to the role of the empty background in accommodating the oval circuit of energy set in motion by the crossed leg, the curving right arm, and the slight downward angle of the pensive head. Perhaps an Attic grave relief among the numerous antiquities in the various Gonzaga collections served as his inspiration. The same or a similar prototype may have inspired the bronze statuette (Hercules?) in the Victoria and Albert Museum (Bober, fig. 4).

Ex collections: Dr. A. von Frey, Vienna, 1934; Edith A. and Percy Straus, New York, 1944.
Exhibitions: Detroit, *Decorative Arts*, no. 239; Metropolitan, *Northern Italy 1440–1540*, no. 26; The Fine Arts Museum of San Francisco, California Palace of the Legion of Honor, *The Triumph of Humanism: Renaissance Decorative Arts, 1425–1625*, October 22, 1977–January 8, 1978, no. 21.
References: Hermann, "Antico"; L. Planiscig, "Bronzes of the Italian Renaissance, I. An Unknown Work by Antico," *BM*, 66 (1935), 127f.; Museum of Fine Arts, Houston, *Catalogue of the Edith A. and Percy S. Straus Collection*, 1945, no. 69; P. Bober, "The Census of Antique Works of Art Known to Renaissance Artists," *Acts of the 20th International Congress of the History of Art, Renaissance and Mannerism*, Princeton, 1963, 82–89; Y. Hackenbroch, "Italian Renaissance Bronzes in the Museum of Fine Arts at Houston," *Connoisseur*, 177 (1971), 121, 124; R. Stone, personal communication, December, 1977.

★*The Infant Hercules and the Serpents, Hercules and the Erymanthian Boar* and *Hercules and the Nemean Lion* (Victoria and Albert); *Hercules Slaying the Hydra* and *Hercules and the Nemean Lion* (parcel gilt, Florence, Museo Nazionale); *Hercules and the Ceryneian Stag* (Vienna, Kunsthistorisches Museum)—see Pope-Hennessy, *Victoria and Albert*, 1, 321–3; the slots at the top of these reliefs suggest they were originally suspended.

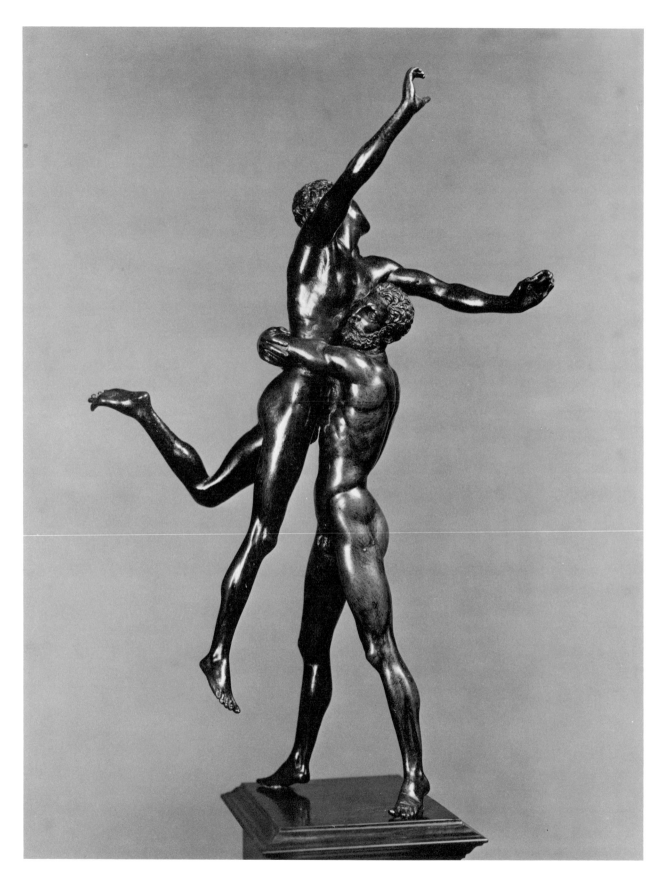

94

94 *Hercules and Antaeus* c. 1520–25

Francesco da Sant'Agata (Padua, active c. 1520)
Bronze; black lacquer patina. 38 × 12 × 26.5 cm.
National Gallery of Art, Widener Collection, 1942
(A-113)

In April 1519 Antico mentioned in a letter to Isabella d'Este that he had made a *Hercules and Antaeus* for Bishop Lodovico, calling the antiquity on which it was based "la più bella antiquità che fussi." The antique was by that time in the sculpture court of the Vatican Belvedere (now Florence, Palazzo Pitti, heavily restored). Discovered sometime during the second half of the fifteenth century the work—whether a second-century B.C. Greek original based on Lysippos or a Roman copy is debatable—was nevertheless little more than a sketchy fragment that indicated only the basic orientation of the figures "truncus fracti marmoris," as Albertini described it (1510).

Antico's remark was intended to praise the underlying conception of the group, in which Hercules clasps Antaeus from behind, the two figures opposed in mortal struggle yet visually unified. This formal theme, so appealing to the sixteenth-century love of paradox and juxtaposition of apparent opposites in artistically imposed harmony, was to dominate much of Mannerist sculpture from Michelangelo to Giovanni Bologna. The subject of Hercules and Antaeus presented a unique challenge in the revival of the two-figure group in free-standing sculpture, since, in the myth, Hercules must overpower the giant Antaeus without allowing him to touch the earth, the source of his strength. Furthermore, by 1500 the subject had become a recognized allegory of virtue overcoming lust.

Antico's *Hercules and Antaeus* reconstructs the missing elements, which included the legs of both figures. He causes the head of Antaeus to loll backward and to one side, as if the giant's strength is fading rapidly. In this detail Antico ignored the clue presented by the fragment, in which Antaeus's neck strains *forward* as he struggles to push away his adversary's arms. Characteristically, he "improved" even as he reconstructed. The resulting contour is more open and less classical than that of the antique.

The great popularity of this subject gave rise to a number of compositions, many having no reference to the antique in the Vatican Belvedere. Mantegna, however, does seem to have derived his *Hercules and Antaeus* in the Camera degli Sposi (1465–74) from the classical group. The composition invented by Antonio Pollaiuolo (bronze in Bargello, c. 1475–80) was equally influential. In that bronze Antaeus's upper body is fully extended in an agonized arc as Hercules locks the giant in a deadly embrace in order to break his spine. The sculptor of the Widener bronze retains the facing position, but little else, of Pollaiuolo's concept. Hercules, his weight carried on his toes, holds the twisting Antaeus who seems caught in mid-leap—"a bronze by Balanchine" as Pope-Hennessy says ("Statuettes," 23). The bodies of both are slender and attenuated; little sense of physical force emanates from Hercules. In fact, the violence given expression by Pollaiuolo's bronze is absent.

The attribution of the Widener bronze and others which are clearly by the same hand (*Faun Playing a Double Flute,* Louvre and Frick; *Niobid,* Wallace collection) rests on a boxwood *Hercules* in the Wallace collection signed "Opus Francisci Aurificis P.," recorded by P. Bernardino Scardeone (b. c. 1485) as carved by Francesco da Sant'Agata in 1520. Nothing is known of this artist beyond Scardeone's reference to him. In 1958 Herbert Landais published his opinion that the boxwood *Hercules* was copied from a bronze in the Ashmolean whose author was an unknown Paduan bronze sculptor ca. 1500. Pope-Hennessy then attributed the group of bronzes to Camelio on the basis of stylistic similarities to the scene of sacrifice on the reverse of his self-portrait medal (see 84). Weihrauch objected on the grounds that the autograph bronze relief *Battling Giants* in the Cà d'Oro gives a more dependable indication of Camelio's style than the medallic reverse. He retained the name Francesco da Sant'Agata with a query for the Widener *Hercules and Antaeus*. He noted its importance as an early example of anti-naturalistic attitudes in the presentation of the motif of struggling figures, the intrinsic beauty of the movement being the principle interest of the group.

Ex collections: Mme. Louis Stern, Paris (to 1911 or later); Baroness Alphonse de Rothschild, Paris, 1915; [Duveen]; Widener collection (1917–1942).
Exhibition: Buffalo Fine Arts Academy—Albright Gallery, "Master Bronzes," 1937, no. 139.
References: J. G. Mann, *Sculpture* (Wallace Collection Catalogues), London, 1931, nos. #73 and S 273 (*Niobid* and boxwood *Hercules*); C. Seymour, Jr., *Masterpieces of Sculpture from the National Gallery of Art,* N.Y., 1949, no. 43 (illustrations); H. Landais, *Les bronzes italiens de la Renaissance,* Paris [1958] 42; Pope-Hennessy, "Statuettes," 22–23; Weihrauch, *Bronzestatuetten,* 129–132; Brummer, *Statue Court,* 138–141; H. Möbius, "Vier hellenistische Skulpturen," *Antike Plastik,* 10, pt. 3 (1970), 39–47.

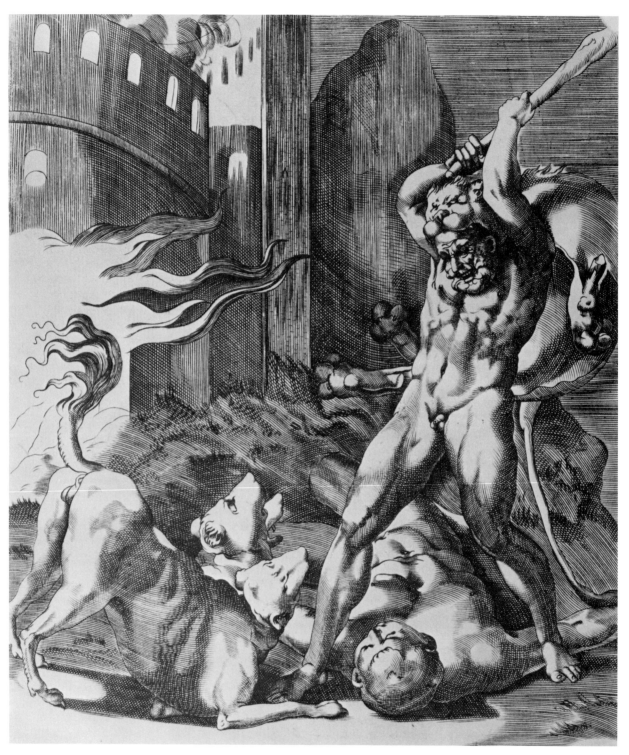

95

95 *Hercules and Cerberus* 1526–early 1527

Gian Jacopo Caraglio, after Rosso Fiorentino (Verona 1505/Cracow 1565)

Engraving; B. 15, 85, 44. 22.2 × 18.4 cm.

The Metropolitan Museum of Art, Elisha Whittelsey Collection, the Elisha Whittelsey Fund, 1949 (49.95.170)

In 1526 Baviera, a publisher of contemporary prints, commissioned from Rosso six designs illustrating the Labors of Hercules to be engraved by Caraglio. During the ten years prior to the Sack of Rome (May 1527), series of prints illustrating scenes from classical mythology were widely circulated in Rome. Prints, in fact, were the main vehicle for the dissemination of Roman Maniera style throughout Italy. "In terms of iconographical conventions, figure style and lighting effects, the *Labors of Hercules* series must be considered as one of the most significant graphic works" of this period (Campbell, 76). These engravings demonstrate how classical subject matter and the heroic forms of Hellenistic sculpture, translated into a modern style by Michelangelo, served the formal and expressive ends of the Maniera.

Hercules is shown about to club Cerberus, with the walls of Tartarus in the background. The figure lying at his feet may be the god Hades, since in a Homeric variant of the myth (*Iliad*, V) Hercules had to defeat the god himself before subduing Cerberus (Campbell). Hercules' pose derives in a general way from the figure with an axe at the right in Pollaiuolo's *Battle of the Nudes* (44), a figure which was itself derived from a classical *Hercules and the Hydra* on a sarcophagus. Yet the energy collected and controlled in Pollaiuolo's contours is now discharged in discontinuous groups of delicate, closely-spaced hatching lines that allow the subtly graduated tones in the engraving to take on a disconcerting life of their own. The uncommonly active surface that results imparts a hypnotic visual effect to the print, especially compelling in a good impression such as this one.

Note: the following information applies also to 96 and 97.
Exhibition: Brown-RISD, *First Maniera*, 75–78, nos. 80, 82, 83 (Richard Campbell).
References: Barocchi, *Rosso*, 64–65; H. Zerner, "Sur Giovanni Jacopo Caraglio," *International Congress of the History of Art*, Hungarian Academy of Sciences, Budapest, 1973, 691–695.

96 *Hercules Killing the Hydra* 1526–early 1527

Gian Jacopo Caraglio, after Rosso Fiorentino (Verona 1505/Cracow 1565)

Engraving; B. 15, 85, 46. 22.2 × 18.4 cm.

The Metropolitan Museum of Art, Elisha Whittelsey Collection, the Elisha Whittelsey Fund, 1949 (49.95.172)

In this engraving Caraglio, following Rosso, depicts Hercules and Iolaos as *contrapposti*. Hercules, seen from behind, strides into the picture space with his flaming club raised; Iolaos charges forward with his club lowered. Ovid's account of the killing of the Lernaean Hydra is illustrated. One of the monster's severed heads and the crab sent by Hera to aid the Hydra are visible in the foreground. By contrast, in Pollaiuolo's *Hercules and the Hydra*, all attention is concentrated on the hero and the monster (ill. *EWA*, 10, pl. 249).

Hercules' pose here is an adaptation of the *Hercules Carrying the Erymanthian Boar* pose as seen on sarcophagi. It is modified by recourse to the large repertory of figure-in-action types evolved by Raphael and his associates. Their understanding of functional anatomy depended in turn on prior absorption of well-studied antiques like the Dioscuri (see 47, 48) and the Laocoon (60–62). In fact Hercules' torso in this engraving could easily refer to the elder priest in the Laocoon group.

As in the graphic work of Marcantonio Raimondi (see 45, 56), a Northern flavor is contributed by details: the sylvan setting, the fantastic animal composite Hydra, the headgear and beard of Iolaos. In this engraving the sources seem to be engravings by Dürer (Campbell). The antique subject matter is appreciated as Dürer appreciated it, for its juxtaposition of the heroic and the grotesque. The independent pattern of lights and darks resembles that in the *Hercules and Cerberus* (see 95), but the tonal areas here are broken down in a more even distribution with respect to the overall design.

Note: see 95 for exhibition and references.

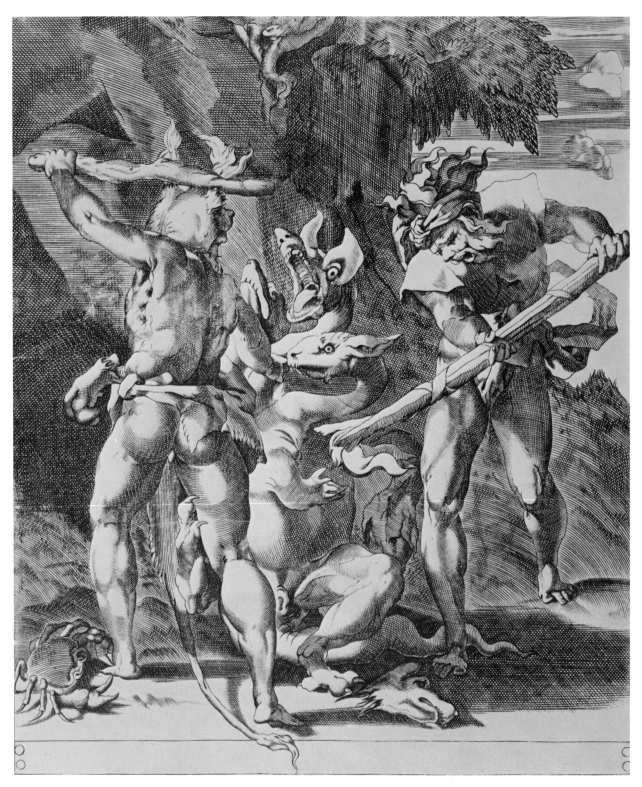

96

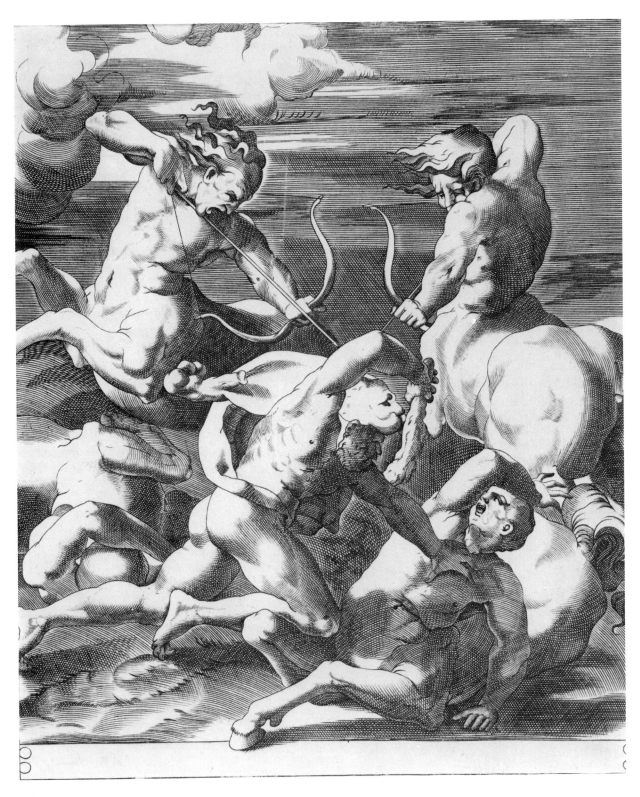

97

97 *Hercules Battling the Centaurs* 1526–early 1527

Gian Jacopo Caraglio, after Rosso Fiorentino (Verona 1505/Cracow 1565)

Engraving; B. 15, 85, 47. 22.2 × 18.4 cm.

The Metropolitan Museum of Art, Elisha Whittelsey Collection, the Elisha Whittelsey Fund, 1949 (49.95.173)

Unlike *Hercules and Cerberus* and *Hercules Killing the Hydra*, in this engraving the figures, set against minimal indications of a landscape setting, occupy almost the entire surface of the image. Hercules was forced to fight the centaurs because on his way to hunt the Erymanthian Boar the centaur Pholos offended his fellows by allowing him to drink from the communal wine jar (Apollodoros). In the engraving one centaur has already fallen at left; Hercules pins down and clubs another, who tries in vain to ward off the blows. The two centaurs at left and right aim arrows at Hercules, forming an X shape in this complex design of tightly interlocked shapes. A probable ultimate source for Hercules' pose was identified by Campbell as the swordsman slaying an enemy in the fresco of the *Battle of Ostia* (Vatican, Stanza dell'Incendio). He observed that the vigorously muscular, foreshortened forms of all the figures resemble Rosso's own *Moses and the Daughters of Jethro* of c. 1523. The violent contrast often characteristic of antique myths unites here with Rosso's personal style of abstract contrasts and abrupt discontinuities of tone and texture, rendered with sympathetic understanding and corresponding technical bravura by Caraglio, shown here in an impression which retains much of the plate's original power and bite.

Note: see 95 for exhibition and references.

98 *Gli oscuri et dificili passi dell'opera ionica* 1558

Vitruvius Pollio

Printed book; folio; Mantua, Venturino Ruffinelli. (Translation by Giovanni Battista Bertani.) Engraved frontispiece by Giorgio Ghisi after Bertani; 21 woodcuts in text. 38.9 × 26.7 cm.

Houghton Library, Harvard University, Gift of Philip Hofer, 1970 (Typ 525.58.871F)

Gli oscuri et dificili passi dell'opera ionica contains passages from Vitruvius's discussion of the ionic order selected and translated by Giovanni Battista Bertani (c. 1510–76) with his commentary on their meaning. In his treatise Bertani challenges the interpretations and technical abilities of recent architectural theorists and claims to have reached a more accurate understanding of phrases like *scamilli impares* that, by 1556 (the date of writing), were acknowledged as especially difficult.

This copy from the Houghton Library, as well as some other copies of the book, includes an engraved frontispiece, signed in the form of tablets in the border with Bertani's initials as designer and the name of Giorgio Ghisi as engraver. It shows Hercules with the slain hydra in a style dramatically exemplifying Mannerist use of antiquity. The *Hercules* has obvious reference to Bertani's patron, Cardinal Ercole Gonzaga, to whom the book is dedicated. After the death of his brother Federico II Gonzaga in 1540, Ercole, as regent during the minorities of his nephews Francesco and Guglielmo, assumed control over the affairs of Mantua. His artistic patronage is alluded to by the musical instruments, books, sibylline angels and astronomical devices depicted in the engraving's wide, ornate borders.

Bertani, a native of Mantua, had made two trips to Rome to study antiquities and contemporary architecture during the pontificate of Paul III (1534–49). His second trip was made c. 1540 or shortly afterwards, since Ghisi, born c. 1520, accompanied him. Bertani, who was to become the prefect of the Ducal constructions in Mantua in 1549, thus may have been in Rome when the Farnese Hercules (Naples, Museo Archeologico), the model for the Hercules of this engraving, was unearthed (1540; see entry for 100).

Bertani preserved some major features of Lysippos's conception as transmitted by the Greek sculptor Glycon in the impressive, over-lifesized Hercules. The contrast between the hero's super-human strength and his weariness, which generates sympathetic awareness of his awesome and terrible exertions while obtaining the apples of the Hesperides (held in the hand behind Hercules' back—this detail is also shown in 100), is still present in the engraving, for example. Lysippos's Hercules is a retrospective work: the downcast head, the club wedged beneath an armpit to support the body's heavy weight, and the extension of one non-weight-

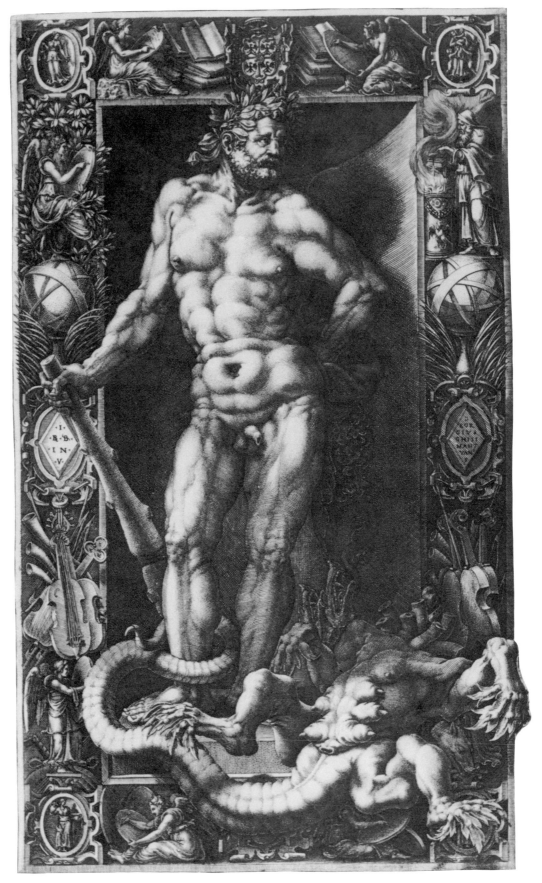

98

bearing leg far forward, all serve to direct the viewer's imagination to the events which preceded this moment of exhaustion, and thereby incorporate the past into the present. But Bertani's engraving carries still further the exaggerated dimensions and musculature of the antique work, the disproportion of its head, tiny in relation to the colossal body, and its facial expression of quizzical cynicism, all of which lend the hero a decidedly anti-heroic air. Moreover, Bertani and his engraver Ghisi chose shapes and textures for the swollen muscles that suggest a knobby, repellent surface. When combined with the grizzly forms of the Hydra, these qualities exploit the subject's shock value to a degree that even surpasses the treatments of this and related episodes by Rosso and Caraglio (95–97).

Furthermore, Bertani's Hercules is an active figure. He carries his own weight; instead of using the club as a prop, he holds it to one side. His head, rather than being contemplatively lowered, is turned; his expression of world-weary exhaustion lies quite outside the noble weariness suggested by Glycon's copy of Lysippos's original. In showing the loathsome, obscene body of the dead Hydra spilling toward the viewer over the engraving's lower border, Bertani continues the manner of challenge and titillation begun in Mantua by Giulio Romano, who was probably his teacher.

One explanation of Bertani's Hercules might propose it as a bizarre and witty self-portrait, rather than as a portrait of so august and dignified a patron as Cardinal Ercole. The seven-headed Hydra could, according to this view, refer to the seven modern theorists on Vitruvius whose interpretations are challenged and, he claims, defeated, in Bertani's treatise: Alberti, Dürer, Fra Giocondo (see 128), Cesariano (129), Serlio, Guglielmo Filandro and Daniele Barbaro.

Ex collection: Philip Hofer.
Exhibition: Harvard, *Sixteenth Century Architectural Books*, no. 6.
References: E. Marani and C. Perina, *Mantova, Le Arti*, v. 3, *Dalla metà del secolo XVI ai nostri giorni*, Mantua [1965], 1–38 (Bertani; on this book see esp. pp. 11, 44–45, nn. 38–40); Mortimer, II, 766–768, no. 548 (ill.).

99 *Mars and Venus* c. 1597

Bartolomaeus Spranger (Antwerp 1546/Prague 1611)
Drawing; pen and ink, wash, on cream-colored paper, heightened with white. 25.7 × 20.9 cm.
Smith College Museum of Art (1963.52)

Mars and Venus is one of two copies of a drawing datable to 1577 or somewhat later. The other copy (Städelsche Institut, Frankfurt) is dated 1596 (Oberhuber). Another version of this subject by Spranger was engraved by Goltzius in 1588 (B. 276).

When this copy was made, Spranger occupied a position of great fame and influence at the court of Rudolf II at Prague, where he had arrived in 1580. During the late 1560s Spranger was in Italy where he was first employed at Parma and later in Rome. His study of the works of Correggio, Parmigianino, Michelangelo, Primaticcio and Salviati formed the basis of a style which had become uniquely his own, as Carel Van Mander recognized, by the time of Spranger's departure for Vienna in 1575.

Despite the northern Mannerist flavor of the drawing's style, Spranger's sources are recognizable. An echo of Raphael's *Psyche* may be noticed in the position of the putto between Venus's legs. Spranger uses the standing soldier seen from behind in Agostino Veneziano's engraving after Michelangelo (B. 423) as the basis for the posture of Mars (Oberhuber). Spranger's debt to Rosso, evident in such earlier works as the *Deposition* (Munich), shows in the menacing head of Mars.

Spranger's interpretation of the classical myth of the love of Venus and Mars (*Odyssey*, VIII, 266–367) typifies a major aspect of the relationship to antiquity shared by many of the painters who worked at Rudolf's court. Single-mindedly, Spranger focuses on the erotic element, as in his paintings *Hercules and Deianira* and *Venus and Adonis* (Vienna, Kunsthistorisches Museum), at the expense of allegorical or symbolic meanings often present in earlier Renaissance renderings of such myths.

Ex collections: Deiker, Braunfels; [Lucien Goldschmidt, New York].
Exhibitions: Deiker coll., Kassel, 1930–31, no. 215; Vassar College Art Gallery, *Dutch Mannerism, Apogee and Epilogue*, April 15–June 7, 1970, no. 89.
References: K. Oberhuber, *Die stilistische Entwicklung im Werk Bartolomaus Sprangers*, Vienna, 1958, 246–247, no. 2, 11; idem, letter of 12/12/69; Reznicek, *Goltzius Zeichnungen*, 1, 155, fig. A XIV; N. Dacos, *Spranger e i pittori rudolfini*, Milan, 1966.

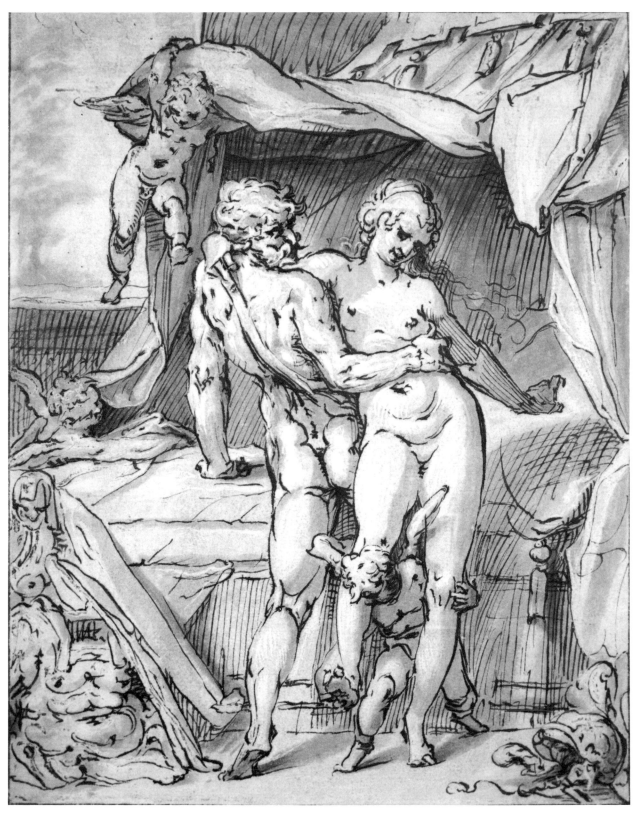

99

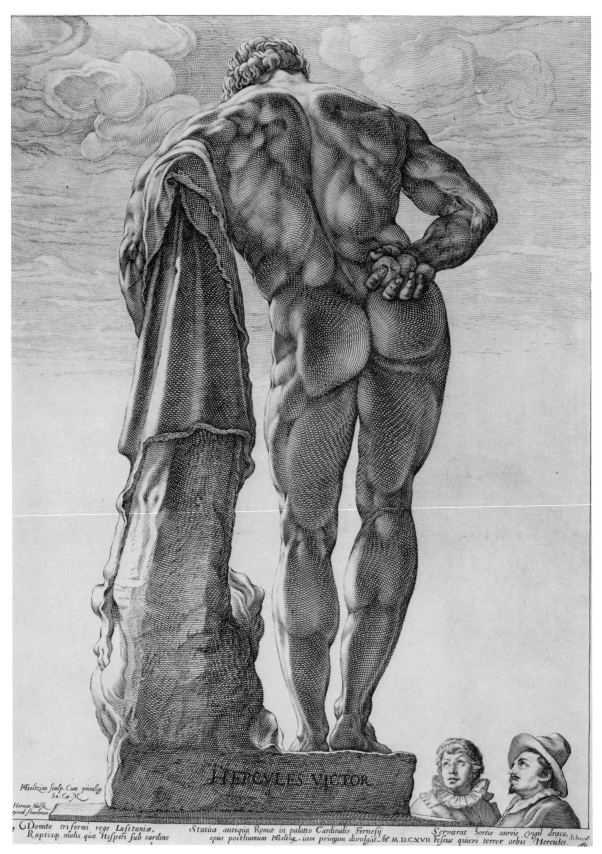

HERCVLES VICTOR

HGoltzius sculp. Cum privileg.
Sa. Cæ. M.

Herman Adolfs.
excud. Haerlemi.

, Domito triformi rege Lusitaniæ, Statúa antiqua Romæ in palatio Cardinalis Fernesij Servarat hortis aureis vigil draco, S. Sevet.
 Raptisqp malis quæ Hesperi sub cardine opus posthumum Goltzij. iam primum divulgát. Añ. M.D.C.XVII Fessus quievi terror orbis Hercules.

100

100 *Farnese Hercules* c. 1592

Hendrick Goltzius (Mühlbrecht, near Venlo, 1558/ Haarlem 1617)

Engraving; Hirschmann 145; Hollstein 8, 33, 145. Inscription on pedestal: HERCULES VICTOR; at left: HGoltzius Sculp. Cum privilig./Sa. Cae. M./Herman Adolfz/excud. Haerlemen.; in margin below, center: Statue antiqua Romae in palatio Cardinalis Fernesij/ opus posthumum HGoltz; iam primum divulgat An° M.D.C.X.VII; at right and left: Domito triformi rege Lusitaniae,/Raptisque malis quae Hesperi sub cardine/ Servarat hortis aureis vigil draco,/Fessus quievi terror orbis Hercules. Schrevel. 41.3 × 29.9 cm.

The Metropolitan Museum of Art, Gift of Henry Walters, 1917 (17.37.59)

The *Farnese Hercules,* a marble copy by the Athenian sculptor Glycon after a celebrated original of the fourth century B.C. by Lysippos, was brought to Rome from Athens by Caracalla. When it was unearthed in the Baths of Caracalla in 1540 during excavations under the Farnese Pope Paul III, its legs and hands were missing. These were so well substituted by Guglielmo della Porta in the judgment of his contemporaries that when the original legs were found in a well in 1560, it was decided to keep the della Porta ones. Thus the legs and the hands holding the apples of the Hesperides, as drawn by Goltzius in 1591, are those of della Porta (Reznicek). The statue remained in the Farnese Palace until the eighteenth century when the collection passed by inheritance to Charles of Bourbon, King of Naples, who established what is now the National Museum there. At that time the original legs were restored.

For this most dramatic of his series of *Three Antique Statues from Rome,* first published in 1617 (cf. 55), a finished drawing exists, which Goltzius probably prepared as a model to follow in cutting the copper plate. Two other drawings by Goltzius of the statue were doubtless done on the spot in the Palazzo Farnese. Yet another drawing shows the two spectators, whose direction and relative positions are reversed in the engraving.

Goltzius may well have intended to do an engraving of the front view also, but he could have decided to make the plate of the back first because no engraving of that view existed, while several of the front had been

published. The back view, in any case, expresses the strength of the hero, emphasizing as it does the power of his calves, buttocks, and back muscles. It also adds a touch of mystery by using the Mannerist device of hiding the face and front of the body—the normal, expected view—from us, although, tantalizingly, revealing it to the fictive spectators. The spectators force us to imagine the frontal view; like that of the artist Goltzius depicts in his *Apollo Belvedere* engraving (55), their puniness contrasts tellingly with the colossal statue of Hercules. Many Renaissance bronze replicas of the *Farnese Hercules* exist; yet this rendition printed on paper may well be the one that conveys most forcefully the statue's weight and impression of colossal strength.

References: U. Aldrovandi, *Di tutte le statue antiche, che per tutta Roma . . .* , published with L. Mauro, *Le antichità della citta di Roma,* Venice 1556, 157–158; Naples, National Museum, *Handbook of the Antiquities,* Naples, 1907, 20–21, no. 6001; O. Hirschmann, *Verzeichnis des graphischen Werks von Hendrick Goltzius,* Leipzig, 1921, no. 145; F. W. H. Hollstein, *Dutch and Flemish Etchings, Engravings and Woodcuts,* Amsterdam 1948–, vol. 8, 145; Reznicek, *Goltzius Zeichnungen,* 1, 336f., nos. 225–227; 418–420, no. 388 (Reznicek, 337, states that in addition to the legs, the head also was lacking when the statue was found [followed by Reiss and Strauss]. These statements reflect confusion between this Hercules and one of several other statues in the Palazzo Farnese, some of which were indeed headless. See Aldrovandi, 156. The Naples catalogue mentions the missing legs but not a missing head, and Howard's excellent article, focusing on della Porta's restoration of this statue, citing Aldrovandi as well as a number of nineteenth-century scholars, says only that it "lacked both legs and, according to Aldrovandi, both hands as well" [p. 403]); S. Howard, "Pulling Herakles' Leg, Della Porta, Algardi, and Others," *Festschrift Ulrich Middeldorf,* 2 vols., Berlin 1968, 1, 402–407; R. B. Reiss, *Incisioni di Goltzius conservate all'Ambrosiana,* Vicenza, 1969, 20f., no. 89; W. L. Strauss, ed., *Hendrick Goltzius, 1558–1617, The Complete Engravings and Woodcuts,* 2 vols., New York, 1977, 2, 562, no. 312 (with ill.).

—*Suzanne Boorsch*

101

101 *Brutus; Pisistratus; Cambyses, King of Persia, and a View of Babylon; Judith with the Head of Holofernes; Pythagoras; King Darius; the Prophet Haggai* c. 1450

Florentine School

Drawing; pen and brown ink and colored washes on vellum. Each figure inscribed with a name and description in Latin, some in French (by a later hand). 31.3 × 20.2 cm.

Ian Woodner Family Collection

Mommsen noted that the trecento illustrators of Petrarch's *De viris illustribus* were not able to match the author's classicism of subject and style, but depicted ancient Rome according to fundamentally unchanged medieval models. As late as the mid-fifteenth century, representations of heroes and heroines of ancient history still did not conform to classical style in bodily proportions or dress. Medieval manuscript tradition remained a dominant force in determining the style in which history was illustrated. In this drawing, as was often the case, history assumes the form of imaginary portraits of illustrious individuals, *uomini famosi*. A Roman Republican hero, two kings of ancient Persia, a Jewish heroine, an Old Testament prophet and an ancient Greek mathematician and philosopher, all identified by inscriptions, are represented together on the same sheet. Two are accompanied by landscape vignettes characterizing their milieu or sphere of action.

This drawing belonged originally to a universal chronicle that may have numbered several dozen pages. It illustrated heroes and heroines from the Bible, legend, classical history and the Middle Ages, arranged in the chronological order provided by a tradition of world chronicles stemming from Eusebius and Isidore of Seville. Such collections were used by artists as sources for the iconography of history painting. The eight pages that remain formed a group called the Cockerell chronicle, after an early twentieth-century owner. A ninth page originally belonging to the same book was discovered in England and bought by the Berlin museum. In 1958 the Cockerell group was dispersed and the sheets are now widely scattered.

Earlier (1952) Ilaria Toesca had noticed the relationship of this group of drawings to a picture chronicle of c. 1436–42 signed by Leonardo da Besozzo in the Crespi collection, Milan. The Crespi manuscript contains pages corresponding precisely to the Cockerell leaves in the order and identity of the figures repre-

sented. The Woodner drawing, for example, corresponds to Crespi fol. 8v. Scholarly attempts to pinpoint the Crespi chronicle's monumental source now incline to the cycle of *uomini famosi* frescoed by Masolino (?) in the Casa Orsini at Monte Giordano, Rome (1430s) (Scheller).

The artist of the Cockerell series, regarded as Florentine by most authorities (following Berenson), "eliminates all vestiges of a grandiose decoration, with its fictive setting, in order to create a simplified and harmonious page with a unified neutral ground" (Laskin). Toesca had already noted the relationship of the Cockerell chronicle's style, with its delicacy of modeling in color and light, to the painting of Piero della Francesca. Classical values are thus present, even prior to the assimilation of the style of Hellenistic and Roman sculpture in the depiction of the human figure, in the form of the generic classicism of Tuscan quattrocento tradition, with its sculptural values and inherent monumentality in the modeling of drapery and sense of harmony and balance in the disposition of figures on the page. The many notations in French on the drawings indicate either that the book found its way to France soon after completion, or that the artist was a French painter under Tuscan influence, like Jean Fouquet. Toesca discerned a greater and lesser hand in the group. The Woodner sheet, with the possible exception of the figure of Cambyses, is attributed to the better of the two (Toesca, 18, n. 6). The four colors—red, green, blue and lavender—used predominantly by the artist corroborate the notion of a mid-fifteenth-century Florentine origin for these illustrations (Laskin).

Ex collections: French Collection ?; [Quaritch, London]; William Morris, Kelmscott House, 1894; Charles Fairfax Murray, sale, Sotheby's, 18 July, 1919; Sir Sidney Cockerell, sale, Sotheby's, 2 July, 1958, lot 22; private collection (anonymous), sale, Sotheby's, 4 July, 1977, lot 152.

Exhibition: Society of Antiquaries, London, 1896.

References: B. Berenson, *The Drawings of the Florentine Painters*, 3 vols., Chicago, 1938, 2, 11, no. 164C; 3, pl. 27; I. Toesca, "Gli 'Uomini Famosi' della Biblioteca Cockerell," *Paragone*, 3 (1952), 16–20; R. W. Scheller, *A Survey of Medieval Model Books*, Haarlem, 1963, 204–206; Ottawa, National Gallery of Canada, *European Drawings*, exhibition catalogue by Myron Laskin, 1969, 12–13, no. 1 (a sheet from the Cockerell group now in Ottawa).

102 *Lucretia* c. 1510–11

Marcantonio Raimondi, after a design by Raphael (Argini, near Bologna, c. 1480/Bologna 1527–34)

Engraving; B. 14, 155, 192; P. 6, 23, 123. Inscription: AΜΕΙΝΟΝ / ΑΠΟΘΝΉΣΚΕΙΝ / ΉΑΙϹΧΡΩΣ / ΖΉΝ (It is better to die than to live in dishonor). 21.3 × 13.5 cm.

Museum of Fine Arts, Boston, Gift of Mrs. T. Jefferson Coolidge (21.10894)

Marcantonio's *Lucretia* was produced in Rome after a design by Raphael. The story of Lucretia was known throughout Roman antiquity and represented pictorially during the Middle Ages and the Renaissance as the supreme example of the chaste wife. Having been raped by one of the Tarquins, she killed herself to expiate her guiltless "crime," an event which led to the end of the monarchy and the establishment of constitutional Republican government at Rome (510–509 B.C.)

In his life of Marcantonio, Vasari confers special importance on the *Lucretia* as the fruit of the earliest association of the newly arrived Bolognese artist with Raphael:

. . . having arrived in Rome, he engraved on copper a most lovely drawing by Raffaello . . . wherein was the Roman Lucretia killing herself, which he executed with such diligence and in so beautiful a manner, that Raffaello, to whom it was straightway carried by some friends, began to think of publishing in engravings some designs of works by his hand . . . and when he had made up his mind, these were engraved by Marc Antonio in such a manner as amazed all Rome. (tr. De Vere, v. 6, 99–100).

Lucretia and *Dido* (B. 187), whose subject is also a symbol of the chaste wife, are often paired as examples of Marcantonio's earliest renderings of Raphael drawings. Of a slightly earlier date, *Dido* is less sculptural and hence less innovative than *Lucretia*. The difference reflects the rapid artistic growth engendered in Marcantonio by his new contact with Rome, especially with the art of Raphael. As shown by 19, Marcantonio's studies of antique sculpture now assumed a far more plastic and self-assured character (cf. 18). At the same time, the landscape background of *Lucretia* also reflects the influence of Lucas van Leyden's engravings, though Marcantonio has classicized the townscape, replacing the Northern crenellated towers with domes and pediments (Schreiber).

A number of engravings, paintings and sculptures seem to have been influenced by a statue discovered in the Trastevere district c. 1500 that Cardinal Giovanni de' Medici, the future Pope Leo X, interpreted as a Lucretia (Stechow). Marcantonio's *Lucretia* would have to serve as the basis for any reconstruction of this lost statue (Oberhuber). The evidence it presents, together with that of other works thought to have been influenced by Cardinal Giovanni's fragmentary "Lucre-

tia," suggests that the statue possessed an exaggerated, swaying contrapposto, similar to the pose of the *Venus of Melos,* with the relaxed leg resting on a raised support. Torsion in the upper body animated the figure to a much greater degree than types like the Capitoline *Venus.*

Perhaps the head and arms of the marble "Lucretia" were missing. Leonardo's standing *Leda* may be in part a reconstruction of it. There the lower body retains the "Lucretia"/*Venus of Melos* pose while the right shoulder, in an exaggerated twist forward and to the left, begins the movement of the crossed right arm with which Leda caresses the swan's neck. Marcantonio varied Leonardo's solution in his engraving of a popular theme—the classical painter Apelles' *Venus Anadyomene* (dated September 11, 1506; B. 14, 234, 312) in which similar extreme forward torsion of the shoulder is used to motivate a gesture of wringing sea water from the goddess's hair. In Marcantonio's version, the crossed arm hides Venus's breasts in the manner of Doidalsas's *Crouching Venus* (see 42, 43), an antique which Leonardo had also studied.

An engraving like Agostino Veneziano's *Cleopatra* of 1515 (B. 14, 158, 193), based on a design by Baccio Bandinelli, seems to have combined the "Lucretia" antique and the older son in the *Laocoon.* Raphael's study of the "Lucretia" pose likewise apparently informed the eventual creation of *Galatea,* via the "Parmenides" in the *School of Athens.*

As with the *Laocoon,* artists drew from the study of the "Lucretia" knowledge of how the counterposed forms of Hellenistic baroque were capable of transforming agitation into pathos. Henceforth, the emotion inherent in the Lucretia story did not require narrative elements often included before, such as the attempt of Lucretia's father and husband to dissuade her from suicide. The emotion is condensed and implicit in the forms themselves without the necessity for narrative. This discovery may help to account for the temporary disappearance at the beginning of the sixteenth century of alternative Lucretia iconographies, such as the rape scene. Stechow termed the full or half-figure renderings that became so popular "monologues." Marcantonio's engraving was one of the most influential examples of this type.

Exhibition: Fogg, *Rome and Venice,* 10 (entry by Beverly Schreiber)
References: W. Stechow, " 'Lucretiae Statua'," *Essays in Honor of Georg Swarzenski,* Berlin/Chicago, 1951, 114–124; Oberhuber, *Renaissance in Italien,* 92, no. 119; A. H. Allison, "Antique Sources of Leonardo's *Leda,*" *AB,* 56 (1974), 375–384 (suggests that Leonardo's standing *Leda* was motivated by the discovery of the *Laocoon*).

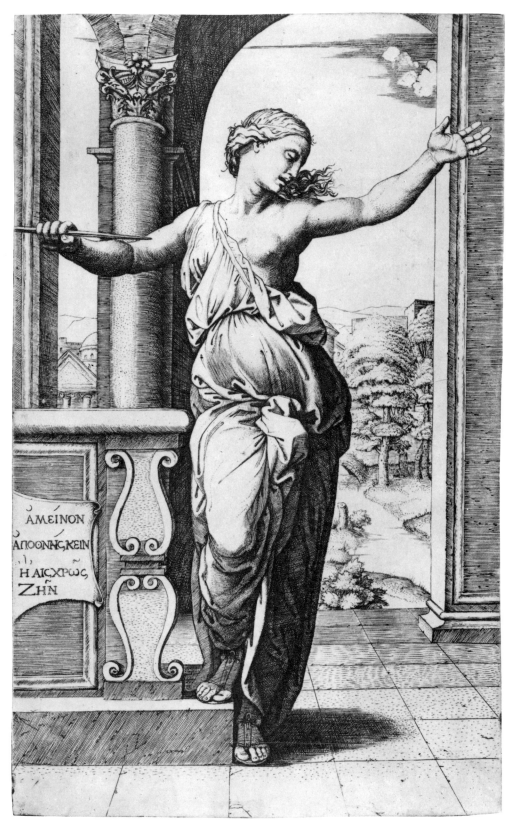

102

103 *Lucretia* 1510–early 1516

Attributed to Antonio Lombardo (Venice ? c. 1458/
Ferrara 1516 before March)

Marble relief. Inscription across base: CASTIS
EXEMPLAR VXORIBVS. 34.3 × 23.8 × 11.1 cm.

The Walters Art Gallery, Baltimore (27.252)

Lucretia is shown as she is about to take her own life.
As in Marcantonio's engraving (see 102) a dagger
would have been held in her right hand, now lost due
to damage. Her left hand rests on a pedestal inlaid with
blue stone; as she steps down, the torsion and contrap-
posto of her nude body can be clearly seen against a flat
blank background. In the left half of the relief is a bro-
ken arch, symbolic of Lucretia's violation by Tarquin.

This relief belongs to a series of heroes and heroines
from antique history and myth, probably created orig-
inally following *modelli* by Antonio Lombardo for Al-
fonso I or another patron belonging to the Este court.
Its popularity was such that a number of exemplars of
each hero or heroine were carved. Stechow argued that
the design and execution of the *Lucretia* was due to An-
tonio Lombardo and not to Mosca, a Paduan sculptor
and medallist influenced in his artistic formation by
both Tullio and Antonio Lombardo. The implications
of Lewis's study lead one to believe rather that the
Lucretia was carved by a sculptor working from a
terra cotta *modello* and under the close supervision of
Antonio.

Subjects of the series to which this relief belongs in-
clude Mucius Scaevola (cf. 104), Portia, Antony and
Cleopatra, Helle and Philoctetes. They have in com-
mon the theme of heroic sacrifice and suffering. Many
of their subjects appear either in Ovid or Valerius
Maximus. A *Venus Anadyomene* (Victoria and Albert),
the Modena *Mars* (Galleria Estense, inv. no. 2054) and
a *Psyche* (?) (Rennes) were recently determined to be-
long or relate to this series.

Planiscig suggested Agostino Veneziano's *Cleopatra*
engraving, based on Bandinelli's design (B. 14, 158,
193) as the source of the *Lucretia*. Stechow, while in-
cluding it among the *Lucretia's* sources, held that the
figure as rendered in marble is less arbitrarily con-
torted, more regular and natural in its treatment of
anatomy. He followed Planiscig though in tracing the
torsion, the motif of the supported hand, and the
pathos of the face, to Agostino's print; a circumstance
which if true would virtually limit the relief's date to
1515. Stechow saw Marcantonio's *Lucretia* (102) as re-
sponsible for the marble *Lucretia's* formal harmony
despite its tragic subject. The relief resembles the en-
graving in the figure's contrapposto and relationship to
a step.

Antonio Lombardo, never having gone to Rome,
nevertheless had access to drawings of classical an-
tiquities, as we know from his relief of *Vulcan's Forge*
(Hermitage, 1506–8), in which the figure of Vulcan is
based on the elder priest in the *Laocoon*. The Roman
"Lucretia" antique (see entry for 102) could have been
known to Antonio as early as late 1506, via Marcan-
tonio's *Venus Anadyomene* engraving (B. 14, 234, 312).
The design of the marble *Lucretia* appears to combine
the contrapposto, raised foot and exaggerated torsion
of Giovanni de' Medici's *"Lucretia"* with a head based
on the elder son of Laocoon.

It was the *Laocoon,* after all, that for the creators of
High Renaissance style had wedded inextricably the
theme of heroic sacrifice and suffering to the formal
problems posed by extremes of torsion. Its discovery
accelerated the new connections being forged between
motion and emotion. Looking at these reliefs of heroes
and heroines, and their cognate engravings, one is
struck by how rapidly this intertwining of antique re-
vival and expressive intentions bore fruit after 1510.
The common theme of *contrapposti* is as much their
subject as any incident of Stoicism they illustrate. They
demonstrate a preoccupation with extremes of move-
ment, as if a centripetal force now began to energize
the dynamics of their poses. The facial expression of
Lucretia, perhaps closest of any to the younger son in
the *Laocoon* (see 60, 61), depends ultimately upon the
Laocoon's own sources in Pergamene Hellenistic sculp-
ture. Because of the influence of the *Laocoon,* pathos
became an acceptable subject in and of itself, increas-
ingly divorced from particular contexts and linked
instead to explicitly formal considerations concern-
ing the figure and its inexhaustible capacities for
movement.

Ex collections: Benoit Oppenheim, Berlin, 1907;
[Lippmann, London ?]; Jacques Seligmann and sons,
1928.

Exhibitions: Sambon, Paris, *Exposition de sculpture,*
1928, no. 124, pl. xlii; Wildenstein, *Italian Heritage,*
no. 137.

References: L. Planiscig, *Venezianische Bildhauer der Re-
naissance,* Vienna, 1921, 259 ff.; W. Stechow, "The Au-
thorship of the Walters 'Lucretia'," *The Journal of the
Walters Art Gallery,* 33 (1960), 72–85, with earlier bib-
liog.; Pope-Hennessy, *Victoria and Albert,* 1, 353–357
(entry on *Philoctetes*); D. Lewis, "The Washington Re-
lief of Peace and its Pendant: A Commission of Al-
fonso d'Este to Antonio Lombardo in 1512," in W. S.
Sheard and J. T. Paoletti, eds., *Collaboration in Renais-
sance Art,* New Haven, 1978, 233–244.

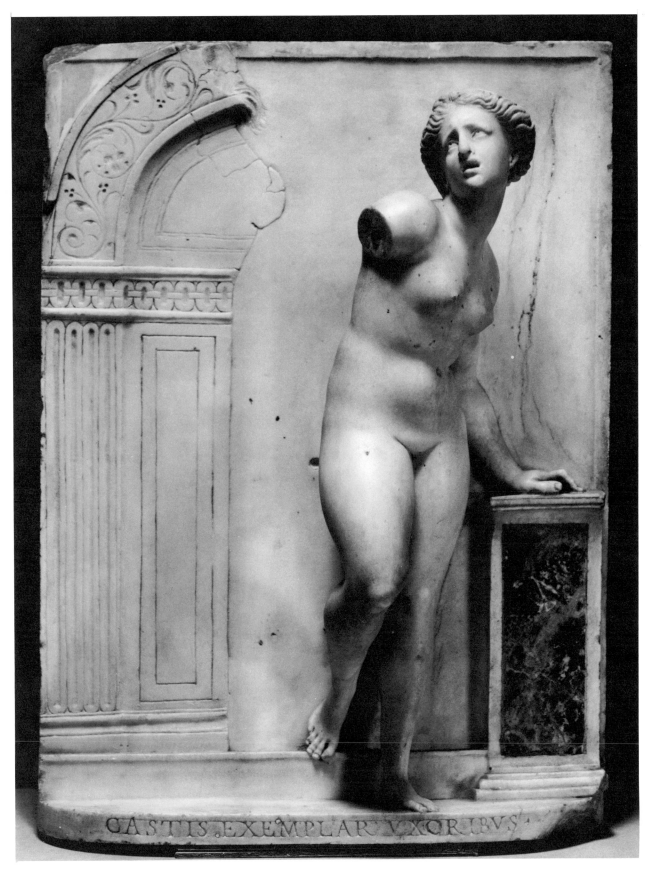

CASTIS EXEMPLAR VXORIBVS

103

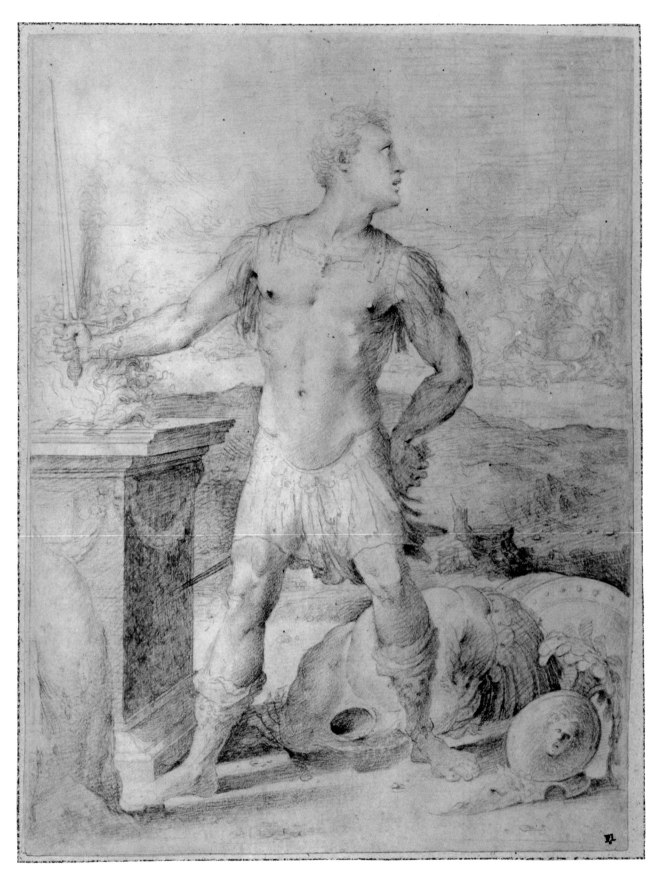

104

104 *Gaius Mucius Scaevola Holding his Hand in the Fire* c. 1525–35

Domenico da Giacomo di Pace Beccafumi (Near Siena 1486/Siena 1551)

Drawing: red chalk. Inscription in pen and brown ink on verso (in an old hand): Domenico Beccafumo detto Meccarino/2.4. 29.6 × 22.4 cm.

The Pierpont Morgan Library, New York, Gift of the Fellows (1964.7)

This highly finished and expressive drawing, perhaps intended for a print, treats the theme of heroic sacrifice and suffering in an overtly dramatic vein (cf. 102, 103). Its style reflects the impact of Michelangelo's and Raphael's art on the Sienese Beccafumi, who visited Rome in 1510–12 and again in 1520. The narrative from Roman historical literature, like the story of Lucretia, has a patriotic moral. The legendary hero, Gaius Mucius, taken prisoner while engaged in a battle against the Tarquins, thrust his right hand into an altar fire in order to demonstrate courage before the enemy. Henceforth he was known as "Scaevola" or left-handed. The story is recounted by Livy, Plutarch and Valerius Maximus.

In Valerius Maximus (III.3.1) Mucius Scaevola's stoic drama is allegorized as Patience. In the drawing, carefully worked out contrasts provide dramatic illumination for the straining turning figure, with legs spread wide as if to brace himself against pain. Both the middle ground behind the figure, with its generalized hillocks and hollows homogeneous in tone, and the delicately lit distance, its peaked tents and Leonardesque battle scene glimpsed through a pale mist, serve to throw the figure into bold relief, enhanced by the strong lighting from above left.

The gigantic empty suit of armor immediately behind Mucius is reminiscent of the fragment of a *Discobolos* (unrecognized as such) that Giulio Romano and Penni bought in 1520 (facts brought together by Summers). Beccafumi uses the antique in the construction of a Mannerist conceit: the contraposition of showing a body simultaneously from the front and rear. The Roman "muscle armor" lends itself to the exaggeration and schematization of undulating musculature that was part of Michelangelo's heritage as understood by the Mannerists.

A sheet of preliminary studies for the composition, also in the Morgan Library, shows that the artist began with a pose deriving from the *Apollo Belvedere* and gradually accumulated the trappings of allegory (Tyler). Despite its inclusion of empty armor, a standard allusion to military triumph (see 107), the scene must be an allegory of Virtue rather than triumph, since Gaius had failed in his initial mission to kill Lars Porsenna. Beccafumi worked on two programs illustrating civic virtues with scenes from Valerius Maximus, one in the Palazzo Bindi-Sergardi, Siena (c. 1524–25), the other in the Sala del Consistoro of the Palazzo Pubblico (1529–35). The episode of Mucius Scaevola does not appear in either.

In the sixteenth century a gem of Mucius Scaevola was known in Venice and used by Maffeo Olivieri as the model for a medal of Jacopo Loredan (Hill, no. 487).

Ex collections: Sir Peter Lely (Lugt 2092); J. Isaacs.
Exhibitions: Bean and Stampfle, *N. Y. Collections,* I, no. 64; Brown-RISD, *First Maniera,* 14 (Claire F. Tyler); see also no. 36, Parmigianino drawing of same subject on verso (Susan E. Strauber: other 16th century representations of this subject).
References: Hill, *Corpus,* no. 487, pl. 91; Pierpont Morgan Library, *Fourteenth Report to the Fellows 1965–1966,* N. Y. 1967, 100; D. Summers, "Contrapposto: Style and Meaning in Renaissance Art," *AB,* 59 (1977), 336–361.

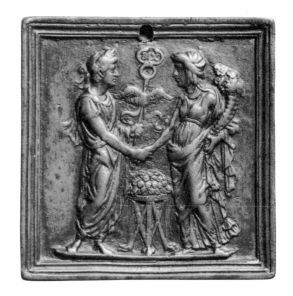

105

105 *An Emperor and Concord* Original invention 1468(?)

Cristoforo di Geremia (Mantua, active 1456/before February 1476)

Bronze plaquette (solid cast); yellowish-brown natural patina with traces of brown lacquer. 7 × 7 cm.

The Walters Art Gallery, Baltimore (54.223)

The second medal signed by Cristoforo di Geremia, who was the favorite medallist of Pope Paul II (r. 1464–71, see 114–116) is based on an antique coin with a portrait of Emperor Constantine (Hill, *Corpus,* no. 755). On the medal's reverse, inscribed CONCORDIA AUGG, "Concord of the Augusti," the emperor holds a caduceus and grasps the hand of a female figure with a cornucopia. According to Hill, this medal was probably cast to commemorate the visit of the Emperor Frederick III to Rome at Christmas, 1468. Thus the allegorical female figure symbolized the Church, and the image as a whole alluded to a harmonious relationship between the moribund Holy Roman Empire and the papacy.

Geremia used the reverse again on a medal of Pope Sixtus IV (Hill, *Corpus,* no. 753), this time including a tripod filled with fruit between the figures. This small plaquette reproduces the reverse as an independent composition that could be used decoratively in any number of ways. *Concordia* is often depicted on Roman coins and Geremia's dependence on such images is demonstrated by his correct interpretation of details such as the emperor's toga, Concordia's helmet, and the tripod. On the other hand, as Vickers notes, a caduceus held by an emperor as shown here is not an authentic classical feature.

Geremia's medals and plaquettes represent an early phase of antiquarian study pre-dating much of Mantegna's work. The style owes its inspiration at least in part to the fanatical interest of Paul II in antique coins and gems, such as 8, which he owned.

References: G. F. Hill, "Classical Influence on the Italian Medal," *BM,* 18 (1911), 267; G. F. Hill, *A Guide to the Exhibition of Medals of the Renaissance in the British Museum,* London, 1923, 25–26; E. Maclagan, *Catalogue of the Italian Plaquettes* (Victoria and Albert Museum), London, 1924, p. 47; Hill, *Corpus,* nos. 753, 755; Pope-Hennessy, *Kress,* no. 54, with additional references; M. Vickers, personal communication, 3/29/78.

106 *An Allegorical Figure (Victory)* Last quarter of 15th century

North Italy, Padua(?)

Drawing; pen and ink on buff paper faded light brown. Inscription, lower right: Alexand Veroes. 22.2 × 17.3 cm.

Fogg Art Museum, Harvard University, Cambridge, Massachusetts, Bequest of Charles Alexander Loeser (1932.272)

The introduction of classical motifs into north Italian pictorial art in the 1450s by Mantegna and Jacopo Bellini influenced the inventions of other artists. This drawing of an allegorical figure is probably an instance of that influence. The artist seems also to have been familiar with techniques followed by engravers in the circle of Mantegna and to have derived from them the overlapping hatching strokes that give to the shadows the effect of an iridescent sheen. This quality is particularly noticeable in the engravings of Zoan Andrea (see 14). The artist was also apparently familiar with types and techniques current in the Venetian studio of Giovanni Bellini. A Paduan artist like Bernardo Parentino, whose style retains Gothic mannerisms yet whose interest in and attempts to assimilate antiquity are often paramount in his work, comes to mind.

Elements like the spray of olive and caduceus held in the figure's right and left hands, the water flowing from an overturned vase on which her right foot is resting, the owl, symbol of Athena, faintly visible perched on a branch at right, and the empty cuirass on the ground with a winged putto resting on it, suggest an allegorical interpretation for the figure as a symbol of Peace, or perhaps a double figure of Peace and Victory like the personification in Antonio Lombardo's bronze *Peace* of 1512 (107). Comparison of the Fogg drawing with Antonio's relief dramatizes the way in which the depth of understanding of antique types achieved by key artists like Leonardo, Raphael and Giorgione, and shown in their imaginative, sometimes hard-to-recognize adaptations of such types, contributed to the overall ripening of artists' mastery of the classical element in Renaissance style after 1500.

Ex collection: Charles A. Loeser.
Reference: Mongan and Sachs, *Fogg Drawings,* 1, 39, no. 47; 2, fig. 42; Z. Wazbinski, *Bernardo da Parenzo . . . Étude sur la fin du quattrocento à Padoue,* Venice, 1963 (Memorie del Istituto Veneto di Scienze, Lettere ed Arti, 33, fasc. 4).

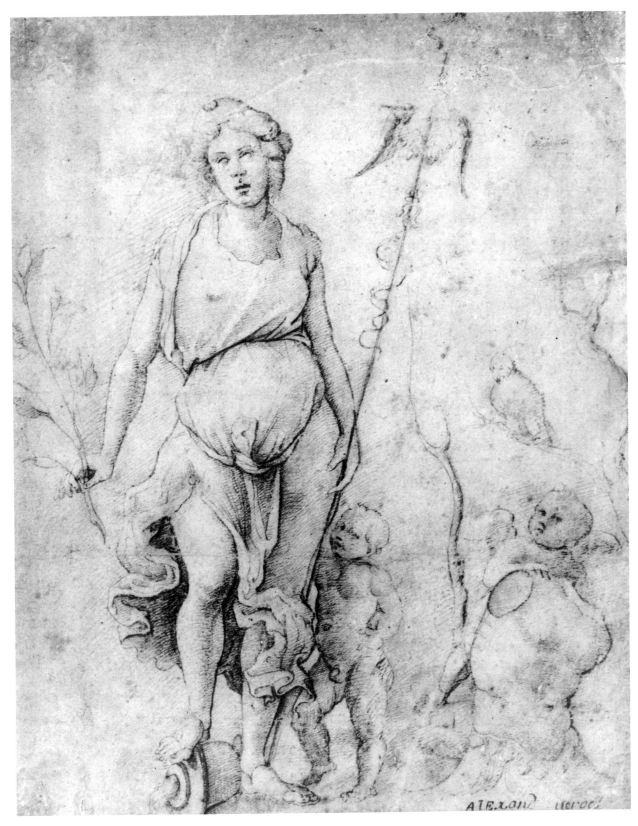

106

107 *Peace Establishing Her Reign: An Allegory of the Victory of Ravenna* 1512

Antonio Lombardo (Venice? c. 1458/Ferrara before March 1516)

Bronze relief; heavy black lacquer over very dark reddish-brown bronze. 40.6 × 33.9 × 7.6 cm.

National Gallery of Art, Ailsa Mellon Bruce Fund, 1972 (A 1750)

In this relief a woman partially draped is shown resting against a cuirass on the ground. She lowers a staff or wand around which two serpents twine. The continuous wedge-shaped curve of her body sweeping upward, then reversing direction in the opposing hip and arm, is the major motive of the work's design and inspires its graceful vitality.

The presence of armor, serpents and palm, and the idealized, classicized figure and drapery, signal the allegorical intent of the relief. Some elements may have been inspired by antique coin types like the Peace on a medal of Claudius described by Ripa: "A woman, who points a caduceus down toward the ground where there is a serpent with intense intwinements" (Lewis). The subject of the allegory is the victory on the 11th of April, 1512, of the combined French and Ferrarese forces against Papal and Spanish armies at the Battle of Ravenna. Duke Alfonso I d'Este, Antonio Lombardo's patron, directed the successful assault. The victory has been attributed to the maneuverability of Alfonso's artillery—a decisive factor for the first time in history. Alfonso was unusual in that he himself practiced the art of bronze casting, designing and helping to cast pieces to add to the artillery's armory. Thus bronze itself as a material was connected to the victory of Ravenna, providing a witty conceit to underlie Antonio Lombardo's allegorical relief. The sadness on the face of *Peace*, otherwise anomalous in an image of Victory, may refer to the death of the precociously brilliant French commander, Gaston de Foix, which led ultimately to France's final loss of Milan, a crucial step in the total withdrawal of France from Italy and the consequent triumph of Spain.

Peace Establishing her Reign relates in type and size to a series of marble reliefs attributable to Antonio Lombardo and his associates and followers (Lewis). Among Antonio's first works after entering the service of Duke Alfonso I d'Este of Ferrara in 1506 were twenty-eight reliefs, four figurated, with mythological scenes, the rest purely decorative, now in the Hermitage. Two are dated ALF. D. III, and one M. D. VIII in addition, which connects them to Alfonso's castle at Ferrara in 1508, the third year of his reign as duke. Their original location seems to have been the Camerino di marmo, a *studiolo* described in a letter of 1 June 1517 from Stazio Gadio to Isabella d'Este as "uno

bellissimo camerino fatto tutto di marmoro da carrara et di meschi con figure et fogliamenti molto belli excellentemente lavorati, adornato de vassetti e figurine antiqua et moderne i di marmor i di mettal" (Hope). This letter establishes that there were bronzes as well as marbles in the room.

A second group of at least 15 marble reliefs, mostly of heroes and heroines of antiquity (see 103), has been linked stylistically to the Hermitage reliefs. There are three whose size, technical finish and figural invention relate them to the *Peace: Philoctetes* (a work based on a cameo by the Hellenistic artist Boethos), *Venus Anadyomene* (both Victoria and Albert Museum) and the *Eurydice* in Naples (Lewis). Even closer, however, is the *Mars divesting the Armor of War* in Modena, to which the *Peace* was a pendant, as Lewis demonstrated, following a suggestion first made by Richard Stone. The *Mars* "exhibits such a manifest superiority of composition and technique as to make it a touchstone of quality, against which the plethora of reliefs claiming some relationship to the 'hero and heroine' series . . . must all be measured" (Lewis). The *Peace* might have been executed in bronze as a contrasting medium, or because of the importance of the occasion it commemorates and/or the dependence of the victory on bronze and other metal casting skills.

In style, *Peace*, while linked in general terms to Antonio's earlier Venetian works, represents an accommodation to the more abstract, refined neoclassicism of Antico, to whose style he was certainly exposed on arrival in Ferrara (Stone). The specific pose recognizes the new concept of animated contrapposto that had arisen first in the work of Leonardo. The posture is in some ways closest to the Virgin in the Louvre *Virgin and Child with Saint Anne,* whose composition had been being worked out by Leonardo for several years just prior to the 1510–12 period. Conceivably Antonio fused this Leonardesque pose with that of an antique in Alfonso's collection, the *Seated Ariadne* now in Dresden.

Ex collections: "A French chateau"; Paris art market; [Michael Hall Fine Arts, 1970–1972].
References: P. Herrmann, *Verzeichnis der antiken Originalbildwerk der Staatlichen Skulpturensammlung zu Dresden,* Dresden, 1925, no. 241; C. Hope, "The 'Camerini d'Alabastro' of Alfonso D'Este—I," *BM,* 113 (1971), 649; R. Stone, conversations with Douglas Lewis and cataloguer, 1976, 1977; D. Lewis, "The Washington Relief of *Peace* and its Pendant: A Commission of Alfonso d'Este to Antonio Lombardo in 1512," in W. S. Sheard and J. T. Paoletti, eds., *Collaboration in Renaissance Art,* New Haven, 1978, 233–244.

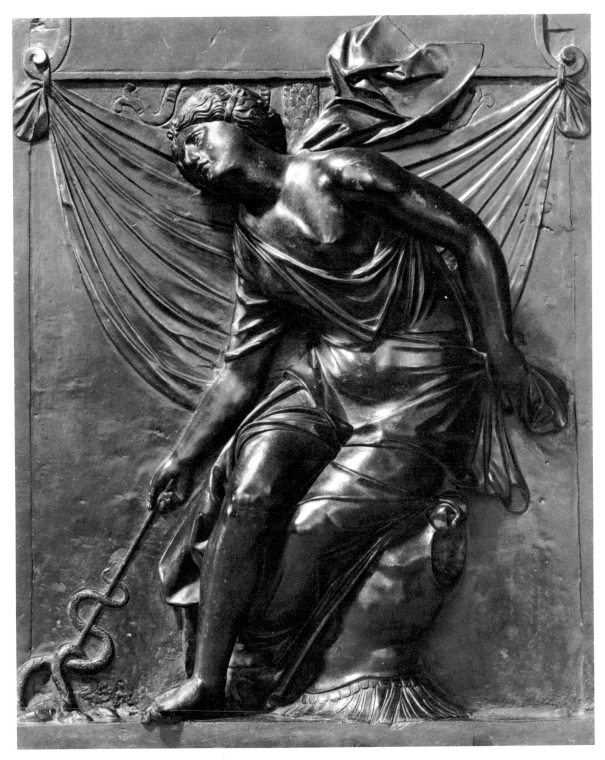

107

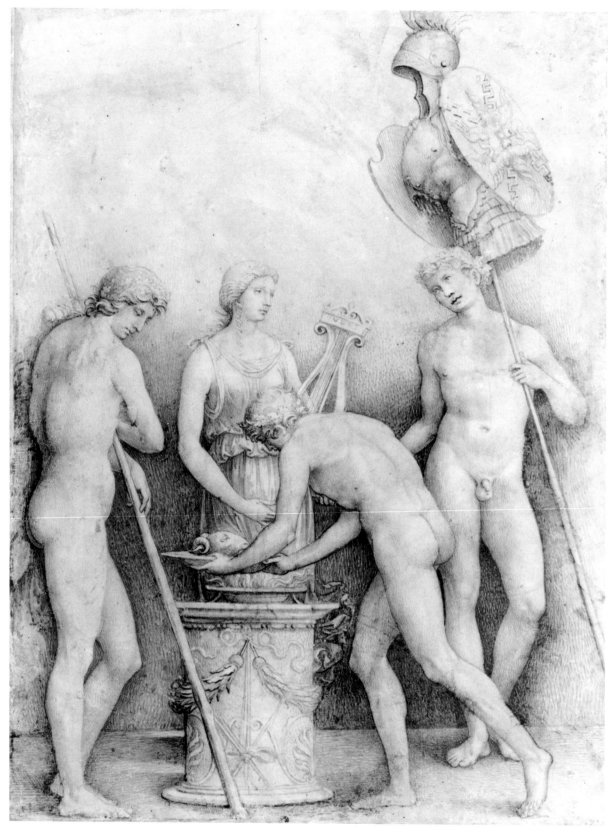

108

108 *A Pagan Sacrifice* c. 1500(?)

Attributed to Francesco Raibolini, called Francia (Bologna c. 1450/Bologna 1517–18)
Drawing; brush and brown wash, with some contours accented in pen, on vellum. 29.1 × 22.3 cm.
The Pierpont Morgan Library, New York (Fairfax Murray, I, 95)

This carefully worked, highly finished drawing of a classical sacrifice by three nude men and a draped woman holding a lyre represents antique revival in the romantic, as opposed to the archaeological or antiquarian, mode. It is true that details like the garlanded pedestal, with its ribbons and palmettes, and the Roman armor held up on a pole as a trophy, reflect accurate observation of Roman art and thus the more scientific archaeological current in north Italy fostered by the work of Mantegna. The overall mood of the drawing, however, differs from Mantegna's approach. The scene is a fantasy that projects, by the indolent poses and melancholy expressions, a mood of dreamy pathos not unlike Francesco Colonna's *Hypnerotomachia Poliphili,* in which fantastic ruins and evocations of scenes from classical poetry provide the backdrop for an allegory of love.

The *Pagan Sacrifice* has been related to a group of drawings attributed to Francia on the basis of a letter to him by Raphael (autumn 1508) published by Malvasia (*Felsina Pittrice,* 1841, v.1, 47; whereabouts unknown) referring to Francia's drawing of *Judith and Holofernes.* Among the many existing versions, one in the Louvre and another in the Morgan Library (I, 94) are considered of the highest quality (Bean and Stampfle). The technique of building up a dense background texture with delicate but deliberate small brush strokes to contrast with the figures and achieve an effect of relief sculpture has been interpreted by scholars as reflecting Francia's training as a goldsmith, niellist and engraver. Francia took up painting in 1494, relatively late in his career. A *Judgment of Paris* (Vienna, 4859) resembles the *Pagan Sacrifice* in composition, details, technique and mood, but seems somewhat coarser in its treatment of the nude figures. The disposition of the figures on either side of an altar is reminiscent of a Jacopo Bellini drawing (Munich, Graphische Sammlung, 1970.20) in which Bellini adapted the circular relief on the Arch of Constantine showing Hadrian's sacrifice to Diana (Degenhart and Schmitt).

The *Apollo Belvedere* from Berlin (53) was connected by Winner to *A Pagan Sacrifice* and its group of related drawings. In it, the characteristic background texture is used more sparingly. Restricted to the immediate area around the figure's contours, it imparts to the statue a kind of vibrating radiance appropriate to its charisma as a cultural icon. Representing a face-to-face confrontation with antiquity, the *Apollo Belvedere* drawing is totally devoid of the quality of romantic melancholy that permeates *A Pagan Sacrifice.*

Ex collections: W. Y. Ottley; Sir Thomas Lawrence; J. C. Robinson; Charles Fairfax Murray; J. Pierpont Morgan.
Exhibition: Los Angeles County Museum of Art, *Old Master Drawings from American Collections,* April 29–June 13, 1976, cat. by E. Feinblatt, 70, no. 76.
References: C. Fairfax Murray, *Drawings by the Old Masters: Collection of J. Pierpont Morgan,* 4 vols., London, 1905–12, 1, n.p., no. 95; K. T. Parker, *Catalogue of the Collection of Drawings in the Ashmolean Museum,* 2, *Italian Schools,* Oxford, 1956, 7, no. 10 (ill.); Bean and Stampfle, *N. Y. Collections I,* 25, no. 12; O. Benesch with E. Benesch, *Master Drawings in the Albertina,* Greenwich, n.d., 322, no. 15; Winner, "Apollo Belvedere," 190–97; B. Degenhart and A. Schmitt, "Ein Musterblatt des Jacopo Bellini mit Zeichnungen nach der Antike," J. A. Schmoll gen. Eisenwerth, M. Restle, H. Weiermann, eds., *Festschrift Luitpold Dussler,* Munich-Berlin, 1972, 139–168, figs. 1, 2.

109 *Pan Listening to Echo* 1515–25

Attributed to Andrea Riccio (Padua 1470–75/1532)

Bronze inkstand (hollow cast); dark brown patina.
19.3 cm.

Ashmolean Museum, Oxford (Fortnum 1077)

As his epitaph proclaimed, Riccio was known as an artist "whose works came closest to the glory of the ancients" (trans. Meller). His style as a sculptor in bronze stemmed from Hellenistic bronzes in which a classical attitude toward idealized form and harmonious, balanced movement is combined with anatomical naturalism. His large Paschal candlestick (1507–16) in S. Antonio, Padua, is the first example of this style as it is applied to Christian subjects interspersed with pagan decorative motifs: sphinxes, satyrs, centaurs, putti. These were the predecessors of his many statuettes, most dating from the 1510–30 period.

Pan Listening sums up Riccio's unique contribution to the art of small bronzes in the Renaissance. Pan is a slender youth, recognizable as the sylvan god only by two unobtrusive horns. Riccio's portrayal, harking back to a Polykleitan type of Pan, contradicts the idea of Pan as a Shaggy, ferocious, cloven-hooved hybrid whose appearance announces his kinship with the terrifying noises of the woods which strike "panic" terror in the hearts of the unwary (Herbig). He sits holding an urn intended as an ink-well for the poet for whose desk the piece was designed. His right hand holds the syrinx or "pan pipe," whose use was discouraged by Plato because the music of wind instruments too easily aroused passion. Instead of playing, he pauses to listen to Echo, or to an inspiring Muse, in kinship with the writer he aids.

With Riccio's rustic, deeply pagan creatures, we feel we have entered into an antique world quite different from the Roman history and civilization celebrated by Mantegna. By the beginning of the sixteenth century, artists turned for inspiration to the works of ancient poets, in addition to and sometimes instead of visual sources. Ovid's world of centaurs, Pans, satyrs and satyresses sprang to life in the inventions of Riccio. Their corollary was eroticism, implicit or explicit, a part of the antique heritage that was ignored in large-scale public works in the *all'antica* style. And the erotic, in the pastoral mode, often brings with it that sense of melancholy expressed by Riccio's *Pan.*

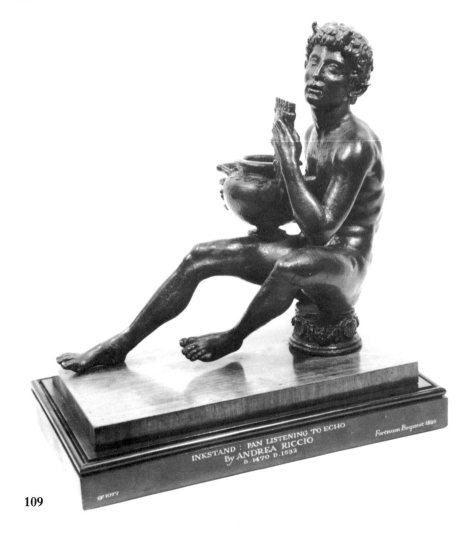

109

Ex collection: C. D. E. Fortnum (purchased 1848 in Genoa).

Exhibitions: Detroit, *Decorative Arts,* 244; Amsterdam, Rijksmuseum, *Meesters van het brons der Italiaanse Renaissance,* Oct. 29, 1961–Jan. 14, 1962, exhib. cat. with introduction by John Pope-Hennessy, no. 49 (show also traveled to Victoria and Albert Museum, London, and Palazzo Strozzi, Florence).

References: L. Planiscig, *Andrea Riccio,* Vienna, 1927, 423f.; R. Wittkower, "L'Arcadia e il Giorgionismo," *Umanesimo Europeo e Umanesimo Veneziano,* ed. V. Branca, Florence, 1963, 473–484; P. Meller, "Riccio's Satyress Triumphant: Its Source, Its Meaning," *Bull. of the Cleveland Museum of Art,* 63 (1976), 324–334; J. D. Draper, "Andrea Riccio and his Colleagues in the Untermyer Collection," *Apollo.,* n.s. 193 (1978), 170–180 (recent discussion in English of Riccio's style; *Seated Satyr* in Untermyer Coll. attr.).

110 *Seated Shepherd with Reed Flute* c. 1505–20
Attributed to Andrea Riccio (Padua 1470–75/1532)
Bronze; brown with olive undertones and areas of rubbed black lacquer patina. 21.3 cm.
The Walters Art Gallery, Baltimore (54.234)

The *Seated Shepherd* is close in many ways to the Ashmolean *Pan Listening to Echo* (109). The poses are similar, with right leg outstretched and left flexed, but instead of an elegant garlanded plinth, the *Shepherd* is seated on a formation of angular rocks. Both hold reed pipes. Their hair is shaped into the close-cropped, curly mass in imitation of the artist's own hair style that Meller refers to as Riccio's "visual signature." Both are *unicums,* single examples of which no other casts have so far been located.

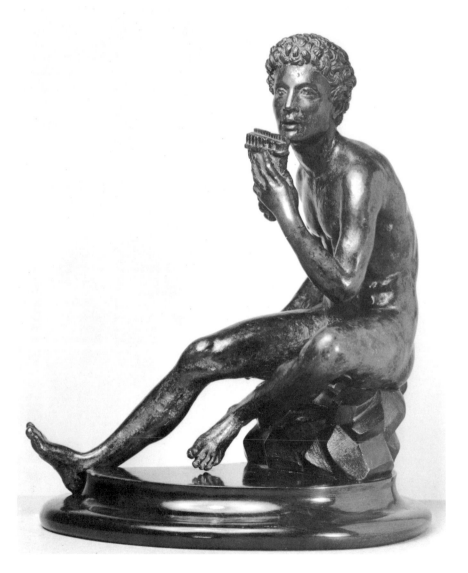

The similarity of the two bronzes renders their differences rather interesting. The Walters *Shepherd* of course lacks Pan's horns. Unlike the *Pan,* which holds an inkstand, the *Shepherd* is not meant to serve a practical purpose. Though both portray the act of listening, an earlier moment characterizes the *Shepherd.* He has just stopped playing the pipes—his lips are parted and he seems still to be caught up in the last few notes of the music.

The act of listening is also given a different interpretation or mood in the two figures. In the *Pan* it is made to seem dramatic, suspenseful. Pan's body is filled with tense expectation. An effort of concentration informs every muscle. In contrast, everything about the *Shepherd*'s body appears loose and relaxed. His center of gravity is stable and low. The figure lacks the incipient spiral and suggestion of contrapposto movement of the *Pan,* yet the slightly raised right foot seems to express an initial impulse toward movement, the starting point of the transition from enraptured performance to inquisitive listening. Corresponding with the difference in the exact moment portrayed and the definition of its appropriate mood, the proportions of the two figures differ. The head of the *Shepherd* is larger in relation to his torso, the planes of his face broader, more Hellenic and idealized. Absent is the pathos of the hybrid's ambiguous status, evident for example in Riccio's satyrs (cf. 124). The lyrical beauty and sweetness projected by the *Shepherd*'s face, if it conveys the nostalgia for Arcadia that is usually Riccio's hallmark, does so without pathos.

Whether these differences should be taken as indications of two different artists at work is a matter of dispute. Pope-Hennessy after initially accepting the Walters bronze as by Riccio preferred to see in it a creation of Camelio, whose lyrical and poetic sensibility he had defined largely on the basis of the reverse of his *Self-portrait* medal (84). Verdier interpreted the differences as a question of degree that implied an earlier date for the Walters bronze (1505–10). He found that the "accentuation of local volumes tightened by the nervousness of the whole frame" characteristic of Riccio was shared equally by both figures.

Ex collections: Jacques Seligmann and Co., Paris, before 1934; Henry Walters, 1954.
Exhibitions: Detroit, *Decorative Arts,* no. 247; Columbus Gallery of Fine Arts, "The Renaissance Image of Man and the World", Oct.–Nov. 1961, cat. no. 50; Smith College, *Renaissance Bronzes,* no. 12; Wildenstein, *Italian Heritage,* no. 47; Museum of Western Art, Tokyo, and National Museum, Kyoto, Japan, "Masterpieces of World Art from American Museums . . .", September–December, 1976, no. 24.
References: P. Verdier, "An unknown Riccio," *Bull. of the Walters Art Gallery,* 6, no. 6 (1954), [1–3]; Pope-Hennessy, "Statuettes", 23; P. Meller, "Riccio's Satyress Triumphant: Its Source, Its Meaning," *Bull. of the Cleveland Museum of Art,* 63 (1976), 324–334 (various Riccio questions in connection with the bronze *Satyress* relief).

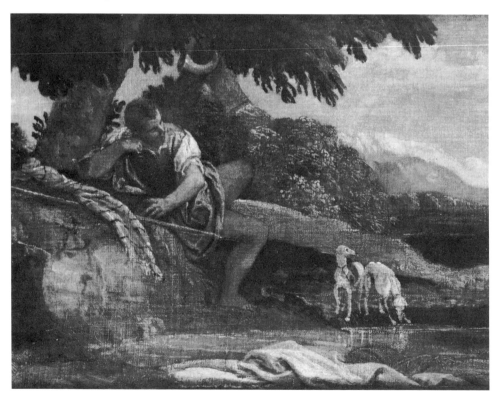

111 (detail)

111 *Diana and Actaeon* c. 1560

Paolo Caliari, called Veronese (Verona 1528/Venice 1588)

Painting; oil on canvas. 25.4 × 110.5 cm.

Museum of Fine Arts, Boston, Gift of Mrs. Edward Jackson Holmes (59.260)

Veronese's *Diana and Actaeon* belongs to a series of four canvases of identical format depicting classical myths. The other three, also at the Boston Museum of Fine Arts, are *Atalanta and Meleager, Mount Olympus* and *Venus and Jupiter*. A slightly shorter canvas of the same height (25 × 88 cm.; Rasini collection, Milan) depicts *The Rape of Europa* and is close in style to the Boston pictures (Pignatti). The original context suggested by these dimensions is a *spalliera* or narrow frieze of paintings running along the wall of a room at or slightly above shoulder level, separated by framing elements. Such a series was referred to by Ridolfi (1648) as painted by Veronese for the statesman and writer Marcantonio Barbaro, the brother of Daniele, the humanist and editor of Vitruvius who commissioned the villa at Maser from Palladio (Pallucchini). *Diana and Actaeon* is a work of high quality, with a strong claim, accepted in the most recent monograph (Pignatti), to being an autograph work. Pallucchini (1939), followed by subsequent scholars, dated the four decorative works c. 1560.

Veronese's treatment of the theme, in which Diana's objections to Actaeon's suddenly discovered presence are not expressed by any dramatic movement or gesture, is at variance with Titian's approach to the same subject in his *Diana and Actaeon* painted for Philip II of Spain in 1556–59 (Edinburgh, National Gallery of Scotland). It also differs from Ovid's account of the event, probably the best known classical literary source, in which the nymphs' agitated horror and revulsion at the sight of Actaeon is stressed. The overall mood of Veronese's painting, despite the inherently dramatic subject matter, is one of serenity, as if in conscious rejection of the dynamic embodiment of the dark side of the Greek myths represented by Titian's contemporary treatments of Diana's deadly rage and its consequences. Veronese's harmonious composition, with its glimpses of distant landscapes closed off behind the major figure groups by foliage and architectural elements which anchor the figures close to the picture surface, harks back instead to the idyllic pastoral scenes of the early High Renaissance in Venice and to the corresponding phase of Raphael's style. The passages of impressionistic brushwork and pure color accent the draperies' highlights, the nymphs' golden hair, and the distant sunlit meadows and snow-covered peaks. Especially piquant is the handling of the pair of hounds, one drinking from the pool, sketched in rapidly with a loaded brush. Such freedom and spontaneity of technique help convey the sense of joyous, carefree pastoral abundance that Veronese must have found appropriate for a purely decorative scheme such as the *spalliera* series to which this canvas belonged.

Ex collections: Holford Collection, Dorchester House, London, 1927; Edward J. Holmes, 1959.

Exhibitions: London, Burlington House, *Winter Exhibition,* 1902, no. 114; London, Burlington Fine Arts Club, Winter Exhibition, *Pictures from the Holford Collection,* 1921–22, 21, no. 23; Venice, *Mostra di Paolo Veronese,* April 25–November 4, 1939, cat. by Rodolfo Pallucchini, 85, no. 31; Metropolitan Museum of Art, *One Hundred Paintings from the Boston Museum,* May 29–July 26, 1970, catalogue by Kent Sobotik, 35, no. 19 (color ill.); Birmingham, Alabama, Museum of Fine Art and Montgomery Museum of Fine Arts, *Veronese and his Studio in North American Collections,* Oct. 1–Dec. 31, 1972, 18.

References: The Holford Collection, Oxford, 1927, 1, 41, no. 82; E. von der Bercken, *Veronese,* Milan, Florence, 1952, 28–31; T. Pignatti, *Veronese,* 2 vols., Venice, 1976, 1, 129, no. 148; 2, fig. 405 (black and white ill.).

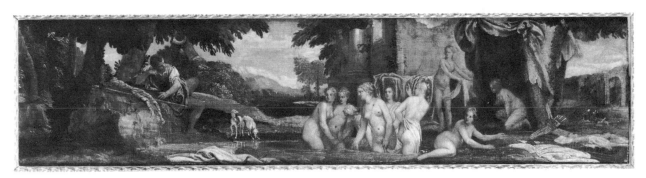

111

112 *Silver Medallion with Head of Medusa* Early
3rd century B.C.

South Italy, Hellenistic

Silver plaque, originally partly gilt (some traces of gilding on head). 7 cm. (diameter)

The Art Museum, Princton University (51–5)

113 *Silver Medallion with Head of Hermes* Early
3rd century B.C.

South Italy, Hellenistic

Silver plaque, originally partly gilt (some traces of gilding on head). 7 cm. (diameter)

The Art Museum, Princeton University (51–6)

These plaques are part of a known set of six (four of which are in the Museum of Fine Arts, Boston) that probably originally contained more. A long oval plaque in a private Swiss collection, showing a flying Nike bearing a trophy, is thought to have belonged to the group. They may have decorated large plates or wooden chests or served as part of a ceremonial suit of armor or horse's bridle. The reported findspot for the plaques was near Tarentum (Taranto). They exemplify the "classic period of metalwork (320–239 B.C.)" (Langlotz), a time of great prosperity in Tarentum during which it was preeminent in the manufacture of such luxury objects.

The style of these plaques has been connected by Segall to the early-third-century "Tarantine Bowl" (lost), "one of the most elegant toreutic works of antiquity . . . unquestionably from the hand of a great master" (Langlotz). Segall also commented on the unusual beauty and power of the Medusa heads (another is in Boston) in particular. In the Princeton plaque two snakes are seen emerging from the Medusa's hair, their tails tied in a square knot. Though the loose, free treatment of the hair shows a humanization that differentiates this Medusa from the apotropaic monster of the Archaic and Classical periods, the facial expression reflects the Gorgon's severity and indifference to the fate of her human victims (Segall). On the second

plaque from Princeton, Hermes, wearing his flat cap and with his herald's staff over his left shoulder, is similarly individualized. The treatment of the head seems to echo the inventions of Skopas. There is an expressive spontaneity about these medallions that is enhanced by the juxtaposition of the very high relief of the heads against the low, incised relief of the backgrounds.

The type of wave pattern on the rims of these plaques was popular on South Italian vases and coins. This substantiates their place of origin. Syracusan, Catanian or other South Italian coins of the late fifth to fourth centuries B.C. showed three-quarter frontal heads, which might also have inspired the South Italian metal craftsman in the design of these plaques (Vermeule).

The idea of medallions with heads as a decorative motif survived throughout the middle ages as a common reminiscence of antiquity. In the Renaissance the motif decorated such major programs as Ghiberti's bronze doors for the Florentine Baptistry and Filarete's for St. Peter's. In Venice they form part of the mosaic decoration of the Mascoli Chapel in St. Mark's (c. 1450). In the sixteenth century they appear in bronze as door handles and door knockers. Considering the importance of the Tarentum area as a center of decorative metalwork in Hellenistic times, objects such as these plaques were very likely known in the Renaissance and served as sources in the making of objects of decorative art.

Ex collection: [Piero Tozzi, New York].
References: F. F. Jones and R. Goldberg, *Ancient Art in the Art Museum,* Princeton, 1960, 48–49; E. Berger, *Kunstwerke der Antike,* Lucerne, 1963, E 4 (emblem in Käppeli coll.); E. Langlotz, s.v. "Greek Art, Western," *EWA,* 7 (1963) 150–161, esp. 152; B. Segall, "Alexandria und Tarent," *Archaeologischer Anzeiger,* 1965, 553–588; C. C. Vermeule, "Additions to the Greek, Etruscan and Roman Collections in Boston," *Classical Journal,* 58 (1962), 7–9.

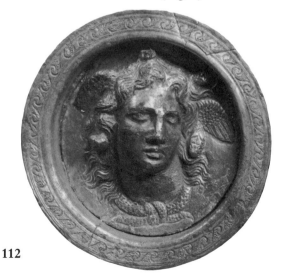

112

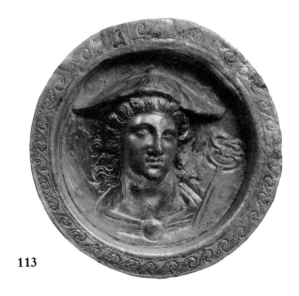

113

114 *Furniture Panel with Birds and Urn* 1464–71
Rome

Wood panel, colored with tempera. 19 × 35.5 cm. (framed)

Collection of Kenneth E. Swoik

115 *Furniture Panel with Griffin and Arms of Pope Paul II* 1464–71
Rome

Wood panel, colored with tempera. 26.5 × 52.1 cm. (framed)

Collection of Kenneth E. Swoik

116 *Furniture Panel with Centaurs and Human Face* 1464–71
Rome

Wood panel, colored with tempera. 19 × 35.3 cm. (framed)

Collection of Kenneth E. Swoik

These wood panels were originally part of a piece of furniture such as a chest or writing table and were arranged so that the largest of the three (115) was probably featured between the smaller panels (114, 116). The set belonged to Pope Paul II whose papal arms appear on the central panel. During the papacy of Paul II the classicizing culture of Rome assumed visual form in small-scale objects such as furniture, bronzes, medals, plaquettes (105), and illuminated manuscripts somewhat earlier than was true in the more monumental forms of sculpture and architecture. This classicizing tendency is evident in the panels' motifs of delicately painted acanthus arabesques interspersed with figures from the vocabulary of antique decoration—diminutive human figures, masks, griffins, centaurs, birds, an urn. The graceful whimsy of the decoration of these panels suggests in a general way artists' knowledge of antique Roman wall painting before the wave of *grottesche* style decoration touched off by the excavation of Nero's Golden House beginning c. 1480 (cf. 121–123).

Ex collection: John Maxon.
References (unpublished): R. Weiss, *Un umanista veneziano Papa Paolo II,* Venice/Rome, 1958 (Paul II and classical culture); Dacos, *Grotesques,* 1–4 (knowledge of Roman wall painting schemes prior to 1480).

114

115

117 *Two Candelabra* Last quarter of 15th century

North Italian artist working in Rome(?)

Drawing; pen and ink on white paper. 25.7 × 17.8 cm.

Fogg Art Museum, Harvard University, Cambridge, Massachusetts, Bequest of Charles A. Loeser (1932.311)

This drawing allows us to observe at first hand the process by which antique decorative motifs were transmuted into the decorative art of the Renaissance. In all likelihood the base of the candelabrum on the left and the stem of the one on the right depict a marble of the Trajanic era (A.D. 98–117) whose basic shape and decoration were adapted in bronze early in the sixteenth century (Florence, Bargello; ill. Mongan and Sachs, *Fogg Drawings,* v.1, 38, fig. A). Mongan and Sachs identified the antique source as a candelabrum in S. Agnese fuori le mura, Rome, which orginally belonged to a group of six (four in Vatican Museum, Galleria dei Candelabri, inv. 341, 342, 353, 354; whereabouts of the fifth unknown). They pointed out that Piranesi etched the same candelabrum in his *Le antichità romane* (v. 2, pl. XXV).

The antique candelabrum belongs to a type with a three-sided or pyramidal base which was adapted in the inkstand with Moderno plaquettes in the relief fields (124). The sphinxes, rams' heads and bucranes that mark the corners, as well as the acanthus-leaf sheathing, blossoms, swags, leaf-and-dart moldings and imbrication, were all popular elements of *all'antica* decorative style in the Renaissance beginning c. 1450. The sea creature in the Lombardo drawing (118) belongs to the same world of forms as the erote ending in an arabesque on the left-hand candelabrum. Middeldorf identified two drawings of candelabra which recombine these motifs by the same left-handed artist (Berlin, Z. 5633, 5635).

Ex collection: Charles A. Loeser.
Exhibition: Detroit, *Decorative Arts,* 25, no. 3A (ill.).
References: Mongan and Sachs, *Fogg Drawings,* 1, 38, no. 45; 2, fig. 41; *EAA,* 2, 304ff. (candelabra); Helbig, 1, 416, no. 526 (entry by H. V. Steuben: group of six candelabra discovered in seventeenth century).

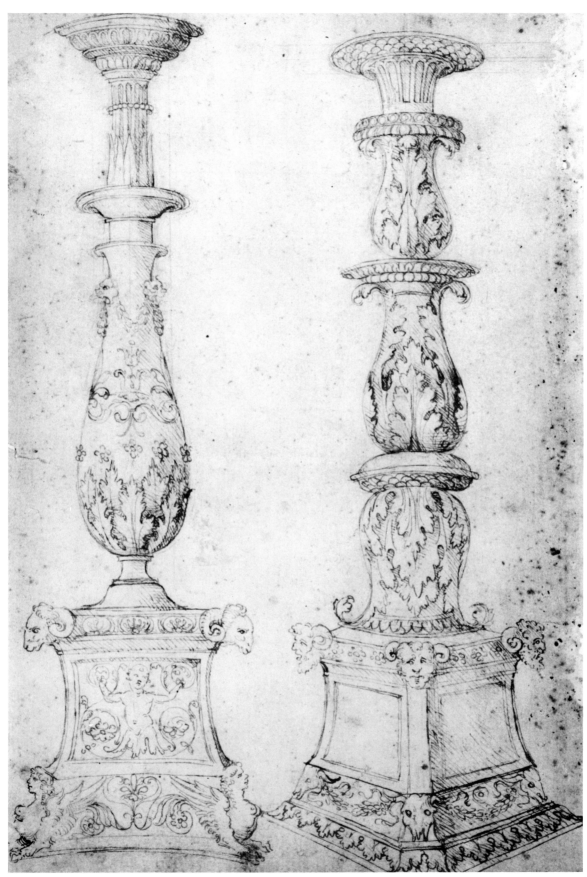

117

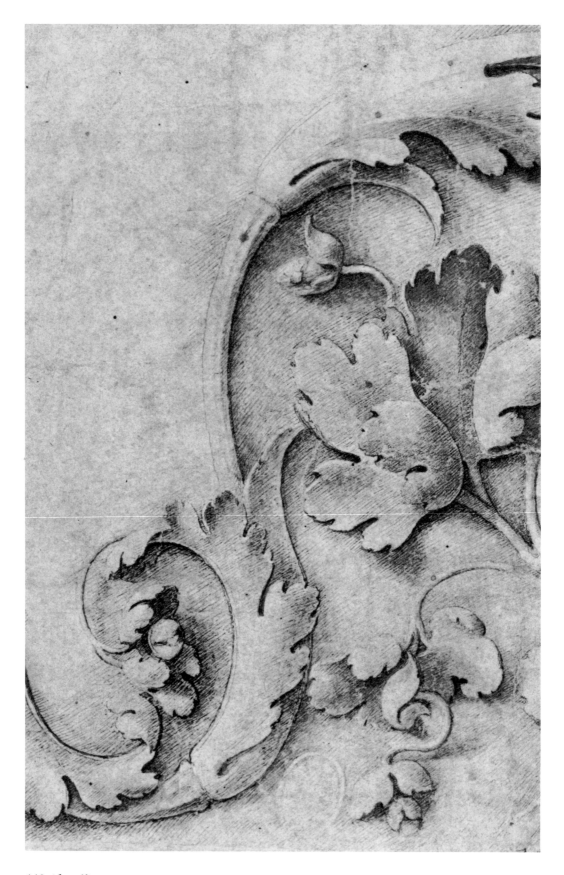

118 (detail)

Decoration all'antica

118 *Study for a Frieze with Siren and Acanthus in Sta. Maria dei Miracoli, Venice* c. 1481

Tullio Lombardo (Venice? c. 1455/Venice 1532) *or* Antonio Lombardo (Venice? c. 1458/Ferrara before March 1516)

Drawing; brown ink on cream laid paper. Inscription in pen, lower left: Giovanni D'Udine. 19.5 × 28.4 cm.

Private collection

Pietro Lombardo's sons Tullio and Antonio (see 38, 85, 107) were trained first and foremost as carvers of marble architectural ornament. The style of decoration that later became known as "Lombardesque" after the Lombardo family firm was first seen in the pilasters and friezes of the triumphal arch and *cappella maggiore* of the church of S. Giobbe in Venice. This chapel, decorated c. 1468–72, was a memorial to Doge Cristoforo Moro. Certain pilasters and door frames in the palace of Federico da Montefeltro at Urbino (c. 1472–74) also display the Lombardesque style. Two schemes of pilaster decoration—the candelabra (as in 120) and the running rinceau—were employed in S. Giobbe and at Urbino. Lush vegetable forms, based on acanthus in Roman architectural decoration, were used almost exclusively, recalling the contemporary decoration of the main doorway of Alberti's Sant'Andrea in Mantua. Ambrogio Barocci, also a Lombard, was one of the inventors of this style of architectural decoration. Ambrogio, who designed the decoration of the facade of S. Michele in Isola, Venice, beginning c. 1469, worked with the Lombardi in S. Giobbe, and then went on to become the principal designer and carver of the richly ornate and classicizing marble decorations in Federico da Montefeltro's palace.

In the 1480s, Lombardesque decoration became less purist in its use of acanthus leaves and flowers, which were now interspersed with animals, birds, hybrids, helmets, masks and other *all'antica* imagery, and patrons' emblems. This phase of decorative style can be best studied in the church of Sta. Maria dei Miracoli (1481–89). There the triumphal arch bases are adorned with friezes of marine hybrids, putti and winged cherub heads. Before their surfaces became badly corroded by moisture and pollutants these reliefs must have been among the major decorative splendors of the quattrocento. The *Study for a Frieze* was connected to the Miracoli at the time of its original publication (*Art in New England*).

An armless siren with body ending in acanthus adjoins a richly modeled arabesque, its stalk terminating in a central burst of leaves and flowerets. A similar motif was used for the friezes below the wall tomb of Doge Pasquale Malipiero in SS. Giovanni e Paolo,

Venice (late 1460s). That design, a siren between acanthus scrolls, was a popular and recurrent image surviving from antiquity which had appeared in north Italian pre-Romanesque and Romanesque architectural decoration.

The Lombardo shop, in order to carry out its numerous commissions in the 1470s and 80s, maintained an array of stoneworkers of varying degrees of skill and types of specialization. Pattern books were employed in which favorite decorative motifs were recorded. The present drawing, as well as functioning in the planning of a carving, could well have been included in a pattern book collection. That it was circulated as part of such a collection is suggested by a Giovanni da Brescia engraving, *Ornament Panel with a Mermaid*, which has the same combination of nude mermaid or siren and acanthus scroll, but in reverse to this drawing (H. 5. 52, 53).

Since no drawings other than architectural plans have been convincingly connected to Tullio or Antonio Lombardo, attribution remains problematic. A red chalk drawing of an antique Venus Genetrix was attributed to Tullio by the Tietzes (Louvre; possibly lost). This is an attractive attribution, given Tullio's demonstrated interest in antiques, his reinterpretations of antique types in virtually every aspect of his work, and the fact that he owned an antique draped female figure. Apart from these circumstantial factors, there is little hard evidence. The drawing's numerous delicate and closely-spaced hatching strokes, alternating with relatively empty areas, produce an active yet subtle, shimmering surface. Its connection to decorative motifs known to have been employed by Tullio and Antonio in the Miracoli church at least provides a basis for assignment to its proper context. Its superlative quality reflects the artist's up-to-date translation of antique motifs into new visual language communicating nostalgia for a disappearing pastoral paradise, as well as superior draftsmanship. Both aspects are what one would expect from a drawing by Tullio or Antonio Lombardo.

Ex collection: D'Hendecourt.
Exhibition: Museum of Fine Arts, Boston, *Art in New England*, Boston, 1939, 107, no. 186 (attr. Pietro Lombardo).
References: H. Tietze and E. Tietze-Conrat, *The Drawings of the Venetian Painters of the 15th and 16th Centuries*, N.Y., 1944, 41, no. A 71; P. Rotondi, *Il Palazzo Ducale di Urbino*, 2 vols., Urbino, 1950, 1, 240–242, 260–262, 280–285; ills. in v. 2; W. S. Sheard, "The Tomb of Andrea Vendramin in Venice by Tullio Lombardo," unpublished Ph.D. dissertation, Yale University, April, 1971, 1, 414, 418–421, and *passim*.

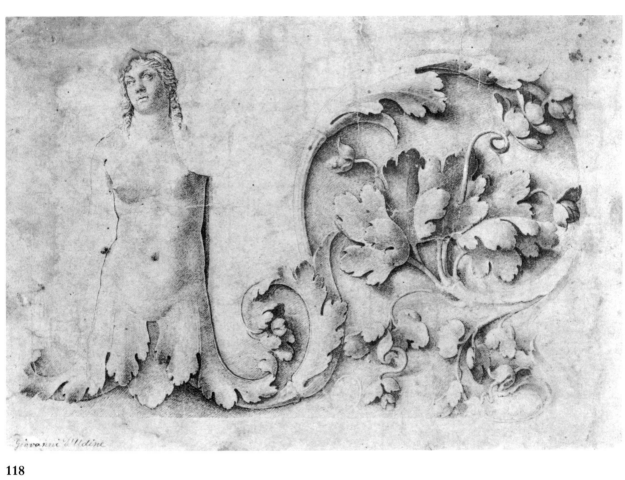

118

119 *Sleeping Cupid* 1500–1520(?)

Circle of Antonio Lombardo? (Venice? c. 1458/Ferrara 1516 before March)

Bronze; remains of brown lacquer over yellowish bronze; remains of oil gilding on hair, leaves, baldric, arrows and tree stump. 22.5 × 20.3 cm.

The Metropolitan Museum of Art, Edith Perry Chapman Fund (51.175)

Cupid, asleep on a mound, props his head up on a tree stump decorated by vine leaves, a lion skin beneath him. The stylized curls on his head resemble two

bronze portraits of children ascribed to Antonio Lombardo (Museo Correr and Museo Nazionale, Florence, ill. Weihrauch, figs. 141 and 144).

Cupids or putti on their own or in a religious context were among the most frequently represented themes of the Renaissance. Leonardo began his study from nature of babies and children while he was still in the shop of Verrocchio in Florence in the 1470s. The resulting types, used most often to portray the infant Christ or St. John Baptist as a small child, were quickly adopted by other artists. The Verrocchiesque head of a Child in the Casa Buonarroti is a good example. The

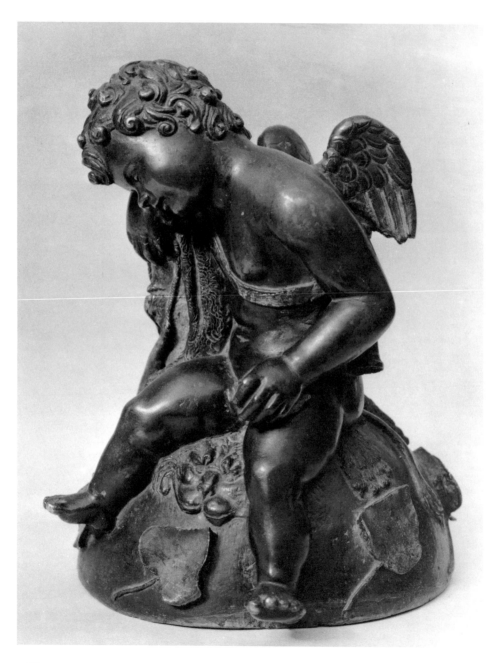

transfer of Verrocchio's shop to Venice in the 1480s made these ideas available to north Italian artists.

The Hellenistic subject of Cupid asleep was revived toward the end of the fifteenth century. Michelangelo's marble *Sleeping Cupid,* bought by Isabella d'Este in 1502 and exhibited in her *grotta* opposite a marble *Sleeping Cupid* attributed to Praxiteles, must have spurred the popularity of the subject. Though the physical appearance of Michelangelo's *Sleeping Cupid* is not known, the belief that it was portrayed by Tintoretto in his *Venus, Mars and Vulcan* (Munich) as Eros asleep on his back with his bent right arm behind his head in the "Sleeping Ariadne" pose seems well founded (de Tolnay). There is a marble *Sleeping Cupid* in exactly that pose in the collection of Lord Methuen at Corsham Court (de Tolnay, 1971, pls. V, VI) which, although recut, preserves a lion skin head on the side beneath Cupid's head that corresponds in concept and technique to Michelangelo's work. The Metropolitan's *Sleeping Cupid* from the circle of Antonio Lombardo, probably dating after the acquisition of Michelangelo's *Cupid* by Alfonso d'Este's sister, follows neither the type which de Tolnay has identified as Michelangelo's, nor the well-known antique type represented by the bronze third- to second-century B.C. *Sleeping Eros* in the Metropolitan Museum (43.11.4). Antique inspiration has, however, clearly determined its forms and attributes, and knowledge of Michelangelo's *Cupid* is suggested by the lion skin head, not otherwise a typical attribute of Eros.

Ex collections: Stroganoff, St. Petersburg; [Rosenberg and Stiebel, Berlin]; Bruno Kern, Vienna; Blumka.
Exhibition: Metropolitan, *Northern Italy, 1440–1540,* no. 18.
References: L. Planiscig, "Bronzi ignoti di autori ignoti," *Dedalo,* 12 (1932), 742f. (Venetian, end of fifteenth century); *Bull. Metropolitan Museum of Art,* n. s., 10 (1952), 246 (ill.); Weihrauch, *Bronzestatuetten,* 126–127, fig. 142 (Venetian, c. 1500: a fountain figure by a master associated with late quattrocento copyists of antique bronzes); C. de Tolnay, *The Youth of Michelangelo,*[2] Princeton, 1969, 201–203 (Michelangelo's *Sleeping Cupid*); C. de Tolnay, *Alcune recenti scoperti e risultati negli studi Michelangioleschi,* Rome, 1971 (Accademia Nazionale dei Lincei, *Problemi Attuali di Scienza e di Cultura,* Quaderno 153), 8ff, pl. V, VI).

120 *Ornament Panel with Dragons, Masks and Instruments of War* c. 1505

Zoan Andrea (Mantua and Milan, active 1475 or earlier/1519 or later)

Engraving; H. 5, 70, 27. 30.3 × 13.4 cm.

National Gallery of Art, Rosenwald Collection (B-2,996)

Despite the lack of a large section at the top of this impression, the engraving's basically rectangular format, which derives from architectural ornament (notably the richly carved pilasters by north Italian and Venetian sculptors that began to be employed in large numbers starting in the early 1470s), is clear. The mechanical devices such as cannons, wheels, and pulley systems intermingled here with leaf and mournful looking animal hybrids recall the exploding bombs interspersed with acanthus, cornucopias and vases with which Federico da Montefeltro had sculptors decorate his grand staircase at Urbino (1472–74). They relate contemporary warfare technology and Gian Francesco Gonzaga's image of himself as a military hero (see entry for 10) to an antique mode by the symmetrical disposition of such motifs around a central vertical element. This follows a type of ornament frequently encountered in Roman architecture on pilasters (for example, those framing the reliefs of the Triumph of Titus on his arch in Rome). The proportions of Zoan Andrea's grotesque creatures in relation to the candelabrum do not yet reflect influence of the grotesques of first-century A.D. Roman painting studied by numerous artists in Rome beginning in the 1480s. Yet his combination of such bizarre creatures with mechanical elements in a system that, at least on the surface, remains faithful to classical principles of design, reflects the stylistically ambiguous "anticlassical moment" detected by Battisti, Dacos and others in late fifteenth-century decoration.

Ex collection: Lessing J. Rosenwald.
Exhibitions: Philadelphia Museum of Art, 1960; Antioch College, 1964; Museum of Fine Arts, Boston, 1973; *Prints of the Italian Ren.,* no. 214.
References: Dacos, *Grotesques,* 60, 95 and n. 3; P. Rotondi, *The Ducal Palace of Urbino,*[2] London, 1969, 55f., figs. 98, 99; Levenson, Oberhuber and Sheehan, no. 101 (J. L. Sheehan).

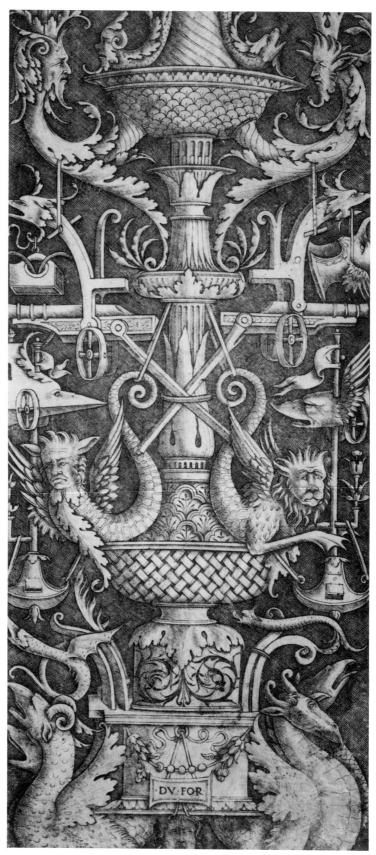

120

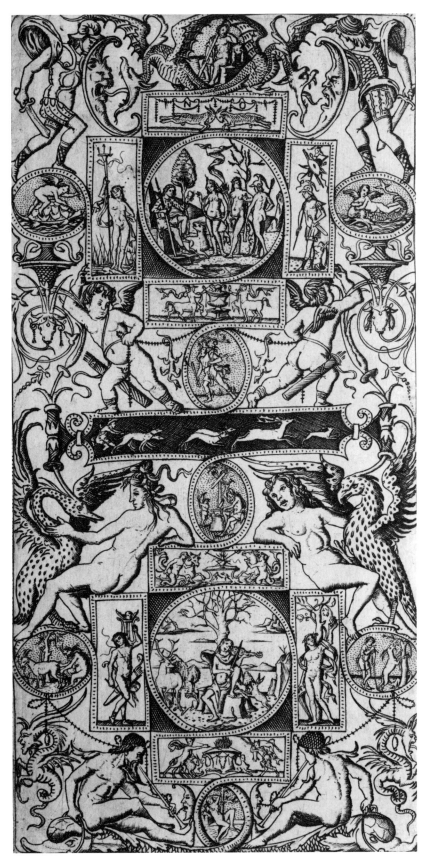

121

122

121 *Ornament Panel with Orpheus and the Judgment of Paris* c. 1507–12

Nicoletto Rosex, called da Modena (Ferrara, active 1500 or before/1512 or later)

Engraving; H. 5, 135, 103(I). 26 × 13 cm.

National Gallery of Art, Rosenwald Collection (B-4,933)

From the 1460s on, interest in antique decorative schemes and motifs assumed increasing importance within the overall antique revival movement (cf. 114–116). After the discovery of the painted decoration of Nero's *Domus Aurea* beneath the Oppian park (c. 1480) throngs of artists groped through the underground passages exploring *grotte,* or caves, leaving behind graffiti that record their presence. They looked in wonder at the seemingly endless succession of rooms painted in first-century A.D. decorative styles, showing strange, delicate, sometimes wistfully humorous creatures, human and hybrid, at play among wispy garlands and acanthus scrolls. One of the earliest examples of a systematic re-creation of decoration in the Neronean manner was the *loggia* of the Villa Belvedere in the Vatican, painted by Pinturicchio for Pope Innocent VIII (1484).

In the Golden House of Nero a graffito reading "Nicholeto da Modena/Ferrara 1507" is one of only two certain documentary references for the career of the painter and engraver Nicoletto. His *Ornament Panel with Orpheus and the Judgment of Paris,* and other engravings closely related to it (for example, 122) do not accurately imitate the first-century grotesque style as did Giovanni da Udine's *grottesche* designs for the *Stufetta* of Cardinal Bibbiena, but instead adopt the essentially late-fifteenth-century version of it that had been created by Pinturicchio, Signorelli, Aspertini and others (Sheehan). In this engraving mythological scenes in Greek cross frames form two focal points around which symmetrically counterposed nude figures, putti and battling warriors are arranged with dragons, sea monsters and other creatures and vegetal ornament. Ovals inspired by ancient cameos extend the ends of the Greek cross frames. The shifts of scale and the ambiguity of the border which at bottom and top blossoms into the tails of monstrous creatures capture something of the spirit of the unexpected and droll that fascinated the Renaissance discoverers of ancient painted decoration. The overall effect of the panel's organization is not unlike the *quadri riportati* of ceiling schemes a century later.

Sheehan interpreted the panel's theme as Love as the Cause of War. Leda and the swan can be associated with the scene in the upper roundel of the Judgment of Paris which led to the abduction of Helen, one of the offspring of Zeus and Leda. The scene of Orpheus charming the animals in the lower roundel can be seen as an allusion to Orpheus's death because of his love for Eurydice. Sheehan's interpretation connects the engraving to the warlike themes in the print that follows it in the sequence (H. 104)

Ex collection: Defer-Dumesnil (Lugt 739).
Exhibitions: Philadelphia Museum of Art, 1960; Museum of Fine Arts, Boston, 1973; *Prints of the Italian Ren.,* no. 325.
References: Dacos, *Grotesques,* 95f., 101f., 121f., 148; figs. 156, 157; Levenson, Oberhuber and Sheehan, 466–468, Nicoletto; no. 172 (Sheehan).

121 (detail)

122 *Ornament Panel with a Birdcage* c. 1507–12

Nicoletto Rosex, called da Modena (Ferrara, active 1500 or before/1512 or later

Engraving; H. 5, 136, 105(I). 25.9 × 13 cm.

Prints Division, The New York Public Library, Astor, Lenox and Tilden Foundations

This panel, the third in the sequence of four beginning with 121, adopts the "candelabrum" organization with motifs disposed symmetrically around a central vertical. Compared to 120, the forms of both grotesque motifs and supporting armature have become much more slender, reflecting the style of Roman painting in Nero's Golden House. Like 121, the entire panel is organized with upper and lower focal points. In this instance the "platform" elements support addossed bound figures, above, and animal hybrids below. The center is occupied by a third important motif, a winged Victory holding trumpets and supporting a birdcage on her head and, on the same base, an opposed running nude and warrior. Unlike 121, however, there is no framing device comparable to the round and oblong fields and narrow border connecting all elements, with the result that legibility is somewhat diminished.

In the sequence of themes this panel shows the battle ended, with the caged bird possibly symbolizing Hope (Sheehan). "Although a battle is taking place just above the birdcage, the relief near the base of the candelabrum depicts a triumphal procession." The inscriptions on the tablets held by the putti at the top have been interpreted as "S[enatus] P[opulus] Q[ue] R[omanus] D[iis] I[mmortalibus]" and "D[ivi] M[arti]."

Nicoletto's engravings were among the major influence in the diffusion of the fashion for grotesques. Their element of caprice, expressed with charm and inventiveness, became a major ingredient of Mannerist decoration schemes around mid century.

Exhibition: Prints of the Italian Ren., 327.
References: Dacos, *Grotesques,* 95f., 121–135; *passim;* Levenson, Oberhuber and Sheehan, 466–468, Nicoletto; no. 174 (Sheehan).

123 *Ornament Panel with Grotesque Figures*
 1514–15
Giovanni Antonio da Brescia (Active c. 1490/after 1525)

Engraving; H. 5, 50, 46. 27.6 × 16.4 cm.

Museum of Fine Arts, Boston, Stephen Bullard Memorial Fund (42.46)

Giovanni Antonio da Brescia, an engraver who spent sixteen years or more in Mantua in the circle of Mantegna (c. 1490–1506, cf. 11), seems to have moved to Vicenza after Mantegna's death, where he was influenced by the work of Bartolomeo and Benedetto Montagna (see 33, 35). No later than 1513 he went to Rome. There he was influenced by Raphael and his

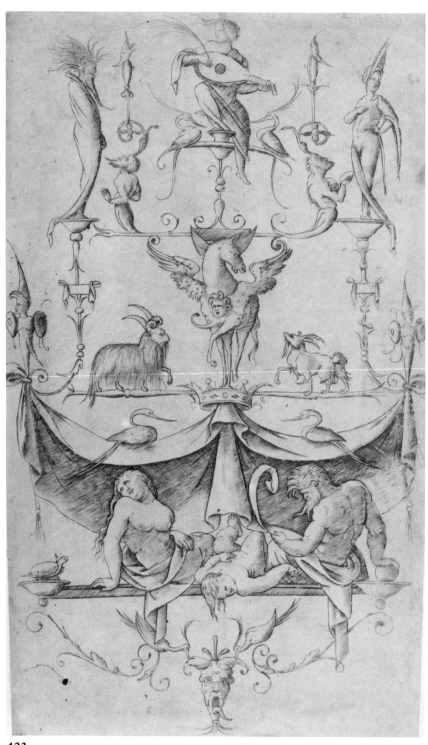

school, Peruzzi, Marcantonio Raimondi (see 45, 56, 102), and Aspertini (22), who very likely provided the drawing for this engraving.

Usually Giovanni Antonio worked from designs provided by others. His graphic technique was highly developed. The sharp outlines and fine, regular modeling lines associated with his prints after drawings or engravings by Mantegna became freer with the "light and free technique of cross-hatching" (Sheehan, 236) seen in such engravings as his *Hercules and the Cretan Bull* (H. 41, 16) based on a Campana plaque. He copied at least one ornament panel print from Nicoletto da Modena (see 121, 122; H. 50, 45), but another in the same series was based on an antique pilaster now in the Uffizi (H. 50, 42). Giovanni Antonio's own study of the antique is also recorded in his engraving of the *Laocoon* (in reverse to the sculpture, H. 43, 20), perhaps the earliest record of the group after its exhumation, and in his *Torso Belvedere* (H. 42, 19).

Although Giovanni Antonio's reputation is as more of a reproductive engraver than a painter engraver, this plate shows his sympathy toward innovation in the early cinquecento process of transforming Neronian decoration into a modern idiom. Another print in this series in which he superimposed aedicules surrounded by foliate decoration of extreme delicacy in a free-floating composition represents a wholly new and profoundly original stage in exploring the possibilities of the *Domus Aurea* vaults (H. 51, 50). Hind notes its resemblance to the Vatican *Logge* decorations.

The *Ornament Panel with Grotesque Figures* anticipates this newly pictorial approach. The partially draped man and woman, the nude infant between them in dramatic foreshortening, recall those in Marcantonio's *Massacre of the Innocents* (45). They exemplify what Laurie Fusco has termed the "pivotal presentation" of Pollaiuolo (44; Levenson, Oberhuber and Sheehan, 77), with the additional symmetry of a male-female contrast. The triad may mean that the engraving has some symbolic meaning not yet deciphered. The wonderful strangeness of the figures on the uppermost tier and the animals on the flimsy supports on either side of the Pegasus encumbered by the wailing horse-cherub have a fantastic quality that far surpasses Nicoletto da Modena's grotesques. The spatial organization, moreover, in allowing more air and space to circulate among the figures and animals, reflects a lessening of the *horror vacui* that often characterizes the grotesque decoration that is still under the sway of the Pinturicchio style of the 1480s (121, 122).

Exhibition: Prints of the Italian Ren., no. 209.
References: Hind, 5, 33–54 (G. A. da Brescia); Dacos, *Grotesques,* 96; Levenson, Oberhuber and Sheehan, 197–199, Mantegna School; 235–237, Giovanni Antonio da Brescia (Sheehan).

124 *Inkstand with Inset Reliefs of Scenes from the Life of Hercules* c. 1515–20(?)

Attributed to Moderno, Galeazzo Mondella? (North Italy, Verona?, active c. 1500, in Rome by 1506?)

Bronze (hollow cast); dark red-brown lacquer rubbed to russet highlights on the reddish bronze of the plaquettes with paler yellowish bronze in the figures. 24.9 × 19 × 16 cm.

National Gallery of Art, Widener Collection, 1942 (A–134)

Toward the end of the fifteenth century growing interest in antique decorative art was expressed in Padua with the manufacture of objects that could combine the taste for antique ornamentation while serving some useful function. Appurtenances for a writer's study characteristically contributed some visual antique reminiscence to the labors of scholarly work or literary composition. Wondrous concatenations of fanciful acanthus-leaf–pastoral–marine–hybrid creatures resulted (compare 9, 101, 102). Suave and elegant candlesticks, lamps and sandboxes belonged to this category of *all'antica* decorative taste (117, 125).

The first rank of quality among such utilitarian objects is represented by this impressive inkstand. Its attribution to Moderno follows from the three plaquettes by him adapted for the decoration of the three sides: *Hercules and a Centaur* (Bange 483), *Cacus Stealing the Oxen of Hercules* (Bange 482), and *Hercules and the Oxen of Geryon* (Bange 485), in which the running figure of Hercules, seen from behind, resembles the central warrior fighting with an axe-wielder in Pollaiuolo's *Battle of the Nudes* (44).

The inkstand's lid and three corners are decorated with bound satyrs that, like Riccio's small bronze satyrs, "seem to express all the incoherent aspirations of some sub-human species towards a state that it cannot attain" (Pope-Hennessy). Riccio first perfected the motif on his *Paschal Candlestick* for S. Antonio, Padua, installed in 1516. A post-1516 dating is often given for sculptures, like these satyr embellishments, thought to be descended from it. Ultimately the motif may derive from the *Volta Gialla* of Nero's Golden House, where two bound satyrs are portrayed at the foot of a trophy (Dacos, figs. 53, 54), or from a gem like the brown sard intaglio in the collection of Lorenzo de' Medici depicting Marsyas bound to a tree and Apollo with his lyre (Vollenweider, pl. 64; earlier in the collection of Lorenzo Ghiberti). On the *Paschal Candlestick,* Riccio rendered it with new imaginative force and directness, creating models that were often, as in this instance, followed by his shop and Moderno's. The lush garlands, shells and grotesque masks recall the decorative vocabulary bequeathed by Donatello to his followers during his ten-year stay in Padua (1443–53).

Ex collections: Marquess of Exeter, Burghley House, 1888; John Edward Taylor, London, 1912; [Duveen, New York]; Widener, Elkins Park, 1942.
References: Bange, nos. 482, 483, 485; L. Planiscig, *Andrea Riccio,* Vienna, 1927, 335 and fig. 396; 489, no. 195; Pope-Hennessy, *IRS,* 106; *Kress,* nos. 135, 136, 137; C. Seymour, Jr., *Sculpture in Italy, 1400–1500,* Harmondsworth/Baltimore, 1966, 124; Dacos, *Grotesques,* 38 and n. 9; M. L. Vollenweider, *Die Steinschneidekunst und ihre Künstler in spätrepublikanischer und augusteischer Zeit,* Baden-Baden, 1966, 114, pls. 63, 64.

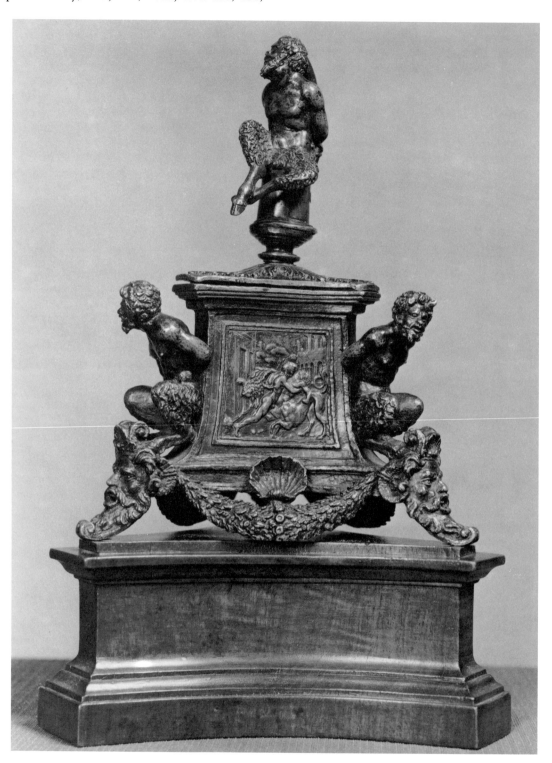

124

125 *Lamp in the Form of a Grotesque Sphinx*
16th century

After Andrea Riccio (Padua 1470–75/Padua 1532)

Bronze oil lamp; remains of dark brown lacquer patina. 12.4 cm.

The Metropolitan Museum of Art, Rogers Fund, 1911 (11.38.2)

This amusing oil lamp demonstrates the Renaissance delight in and fascination with the grotesque. Hybrids like this sphinx which draw upon the forms of rediscovered Roman first-century A.D. painting (Dacos) were increasingly favored as decoration. In north Italy, Andrea Riccio's inventions in bronze revealed the rich gamut of his fantasy, by turns whimsical, classical, and romantic (109, 110), inspiring the many decorative objects employing antique motifs as novelties.

The sphinx lamp has the head of a woman and the body of a lion. She has leaflike shoulder joints, furled volute-wings, a leaf ornament down her spine, and a ram's horn headdress, originally surmounted by a lion's head crest, that survives in one exemplar (Louvre; Planiscig, fig. 478). A wick was lit in the projecting oil container, fueled via a hole in the sphinx's back with a shell lid. With a delightfully ironic, world-weary expression, the sphinx puffs out her cheeks as if resigned to keeping alive the flame of inspiration.

Sphinxes appear on Riccio's Paschal candlestick (1507–16) and figure prominently in the Della Torre monument S. Fermo Maggiore, Verona (c. 1515–21; reliefs in Louvre). The motif was well-attuned to the taste for bronze decorative objects with classically inspired themes. Riccio's bronze-working shop was for almost two decades the primary manufacturing center for such furnishings in north Italy. After his death, the production was continued by Desiderio da Firenze and others. The present state of knowledge does not permit a definitive attribution of the model for this lamp to Riccio. Variants exist in the Louvre; the Museo Nazionale, Florence; the Weinberger collection, Vienna (1927); the Bachstitz Gallery; and the Landesmuseum, Troppau.

Ex collection: Adolf von Beckerath.
Exhibition: Metropolitan, *Northern Italy, 1440–1540,* no. 37.
Reference: L. Planiscig, *Andrea Riccio,* Vienna, 1927.

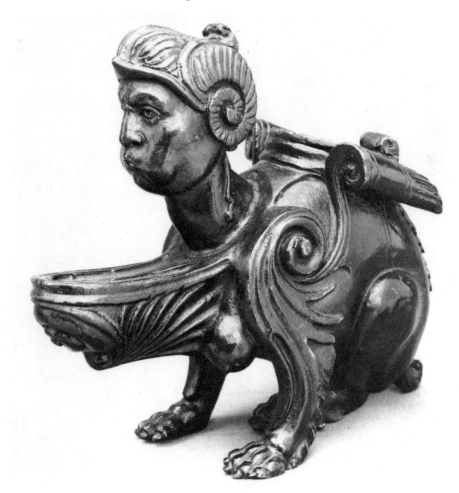

126 *Toad with a Young Toad on Its Back*
16th century

Padua

Bronze (hollow cast); natural brown patina with traces of brown-black lacquer. 6.5 × 12 × 12 cm.

The Metropolitan Museum of Art, Gift of Ogden Mills, 1925 (25.142.24)

The fashion for bronze casts of animals taken directly from nature arose in Padua c. 1500. There artists, still following the tradition established by Donatello during his ten-year residence in Padua (1443–53), did not regard naturalism as incompatible with antique revival. From the viewpoint of their humanist patrons, the science of natural history was itself an aspect of antique revival. The upsurge of interest in one's natural surroundings was especially evident in Padua, where by 1500 the intellectual ferment culminating in Galileo's scientific method was already a century old. The advances in anatomy made by the Paduan doctor Marc Antonio della Torre during the first decade of the sixteenth century partook of the same current of scientific observation, which arose

out of the critical re-evaluation of Aristotle's scientific principles.

Lysistratos, the brother of Lysippos, began the practice of taking casts of the human face (or possibly the entire body; Pliny, *Nat. Hist.* 35, 153, cf. comment by Pollitt) and perfecting them in the wax model. This practice in ancient times was referred to as early as Cennino Cennini's *Treatise* (c. 1390). The taking of plaster casts, as for funerary portraits, was thus regarded as a continuation of antique traditions, and not as an aid to naturalism at variance with classical idealism.

Animals cast in bronze from nature were very likely first produced in the shop of Andrea Riccio, given the artist's close connections with such Paduan intellectuals as Girolamo della Torre and his three sons, and the fact that his was the major bronze-producing shop in the city from c. 1510 until the artist's death. The *Toad with a Young Toad on its Back* is an example of the casts of small animals—frogs, salamanders, crabs, turtles and snakes—that became expected accouterments of a humanist's or doctor's study early in the cinquecento in Padua. Such casts were part of the same current of

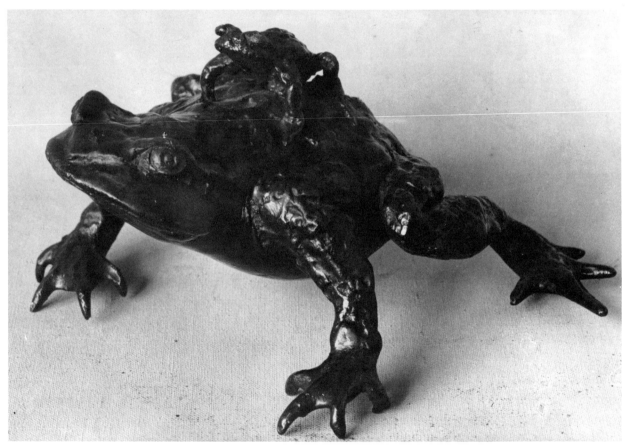

126

taste that favored candlesticks (117), inkstands (124) and lamps (125) with decoration inspired by antique painted grotesques. These objects were often painted to give them an even more naturalistic appearance. They came to be regarded as curiosities in miscellaneous collections that mingled artifacts, found objects, antiques and souvenirs by collectors who were not scientists or intellectuals.

Ex collection: Ogden Mills, 1925.

Exhibition: Metropolitan, *Northern Italy, 1440–1540,* no. 38.

References: C. Cennini, *Il libro dell'arte* (1390), trans. D. V. Thompson, Jr. as *The Craftsman's Handbook,* New Haven/London, 1936, 127; E. Kris, "Der Stil 'Rustique,' die Verwendung des Naturabgusses bei Wenzel Jamnitzer und Bernard Palissy," *JKS,* new series, 1 (1926), 137–208, esp. 137–143; L. Planiscig, *Andrea Riccio,* Vienna, 1927, 363–366 (animals cast in bronze after nature illustrated in figs. 450, 453–456, 463–464); F. Saxl, "Pagan Sacrifice in the Italian Renaissance," *JWarb,* 2 (1938–9), 346–367; J. H. Randall, Jr., "The Development of Scientific Method in the School of Padua," P. O. Kristeller and P. P. Wiener, eds., *Renaissance Essays,* New York/Evanston, 1968, 217–251 (first published 1961); Pollitt, *Art of Greece,* 151.

127 *Panel of Grotesque Decoration* c. 1547

Attributed to Perino Buonaccorsi, called del Vaga (Florence 1501/Rome 1547)

Drawing; pen and brown ink with watercolor. 19 × 22.8 cm.

The British Museum (1918–6–15–1)

Giovanni da Udine's *grottesche* designs for Cardinal Bibbiena's *Loggetta* and *Stufetta* and for the great *Logge* in the Vatican aimed to re-create Roman painted and stucco decoration, especially as it existed in the Golden House of Nero, which, to Renaissance visitors, seemed a mysterious warren of interconnecting underground rooms on whose walls many inscribed their names (Dacos). This beautifully colored drawing was long attributed to Giovanni, the principal re-creator of Roman painting style *alla grottesca*. P. J. Mariette, convinced of the attribution, inscribed Giovanni's name on the drawing's mount.

Its hues as well as its forms recall Roman painting as well as Giovanni's Vatican decorations. Fragile, airy architectures inhabited by slender animated figures and animals, with delicate swags and arbors above, seem to

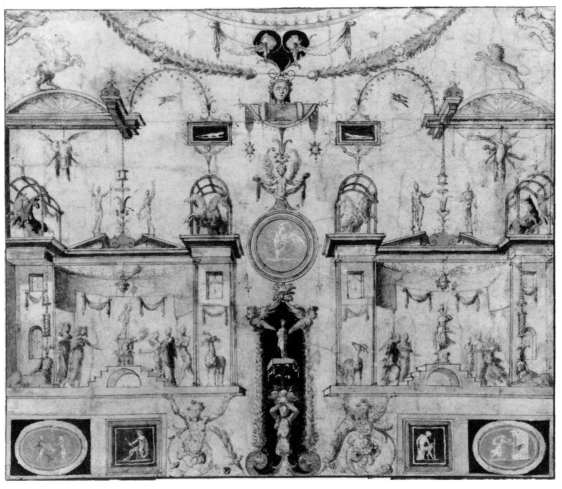

127

float on either side of a central vertical candelabrum of grotesques and a bird brushed in with rapid impressionistic strokes against a golden circle, like a cameo of yellow stone. Four other oval and square cameos along the lower edge are colored with brighter, more intense hues than the pale lavenders and earth tones of the architectures. Agile leafmen improbably support the entire dreamlike structure from below.

In attributing the sheet to Perino with a query, Pouncey and Gere noted that no drawings of grotesques have been securely attributed to Giovanni as autograph works. They linked the drawing instead to a group of Perinesque architectural and ornamental studies at Windsor, connected to his work in the Castel Sant'Angelo (c. 1545). A few of these are by Perino himself, but most were done after his death by a follower. The life and spontaneity exhibited by the forms in *A Panel of Grotesque Decoration* would warrant an attribution to Perino. However, one of the Windsor sheets bears the papal arms of Julius III, who reigned after the artist's death (1550–55). This persuaded Pouncey and Gere that the entire group may very well postdate Perino, although they chose to let the attribution stand with a query.

During his career as one of the principal inheritors of the style and techniques of decoration bequeathed to his workshop team by Raphael, Perino del Vaga was called upon repeatedly to depict scenes from classical mythology or ancient history. His recourse to antique prototypes is shown by the *grisaille* based on a much-copied sea battle relief in the Grimani family collections (now in the Museo Archeologico, Venice). The scene, in a fictive frame in the *spalliera,* is immediately beneath Raphael's *School of Athens* (a version of the composition, possibly made for an engraving, is also in the British Museum [1946–7–13–470]). Since Perino joined the assistants working in the Vatican *Logge* in 1518, and "a significant share of the painting of the later bays came to be assigned to him" (Freedberg, 138), his assimilation of the style of grotesque decoration invented and promoted by Giovanni da Udine is altogether understandable. Nearly thirty years later, in designs for the Sala Paolina in the Castel Sant'Angelo, the handling of decorative motifs occasionally recapitulates motifs familiar from the earlier programs, albeit within a differently conceived framework of fictive architectural forms (Gere, figs. 16, 17).

Ex collections: Unidentified eighteenth-century collector who inscribed artists' dates on his mounts; P.–J. Mariette (Lugt 2097: sale, Paris, Basan, 1775, lot 539); Seroux d'Agincourt; Count M. von Fries (Lugt 2903); Marquis de Lagoy (Lugt 1710); Sir T. Lawrence (Lugt 2445); W. Russell (Lugt 2648; sale, Christie, 11 December 1884, lot 430); Sir E. J. Poynter (Lugt 874: sale, Sotheby, 25 April 1918, lot 187); [Colnaghi]; Sir Otto Beit.

References: J. A. Gere, "Two late fresco cycles by Perino del Vaga: the Massimi Chapel and the Sala Paolina," *BM,* 102 (1960), 9–19; British Museum, *Italian Drawings, Raphael and his Circle,* catalogue by P. Pouncey and J. A. Gere, 2 vols., London, 1962, I, 109–110, no. 184; II, pl. 154; B. F. Davidson, *Perino del Vaga e la sua cerchia,* exhibition catalogue, Florence, 1966; M. Hirst, "Perino del Vaga and his Circle," *BM,* 108 (1966), 398–405; Dacos, *Grotesques,* 3–25, 139–160, and passim; S. Freedberg, *Painting in Italy, 1500–1600,* Harmondsworth, Middlesex; Baltimore, 1970, 43–44, 138–142, 169–172; B. F. Davidson, "The Decoration of the Sala Regia under Pope Paul III", *AB,* 58 (1976), 395–423.

127 (detail)

Antique Revival in
Architectural Theory

LIBER QVARTVS.

VM aíaduertiſſem Impator plures de architectura
ꝓcepta volumíaꝗ cómétarioꝝ nó ordinata ſed íce/
pta vti particulas errabũdas reliqſſe,dignã & vtiliſ/
ſimã ré putaui antea diſciplinæ corpus ad pfectã or
dinatíoné ꝓducere, & ꝓſcriptas in ſingulis volumi
nibus ſingulorum generum qualitates explicare.

Itaꝗ Cæſar prio volumine tibi de officio eius & ꝗbus erudítũ eé rebus ar/
chitectum oporteat,expoſui,Secũdo de copiis materiæ e ꝗbᵒ ædificia cóſti/
tuunt,diſputaui,Tertio aũt de ædiũ ſacraꝝ diſpoſitióibus & de eaꝝ geneꝛ
varietate ꝗſꝗ & quot ha
beãt ſpés,earũꝗ, ꝗ ſũt in
ſingulis gñibᵒ, diſtribu/
tíóes, ex tribuſꝗ gñibᵒ ꝗ
ſubtiliſſimas hérét ppor
tóibᵒmoduloꝝ ꝗlitates,
ionici gñis mores docui
Nũc hoc volumíe de do
ricis coríthiiſꝗ íſtitutis
& oíbus dicã,eorũꝗ di/
ſcrimía & proprietates
explicabo.

De tribus gñibus co
lumnarũ origines & in/
uentióes. Cap. I.
Columnæ corinthíæ ꝓter
capitula oés ſymmetri/
as hñt,vti ionicæ,ſed ca/
pituloꝝ altitudíes effici
unt eas pro rata excelſio
res & graciliores,ꝗ ioni

ci capituli altitudo ter/
tia pars é craſſitudís co/
lũmæ,corithii tota craſ/
ſitudo ſcapi,Igit̃ ꝗ duæ
partes e craſſitudine co/
lũnarũ capitulis corin/
thíoꝝ adiiciunt efficiũt
excelſitate ſpeciem eaꝝ
gracílioré.Cætera mem

128 [*De architectura*] 1511
Vitruvius Pollio
Printed book; folio; Venice, Giovanni Tacuino. (Edited by Giovanni Giocondo.) Woodcut title border; 136 woodcuts in text. 31.8 × 22.3 cm.
Houghton Library, Harvard University, Gift of Mary B. Brandegee in memory of William Fletcher Weld (★fOLC.V834.511 (A))

Illustrated editions of Vitruvius's first-century Roman treatise on architecture were among the earliest examples of sixteenth-century architectural books, described by Peter Wick as "a genre of the most splendid Renaissance book illustration and design, involving the awakening excitement to classical antiquity by the leading practitioners, many of them engaged in heroic building commissions for royal and princely patrons." This 1511 edition published in Venice by the firm of Giovanni Tacuino was the first Vitruvius to have illustrations other than diagrams, illustrations which reveal Giocondo's remarkably advanced understanding of the text. The first published edition of Vitruvius was that of Eucharius Silber at Rome, c. 1486, which contained one diagram at the end of Book I. The woodcuts illustrating this edition of 1511 were copied in the Venice editions of 1524 and 1535. Reduced copies were made for Florentine octavo editions of 1513 and 1522.

Giovanni Giocondo's reputation as an architectural theorist and scholar was secured by his edition of Vitruvius's treatise. A Dominican monk born at Verona c. 1433, Giovanni showed deep interest in the culture of antiquity by his activity in epigraphy, a field he attempted to reform by insisting on topographical arrangement and accurate reporting of inscriptions. He worked as an architect in Naples (1489–93) and went to France at the behest of Charles VIII (1495), where he built the Pont-de-Notre-Dame, Paris (1500–08). During Bramante's last illness he became a supervisor of St. Peter's and after Bramante's death in 1513, he shared this post with Raphael and Giuliano da Sangallo until his own death in 1515.

Foelicus Sabellus, a sixteenth-century owner of this copy of *De architectura,* made numerous marginal notes. Sabellus's annotations demonstrate an educated man's reading of Vitruvius with the aid of ideas remembered from Pliny and Ovid (as at pp. 22–23) and "moderns" of the last century, such as Alberti (p. 25).

Ex collection: Foelicus Sabellus (sixteenth century).
Exhibition: Harvard, *Sixteenth Century Architectural Books,* no. 1.
References: Weiss, *Discovery of Antiquity,* index, s. v. Giocondo; Mortimer, v. 2, 755–756, no. 543 (ill. title border).

129 *De architectura libri dieci* 1521
Vitruvius Pollio
Printed book; folio; Como, Gottardo da Ponte. (Translated by C. Cesariano.) Woodcut title border; 117 woodcuts in text. 43.5 × 29 cm.
Houghton Library, Harvard University, Gift of Thomas Hollis (★fOLC.V834.Ei521 (B))

Cesare Cesariano's Italian translation of Vitruvius's *De architectura libri decem* made available for the first time the text of the major theoretical and practical architecture treatise to have survived from classical antiquity. Cesariano, the editor and principal illustrator as well as the translator, had studied painting under Leonardo in his native Milan, and architecture under Bramante. His commentary on Vitruvius reflects their ideas.

Leonardo's influence on the illustrations of the Como edition has often been noted. Cesariano's figure of a man inscribed within a square and circle on a grid (folio L), illustrating the Vitruvian scheme of human proportions, is related to Leonardo's famous *Vitruvian Man* drawing (Venice, Accademia). This illustration, like those in Giovanni Giocondo's 1511 edition (128), was probably made within the context of theoretical discussions among artists and scientists at the Milanese court of Lodovico il Moro in the later 1480s. Cesariano accompanied his illustration with the comment that with the Vitruvian figure one can determine the proportions of everything in the world. This was commonly taken to mean architectural membering and often applied literally to the association of church designs with the shapes of the human body. Architects' uses of Vitruvius as an ancient authority for a philosophical system linking architectural proportions with Christian cosmology, an aspect of classical revival that typifies Renaissance syncretism, was elucidated by Wittkower in *Architectural Principles in the Age of Humanism.* The publication of Cesariano's edition in 1521 coincides with the beginning of an era when study and application of Vitruvian theory became a kind of architects' Bible.

Cesariano's approach to the antique text is also noteworthy for the attention paid to local Milanese monuments and the attempt to include within a Vitruvian framework examples of the Gothic style in architecture. Cesariano's section diagram of Milan Cathedral, analyzed in terms of his system of triangulation, is the first such illustration of Gothic architecture ever published.

Exhibition: Harvard, *Sixteenth Century Architectural Books,* no. 2
References: R. Wittkower, *Architectural Principles in the Age of Humanism,* N. Y., 1965 (Columbia University Studies in Art History and Archaeology, 1) 13–15; Mortimer, v. 2, 756–759, no. 544 (illus.).

COLVMNARVM EX SEX GENERIBVS CAPITVLORV: BASIV & SPIRARᵉ ALIORᵉ QVOQᵹ
GENERV CAPITVLOBᵉ QVOBᵉ A VITRVVIO SYMMETRIÆ PERSCRIPTÆ SVT AFFIGVRATIONES.

li Epiftylii Zophori & corone & fic de fingulis : Li capitelli de quefte fono quafi di tanta uenuftate : quanto li Corinthii : & fono
faſti in narii modi : ma quaſi perho con pocha comentatione de fymmetrie diferente ut diçtum eſt da li Corinthii : La uarietate
de li quali & de altri capitelli imitati da le fymmetrie de le campane & uafi : fi como e fignata la diçtione ᴈ. & Si como da molti
Romani ædificii ho exemplato alcuni quiui etiam per dimonftrarte di quello dice Vitruuio in la præfente leçtione li ho affigurati.

Ma il tertio quale Corynthio fi díce ha imitatione de uírginale gracili
tate : per che le uírgine per la tenereza de la ætate con piu fubtili mem
bri figurati receueno li effeçti piu uenuſti in lo ornato . Ma la prima in
uentione di epfo capitello eſſere façta coſi fe memora : una uírgine Cí

❡ Ma il tertio che Corynthio fi dice &c.
Vitruuio quiui defcribe la inuentione del
capitello Corinthyo con breuita del hiſto
ria . ❡ Matura a le nuptie : ideſt epſa uir
gine era Matura ad eſſere maritata : feu
da ponerla in la religione . per che in qui

129

Index

Index